lectulum ⁊ obiit. appositusque ad populum suum. Quem cernens Ioseph ruit super faciem patris flens et osculans eum. Precepitque servis suis medicis ut aromatibus condirent patrem. Quibus iussa explentibus transierunt quadraginta dies. Iste quippe mos erat cadaverum conditorum. Flevitque eum Egyptus septuaginta diebus. Et expleto planctus tempore locutus est Ioseph ad familiam Pharaonis. Si inveni gratiam in conspectu vestro loquimini in auribus Pharaonis eo quod pater meus adiuraverit me dicens. En morior in sepulcro meo quod fodi mihi in terra Chanaan sepelies me. Ascendam igitur et sepeliam patrem meum ac revertar. Dixitque ei Pharao. Ascende et sepeli patrem sicut adiuratus es. Quo ascendente ierunt cum eo omnes senes domus Pharaonis cunctique maiores natu terre Egypti. domus Ioseph cum fratribus suis absque parvulis et gregibus atque armentis que dereliquerant in terra Gessen. Habuit quoque in comitatu suo currus et equites et facta est turba non modica. Veneruntque ad aream Atad que sita est trans Iordanem. ubi celebrantes exequias planctu magno atque vehementi impleverunt septem dies. Quod cum vidissent habitatores terre Chanaan dixerunt planctus magnus est iste Egyptiis. Et idcirco appellaverunt nomen loci illius planctus Egypti. Fecerunt igitur filii Iacob sicut preceperat eis. Et portantes eum in terram Chanaan sepelierunt eum in spelunca duplici quam emerat Abraham cum agro in possessionem sepulcri ab Ephron Ethheo contra faciem Mambre. Reversusque est Ioseph in Egyptum cum fratribus suis et omni comitatu sepulto patre. Quo mortuo timentes fratres eius et mutuo colloquentes ne forte memor sit iniurie quam passus est et reddat nobis omne malum quod fecimus: mandaverunt ei. Pater tuus precepit nobis antequam moreretur ut hec tibi verbis illius diceremus. Obsecro ut obliviscaris sceleris fratrum tuorum et peccati atque malitie quam exercuerunt in te. Nos quoque oramus ut servo Dei patris tui dimittas iniquitatem hanc. Quibus auditis flevit Ioseph. Veneruntque ad eum fratres sui et proni adorantes in terram dixerunt servi tui sumus. Quibus ille respondit. Nolite timere. Num Dei possumus resistere voluntati? Vos cogitastis de me malum et Deus vertit illud in bonum ut exaltaret me sicut in presentiarum cernitis et salvos faceret multos populos. Nolite metuere ego pascam vos et

parvulos vestros. Consolatusque est eos et blande ac leniter est locutus. Et habitavit in Egypto cum omni domo patris sui: vixitque centum decem annis. Et vidit Ephraim filios usque ad tertiam generationem. Filii quoque Machir filii Manasse nati sunt in genibus Ioseph. Quibus transactis locutus est fratribus suis. Post mortem meam Deus visitabit vos et ascendere faciet de terra ista ad terram quam iuravit Abraham Isaac et Iacob. Cumque adiurasset eos atque dixisset. Deus visitabit vos asportate inquit vobiscum ossa mea de loco isto. Mortuus est expletis centum decem annis vite sue. Et conditus aromatibus repositus est in loculo in Egypto. Explicit liber Genesis. Incipit liber Exodi.

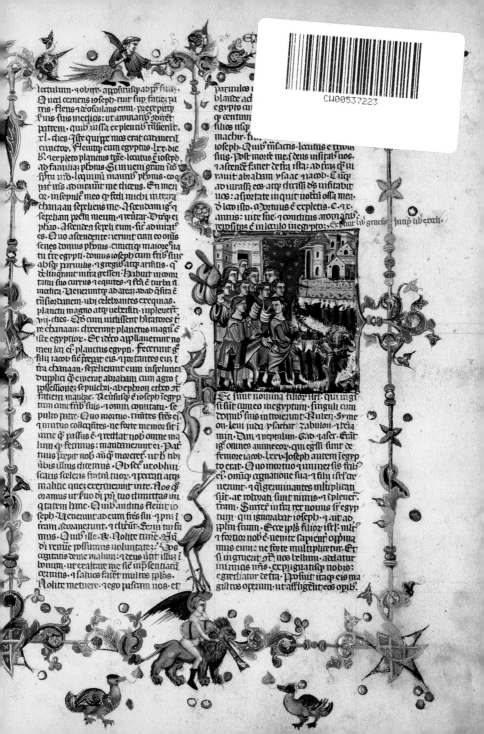

Hec sunt nomina filiorum Israel qui ingressi sunt cum eo in Egyptum cum Iacob: singuli cum domibus suis introierunt. Ruben Symeon Levi Iuda Isachar Zabulon et Beniamin. Dan et Nepthalim. Gad et Aser. Erant igitur omnes anime eorum qui egressi sunt de femore Iacob septuaginta. Ioseph autem in Egypto erat. Quo mortuo et universis fratribus eius omnique cognatione sua et filii Israel creverunt et quasi germinantes multiplicati sunt. ac roborati impleverunt terram. Surrexit interea rex novus super Egyptum qui ignorabat Ioseph et ait ad populum suum. Ecce populus filiorum Israel multus et fortior nobis est. Venite sapienter opprimamus eum ne forte multiplicetur. Et si ingruerit contra nos bellum addatur inimicis nostris expugnatisque nobis egrediatur de terra. Preposuit itaque eis magistros operum ut affligerent eos oneribus.

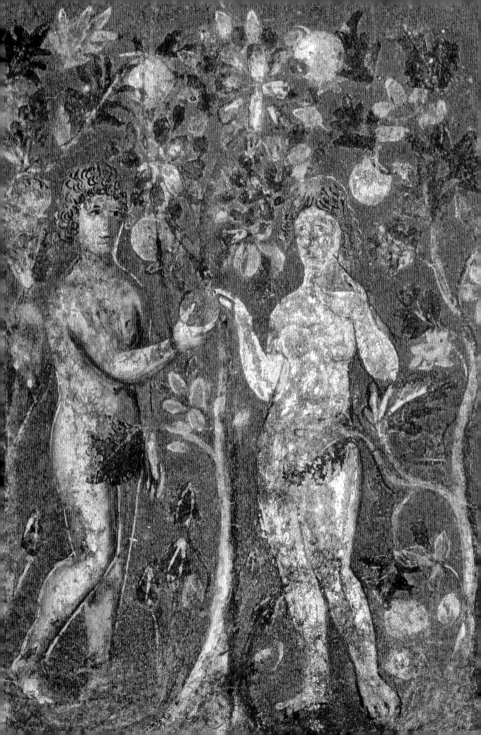

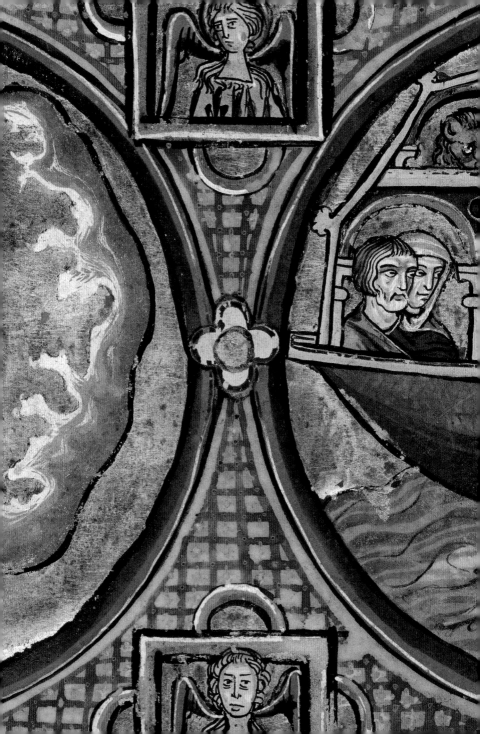

Österreichische
Nationalbibliothek

THE
BOOK OF
BIBLES

THE MOST BEAUTIFUL ILLUMINATED
BIBLES OF THE MIDDLE AGES

Edited by Andreas Fingernagel
& Christian Gastgeber

TASCHEN

Bibliotheca Universalis

Contents

Magnificence and grandeur – luxury Bible manuscripts

Biblical exegesis from the Church Fathers to Scholasticism

Medieval versions of history in world chronicles and history Bibles

The juxtaposition of the Old and New Testaments in typological picture Bibles

Bible manuscripts of the Jewish and Eastern Orthodox faiths

Appendix

Bible production in medieval monasteries

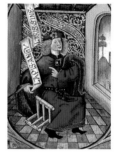

"Oh, you lucky reader, before you touch a book wash your hands, turn the pages carefully and keep your fingers well away from the letters! For someone unable to write Cannot imagine what an immense labour it is.

Oh, how hard is writing: it blurs the eyes, squeezes the kidneys and tortures every limb.
Only three fingers write, but the whole body suffers..."

This graphic description of the sorrows of a scribe (found in a Visigothic dictionary dating from the 8th century) offers us a glimpse not just of the laborious nature of the work, but also of the precious nature of the manuscripts thus produced. With their minds deeply concentrated and their bodies stooped or hunched, monks or lay brothers devoted themselves day after day to the service of God, toiling for over 12 hours a day in the light-filled summer months, writing out the texts of the Holy Scripture with painstaking accuracy and in a standardized script. As well as complete Bibles, they copied out Gospel Books and Epistolaries containing selected passages from the scriptures, liturgical texts, the writings of the Church Fathers and those, too, of the "ancient heathens".
A complete edition of the Bible, extending to some 1200 pages in a folio format, would take a scribe between two and three years to write out single-handedly. Often, therefore, several copyists were engaged upon the same manuscript; in such cases, we speak of several "hands" being involved. Once the text was written out, the next task – performed if necessary by another scribe – was rubrication, i.e. the identification in red ink of the beginnings of sentences or *nomina sacra*. Only after this, as the third stage of the production process, came the illumination of decorative initials and borders surrounding the introductory chapters, etc.

Eberler Bible, Cod. 2770, detail from fol. 85r (Daniel, Prologue): The prophet Daniel with banderole inscribed: *LAPIS ANGULARIS SINE. CA(PITULUM) II.* ("A stone was cut out without [hands...], Chapter 2").

▶ Neapolitan Luxury Bible, Cod. 1191, detail from fol. 3v: Jerome hands a monk one of his writings.

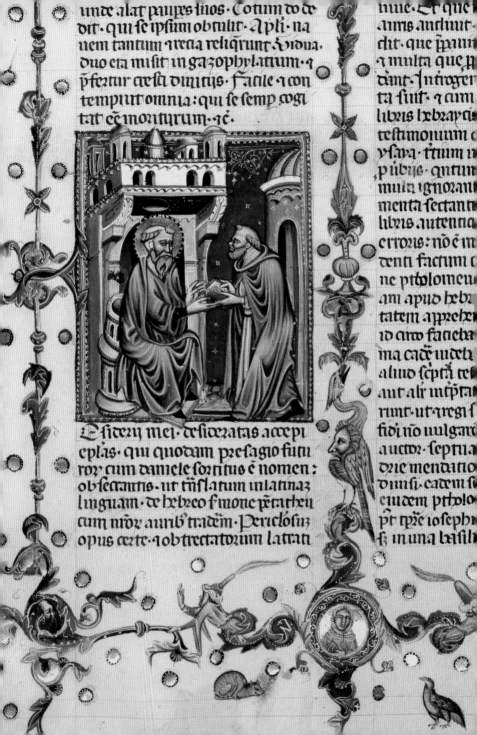

unde alat pauperes suos. Et otium de-
dit. qui se ipsum obtulit. Apli na-
nem tantum retia reliqrunt. Et vidua
duo era misit in gazophylacium. ꝯ
pfertur cresi diuitiis. Facile ꝯ con-
tempnit omnia: qui se semp cogi-
tat ee moriturum. ꝛc.

Esiderii mei desideratas accepi
eplas. qui quodam presagio futu-
ror cum daniele sortitus e nomen:
obsecrantis. ut tñslatum in latinaz
linguam. de hebreo sñmone pñtatheu
cum nrox auribº tradem. Periclosuz
opus certe. ꝯ obtrectatoriuz latrati

nume. Et que
auimus audiuit
dit. que ppann
ꝯ multa que p̄
dint. Introuer
ta fuit. ꝯ cum
libris lxbrayc
testimouium c
ysaya. ttium u
ppubus. qntuñ
multa ignorant
menta sectant
libris autentiã
errois: nõ ê m
denti factum c
ne ptholomeu
am apud hebr
tatem apprehe
ro auro faciebã
ma cade uidetª
aliud scptá ret
aut alr iñpta
runt. ut ꝯ regi s
fidi ñ uulgari
auctoꝛ. septua
oñe mendatio
diuisi. eadem s
eiudem ptholo
pt ipse ioseph
ꝯ in una basili

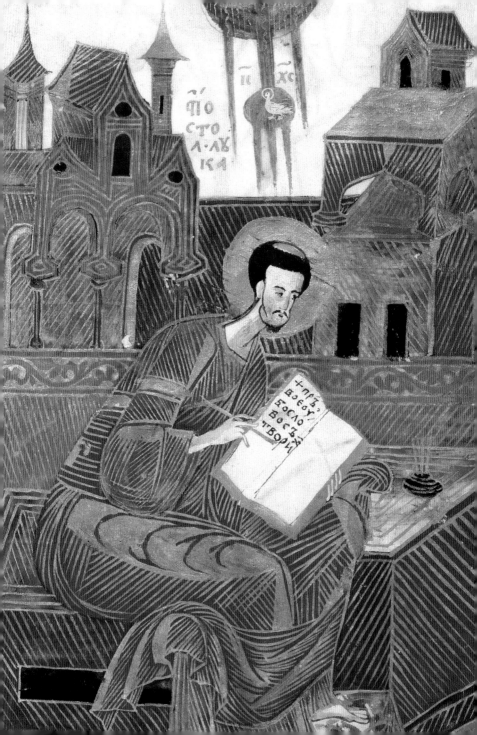

Since daylight was an important prerequisite for the work of a scribe, the
room used as the scriptorium in a monastery can often be identified by its numer-
ous, if fairly small windows. In the depiction of two scribes in the scriptorium
of the abbey church of Echternach (ill. p. 30), for example, we see – within
an idealized and stylized view of the monastery – a long row of small windows
and, copying manuscripts beneath them, a layman on the left and, on the right,
a monk with habit and tonsure. They are sitting, in the hunched position already
mentioned, behind angled desks and are holding their quills with three fingers.
This 11th-century miniature adorns an Epistolary produced for Henry III (today
in the Staats- und Universitätsbibliothek Bremen, Ms. 216, fol. 124v), a type of
manuscript which contains the passages from the Gospels read out during the
Mass, arranged according to the liturgical year.

For an entire millennium, between 500 and 1500, monasteries were the chief
centres of writing, of manuscript production, of the housing of books in libraries
and often, too, the chief centres in which they were used. In the 6th century, af-
ter the collapse of the Roman Empire and prior to the rebuilding of secular power
centres in Europe, the papacy took over the task of safeguarding the cultural
heritage both of Greek and Roman antiquity and of Christianity. Reformist popes
such as Father of the Church Gregory I, known as Pope Gregory the Great
(reg. 590–604), were supported by the monasteries, within whose strict, hierar-
chical structure the study of the Christian scriptures and their translation into
contemporary modes of expression were the prime concern.

In the *Regula de servis dei* which he wrote for the new monastic communi-
ties springing up across North Africa and southern Europe, St Augustine († 430)
placed the personal striving for perfection at the centre of monastic community
life.
To this belonged the reading of the Holy Scripture. Augustine names – as if it
were a matter of course – a librarian as guardian of this important monastic office.

Of even greater significance for manuscripts and their use was the Rule of
St Benedict of Nursia, who founded the monastery of Monte Cassino in around 530.
His philosophy, summarized in the well-known phrase *Ora et labora*, required
monks to remain in the same community all their lives and to accept the rule of
their abbot, who assigned every member of the monastic community a specific

task in the self-sufficient running of the monastery. The Rule of St Benedict also required prayers and devotions to be performed in the rhythm of the liturgical hours and the *lectio* to be read at mealtimes. In idealized medieval depictions of monasteries, the room devoted to the Library is generally located near the church, so that the books required for liturgical use, divine offices and readings were ready to hand. A scriptorium is usually also nearby. Benedictine monasteries spread rapidly across northern Europe; at least 70 were founded over the course of the 7th and the 8th century, 70 in the 9th and the 10th century respectively, and about 100 in the 11th and 12th century respectively. These Benedictine monasteries played an important role in supporting the educational policies of Emperor Charlemagne (crowned in 800), who initiated not only a reform of handwriting (introducing the Carolingian minuscule) but also, and most significantly, a book-learning and library programme whose impact would endure even into the Middle Ages.

The number of books housed in one monastery varied markedly. We can assume a figure of somewhere between 30 and 60 manuscripts, most of them for liturgical use; only in a few instances up to the 12th century did the total exceed 100. One exception, however, was the Benedictine monastery of Lorsch (764–1248), which particularly profited from Charlemagne's patronage of learning and which according to a catalogue dating from the 9th century housed some 590 codices. These included lavishly illuminated Lectionaries, Epistolaries and Bibles, but also texts by Livy and Sallust as well as others by Greek historians.

Two monastic reforms played an important role in the following centuries, the first introduced by Abbot Berno († 927) at Cluny abbey in France. Berno not only reinstated the strict monastic discipline set down in the Rule of St Benedict, but above all sought to make newly-founded monasteries independent of bishops and secular feudal lords and to place them directly under the authority of the pope. This reform, which was propagated by the monastery of Gorze in Lotharingia as well as by Cluny, contained the instruction – significant for the history of libraries and books – that the scriptorium was one of the most important focuses of work in a monastery. Canon Geoffroy of Sainte-Barbe-en-Auge, writing around 1170, expressed the opinion that *Claustrum sine armario quasi castrum sine armamentario* – "a monastery without a scriptorium is like a castle

without an armoury". Drawing its imagery from life in a Carthusian order, the
charterhouse in Basle later expanded upon this comparison in its *Informatorium
bibliothecarii*:

> *Monasterium sine libris est sicut civitas sine opibus,*
> *castrum sine muro, coquina sine supellectili,*
> *mensa sine cibis, hortus sine herbis,*
> *pratum sine floribus, arbor sine foliis.*

> A monastery without books is like a community without wealth,
> a castle without walls, a kitchen without utensils,
> a dining room without food, a garden without herbs,
> a meadow without flowers and a tree without leaves.

The Cluny reforms prompted the foundation of several new monastic orders,
including the Carthusians in around 1084, the Cistercians in around 1098,
the Augustinian Canons in around 1059 and the Premonstratensians in around
1120. The Carthusians and Cistercians in particular adopted a strict, hierarchical
organization, with the head of the Order directly subordinate to the pope. The
Carthusians evolved out of a colony of hermits established in 1084 by St Bruno
of Cologne († 1101) in La Chartreuse, near Grenoble. In addition to poverty and
self-denial, their prime emphases lay upon meditation and the reading of the Holy
Scripture, accompanied by a strict observance of silence. The copying of books
was thereby set down in the Carthusian Rule as the main focus of manual labour,
making writing and study essential aspects of service to God. Precise instructions
were also laid down with regard to copying, writing materials etc. and even
extended to directions about the lending out of manuscripts. Book production
took place under the charge of the *sacrista*, who held overall responsibility for the
writing utensils and manuscripts and who oversaw copying itself. There emerged
from this a preoccupation with textual accuracy, as works of philological scholar-
ship also became important in their monasteries.

The Carthusians proceeded to build up extensive collections of manuscripts,
collections rivalling the libraries of the Benedictines. Thus an inventory drawn up

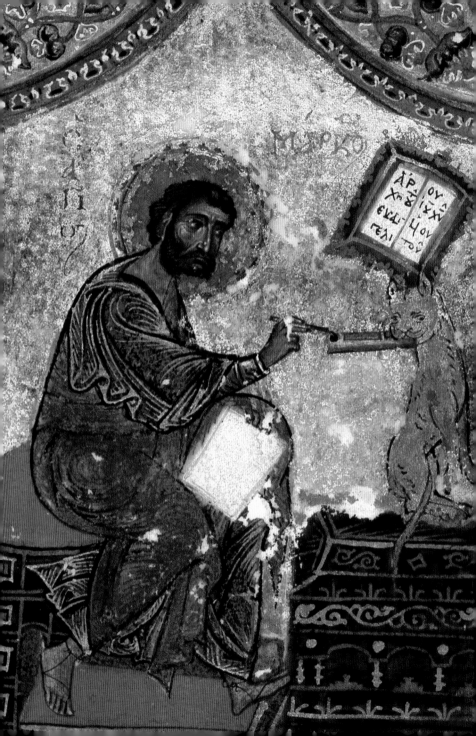

at the charterhouse in Mainz (founded in 1308) in *c.* 1470 lists some 1500 manuscripts and incunabula, including not just Bible manuscripts, theological works and devotional tracts, but also scholastic textbooks as well. The library rules stated that all lendings had to be written down and reviewed every six months, that senior monks enjoyed precedence over junior ones when it came to borrowing manuscripts, that a slip bearing the number of the cell of the borrower had to be put in the place left by a removed book as a "substitute", and that a maximum of five volumes could be borrowed at once. Manuscripts could only be lent out to other monasteries with the permission of the prior.

The new orders being founded in the 13th and 14th century, in particular the so-called mendicant orders, had different requirements of their libraries. The Franciscan Order, founded by St Francis of Assisi in 1209 and granted papal approval in 1223, embraced a life of poverty and itinerant preaching. Although the Franciscans used liturgical books in the Mass, their Rule did not specify a daily reading of the scriptures. Since what possessions the individual houses did own had to be as simple as possible, the few surviving manuscripts from Franciscan monasteries of the 13th/14th century are generally written on plain parchment without embellishment. The oldest documented Franciscan library is that of St Emmeran's abbey in Regensburg, where an inventory of 1347 lists 86 manuscripts, primarily works of biblical exegesis and patristics as might be expected, but also including works on jurisprudence and a copy of Ovid. In Amberg in the Upper Palatinate, on the other hand, the number of manuscripts recorded around 1500 is 52, and in Kehlheim 21 – considerably fewer, in other words, than in the case of the so-called "old orders".

The Order of St Dominic († 1221), based on the Augustinian Rule, aimed to convert heretics through the persuasive power of preaching. Since preaching and serving as confessor were central to the Order, Dominic attached great value to theological training. Study and scholarship were an automatic part of Dominican life. No one was allowed to become a preacher unless they had completed at least three years of theological training, and without at least four years' study of theology, no one could teach in public. The monks were permitted a minimum of personal possessions, a restriction which also extended to books. The Dominican Rule laid down precise regulations for libraries. It was the responsibility of the

cantor to look after the liturgical books, and the scriptorium was headed by a
librarius. The Rule also included instructions relating to how manuscripts should
be housed, looked after, copied, displayed, catalogued and used.

From the Dominican Rule we also learn how a library might grow: firstly,
through the labours of its own scribes, secondly, by contracting work out to
external scribes, and finally by selling duplicate manuscripts in order to be able
to purchase works the library lacked. Libraries also received no small number
of manuscripts as donations and might also inherit books owned by monks who
had died. Since Dominicans were intended to devote themselves first and fore-
most to study, waged scribes were employed to take over some of the work
of copying. All consultation of books was subject to censorship by the librarian
and the prior, in order to prevent any heresy from creeping in. Special permis-
sion had to be obtained in advance for each copy. It was advised not to collect
too many books, but to concentrate upon manuscripts of a sound content, upon
a good selection of authors and upon the accuracy of the text – illumination
was largely avoided.

The first Dominican monastery within the German-speaking sphere was
founded in 1222 in Cologne. Its members included Albertus Magnus († 1280),
Thomas Aquinas († 1274) and the mystic Master Eckart († c. 1328). Teaching at
the University of Cologne, founded around 1388, was for a long time dominated
by Dominican thought: in a fire which swept the library in 1659, autograph
works by Albertus Magnus and Thomas Aquinas were amongst those destroyed.
The Dominican monastery founded in Vienna in 1226 still exists today; a cata-
logue of its library, drawn up in 1490, lists a huge collection of 985 manuscripts.
The books were laid out on desks in systematic order, with the first book always
being the Bible.

Mention should also be made of the Brothers of the Common Life in the
Netherlands and Lower Rhineland, who made an important contribution to
the distribution of books during a period when the age of the manuscript was
drawing to its close. Founded shortly before 1400, this loose association of lay-
men embraced as their goal moral perfection through the personal discovery of
God. Without taking the monastic vow, they lived a communal life with no per-
sonal possessions. They held Scholasticism to be outmoded and wanted to replace

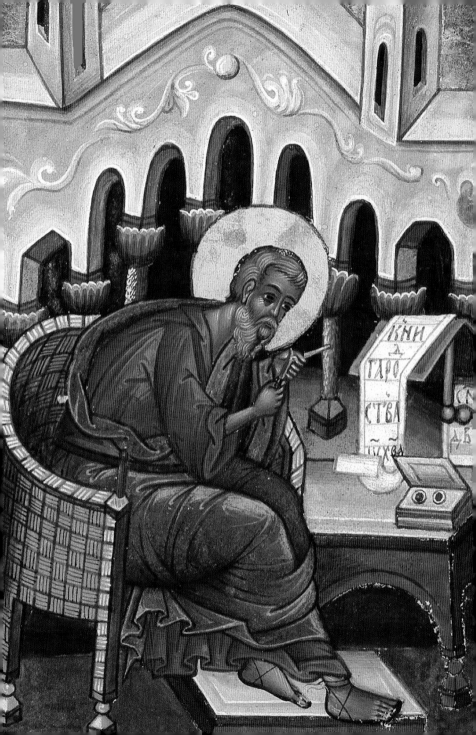

monastic piety, with its renunciation of the world, with a new, popular mysticism, a cosmopolitan *Devotio moderna*. They devoted themselves to caring for the poor and sick, but also to providing spiritual welfare through the dissemination of religious texts. Their particular target groups were impoverished students and clerics, whom they wanted to protect from moral dissipation. Copying books was their sole manual labour. Since they also earned their living from it, one might almost speak of a commercial publishing enterprise, even if they were thereby aiming at a higher goal: preaching not through words, but through writing – *Fratres non verbo sed scripto praedicantes*.

Each fraternity had its own librarian (*librarius*), who as well as managing its manuscript holdings also supervised the accuracy of the copies being made and set the prices at which they were sold, writing master (*scripturarius*), book painter (*rubricator*) and bookbinder (*ligator*). The books these fraternities owned were simple and largely plain, but highly legible. The Brothers of the Common Life produced not only Bibles, but also liturgical books, patristical works, prayer books, meditations and collections of sermons, in many cases in the German language. They also compiled their own anthologies, often containing pious quotations from the works of the Church Fathers. The expansion of the Brothers of the Common Life in the 15th century coincided with the advent of printing, which the fraternity was relatively quick to exploit. Mariental monastery in the Rhineland had its own printing press by as early as 1474, Rostock as from 1476. Working as a scribe in Deventer, for example, was Thomas à Kempis, whose *De imitatione Christi* served as a model example of edifying sermons composed in the spirit of the *Devotio moderna* movement. It is thanks to the efforts of the Brothers of the Common Life that German versions of the Bible were published in print in Cologne at a very early date, 40 years before Luther's ground-breaking translation.

In a codex in the possession of Michelsberg monastery in Bamberg (today housed in the Bamberg Staatsbibliothek), dating from the 3rd quarter of the 12th century and largely devoted to the writings of St Ambrose of Milan, we find a pen drawing illustrating numerous stages of book production (ill. p. 29). Appearing in the central field is the Archangel Michael, who is being venerated by four monks at his feet, with the artist himself on the left placing the final flourish, so to speak. The upper and lower medallions in the central axis portray monks reading and teaching with the aid of books, while in the vertical axes on either side we are shown the various activities involved in making a codex. Pictured on the left, starting from the top, are monks sharpening a stylus, writing on a wax tablet, stretching and scraping the parchment and preparing the wooden boards for the covers. On the right, from the top, a scribe (with a quill behind his ear) is sorting the gatherings which, in the medallion underneath, are being laid in a sewing frame. Only then do we see the edges being trimmed and the clasps being hammered on.

For 1500 years after Christ, the main and most important writing material used for precious manuscripts was not the papyrus that had been used in antiquity for centuries, but parchment. Animal skins were first soaked in a solution of lime and water, in order to remove any remaining scraps of flesh and also to make the parchment more durable. It was then stretched taut on a frame and scraped one more time with a knife, leaving a smooth surface. The scribe gave the parchment a final rub with pumice before starting to write.

Parchment was a very precious material, one for obvious reasons not easily obtainable and therefore also very expensive. A codex of 600 to 800 pages required the skins of some 300 to 400 sheep. Figuratively speaking, a large herd of sheep thus had to be slaughtered and skinned for a single work. In addition to sheep, the skins of goats and calves were also used, and occasionally also donkeys, deer and gazelle, and in special cases even camels. Particularly thin parchment, obtained from the skins of young animals, was highly sought-after, and Books of Hours were even written on the skins of animal foetuses. The skins had to be as flawless as possible, free of scars left by insect bites or injuries, for example, or holes where bones had pierced the skin. Small tears and holes were often sewn up, or left in the parchment and simply written around.

Purple parchment was particularly costly, and was written upon with gold, silver or white ink. This luxury format was chosen first and foremost for Bible manuscripts. More common were brown and black inks, which could be made with materials that were generally readily available in a monastery. To make the normal carbon ink (as described by Pliny in the 1st century AD in his *Naturalis historia*), you simply needed lamp-black and gum. This gum could be obtained north of the Alps from the resin of stone-fruit trees. Pinewood soot was the best for ink. The usual ingredient of brown ink, on the other hand, was blackthorn bark, cut in April or May. The dried bark was pounded, peeled, soaked in water and finally boiled down.

Iron-gall ink was also employed. These deep-black inks were wipe-proof, but depending on their chemical constitution could also react aggressively. In damp conditions, in particular, they ate into the parchment and left a number of holes. Iron-gall inks are made out of metallic salts such as ferrous or copper sulphate, binders such as gum, and solvents, for which wine, beer or vinegar might be used. There were countless recipes for such inks, varying significantly in their ingredients.

Pure gold ink was also employed for particular display. Fragments of gold leaf were ground in a mortar and mixed with nitrates. Oxgall and copper bloom were added, and the whole mixed and poured through a sieve. The resulting ink was then applied with a quill and finally burnished. Gold was frequently depicted using orpiment, a yellow arsenic trisulphide which produced a sulphur-yellow

colour but which was not without its dangers. It was extracted from mines and sold at a high price. So too was green made from malachite, also known under the name of mountain green after its source. Red and yellow ochre were obtained from earth and were simply ground and mixed with water. Pure ultramarine blue was obtained from pulverized lapis lazuli. Since white was relatively difficult to manufacture, white lead was the usual choice. An old recipe contains the following instructions: "Take lead, shape it into sheets, hang it over vinegar, collect the bloom and wash it until it is clean, then you will get white lead." Verdigris – i.e. copper oxide – was also used. Such paints and inks were thus by no means harmless, and the idea, put forward in Umberto Eco's *The Name of the Rose*, of contaminating an illuminated manuscript with a secret poison is not at all far-fetched. Anyone licking their finger frequently while working with these substances would rapidly suffer their ill effects. Instructions on making medieval inks and paints and on preparing parchment are handed down in numerous treatises and in workshop manuals known as pattern books.

We opened this essay with a description of the sufferings of the scribe, who only receives his rightful reward on Judgement Day. The title page of a manuscript containing the twenty books of the *Etymologiae* by Isidore of Seville, dated to the years 1160–65 and today housed in the Bayerische Staatsbibliothek in Munich (Clm 13 031, fol. 1r; see ill. p. 33), shows in the upper half of the picture Isidore in his bishop's robes with a quill in his hand. The scroll bears the words *Fac mea scripta legi que te mandante peregi* – "Prepare my writings, which I have composed at your behest, for reading." The publisher of these writings, Bishop Braulio, accepts the scroll. In the lower half of the picture, the scribe named Swicher is seen on his deathbed. Opposite him sits Christ, also with a book in his hands, passing judgement on the scribe's life. The angel on the right is holding a set of scales and weighing the scribe's achievements in the shape of a codex, which quite literally tips the balance: the devil is forced to flee, and in the middle of the picture the soul of the scribe is taken up to Heaven by an angel. In this manner, not just writing a devotional treatise but also making a copy of a precious manuscript is shown to be a pious form of service to God.

The term "codex" comes from the Latin *caudex*, a wooden board, and thus simply refers to the external shape assumed by the manuscript, as distinct from

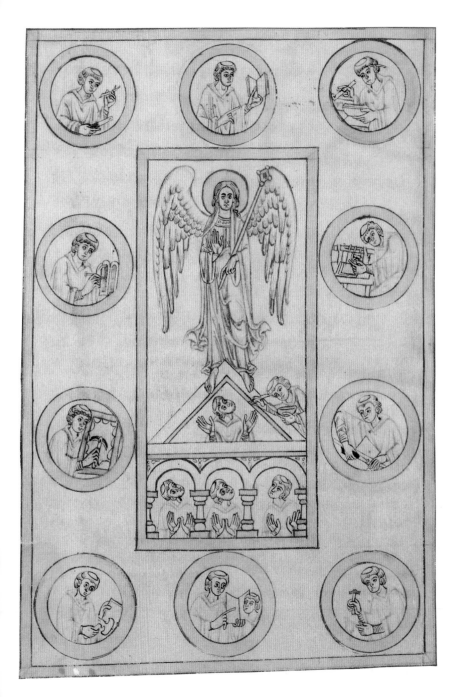

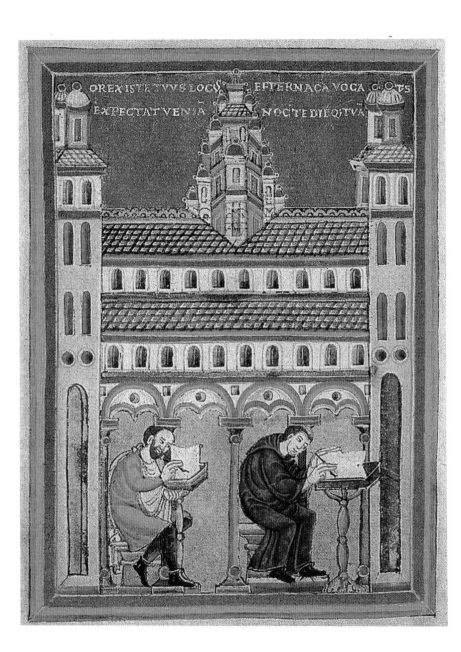

the roll. The codex form was adopted in the first centuries AD both for legal codices and for shorter literary texts, such as Martial's *Epigrams* and the books of the New Testament. It is evident that the codex was easier to use than the more awkward roll.

Papyrus continued to be used into the 5th century AD. Paper made its first appearance from AD 1000 in North Africa and within the cultural sphere of Islam, which had emerged in the Orient in the 2nd century AD and had been spreading across the Arab world since the 8th century. The first paper mills appeared in Moorish Spain in the 12th century; the first north of the Alps were those in Nuremberg, established in 1390. This signified an important change of writing material, without which printing could never have achieved its mass impact. Whether parchment or paper, both materials were squared off and folded into gatherings of 2, 4 or 8 leaves. The writing area was then marked out with fine dots and if necessary the pages ruled with fine lines. Writing itself was carried out with a split-reed pen or feather quill, both of which required frequent sharpening. As a rule, scribes also had to prepare their own inks. With the gatherings in front of them, they first wrote on the recto and verso of the first half of the bifolia, then the second half. Each gathering was given an identifying mark of some kind, to ensure that the quires would be assembled in the correct sequence. These marks variously took the form of pen-strokes, letters and numbers. Later it became the custom to use catchwords, whereby a few words or syllables from the opening lines of the next quire were included in the bottom margin of the last page of each gathering.

Two ink-pots are often depicted in front of the scribe, indicating that he carried out the preliminary rubrication himself. As a rule, however, the actual illumination of a manuscript formed a separate phase of production, one demanding its own talent and skill. The scribe would frequently leave spaces to be filled in with decorative initials, writing a tiny letter – a so-called "representative" – in the gap so that the illuminator would know which initial was required. This custom was adopted in early incunabula, in which printed "representatives" can still clearly be seen in copies that were never subsequently illuminated by hand. After the work of writing and illumination was finished, the quires were bound. In earlier centuries they were stitched together, one sewn directly on top of the

other; only with the invention of the sewing frame, visible in the miniature reproduced here (ill. p. 29), did it become possible to join together a larger number of quires without actually attaching them directly to each other. Instead, they were stitched to bands of leather or parchment which increased the stability of the whole and could be attached in turn to the wooden boards making up the covers. These sewing frames are documented from the 12th century onwards, and some researchers believe they were in use even earlier than this.

Beech, oak and elm were commonly used for the wooden boards. The spine and boards were first covered with leather and parchment, and the quires attached directly to the spine, which accounts for the notable rigidity of many bindings from the 10th to 12th century. Only gradually did it become possible to make hollow backs, allowing greater flexibility. The leather covering was decorated with blind-tooled lines or stamping, for example with a *supralibros*, an ex libris inscription. Bindings were often further adorned with clasps and bosses, which both prevented manuscripts from gaping open and ensured they lay better – manuscripts were namely housed lying flat on the shelf, not standing up in a row. The metal bosses also offered a degree of protection from damp and allowed the air to circulate through the gap they created between manuscript and shelf. In some libraries whose collections were consulted for study purposes, all the books were physically chained to desks as *libri catenati* (chained books). The chained library in Cesena in central Italy can still be admired today.

Since this short introduction has concentrated solely upon the production of Bible manuscripts, no mention has been made of manuscripts produced in secular workshops, commissioned for the libraries of royalty and the nobility and produced for the universities. At the early universities of the late 12th and 13th century in Paris and Bologna, there arose an entirely new system of copying by lay scribes. In this system, universities drew up standard exemplars of their textbooks and placed them with a *stationarius* (the English "stationer" is derived from this term). Individual gatherings from these exemplars were then lent out to lay scribes for copying and the transcripts subsequently checked by the universities for accuracy.

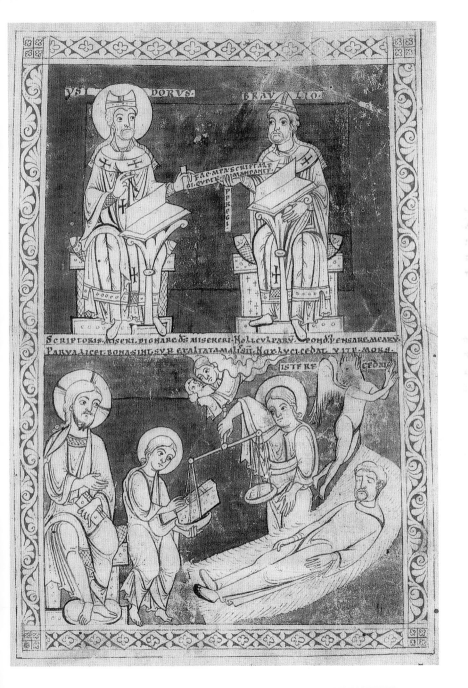

ISIDORVS. BRAVLIO.

The quality of the writing materials, the costliness of the inks and illumination and the expensive, ornamented covers of the bindings all reflected the importance attached to Bibles and the respect in which they were held. Their value was ultimately determined, however, by the laborious, skilled contribution of the scribes and illuminators, who thereby – as we have seen – hoped to secure their own place in eternity.

Stephan Füssel

From Royal Collection to National Library

The manuscripts and their provenance

Reconstructing the many paths by which the manuscripts in the collection of the Austrian National Library originally reached the library represents a science in itself. Signposts are provided first and foremost by the codices themselves. Ownership inscriptions, often deleted and written over by subsequent owners, notes which site a codex within a family or broader historical context, together with cataloguing inscriptions, form the most solid pointers. But entries made by readers, and the refurbishment of old manuscripts with "modern" bindings bearing coats of arms and monograms which preserve for posterity the identity of the owner, all yield clues which ideally enable us to trace the entire history of the manuscript from its production to its acquisition by the library.

Information can be gleaned, secondly, from inventories and lists of manuscripts that have passed to the library – for example in the wake of monastery closures. While such catalogues may indicate whether a codex was formerly in private possession or belonged to a religious foundation, the details they contain are often very general and frequently make it difficult to assign a codex to a specific former owner.

Accounts of the library's foundation also deviate all too often from demonstrable fact, and much of the historical research conducted into the origins of the institution is built upon speculation. It concentrates upon the reconstruction of the collections assembled by the titled heads of the Austrian branch of the house of Babenberg, and the Habsburgs who followed them. Only in a few cases, however, is it possible to link surviving manuscripts with concrete names. The title of "founding codex" can only be demonstrably assigned to a luxury manuscript in Habsburg possession in the late 14th century.

Only much later, with the appointment of Hugo Blotius (1575–1608) as the first official imperial librarian, do we find tangible evidence of the library developing into

St Jerome, Commentaries on the Bible, Cod. 930, detail from fol. 1r: Portrait of King Matthias Corvinus.

▶ History Bible of Evert van Soudenbalch, Cod. 2771, detail from fol. 10r (Genesis): Dedication scene with patron Evert van Soudenbalch, the canon of Utrecht cathedral, who commissioned the manuscript.

an official institution, and only with the building of the Vienna Hofbibliothek in the 18th century was the imperial collection of precious books given a fitting home, one where it could be displayed, administered and consulted (the public was granted limited access to the collection even in those days).

Its function as a Hofbibliothek (Royal Library) – it only assumed the title of Österreichische Nationalbibliothek (Austrian National Library) in 1945 – exercised a strong influence, in its early days, over the library's collection and acquisition policy, and consequently over the character of its first holdings. A large proportion of its precious manuscripts derived from the private collections of leading aristocratic houses. By tracing these manuscripts back to their individual owners and thus reconstructing the latter's holdings, we can identify a collector's particular interest in certain subjects and themes, or their "merely" aesthetic preference for certain epochs in manuscript illumination or binding. Common to all these collectors – in line with their elevated position in society – is their orientation towards the most sumptuous and best that their age had to offer, both in the case of manuscripts intended for private use (such as prayer books) and in codices of a more official and public character, such as those donated to religious foundations.

Serving as a sort of collecting basin for royal manuscripts was the library of Archduke Ferdinand II of Tyrol (1529–1595), which was housed in Ambras Castle near Innsbruck (see pp. 72–77, 138–157, 176–187, 198–205, 280–285, 362–371). In 1665, following the extinction of the Tyrolean line, the collection was transferred to the Vienna Hofbibliothek under praefect Peter Lambeck (1663–1680). With it came a large number of luxury manuscripts from the former possession of Emperor Friedrich III (1452–1493) and Emperor Maximilian I (1493–1519). In addition to these imperial treasures, mention should also be made of the manuscripts which Count Wilhelm von Zimmern (1549–1594) selected from his rich collection of codices in Old and Middle High German and presented to Ferdinand II in 1576 (see pp. 286–301).

The Österreichische Nationalbibliothek owes a considerable number of major works of Renaissance illumination and bookbinding to acquisitions from one of the greatest royal libraries of the late Middle Ages, the famous *Bibliotheca Corviniana* built up by King of Hungary Matthias Corvinus (1458–1490; see pp. 212–219, 250–253). Regrettably, this library was extensively decimated over the course of time and its collection scattered far and wide, and only a small proportion of its original holdings still survives.

Before the middle of the 18th century, finally, the Hofbibliothek purchased the library of the bibliophile general and statesman Prince Eugene of Savoy (†1736), who had also made a name for himself as a collector through his acquisition of precious illuminated manuscripts (see pp. 302–329, 336–347, 388–393, 430–437). His collection embraces a fascinatingly wide range of codices, organized – entirely in line with the need for a classification of the "world of books" – into subject areas. Bound at the

Prince's behest in different-coloured morocco bindings bearing his coat of arms, the books thereby also presented the imposing appearance their owner desired. Through the visual impression made by their coloured spines, moreover, the *Eugeniana* become an integral part of the magnificent Baroque architecture of the library in which they are housed.

Manuscripts from monastic houses, by contrast, only entered the Hofbibliothek intermittently prior to the late 1700s, for example after being "borrowed" by court historiographers acting on behalf of the emperor. Only in the wake of the secularization linked in Austria with the name of Emperor Joseph II (1741–1790) did the manuscript holdings of closed monasteries occasionally pass to the Hofbibliothek. These included, as from 1780, the libraries of the Augustinian abbey of St Dorothy's in Vienna (see pp. 98–101), the Jesuit colleges in Vienna (see pp. 158–163, 254–257) and Krumau (see pp. 348–355), the Benedictine monastery in Mondsee in Upper Austria (see pp. 228–231, 246–249) and the Damenstift convent in Hall in Tyrol (see pp. 94–97, 336–347). During this period, finally, the Hofbibliothek secured one of its most important acquisitions of monastic manuscripts with the transfer to Vienna of the Salzburg Cathedral library and the Archbishop's library (see pp. 188–197, 220–223, 224–227, 258–267).

The Hofbibliothek also added to its holdings from a third source of manuscripts, namely the private collections of scholars, which at the instigation of its dedicated librarians it began to purchase in growing numbers. In the context of the present volume, particular mention should be made of two acquisitions secured during the early years of the Hofbibliothek through the efforts of its first librarian, Hugo Blotius. In 1578 Blotius purchased from Johannes Sambucus, who was in financial difficulties, the latter's collection of predominantly Latin and Greek classics (see pp. 66–71). Shortly afterwards, the no less important collection owned by the imperial envoy Ogier Ghislain de Busbecq, dominated by Greek manuscripts that he had purchased in Constantinople (see pp. 382–387), was also acquired for the Hofbibliothek.

The many and varied sources from which the library's holdings are drawn make it possible to paint a comprehensive picture of specific areas of focus – such as the Bible in the Middle Ages under the spotlight here – from a number of different angles. The collections built up by Austria's ruling princes, which centred around luxury manuscripts prized, in many cases, not just for their sumptuous illumination and materials but also for the glory they reflected upon their owners, thereby represent the glittering showpieces. From the monastic libraries, with their more scholarly, theological focus, stem many examples of exegetic literature. The present library is enriched, lastly, by its acquisition of manuscripts from scholars and educated individuals who had themselves acquired them out of a humanist interest in the broadest sense.

Andreas Fingernagel

▶ Ludolf of Saxony, Life of Christ, Cod. 1379, detail from fol. 1r: The Gonzaga coat of arms.

c folliatam confessionem et
roporum semp declinandi a
ndi bonum . Scando
in xpo fidelis estuus tanq ipi p

Scaundo ppsm illuminatoem.
m au asistat lux & in tencbs lucens. au
illustrat doctur ordinate disponere
suam ad xpm et celestia ad seipsu &

Textual traditions and editorial revisions: Bibles from their beginnings to the standardized Bibles of the 13th century

The biblical texts of early Christianity were written, in Greek, on papyrus – in a manner distinctive of Bible production: the papyrus (almost) never assumes the form of a scroll, but is laid out as a codex, corresponding to the modern book. With the embrace of Christianity as the official religion in the 4th century and its acceptance within ever higher circles, Bible manuscripts began to undergo design changes which documented, in visual terms, the importance of the new faith. There was now a demand for luxury Bibles, some of them written and illustrated in gold and silver ink on purple parchment (see pp. 54–65). A very different face is presented by the Hebrew Bible, with its deliberate omission of the Septuagint (see pp. 372–377). In line with the 2nd Commandment, biblical illustrations were fundamentally forbidden. The desire to lend splendour to the appearance of the text therefore often found expression in the Masorah, the commentary written out in the margins in the shape of various figures (see ill. pp. 46, 49, 50, 53), or in the magnificently decorated pages which appeared at the front of individual sections.

In non-Greek-speaking areas, the Bible was gradually translated into the local language (see pp. 372–437), in the Latin-speaking West from the 2nd century onwards. These very literal translations fell into at least two main categories, the European and the African, and are today grouped under the heading of the *Vetus Latina*, the "Old Latin" version of the scriptures. In the 4th century Pope Damasus instructed Jerome to produce a new, binding translation of the entire Bible (see pp. 212–219). In the case of the Old Testament, Jerome thereby referred back extensively to the original Hebrew texts. His new Latin translation, which was completed in 405/6, became known as the Vulgate (*Vulgata*, "the common [version]") and was increasingly embraced from the 7th/8th century onwards.

Bologna Bible, Cod. 1127, detail from fol. 466r (II, III Epistula Johannis, Epistula Iudae): Ornamental initial *S*.

▸ Vienna Genesis, Cod. Theol. Gr. 31, detail from fol. 7r: Rebekah gives Eliezer a drink from the jug.

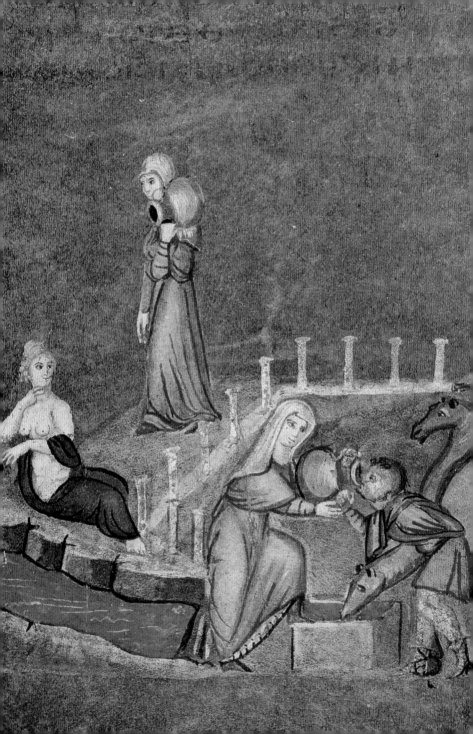

Whereas the contents of printed books can be assumed to remain the same, consistency and reliability are fundamentally problematic in the case of medieval manuscripts. The texts they hand down are characterized by diverging opinions as to the validity and authenticity of scriptural books, individual passages and even individual turns of phrase; every time the manuscript is copied, moreover, there is a danger that mistakes or alterations will creep in. If the continuity of manuscript production was broken for any reason, for example in the era of population migration, new originals, often dating from much earlier times, had to be procured and laboriously re-copied. The scribe endeavouring to produce an accurate manuscript was also faced with the additional challenge of compiling a "valid" text from a number of incomplete and differing variations. The problems inherent in ensuring a continuous Latin-text tradition, however, also encouraged scholars to look back to earlier sources, and in particular to Hebrew texts.

It was this challenge that faced the scholars who, as part of the reforms initiated by Charlemagne, embarked upon a grammatical and orthographic revision of the Bible. After a number of preliminary, unfinished efforts, it was in Tours under Alcuin (c. 730–804), the Anglo-Saxon theologian who originally came from York, that large numbers of such newly-edited Bibles were copied out and sent to patrons all over the empire (see pp. 78–81). Issued as pandects, i.e. in a single volume, these Tours Bibles became in turn the originals from which further copies were transcribed in other monasteries (see pp. 82–85).

Following a decline during the Ottonian era (10th–11th century), the production of Bible manuscripts became the focus of increased interest during the Romanesque period of the High Middle Ages, contributing to the emergence of the Romanesque giant Bibles. Following on from the earlier Carolingian Bibles, this interest was also linked with a concern to uphold established textual tradition. These fresh efforts to produce faithful editions of the Vulgate were sparked by the Gregorian reform movement and are symptomatic of the cultural environment from which they issued. As a rule, they required structured, often centralized forms of organization, such as those provided by the court schools during the Carolingian era, for example, and encouraged during the Romanesque era by the strengthened papacy and the flourishing of monastic orders. Only scriptoria, where manuscripts could be copied out in a reliable and highly sophisticated manner (see pp. 86–89, 90–93), offered the conditions within which traditional texts that had been researched and declared definitive could be accurately handed down.

From the end of the 12th century, the circumstances within which manuscripts were produced started to undergo a fundamental change. While individual orders – in particular the Dominicans, Franciscans and Carthusians – continued to strive for editorial accuracy, book production shifted away from scriptoria, linked exclusively to religious institutions, and more towards the secular realm and the

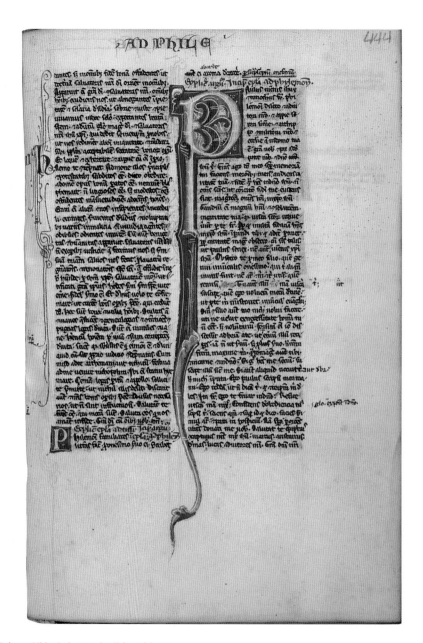

Bologna Bible, Cod. 1127, detail from fol. 444r
(Epistula Pauli ad Philemonem): Ornamental initials
marking the start of the Epistle to Philemon.

ויי אשר יאר שיחמר שויר כהנס כהנס וצהלתה תוזן קן חוזק דות שהרי עתו להוות לו זבו נסהנס יובל יחתה ועל יושר צבע כבהיח לו כני יובל יושר יובל ועל מיוס
קרש להיות מעוד יום כמוזה תעפל יום כשויה מויר שחויר שנה מיוסר יזה ולות על הכהן מות הנכר יריחוס יושר יזה עלה תהוה נמן הכהיר
ויהית עס מי
יהיה עם נא
יהין נעורי
יזה

על שחטתחו לישראל היות לויה ולא ודבותוזו ואפר שהרן ועל הרית ציושהו לנחר מההכות
חמה זו ועל שחויותו ורחלזיו יעבוי לעכות ועל שוכ הו הלחוותה עהל בניהס ושהל נול זחייס

לתיצר כללי עם
תהריך זעם מנהיר זהו
הא אמיר את הרתשום
בתחר רלכוס עלוה
התנבכיס תשיחום ל
גל הריש חושין היא

וַיְדַבֵּר יְהֹוָה אֶל־מֹשֶׁה לֵּאמֹר
וַיְדַבֵּר אֶל־אַהֲרֹן וְאֶל־בָּנָיו לֵאמֹר
זֹאת תּוֹרַת הַחַטָּאת בִּמְקוֹם אֲשֶׁר תִּשָׁחֵט
תִּשָּׁחֵט הָעֹלָה תִּשָּׁחֵט הַחַטָּאת לִפְנֵי
יְהֹוָה קֹדֶשׁ קָדָשִׁים הִוא הַכֹּהֵן הַמְחַטֵּא
אֹתָהּ יֹאכֲלֶנָּה בְּמָקוֹם קָדֹשׁ תֵּאָכֵל כִּ
בַּחֲצַר אֹהֶל מוֹעֵד כֹּל אֲשֶׁר יִגַּע בִּ
בְּשָׂרָהּ יִקְדָּשׁ וַאֲשֶׁר יִזֶּה מִדָּמָהּ עַל־
הַבֶּגֶד אֲשֶׁר יִזֶּה עָלֶיהָ תְּכַבֵּס בְּמָקוֹם
קָדֹשׁ וּכְלִי־חֶרֶשׂ אֲשֶׁר תְּבֻשַּׁל־בּוֹ יִשָּׁבֵר
וְאִם־בִּכְלִי נְחֹשֶׁת בֻּשָּׁלָה וּמֹרַק וְשֻׁטַּף
בַּמָּיִם כָּל־זָכָר בַּכֹּהֲנִים יֹאכַל אֹתָהּ קֹדֶשׁ
קָדָשִׁים הִוא וְכָל־חַטָּאת אֲשֶׁר יוּבָא
מִדָּמָהּ אֶל־אֹהֶל מוֹעֵד לֹא תֵאָכֵל בָּאֵשׁ
תִּשָּׂרֵף וְזֹאת תּוֹרַת הָאָשָׁם
קֹדֶשׁ קָדָשִׁים הוּא בִּמְקוֹם אֲשֶׁר יִ
יִשְׁחֲטוּ אֶת־הָעֹלָה יִשְׁחֲטוּ אֶת־הָאָשָׁם
וְאֶת־דָּמוֹ יִזְרֹק עַל־הַמִּזְבֵּחַ סָבִיב וְאֵת
כָּל־חֶלְבּוֹ יַקְרִיב מִמֶּנּוּ אֵת הָאַלְיָה וְאֶת
הַחֵלֶב הַמְכַסֶּה אֶת־הַקֶּרֶב וְאֵת שְׁתֵּי
הַכְּלָיֹת וְאֶת־הַחֵלֶב אֲשֶׁר עֲלֵיהֶן אֲשֶׁר
עַל־הַכְּסָלִים וְאֶת־הַיֹּתֶרֶת עַל־הַכָּבֵד
עַל־הַכְּלָיֹת יְסִירֶנָּה וְהִקְטִיר אֹתָם הַכֹּ
הַמִּזְבֵּחָה אִשֶּׁה לַיהֹוָה אָשָׁם הוּא כָּ

ליפיהו כלל עם
הקרוסתו והרו גיתמה
עליה הורוי בתחר
קרוש ומתן
דחקת דיתבשל בוזל
הבר ואם במילר יה
מילה יתבשל יה
ויהזרק וישותף ז
כמייהו לריסתא
בכבדא אשל יחר ז
קרש הקושיס הוא
ויבל חטאת אשר יי
יכבל מיזמה לבפוה
בחור שי לא תאכל
בחיר תוזהר
ורא חותיראת האשם
קרש קרשיס היהל
בתחר הזשיטן היה
ישמן הורריבה זה ילה
דמיה יהבשל וחל
דמיה הזריל על גוז
כורבת סוזר פהורי
זה כל
תרבו יקרב ביהובה
אה האליה וזה הרב
רחלב זה גוח וזה
רחליו מולג זיזי רב
רחב ודעלויהם ריעל
חפסים זה הקר אא ה
יהר כבר על כולי
ליתיה
ויקטיזא פל

הבמזברחה אשה ליהוה אשם הוא כל

לש חקו כב ברוי היה ולאו זהרן והכה דלא יריץ ובעב הלריב קוברו זבח תורבות זוה קוריב הולת עצכה הלא ווה יכ
תורה ורחל ברוהו היהל ולות מויר שנה הולוס שחריר שנה ועשר ברחל הלריב כש נתנו יובל חל
יוה יויר טרות הוליס עולס על זבו כמוזה יובל לו זבו כבשוה יובל זה ולו זבח בתן סוה תהכס בתן כבכס

ט
יסמ
לף שאלו עה
שהתלעיה ט עעשיה ווחן לעשוה דון והין הדין לשעו קרשוס וזמיה יש תמריהן מכהב ייהשיקויןועדון ופתויו יתמלחעה וכלו ופיטו רהסתין
שייא עויכו יעיר יומן לעולס זה לס כבתורו ישוה להים הי לשל כהתהרשוה יהתהל חיו הז לתוה שהוהושויה יחתה ביזור דרוהייל זו זשר סתיג עה זה חות זה סזסתו חויו זה מטזיה

realm of the universities – with a number of consequences for Bible production. The centre was Paris: here, over the course of the 13th century, the Vulgate (by now "spoilt" by various additions) was improved and reworked into a "standardized" edition that would long remain definitive (see pp. 94–97). Once again, this new version drew upon the corrections made under Alcuin.

Alongside Paris, the second major international centre of Bible production and distribution in the 13th century was the university city of Bologna, particularly famed for the study of law. Over the period from c. 1230/40 to 1320/30, well over 100 richly illuminated Vulgate manuscripts issued from the Emilian capital. Based on the revised Paris edition, they adopted the text of the Paris Bible, including the variations introduced by *vel* ("or") in the margin, the order of the biblical books, the chapter divisions, the page layout with titles at the head of the page and even, in their initials, the French iconography. The Dominican and Franciscan theology schools in Bologna, in particular, maintained very close links with Paris, as reflected in the manuscripts which records show they exchanged. French scribes and illuminators are also documented in Bologna. In 1249 the Franciscan school already existing in Bologna was granted papal recognition and put on a par with the Parisian school. While the earliest known Bologna Bibles are decorated primarily with ornamental forms (see pp. 98–101), historiated initials appear with increasing frequency from 1240 onwards. One of the earliest Bologna Vulgates with partial illustration is the – up till now, virtually unknown – Bible in Stift Heiligenkreuz (Codex C 7 right). From 1250 onwards, it was usual for Emilian Vulgates to be decorated throughout with historiated initials at the start of the individual biblical books, as seen in the Vienna Codex 1101. It is an interesting fact that, following on from the early pocket Bibles, the format of Bolognese manuscripts subsequently becomes bigger – chiefly, no doubt, to allow space for their ever more lavish illustrations. These reach their high point in the codices executed in the Byzantine manner of the Second Bolognese style, whose chief representative is the Bible housed as Codex 52 in the archives of Gerona cathedral. The workshops which illuminated Bologna Bibles also illustrated legal manuscripts with miniatures.

C.G. / A.F. / K.-G. P.

Torah, Haphtaroth, Megilloth, Cod. hebr. 28, **detail from fol. 149r (Leviticus):** Large Masorah in the shape of a dragon.

Torah, Haphtaroth, Megilloth

France (?), before 1348

The manuscript, copied by an unnamed scribe (who probably emphasized his forename, Chaim, in the biblical text on fol. 35v), contains the Torah (the Pentateuch), the Haphtaroth (readings from the Prophets which follow the reading of the Torah in the synagogue service), and the Megilloth (the five festival scrolls). The ownership inscription on fol. 362v, which is accompanied by a short poem and blessing, shows that the scrolls, as in other examples in the 14th century, were probably originally bound in front of the Haphtaroth. In their present position at the back of the codex, the scrolls finish on fol. 401r with an abbreviated form of the first line of the colophon found – written out in full – at the end of the Haphtaroth.

From approximately the 8th century onwards, Jewish texts were written in codices, so that the scroll as a form served solely liturgical purposes. As a text designed for study, the Torah in the present Codex hebraicus 28 contains, in the middle of the page, the (consonantal) text incorporating vowel signs, symbols indicating the pronunciation of certain consonants, and markings relating to the ceremonial recitation of the text.

Circles above the words refer to the small Masorah (critical notes on textual forms) in the margins beside the main text. The large Masorah (providing an explanation of the small Masorah and cross-references to parallels via key words) is written above, below and even at right angles to the main text and is often shaped into a variety of figures (ill. pp. 46, 49, 50, 53). These figures normally bear no relevance to the content of the biblical text. The Masorah contains information about the occurrence of certain word forms in the Hebrew Bible and thereby ensures that none of the consonants making up the text are lost or changed. It thus enables the codex to serve as a possible model for future copies. A copyist who might otherwise attempt to "correct" the text if faced with an unfamiliar spelling is informed

Detail from fol. 33r (Genesis): Large Masorah (accompanying Genesis 24:54) on the right in the shape of a pitcher – as a reference to Genesis 24:53 (Abraham's servant presents Rebekah with "silver and gold vessels").

▶ **Fol. 186r (Numbers):** Large Masorah in the shape of four dragons, two in the top margin and two in the bottom, linked by their intertwining tails.

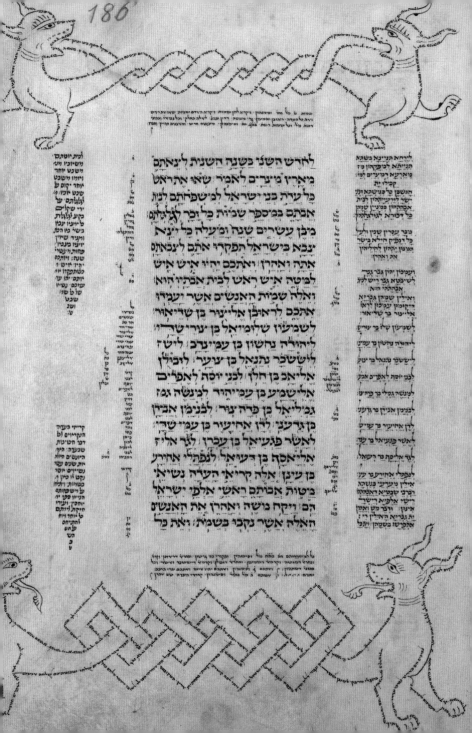

לְחֹ֣דֶשׁ הַשֵּׁנִ֗י בַּשָּׁנָ֤ה הַשֵּׁנִית֙ לְצֵאתָ֔ם
מֵאֶ֥רֶץ מִצְרַ֖יִם לֵאמֹֽר שְׂא֗וּ אֶת רֹאשׁ֙
כָּל עֲדַ֣ת בְּנֵֽי יִשְׂרָאֵ֔ל לְמִשְׁפְּחֹתָ֖ם לְבֵ֣ית
אֲבֹתָ֑ם בְּמִסְפַּ֣ר שֵׁמ֔וֹת כָּל זָכָ֖ר לְגֻלְגְּלֹתָֽם
מִבֶּ֨ן עֶשְׂרִ֤ים שָׁנָה֙ וָמַ֔עְלָה כָּל יֹצֵ֥א
צָבָ֖א בְּיִשְׂרָאֵ֑ל תִּפְקְד֥וּ אֹתָ֛ם לְצִבְאֹתָ֖ם
אַתָּ֣ה וְאַהֲרֹֽן וְאִתְּכֶ֣ם יִהְי֗וּ אִ֣ישׁ אִ֣ישׁ
לַמַּטֶּ֔ה אִ֛ישׁ רֹ֥אשׁ לְבֵית אֲבֹתָ֖יו הֽוּא
וְאֵ֨לֶּה֙ שְׁמ֣וֹת הָֽאֲנָשִׁ֔ים אֲשֶׁ֥ר יַֽעַמְד֖וּ
אִתְּכֶ֑ם לִרְאוּבֵ֕ן אֱלִיצ֖וּר בֶּן שְׁדֵיאֽוּר
לְשִׁמְע֕וֹן שְׁלֻמִיאֵ֖ל בֶּן צוּרִֽישַׁדָּֽי
לִֽיהוּדָ֕ה נַחְשׁ֖וֹן בֶּן עַמִּֽינָדָֽב לְיִשָּׂשכָ֕ר
לְיִשָּׂ֨שׂ֙ נְתַנְאֵ֖ל בֶּן צוּעָֽר לִזְבוּלֻ֕ן
אֱלִיאָ֖ב בֶּן חֵלֹֽן לִבְנֵ֣י יוֹסֵ֔ף לְאֶפְרַ֕יִם
אֱלִֽישָׁמָ֖ע בֶּן עַמִּיה֑וּד לִמְנַשֶּׁ֕ה גַּ֖מ
גַּמְלִיאֵ֖ל בֶּן פְּדָהצֽוּר לְבִנְיָמִ֕ן אֲבִידָ֖ן
בֶּן גִּדְעֹנִֽי לְדָ֕ן אֲחִיעֶ֖זֶר בֶּן עַמִּֽישַׁדָּֽי
לְאָשֵׁ֕ר פַּגְעִיאֵ֖ל בֶּן עָכְרָֽן לְגָ֕ד אֶלְיָסָ֖ף
אֶלְיָסָ֖ף בֶּן דְּעוּאֵ֑ל לְנַפְתָּלִ֕י אֲחִירַ֖ע
בֶּן עֵינָֽן אֵ֚לֶּה קְרוּאֵ֣י הָעֵדָ֔ה נְשִׂיאֵ֖י
מַטּ֣וֹת אֲבוֹתָ֑ם רָאשֵׁ֛י אַלְפֵ֥י יִשְׂרָאֵ֖ל
הֵֽם וַיִּקַּ֥ח מֹשֶׁ֖ה וְאַהֲרֹ֑ן אֵ֚ת הָאֲנָשִׁ֣ים
הָאֵ֔לֶּה אֲשֶׁ֥ר נִקְּב֖וּ בְּשֵׁמֹ֑ת וְאֵ֣ת כָּל

לְפִי חָרֶב וַיִּירַשׁ אֶת אַרְצוֹ מֵאַרְנֹן עַד
יַבֹּק עַד בְּנֵי עַמּוֹן כִּי עַז גְּבוּל בְּנֵי עַמּוֹן
וַיִּקַּח יִשְׂרָאֵל אֵת כָּל הֶעָרִים הָאֵלֶּה
וַיֵּשֶׁב יִשְׂרָאֵל בְּכָל עָרֵי הָאֱמֹרִי בְּחֶשְׁבּוֹן
וּבְכָל בְּנֹתֶיהָ כִּי חֶשְׁבּוֹן עִיר סִיחֹן מֶלֶךְ
הָאֱמֹרִי הִוא וְהוּא נִלְחַם בְּמֶלֶךְ מוֹאָב
הָרִאשׁוֹן וַיִּקַּח אֶת כָּל אַרְצוֹ מִיָּדוֹ עַד
אַרְנֹן עַל כֵּן יֹאמְרוּ הַמֹּשְׁלִים בֹּאוּ
חֶשְׁבּוֹן תִּבָּנֶה וְתִכּוֹנֵן עִיר סִיחוֹן כִּי אֵשׁ
יָצְאָה מֵחֶשְׁבּוֹן לֶהָבָה מִקִּרְיַת סִיחֹן
אָכְלָה עָר מוֹאָב בַּעֲלֵי בָּמוֹת אַרְנֹן אוֹי
לְךָ מוֹאָב אָבַדְתָּ עַם כְּמוֹשׁ נָתַן בָּנָיו
פְּלֵיטִם וּבְנֹתָיו בַּשְּׁבִית לְמֶלֶךְ אֱמֹרִי
סִיחוֹן וַנִּירָם אָבַד חֶשְׁבּוֹן עַד דִּיבֹן
וַנַּשִּׁים עַד נֹפַח אֲשֶׁר עַד מֵידְבָא וַיֵּשֶׁב
יִשְׂרָאֵל בְּאֶרֶץ הָאֱמֹרִי וַיִּשְׁלַח מֹשֶׁה
לְרַגֵּל אֶת יַעְזֵר וַיִּלְכְּדוּ בְּנֹתֶיהָ וַיִּירֶשׁ
אֶת הָאֱמֹרִי אֲשֶׁר שָׁם וַיִּפְנוּ וַיַּעֲלוּ
דֶּרֶךְ הַבָּשָׁן וַיֵּצֵא עוֹג מֶלֶךְ הַבָּשָׁן לִ
קְרָאתָם הוּא וְכָל עַמּוֹ לַמִּלְחָמָה
אֶדְרֶעִי וַיֹּאמֶר יְהוָה אֶל מֹשֶׁה אַל
תִּירָא אֹתוֹ כִּי בְיָדְךָ נָתַתִּי אֹתוֹ וְאֶת כָּל
עַמּוֹ וְאֶת אַרְצוֹ וְעָשִׂיתָ לּוֹ כַּאֲשֶׁר

Fol. 223v (Numbers): Large Masorah in the shape of a dragon on a slender pedestal.

by the notes in the Masorah where else and how often this particular phenomenon occurs, so that he can deliberately preserve the traditional version. The simple presence of the Masorah thus guarantees the integrity of the sacred text.

In addition to the large Masorah, the text is bordered at the top and bottom (and sometimes at the side) by the commentary of the famous Rabbi Solomon ben Isaak ("Rashi", 1040–1105). The Torah is accompanied in the inner margins by the Targum of Onkelos, an Aramaic translation of the Hebrew scripture. This translation may be understood as an elementary commentary and was to be studied weekly in conjunction with the passage from the Torah read out in the synagogue on the Sabbath. Even if the present codex was not actually used in the synagogue, its selection of scriptural texts is based on those recited in the liturgy. Above and below the Targum, written out in a smaller, paler script in the shape of a circle, are more notes on the biblical text.

The ownership inscription on fol. 362v tells the sobering story of someone who saved the manuscript from the flames of a town whose inhabitants were murdered in a pogrom in 1348 (in connection with the plague epidemic of 1348/49?). He himself was able to escape, via Avignon, to Aix, where he was given shelter. In Avignon, which became part of the Papal States that same year, Jews were considered "citizens", and the owner of the manuscript may hence have survived there for some time.

Two readers' notes on the final page (*visto per me Gi[ovanni] Dominico Carretto 1618* on fol. 400v and *Dominico Irosolomi[ta]no 1595* on fol. 401r) point to later users of the manuscript – evidently after the Megilloth had been bound *behind* the Haphtaroth. Domenico Gerosolimitano (*c.* 1552–1621), a Jew born in Palestine who converted to Christianity, lived in Italy and served as a censor of Hebrew books for the Inquisition.

C. L.

Extent: 401 parchment folios
Format: 195 x 285 mm
Binding: Vienna Hofbibliothek leather binding with blind and gold tooling, dating from the late Baroque
Content: Torah, Haphtaroth, Megilloth
Language: Hebrew (Aramaic)
Illustration: figured Masorah (commentaries) and schematic pen drawings (fol. 243v, 244v)

Provenance: The manuscript was formerly in the possession of one "Eliezer" (according to the entry on fol. 1r). Another ownership inscription on fol. 362v does not give a name. According to Schwartz (1925), the codex "probably [came] from the old university library".
Shelfmark: Vienna, ÖNB, Cod. hebr. 28

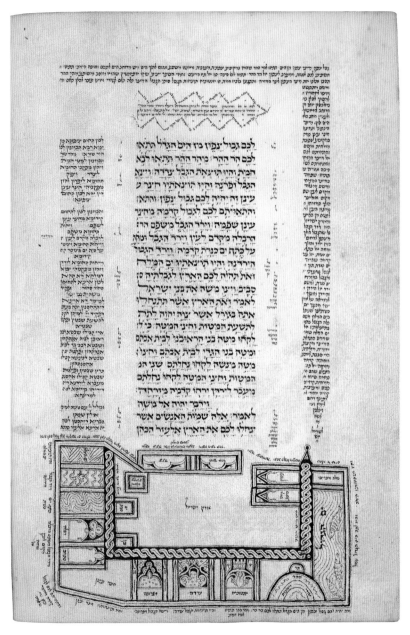

Fol. 244v (Numbers): Drawing of the land of Israel, based primarily on Numbers 34.

▸ Detail from fol. 102v (Exodus): Large Masorah in the shape of a dragon.

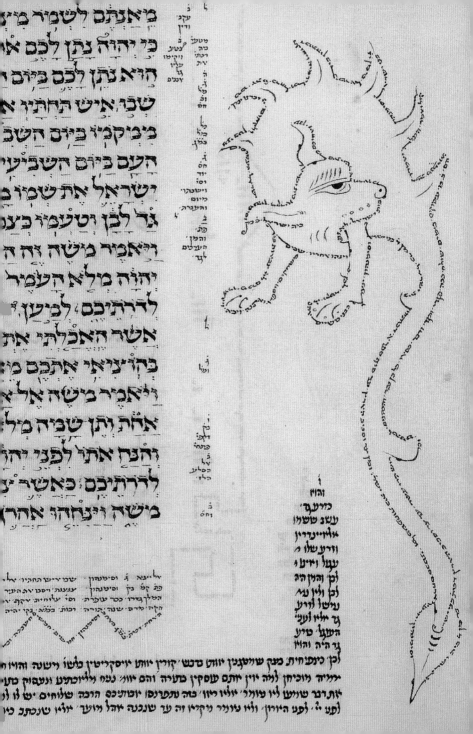

מֵאַתֶּם לִשְׁמֹר מִ...
כִּי יְהוָה נָתַן לָכֶם אֶ...
הוּא נָתַן לָכֶם בַּיּוֹם ו...
שְׁבוּ אִישׁ תַּחְתָּיו אַ...
בְּבִקְעֲמִי בְּיוֹם הַשַּׁבָּ...
הָעָם בַּיּוֹם הַשְּׁבִיעִי
יִשְׂרָאֵל אֶת שְׁמוֹ בּ...
גַד לָבָן וְטַעְמוֹ כְּצַ...
וַיֹּאמֶר מֹשֶׁה זֶה הַ...
יְהוָה מְלֹא הָעֹמֶר
לְדֹרֹתֵיכֶם לְמַעַן...
אֲשֶׁר הֶאֱכַלְתִּי אֶת
בְּהוֹצִיאִי אֶתְכֶם מֵ...
וַיֹּאמֶר מֹשֶׁה אֶל אַ...
אַחַת וְתֶן שָׁמָּה מְל...
וְהַנַּח אֹתוֹ לִפְנֵי יְהֹ...
לְדֹרֹתֵיכֶם כַּאֲשֶׁר צִ...
מֹשֶׁה וַיַּנִּיחֵהוּ אַהֲרֹ...

Vienna Genesis

Region of Syrian Antioch (?), 6th century

The history of Greek Bible illumination currently begins with the Vienna Genesis, which contains the earliest surviving illustrated biblical cycle in codex form. A slightly earlier illuminated Genesis – the Codex Cotton Otho B VI, which dates from the 5th/6th century and is today housed in London – was almost completely destroyed by fire in 1731 and only survives in 129 badly singed fragments.

For Bible manuscript historians, the Vienna Genesis is also the point of departure for a development whose stylistic and iconographic origins cannot be traced to any other surviving manuscript. The inspiration behind its portrayal of successive biblical scenes was probably drawn from a number of quarters: alongside a wide range of heathen sources, Christian motifs could have been adopted from pictorial friezes (such as those in basilicas) or from narrative sequences on tombs or Christian textiles. Although regular attempts are made to explain the heterogeneous nature of the stylistic sources behind the Vienna Genesis in terms of a (now lost) Jewish pictorial tradition, this remains conjecture: no concrete examples of such an art survive, and this line of argument has met with scepticism among experts. The *Vienna Genesis* as a whole has never been cited as the basis for a later manuscript, although its motifs find parallels in Middle-Byzantine ivory reliefs, for example.

The remarkable feature of this manuscript lies in the presentation of its pictures, whereby word and image complement each other. It contains both individual scenes and lengthier cycles (see ill. pp. 60–65), with pictures being divided into an upper and lower half in order to portray a sequence of events. Successive scenes may equally be found within individual pictures, however. The entire text could be followed from the illustrations alone. The text itself was abridged; different rulings on different folios indicate that, depending on the space available, the text has been shortened to the relevant passages by one or several editors, and then written out by one (of two or three) scribe(s).

Detail from fol. 17r: Joseph in prison with Pharaoh's cup-bearer and baker.

▶ **Detail from fol. 1r:** The Fall in three scenes: Adam and Eve recognize their sin.

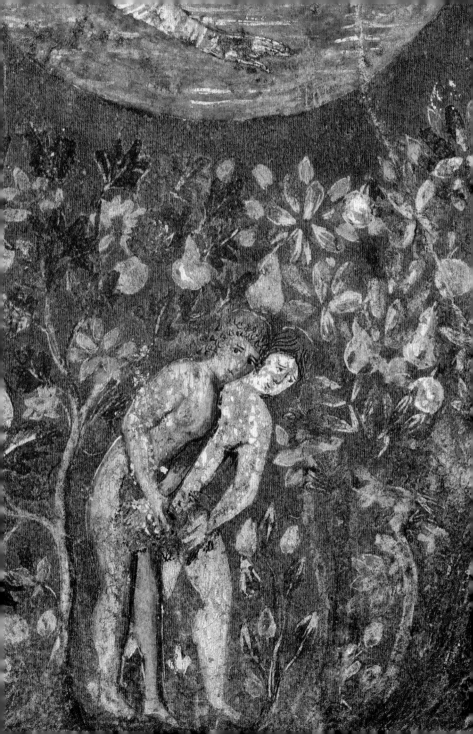

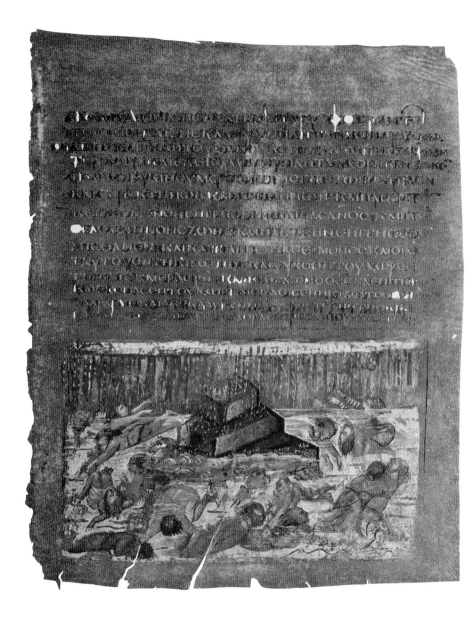

Fol. 2r: The Flood in one scene:
Noah's Ark on the waters.

With its sumptuous materials (gold and silver ink on purple parchment), the Vienna Genesis marks the inception of the luxury Bible, produced to satisfy the awakening demand amongst the bibliophile aristocracy for aesthetically sophisticated Bible manuscripts. Its lavish format suggests that it was commissioned by a member of the nobility. It is conceivable, too, that it was commissioned by an individual, group or institution for presentation to a social superior, as in the case of the Vienna Dioscurides (Vienna, ÖNB, Cod. med. gr. 1) of AD 512, which was dedicated to Princess Juliana Anicia by the guilds of Honoratae, a district of Constantinople. The lack of all specific reference to this codex in the sources indicates that it must have enjoyed probably a quiet existence in an aristocratic household until passing into Western hands as a prize specimen.

In its present form, the Codex theologicus graecus 31 is just a quarter of its original length; it is calculated that it originally comprised 96 folios, with 192 miniatures illustrating altogether 500 individual scenes. Thorough study of the script and miniatures has revealed that the manuscript was produced in a professional workshop in which calligraphers and miniaturists divided the work between them. The hands of probably 11 miniaturists have been identified in the surviving folios, a number which clearly shows that such luxury manuscripts must have been produced in far higher numbers in those days, presumably in response to much higher demand. Sadly today, just a few examples are all that survive from the era in which production of these sumptuous manuscripts was in full flower, and before it was checked by Persian and Arab conquests.

C. G.

Extent: 24 parchment folios extant, individually preserved beneath sheets of acrylic glass (also bound with two sheets from another purple codex relating to Luke 24, part of the St Petersburg Codex GPB gr. 537)
Format: 304–326 x 245–265 mm
Content: Genesis 3:4–50:4
Language: Greek
Miniaturists: A workshop with (at least) 11 contemporary, anonymous miniaturists
Illustration: One miniature in the lower half of each page, comprising (with a few exceptions) several scenes in sequence (125 individual scenes in total)
Provenance: The surviving folios may have been brought to Italy (Venice? cf. Cat. IV.2) by Crusaders. In 1662 Archduke Leopold William bequeathed the sheets, which were bound as an appendix to an unspecified Latin codex, to Emperor Leopold I in his will. In 1664 they entered the Vienna Hofbibliothek.
Shelfmark: Vienna, ÖNB, Cod. theol. gr. 31

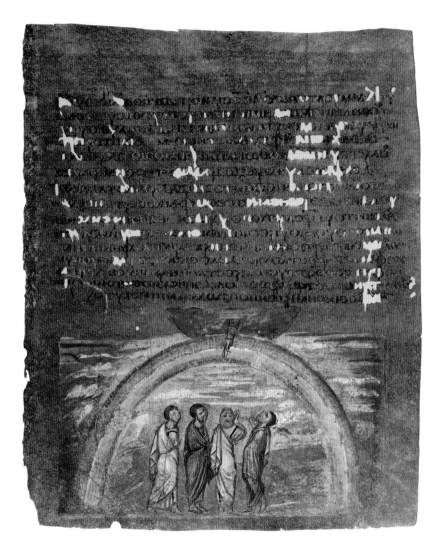

Fol. 3r: God (represented as a hand) makes his covenant with Noah and his sons.

▸ **Detail from fol. 8v:** Abimelech watches Isaac and Rebekah.

▸▸ **Detail from fol. 15r:** Joseph interprets his second dream, in three scenes: Joseph dreaming with the sun and moon; Joseph tells his father and brothers of his dream; the brothers discuss Joseph's dream while watching their flocks.

▸▸ **Detail from fol. 16r:** Joseph flees from Potiphar's wife (in connection with scenes not recounted in the Bible).

▸▸▸▸ **Detail from fol. 19v:** Joseph's brothers return home, in three scenes: one of the brothers finds his purse; he tells his brothers of what he has found; the returning brothers tell their father Jacob about what happened in Egypt.

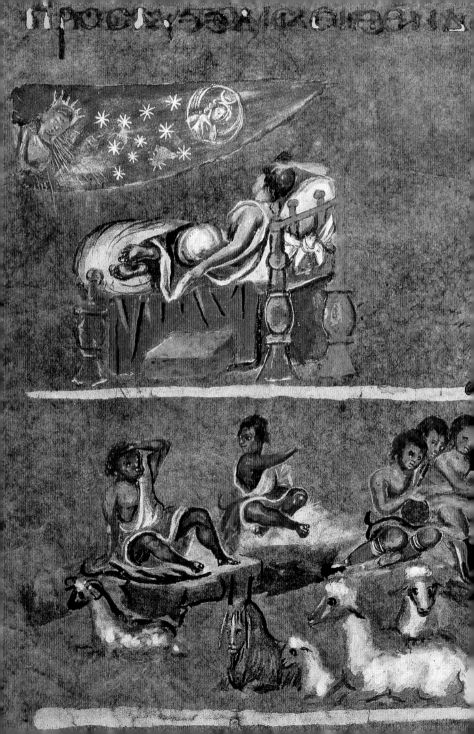

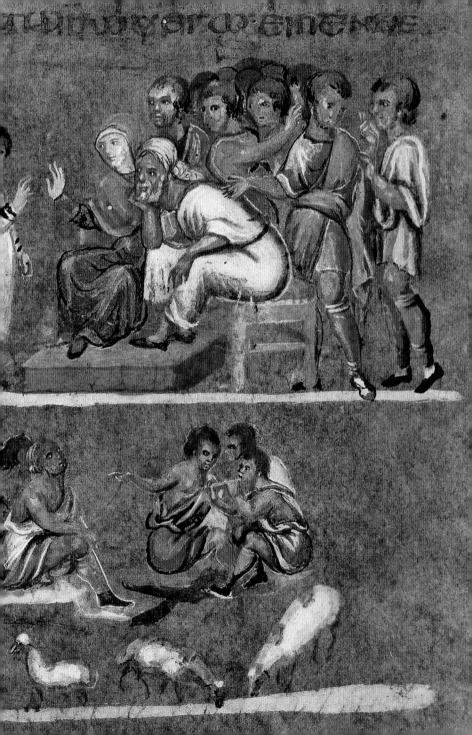

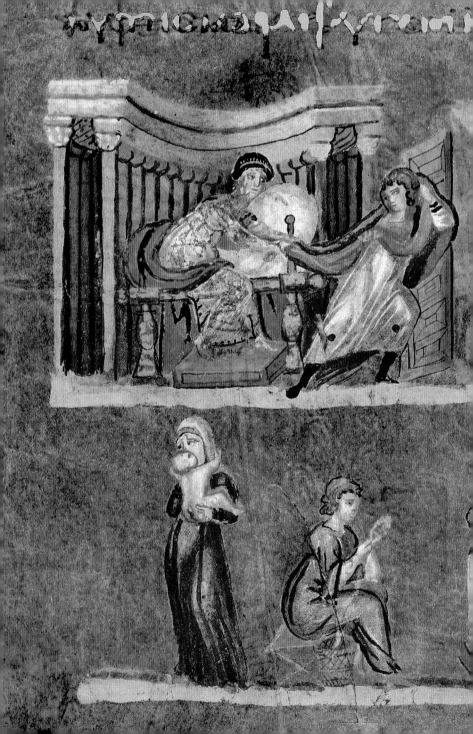

Greek Gospels and Praxapostolos

Constantinople (?), 1st half of the 14th century

With the consolidation of the Byzantine Empire which succeeded the conquest and appropriation of the city of Constantinople by the Latins (1204–1261), the arts also saw a new flowering, one closely linked with the imperial Palaeologan dynasty (1261–1453). Over the previous decades, and in particular following the seizure of Constantinople by the Crusaders, manuscripts had been plundered and destroyed on a scale whose true extent is impossible to estimate. From their seat of government in Nicaea, the exiled Lascarid emperors (1204–1261) sought to preserve their Byzantine culture and in particular to maintain the tradition of sacred manuscripts, an endeavour in which they were joined by the monasteries.

Following the re-conquest of Constantinople and the return from exile of the emperor and patriarch, book production also underwent a number of changes. The untidy scripts of the 13th century were regulated, for example; popular in theological manuscripts from this era is an "archaizing" style which looks back to the minuscule of the 10th/11th century, a script characterized by clear, even lettering which is attractive to look at and easy to read. During this period, the Hodegon monastery in Constantinople developed its own, easily legible style of writing, the Hodegon style, which survived even after the conquest of Constantinople by the Turks (1453).

The Codex theologicus graecus 300 is a concrete example of such efforts to improve script quality, as demonstrated by the clarity and legibility of its writing and its economic use of abbreviations. Its sumptuous illuminations suggest that the manuscript was produced in a very good workshop, which has been localized to Constantinople. One unusual detail allows us to deduce that the codex was executed in the following sequence: first, the copyist wrote out the scriptural texts, leaving one page at the start of each text free for a full-page miniature. A decorative field – taking up about a quarter of a page – was evidently planned at the beginning of each biblical book, since this amount of space has been set aside

Fol. 134v (St John): St John and his scribe Prochoros, who is taking down the beginning of St John's Gospel ("In the beginning"); above left, a ray of light as a symbol of divine inspiration.

ὁ ἅ(γιος) ὁ θεο-
λόγο(ς)

ὁ ἅ(γιος) Πρόχορο(ς)

Nouum Testamentum ·

Liber Andreæ Contrarii ·e· amicorum

Augustissimæ
Cæsareæ
Codex manuscriptus
N.

Bibliothecæ
Vindobonensis
Theologicus Græcus
148 44

Fol. 1r: Renaissance coat of arms of Andreas Contrarius (15th century).

▸ **Fol. 58v–59r (St Mark):** Miniature of St Mark the Evangelist, seated at his desk with all his writing instruments (above left, a ray of light as a symbol of divine inspiration), and the beginning of St Mark's Gospel.

at the start of all four Gospels and Acts (ill. p. 71). The illuminator has forgotten to fill these fields in, however, and so the tops of these pages remain blank.

In the miniatures depicting the authors of the Gospels, we find a characteristic feature of Byzantine Evangelist portraits, namely a detailed portrayal of all the writing utensils that a copyist in those days would have used. In the portrait of St Mark (ill. p. 70), for example, we can make out on the table a pair of dividers used to mark up the rulings, a pair of scissors for trimming the edges and a knife for cutting the quill nib.

The provenance of the manuscript is particularly interesting. A century after it was produced, it was in the possession of the Italian humanist Andreas Contrarius (born in Venice at the start of the 15th century). Contrarius was in touch not only with the most important representatives of the Italian Renaissance, such as Francesco Barbaro and Lorenzo Valla, but also with the Greek scholars Nikolaos Sagundinos and Theodoros Gaza, and engaged in a dispute with Georgios Trapezuntios. It was probably through Sagundinos that he was familiar with Greek. He may have obtained the present manuscript, in which he had his coat of arms painted as a full-page bookplate on fol. 1r (ill. p. 68), through his contacts with these Greek scholars, more and more of whom were being forced into exile by the Turks. Contrarius is known to have owned other manuscripts, but the present example is thought to have been the only Greek codex in his collection.

C. G.

Extent: 361 parchment folios
Format: 189–193 x 137–140 mm
Binding: Vienna Hofbibliothek parchment cover of 1755 (rebound under praefect Gerard van Swieten, 1745–1772)
Content: Gospels and Praxapostolos
Language: Greek
Illustration: five full-page miniatures of the Evangelists and the Apostles Peter and Paul

Provenance: An inscription identifies the first owner as Andreas Contrarius (Venice, 15th century); the manuscript was later purchased by Johannes Sambucus (1531–1584; from 1566 councillor, court physician and court historiographer at the Vienna court) for his library; it is documented in the collection of the Hofbibliothek under praefect Sebastian Tengnagel (1608–1636).
Shelfmark: Vienna, ÖNB, Cod. theol. gr. 300

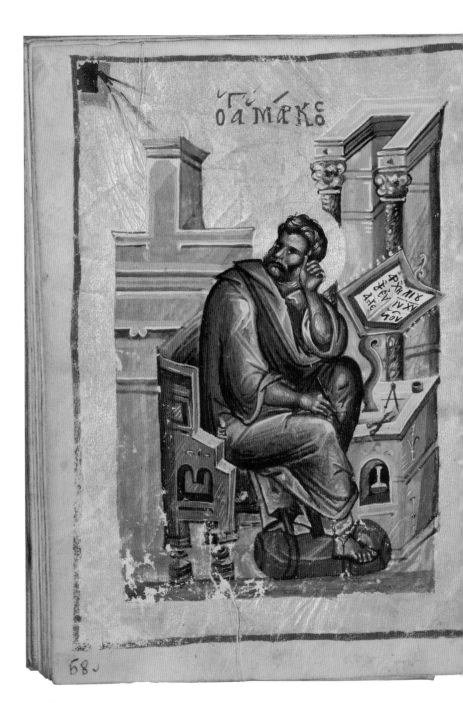

ΤΩ
Ο Α ΜΑΡΚΟΣ

ΑΡ ΧΗ ΤΟ
ΪΕ Υ Ι̅Υ̅ Χ̅Υ̅
Δ ΗС ΟΥ

58

70

ΤΟ ΚΑΤΑ ΜΑΡΚΟΝ ΑΓΙΟΝ ΕΥΑΓΓΕΛΙΟΝ :–

Ἀρχὴ τοῦ εὐαγγελίου ἰ(ησο)ῦ χ(ριστο)ῦ, υἱοῦ τοῦ θ(εο)ῦ· ὡς γέγραπται ἐν
τοῖς προφήταις· ἰδοὺ ἐγὼ ἀποστέλλω τὸν ἄγγελόν μου
πρὸ προσώπου σου· ὃς κατασκευάσει τὴν ὁδόν σου ἔμ-
προσθέν σου· φωνὴ βοῶντος ἐν τῇ ἐρήμῳ, ἑτοιμά-
σατε τὴν ὁδὸν κ(υρίο)υ· εὐθείας ποιεῖτε τὰς τρίβους αὐ(τοῦ)·
ἐγένετο ἰωάννης βαπτίζων ἐν τῇ ἐρήμῳ καὶ κηρύσσων
βάπτισμα μετανοίας εἰς ἄφεσιν ἁμαρτιῶν· καὶ ἐξε-
πορεύετο πρὸς αὐτὸν πᾶσα ἡ ἰουδαία χώρα καὶ οἱ ἱεροσο-
λυμῖται· καὶ ἐβαπτίζοντο πάντες ἐν τῷ ἰορδάνῃ ποταμῷ
ὑπ' αὐτοῦ ἐξομολογούμενοι τὰς ἁμαρτίας αὐτῶν· ἦν δὲ
ὁ ἰωάννης ἐνδεδυμένος τρίχας καμήλου· καὶ ζώνην
δερματίνην περὶ τὴν ὀσφὺν αὐτοῦ· καὶ ἐσθίων ἀκρί-
δας καὶ μέλι ἄγριον· καὶ ἐκήρυσσεν λέγων· ἔρχεται ὁ ἰσχυ-
ρότερός μου ὀπίσω μου· οὗ οὐκ εἰμὶ ἱκανὸς κύψας λῦσαι
τὸν ἱμάντα τῶν ὑποδημάτων αὐτοῦ· ἐγὼ μὲν ἐβά-
πτισα ὑμᾶς ἐν ὕδατι· αὐτὸς δὲ βαπτίσει ὑμᾶς ἐν πν(εύματ)ι ἁγίῳ·
καὶ ἐγένετο ἐν ἐκείναις ταῖς ἡμέραις ἦλθεν ἰ(ησοῦ)ς ἀπὸ ναζα-
ρὲτ τῆς γαλιλαίας· καὶ ἐβαπτίσθη ὑπὸ ἰωάννου εἰς τὸν
ἰορδάνην· καὶ εὐθέως ἀναβαίνων ἀπὸ τοῦ ὕδατος
εἶδεν σχιζομένους τοὺς οὐ(ρα)νοὺς· καὶ τὸ πν(εῦμ)α ὡσεὶ περιστερὰν

Greek Gospel Book (fragment)
Rufinus, Commentary on Genesis

Ravenna (?), 6th century

In the 4th century Eusebius of Caesarea (c. 260–339) devised the system of canon tables. He started by subdividing the four Gospels into self-contained passages, which he numbered consecutively. He then drew up ten tables: the first nine set out the concordance of passages among the Gospels, while the tenth lists the passages in each Gospel which have no parallels in the other three. References to other Gospels and their respective passage numbers were similarly included in the margins beside the Gospel texts themselves, in order to make corresponding passages easy to find. For the first time it was thus possible to systematically pool the Gospel accounts of the life and acts of Jesus.

Accompanied by a letter to Karpianos, the friend to whom Eusebius dedicated his invention and explained its use, the canon tables are usually placed at the beginning of the four Gospels. In terms of the format of these *canones*, or "guiding rules", various traditions have emerged since late antiquity, differing essentially in the number of pages into which they are divided. Laid out in simple columns, they are provided with an architectural surround and thus become firm components of the manuscript's illumination. Some also include figural illustrations in the shape of the Evangelists or their symbols and occasionally also depict biblical scenes.

Codex 847 contains, on fol. 2r–5r, one of the oldest surviving sets of canon tables. Of the originally eleven tables, four are missing, contained on a sheet now lost. That they were formerly part of a Gospel Book is evidenced by an ornamental page (ill. p. 77) whose text refers to the four Gospels that once followed. Each column of numbers is spanned at the top by a plain-coloured arch containing the name of the Gospel to which it relates. Grouping the numerical columns together are richly decorated pillars linked by an arch or gable at the top, which serve to delineate the separate tables. The canon tables are arranged in sequence, in this

Detail from fol. 18r: Text written in late-antique uncial script.

▶ **Detail from fol. 1r:** Ornamental page at the beginning of the Gospel Book.

Fol. 7r: Ornamental page at the beginning of the
Commentary on Chapter 49.

case with the first cross-referencing the passages contained in all four Gospels, then passages found in three of the four Gospels, and so on (see fol. 3v); in the last table (see fol. 4r, ill. p. 76), passages occurring in only one of the Gospels are listed.

The fragments of the Gospel Book are written in late-antique uncial script and are bound with a Latin commentary on Genesis, Chapter 49, by Rufinus (ill. p. 74). It is unclear when the two manuscripts were combined. Notes added by an Italian hand of the 8th century are found on fol. 1v, 5v and 6v of the Gospel fragments, but not in the Rufinus text. By contrast, the latter contains entries by 15th (e.g. fol. 7v, 10v, 12r) and 16th-century hands (fol. 8r–15v) which are absent from the Gospel Book. This would indicate that the two parts were combined at the earliest in the 16th century. Curiously, however, there are close parallels between the decorative style of each: the ornamental page with a ribboned wreath which precedes the canon tables on fol. 1r (ill. p. 73) is directly related to the same illustration at the start of the Rufinus text (ill. p. 74). Not only in their design and repetition of individual motifs (such as the tips of flowering shrubs), but also in their use of colour, the two texts are so closely related that they must have arisen in the same region, and perhaps even in the same workshop. This points towards a place of origin where both Latin and Greek were spoken, most probably the then Italo-Greek east and south coast of Italy, with Ravenna at its centre.

F. S.

Extent: I + 115 parchment folios
Format: 190 x 180 mm
Binding: Baroque Hofbibliothek parchment cover over pasteboard (Vienna 1669)
Content/author: Gospel Book (fragments) and Commentary on Chapter 49 of Genesis by Rufinus (345–410)
Language: Greek and Latin

Provenance: Annotations (fol. 1v, 5v, 6v) place the manuscript in a monastery somewhere in Italy in the 8th century; housed in the 16th century in Ambras Castle, in the collection of Archduke Ferdinand II, whose library passed to the Hofbibliothek in 1665.
Shelfmark: Vienna, ÖNB, Cod. 847

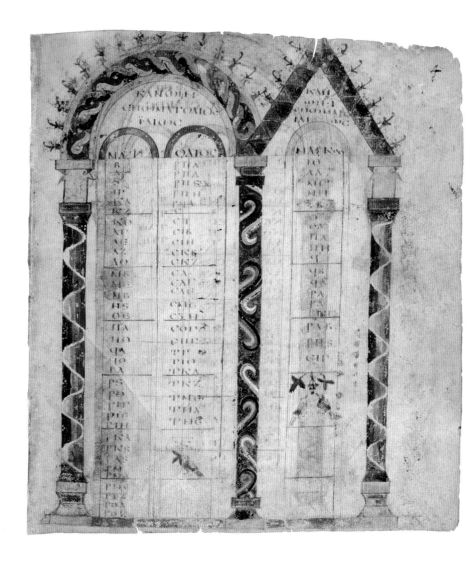

Fol. 4r: Canon table.

► **Detail from fol. 6r:** Ornamental page at the beginning of the four Gospels.

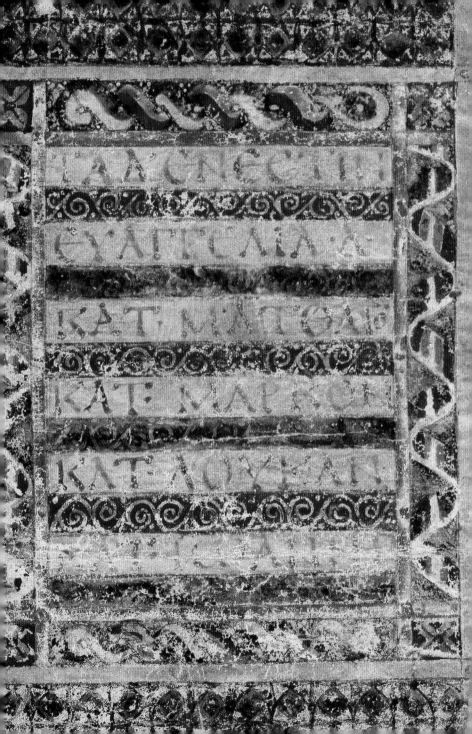

ΤΑΑ CΝ ECΤ Η

ΕΥΑΓΓΕΛΙΑ · Δ ·

ΚΑΤ · ΜΑΤΘΑΙΟ

ΚΑΤ · ΜΑΡΚΟΝ

ΚΑΤ · ΛΟΥΚΑΝ

Tours Bible (fragment)

St Martin's Abbey in Tours (western France),
middle of the 9th century

The three sheets derive from the Vienna Codex 2133, where they were pasted to
the insides of the binding in order to protect the inner manuscript from abrasion
by its wooden covers. In the 14th century, an ex libris inscription was entered on
the present fol. 3r (ill. p. 80), identifying the manuscript as the property of St Max-
imin's Abbey in Trier. In 1936 the six fragments were detached, re-assembled into
three sheets and classified under the shelfmark Codex Series nova 3641.

These surviving folios belong to a Tours Bible from the middle of the 9th centu-
ry, which in the Middle Ages was in Trier and whose remnants are now distribut-
ed between various libraries in Austria, Germany, England and the United States.

In the 9th century, St Martin's Abbey in Tours in modern-day France was
the leading centre of Bible production; over 40 Tours Bibles from the period
c. 800 – c. 850 have survived into the present. Bearing in mind that many others
will since have been lost, the true figure produced during these years must have
been considerably higher. This "mass production" of Bibles began under Abbot
Alcuin (796–804), a close companion of Emperor Charlemagne. The emphasis was
thereby upon pandects, in other words complete Bibles that brought together all
the books of the Bible in one volume. Although this type of Bible was already in
isolated use, it now became the particular focus of production. As can be seen
from Alcuin's poems at the start of certain Bibles, they were intended to express
the oneness of the divine revelation afforded by the Old and New Testaments,
and the oneness of its promulgation by the Church. These pandects were destined
not for libraries but for abbeys, in particular those that were newly founded,
where they were especially intended to be read aloud during divine office. Aside
from their symbolic significance, however, the production of pandects also offered
a more practical advantage: by using small, clearly legible miniscule script and
an economical layout, they required considerably less parchment, which of course
had to be prepared laboriously by hand from animal skins.

In Alcuin's day, the illumination of Tours Bibles was limited to initials and
canon tables. Full-page miniatures only make their appearance under his succes-

Detail from fol. 3r (Hosea): Initial V(erbum) opening
the Book of Hosea.

OSEE PRO
PHETA

ERBUM DÑI
quod factum e̅ ad osee filiu̅
beeri. In dieb; ozie ioatha̅
achaz. hiezechie regum iuda
et in dieb; hieroboam filii ioas.
regis isr̅t; principium loquendi
dño in osee; Et dixit dñs ad osee;
Uade sume tibi uxorem fornicati
onum et fac filios fornicationum!
quia fornicans fornicabitur terra a dño, et abiit
et accepit gomer. filiam debelaim et concepit et pe
perit filium; Et dixit dñs ad eum; uoca nomen
eius iezrabel qm adhuc modicum et uisitabo san
guinem iezrabel super domum ieu. et quiescere
faciam regnum domus isr̅t; Et in illa die conteram
arcum isr̅t. In ualle iezrabel; et concepit adhuc
et peperit filiam et dixit ei; uoca nomen eius absq;
misericordia! quia non addam ultra misereri
domui isr̅t.

Fol. 3r (Hosea):
Initial V(erbum) opening the Book of Hosea.

sors Adalhard (834–843) and Vivian (844–851), when they are placed as frontispieces at the start of the individual biblical books. Thus a miniature at the beginning of Genesis might show the Creation and the Fall, for example, while another, at the start of Exodus, might take as its theme the events surrounding the presentation of the Tablets of the Law. The most lavishly illustrated example of such a pandect is the so-called Vivian Bible (Paris, Bibliothèque Nationale de France, Cod. lat. 1), which was executed by Abbot Vivian and the monks of St Martin's for Charles the Bald, King of the Western Franks.

The present fragments from the Trier Bible date from the era during which manuscript illumination in Tours was at its height. Whether this Bible also contained full-page illustrations is a question yet to be answered. On the folios which have survived into the present, however, or at least those discovered so far, initials are the only form of decoration. Typical characteristics of these initials include interwoven bands concluding the top and bottom of the stem of a letter, and rectangular fields containing ornamental motifs such as interlace or foliate forms, which – as in the case of the only initial in the Codex Series nova 364, found on folio 3r (ill. p. 79) – fill the interior of the letter. Two hundred years later, with Tours Bibles still widely in existence, their decorative characteristics would be taken up by Italian workshops, who – from around 1050 – drew on Tours manuscripts from the Carolingian era in producing their own large-format Bibles (see pp. 86–93).

F. S.

Extent: three parchment folios comprising six fragments
Format: 450 x 330, 340 x 340 and 340 x 350 mm
Binding: cardboard cover added by the National Library in 1936
Content: Bible (fragments from Genesis, Hosea and Daniel)

Language: Latin
Illustration: one initial
Provenance: The folios were detached from Codex 2133, which originates from St Maximin's Abbey in Trier.
Shelfmark: Vienna, ÖNB, Cod. Ser. n. 3641

Carolingian Bible
(also known as the Rado Bible)
Northern France (?), 2nd third of the 9th century

Codex 1190 is also referred to in the literature as the Rado Bible, but this name derives from a misconception. The text of the Bible is preceded by two poems (fol. 16r–16v) composed by Alcuin, abbot (796–804) of St Martin's Abbey in Tours. Due to an error in the transcription on fol. 16v, the text was believed to mention one Rado, who was identified with Abbot Rado of St Vaast (795–815) in Arras in France. The codex was correspondingly assumed to date from the period around 800. In fact, however, the manuscript was only compiled in the 2nd third of the 9th century. The original upon which its text and illustration are based has been identified as a two-volume Bible (Cod. lat. 45 and 93 in the Bibliothèque Nationale de France, Paris) written between 820 and 840 in a Paris abbey, perhaps St Denis. It is therefore likely that Codex 1190, too, was produced in northern France.

The illustration of the manuscript consists of initials and canon tables. Eight large initials in gold, yellow, green, red and brown are found at the beginning of biblical books (ill. p. 82). The initials are filled and embroidered primarily with interlace; in one initial Q(uoniam) on fol. 250r, the descender has been replaced by a bird grasping a fish in its claws (ill. p. 83). The 48 small initials are decorated with foliate motifs, interlace and other patterns (stepping and zigzag) but are not coloured. The decorative architectural surround framing the canon tables is similarly executed in pen only (fol. 237v–238r).

In its conception as a single volume, the present Bible illustrates how the production of pandects at Tours influenced other abbeys (see pp. 78–81). The text of the Bible itself, however, exhibits a number of different influences, which have yet to be fully explained. Although efforts had been continuing since the time of Charlemagne (747–814) to arrive at a correct, standardized biblical text, the Bibles of the Carolingian era demonstrate a confusing variety, not just in the sources on

Detail from fol. 18r (Genesis): Initial *I(n principio)* opening the Book of Genesis.

▶ **Detail from fol. 250r (St Luke):** Initial *Q(uoniam)* at the start of St Luke's Gospel.

bentibus illis undecim · Apparuit Rex
probauit incredulitatem illorum & duritiā
rdis · Quia his qui uiderant eum resur rex
se non crediderunt · Et dixit eis · euntes
mundum uniuersum praedicate euange
um omni creaturae · Qui crediderit & bap
zatus fuerit saluus erit · Qui uero non
rediderit condepnabitur · Signa autem
os qui crediderint haec sequentur · In nomi
e meo daemonia eicient ling[ui]s loquen̄
ouis serpentes tollent · Et si mortiferū
quid biberint non eis nocebit · Super egros
manus inponent & bene habebunt·
t dns quidem ihs post quam locutus est eis·
ssumptus e in caelum & sedit a dextris di
li autem profecti praedicauerunt ubique
no co operante & sermonem confirmā
r sequentibus signis·

VESSVRS
ᴸ ANTIOCHENSIS
te medicus discipulus apostolorum postea
ulum secutus usq; ad passionē ei seruiens dno
se crimine· nam neque uxorem umquam
bens· neque filios · LXXIIII annorum obiit
hithinia plenus spu sco· qui cum iam scrip
essent euangelia p matheum quidem in
udea· p marcum autem in italia· sco instigan
spu· machaiae partibus hoc scripsit euan
elium· significans &iam ipse inprincipio
n alia esse descripta· cui extra ea quae
rdo euangelice dispositionis exposcit· ea
naxime necessitas laboris fuit· ut primū
raecis fidelibus omni profectione uentu
 in carne di xpi manifestatā humani[ta]tis
 eiudaicis fabulis attenti insolo legis de
derio tenerentur · Ne uel hereticis & uana fa
ulis & stultis sollicitarionibus seduci
xcederent auertat· elaborarē dehinc
t in principio euangelii iohannis natiui
ate praesumpta cui euangelium scriberē

Sicq; paulus consummatione apostolicis
actibus daret quem diu contra stimu
lo recalcitrante dns elegit s& · quod
legentibus ac requirentibus dm &sip
singula· expediri a nobis utile fuerat
scientes tamen quod operantem agricolā
oporteat de fructibus suis edere · Ut ita
mus publicā curiositatem ne non tam
uolentibus dm uideremur· quam fasti
dientibus prodidisse·

EXPLICIT PREFATIO

INCIPIT
EVAN
GELIV
SECUNDUM LUCAM

UETUS TESTAMENTUM
ideo dicitur quia ueni et renouae cessa
uit; de quo apostolus meminit dicens;
uetera transierunt; Ecce facta sunt
noua; Testamentum autem nouum
ideo nuncupatur; quia innouat;
non enim illud dicunt nisi homines
renouati; excuntate per gratia;
& pertinent ad testamentum
nouum quod est regnum cælorum;
hæbrei autem uetus testamentum
ezra auctore iuxta numerum
literarum suarum in XXII libros acci
piunt; diuidenctes eos in tres ordines;

legis scilicet & prophetarum & agiographorum; primus ordo legis in quinque libris accipitur; quorum prim
quis bresith; secundus hellesmoht. quod est exodus; Tertius uagecra quod est leuiticus; quartus uagedaber quod
quinquis elleaddabarim quod est deuteronomium; Hi sunt quoque libri moysi; Quos ebrei thoralarim legem ap
proprie autem lex appellatur quæ p mor sen data est; secundus ordo est prophetarum quo continentur libri
primus; iosue ben nun; Qui latine dicitur iesu naue secundus sophthim quod est iudicum; Tertius samuhel
uus taresta quidicitur duodecim prophetarum; qui libri quia sibi pro breuitate adiunguntur pro uno accipiuntur
uus est ordo agiographorum id est saa scribentium in quo sunt libri nouem; Quorum primus iob; Secundus nab
psalterium; Tertius malloth quod est prouerbia salomonis; Quartus coeleth ecclesiastes; Quintus sirasirim
tica canticorum; Sextus danihel; Septimus dabreum; Quod est uerba dierum hoc est paralipomenon
ezras Homilester qui simul omis; Quin que octo & nouem fiunt uiginti duo; Sicut superius com phentisime; Ci
ruth & enoth quod licunt dicit lamentatio hieremie agiographs adiciunt; & xx iiii uolumina testamen
faciunt iuxta uiginti iiii seniores quiante conspectum di assistunt; Quartus e apudnos ordo ueteris

eorum libror quin canone hebraico
n sunt quorum primus sapientiae liber e;
secundus ecclesiasticus; Tertius tobi;
Quartus iudith; quintus & sextus
machabeox; Quos libros rudes int
agiographs separant; etta men xpi
inter diuinas scripturas & honorat & p
dicae; in nouo autem testamento sunt
ordines p prim euangelicus. in atheus
marcus lucas iohannes; secundus
apticus in quo sunt paulus in uen.epts.
petrus in duabus iohannes in tribus
iacobus & iudas in singulis actus apostolor
& apocalypsis; summa aut utriusque
testamenti diuersitate distinguentur id e
in instaurandam rebus in ad p uersus
ista et amal citare & duturu eius; id e
gsta dq daban chis t hominib; c est u
cxterugesse; quod apphetes onum iacu
dixpo et corpore ei; q declt diabolo;

& membris eius; quid deuenit & nouo
populo quod deptus di cui es uirorege
acque iudicio
Libra...

Linquosunt

Fol. 17v: List of the books of the Old Testament.

which their individual books are based but also in the order in which they are presented. Alongside the Vulgate, the Latin translation of the Bible completed by St Jerome (c. 347–419), we also find elements of the so-called *Vetus Latina*, an Old-Latin version of the Bible, translated from the Greek, which had been in use since the 2nd century but which from the 5th century onwards was gradually superseded by the Vulgate. Since scriptural texts such as the Pentateuch (the first five books of the Bible, i.e. Genesis to Deuteronomy), the Book of Psalms and the Gospels were also available as separate codices, and since it appears that every available text was consulted when preparing a complete Bible, it was possible for very different traditions to find their way into the final manuscript. Thus the organization of the books of the Old Testament in Codex 1190 reveals parallels with a group of Spanish Bibles, while that of the books of the New Testament corresponds to Bibles from Tours. The two Old Testament books of Tobit and Judith, meanwhile, which follow the old-Latin translation, are probably derived from a local, northern French source.

The subsequent history of the manuscript can be reconstructed from annotations found in the text. In the latter third of the 9th century it was probably in Corbie, which in the 11th century lay in the German-speaking realm. In the first half of the 12th century, a member of the Orthodox Church made notes in Czecho-Church Slavonic on a list of readings on folios 239v to 247v; the manuscript must therefore have been in a Bohemian monastery at that time. How it subsequently made its way into the Vienna Hofbibliothek is unknown.

F. S.

Extent: 292 parchment folios
Format: 365 x 225 mm
Binding: white leather with blind tooling over wooden covers (Vienna 1707)
Content: Bible (Old and New Testament)
Language: Latin
Illustration: eight large and 48 small initials and canon tables

Provenance: The manuscript was in Bohemia in the 12th century, and by some unknown route subsequently entered the Vienna Hofbibliothek, where it is documented from 1576 onwards.
Shelfmark: Vienna, ÖNB, Cod. 1190

Giant Bible from Nonnberg (fragment)

St Peter's Abbey, Salzburg (?),
around the middle of the 12th century

On account of their size and the durability of their parchment, from the late
Middle Ages onwards it was not uncommon for large-format manuscripts to be
taken apart and used to cover other books (see also pp. 90–93). The two sheets re-
united as Codex Ser. n. 3350 (ill. p. 87, 88) display clear evidence of this practice:
to the left of the large initial in the upper half of each page, brief details of the con-
tents of the new books they were used to bind have been added by a 15th-century
hand. The darker bands running horizontally across each page, meanwhile, mark
the former position of the spines, grown grubbier over time.

In this way, fragments have survived of a Bible containing parts of the Old Tes-
tament books of Moses (Numbers and Deuteronomy, fol. 1r–1v) and the 2nd Book
of Kings (fol. 2r–2v). They can be identified with the fragments described in the
Österreichische Kunsttopographie of 1911 as being in the nunnery of St Erentrud am
Nonnberg in Salzburg. It would seem that they subsequently found their way onto
the art market and in 1926 were purchased for the National Library from a Vienna
antiquarian bookseller; a third sheet, still extant in 1911, is now either in a private
collection or lost.

The sheets were produced in a monastery in the city of Salzburg, probably
St Peter's, although it is also possible that they originated from the nunnery attached
to St Peter's, the Konvent der Petersfrauen, which was founded in *c.* 1130. It is
highly probable that they were written by a single hand, one to whom a monastic
Ritual housed in Klagenfurt is also attributed (Klagenfurt, Kärntner Landesarchiv,
Cod. 6/4); since the contents of this latter manuscript correspond extensively to
a Ritual compiled for St Peter's (Salzburg, Stiftsbibliothek St Peter, Cod. a VIII 1),
the present fragments can also be localised to Salzburg.

The illustration is dominated by the influence of Italian large-format Bibles.
It is to these that we can trace the outsize initials, overly large in relation to the
remaining text, and the majority of the decorative details. Typical of Italian works,
for example, is the way in which the body of the letter is filled with largely rectan-

Detail from fol. 1v: The initial H(*ec*) and – in
continuation of the text – the six initials (*Ha*)*EC*
and *SUNT* from Deuteronomy.

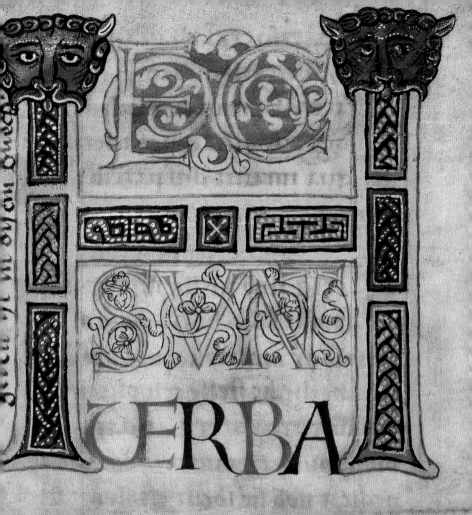

HEC SVNT VERBA

QVE LOCVTVS EST MOYSES
ad omnē isrł transiordanē infoli
tudine cāpestri cont mare ru
brū. intpharan & thophet. &
.#laban. & aseroth. ubi auri ē plu
rimū. unde eī dieb° de horeb. pui

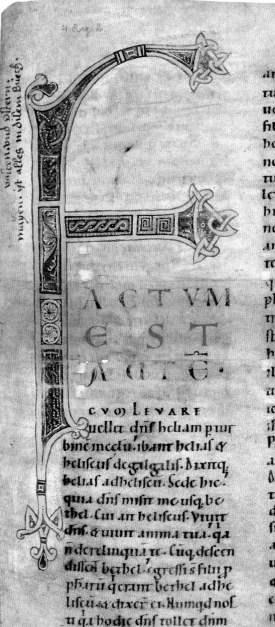

A CT VM
E S T
ITAQ.

CVO LEVARE
uellet dns heliam p tur
bine incelu. ibant helias &
heliseus degalgalis. Dixitq;
helias adheliseu. Sede hic.
quia dns misit me usq. be
thel. Cui ait heliseus. Viuit
dns. & uiuit anima tua. qa
n derelinqua te. Cuq; descen
dissent betthel. egressi s filii p
pharu q erant betthel adhe
liseu. & dixer ei. Numqd nos
ti qa hodie dns tollet dnm

art. Viuit dns. & uiuit anim
tua. qa n derelinqua te. C[um]
uenissent hiericho. accessi
filii ppharu q erant ibi ad
heliseu. & dixer ei flumqd
nosti qa hodie dns tollet
tuu att. Et ait. Ego noui
letq. Dix aut ei helias. Sed
hic. qa dns misit me adiot
ne. Cui ait. Viuit dns. & ui
anima tua. qa n derelinq
te. Ierunt q ambo parit.
quinqginta aut de filiis p
pharu secum 5. & r steter [con]
tra eu longe. illi aut amb
stabant sup iordane. Tulit
helias pallui sua & inuoli
illud. & pcussit. quas q[ue]
uis 5 muttaq. parte. & tra
ierunt ambo psiccu. Cuq;
issent. helias dix adheliseu
Postula qd uis ut facia tib
antcq tollar ait. Dixq; hel
Obsecro ut fiat duplex sp
tuus in me. Qui respond. R
difficile postulasti. At tan
si uideris me quando tollt
ate. erit qd petisti. si aut
uideris nerit. Cuq; pgerent
& incedentes sermocinare
ecce currus igneus & equi
na diuiser utruq. Et ascen

gular fields containing a variety of braid patterns and foliate motifs. Typical, too, is the use of yellow to pick out the borders of the initial.

Alongside the large Italianate initials of *H(aec)* and *F(actum)*, on fol. 1v (ill. p. 87) we also find smaller initials which are very different in character and which derive from local Salzburg book illumination. The initials *E* and *C*, which emerge out of a scrolling pattern of foliate branches, are drawn in red ink on a blue ground and form a continuation of the text between the two upper verticals of the *H*. They correspond in both style and colour with the initials of the Klagenfeld Ritual mentioned above; they are comparable, too, with the initials executed in ink in the huge Admont Bible produced in St Peter's around 1150 (pp. 108–123; see, e.g., fol. 13r, 199r, 214v and 218r). Between the lower verticals, the foliate and floral forms of the blue tendrils weaving through the initials *SUNT* are similarly found in Salzburg manuscripts of the mid-12th century (cf., e.g., Munich, Bayerische Staatsbibliothek, Clm 15 905, fol. 71r).

With their pronounced orientation, in their large initials, towards the ornamental style of Italian giant Bibles, the present fragments occupy an unusual position within Salzburg manuscript illumination; only the Genesis initial in a Bible produced some 15 years earlier, showing a similar combination of local and Italian elements, is comparable (Salzburg, Stiftsbibliothek St Peter, Cod. a XII 18, fol. 6r).

F. S.

Extent: two trimmed parchment folios
Format: 335 x 215 and 350 x 255 mm
Binding: half-linen binding, ÖNB 1928
Content: Bible (fragments of Numbers, Deuteronomy and 2 Kings)
Language: Latin
Illustrations: two large column-width initials, six small foliate initials within one column width

Provenance: Documented in the nunnery of St Erentrud am Nonnberg in Salzburg; acquired for the National Library from Heck's antiquarian booksellers (Vienna) in 1926.
Shelfmark: Vienna, ÖNB, Cod. Ser. n. 3350

Giant Bible of St Florian (fragment)

Abbey of the Augustinian Canons of St Florian (Upper Austria), around 1140/50

On the basis of its layout and script, the present sheet – later used as a cover and hence trimmed and folded – can be assigned to the Giant Bible of St Florian in Upper Austria. No longer fully extant, this Bible originally extended to at least three volumes. For unknown reasons, however, considerable parts were lost, while others were removed from the monastery library. In the 15th century, the majority of those sections that survived were combined into Codex XI/1 in the St Florian library. A further four sheets were used to bind records in the Fürstlich Starhembergischen Schloßarchiv in Eferding and since 1947 have been housed in the Oberösterreichisches Landesarchiv in Linz (*Buchdeckelfunde*, No. 1). The provenance of Codex Ser. n. 4236 remains uncertain.

With so much of this Giant Bible now lost, its decorative programme can no longer be reconstructed in full. The only full-page miniature was apparently St John the Evangelist writing at the start of Apocalypse (Cod. XI/1, fol. 318v). The four Gospels were introduced by quarter-page pictures of the Evangelists (cf. Linz, OÖLA, *Buchdeckelfunde*, No. 1, fol. 1v); a letter from St Jerome at the very start of the Bible is also introduced by a quarter-page miniature of the Church Father, seen writing (Cod. XI/1, fol. 1r). Further figural illustrations are found in the interior of initials (beside scenic depictions primarily of standing figures from the Old and New Testament) and also as replacements for the letter *I* instead of initials.

With its imposing size of approx. 660 x 475 mm, the manuscript takes up the tradition of the *bibbie atlantiche* or Giant Bibles which were produced from the middle of the 11th century onwards in central and northern Italy. These bear witness to a church reform, instigated by the papal Curia, placing new emphasis upon the integral nature of the Old and New Testament and the study of the entire text of the Bible. The unusual format was probably also intended to further underline the importance of the Holy Book. In the 12th century, Giant Bibles and manuscripts influenced by Italian Giant Bibles were produced north of the Alps, too. The St Florian manuscript is thereby the only known example to have arisen not

Detail from fol. 1r (Joel [Minor Prophets]): Dragon initial S(anctus) from the Book of Joel.

cord uero corruerit mens.

INCIPIT PREF.
SCI HIERONIMI PRE.
IN IOHEL PPHETA.

SANCTVS
.
IOHEL

apud ebreos
post osee poni
tur. & sic ibi sub
nomine effraym
ad decem trib. se
fert uastimui
que uel famin.
ut istl sepe me
morantur: sed
inhunc ppheta omne qd dr ud
tribu iuda. & adhyerusale ptine
re credendu est. & nulla omnino

tū incipit probitare. EXPLI
CIT PROLOGVS

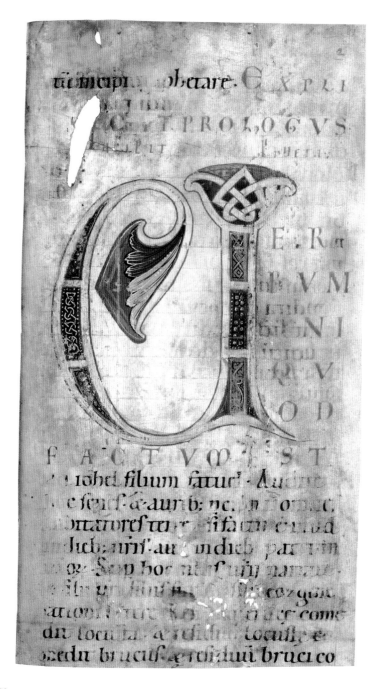

E. Ra
V M
N I
Q V
O D

FACTVM EST
iohel filium fatuel. Audite
e fenes. & aurib; pc. In tocae,
borravores tuos. Si factū est hoc
indieb; nurs. aut indieb; parū iu
og. Sup hoc nlrs. filiis narrate.
esir en sluns sus. & sie eos quie
ationsius. & sie s. rui dei come
dit locusta. & residui locust; e
cedit brucus. & residui bruci co

in a Benedictine abbey, but in an Augustinian chapter. It is thus not possible, as some have recently sought, to explain the appearance of Giant Bibles outside Italy solely in terms of reforms within the Benedictine order.

Going beyond the format, aspects of the illustrations also reveal a very close similarity to Italian Bibles from the regions of Rome and Umbria, prompting suggestions that the manuscript was actually produced in Italy itself. Firm evidence of its origin in St Florian is provided, however, by a group of initials drawn in pen (e.g. fol. 6r, 66v, 131v, 229v and 336r), which are stylistically linked to several other manuscripts in the same library (cf. e.g. Cod. XI/14/1–4 and Cod. XI/19).

The juxtaposition of Italian and "local" forms is also reflected in the initials of Codex Ser. n. 4236. Thus the initial U(erum) on fol. 2r (ill. p. 92), with its yellow, in places interlacing edging bands and the decorative fields within its uprights, reveals typical Italian characteristics (see also pp. 86–89), whereas the S(anctus) formed by a dragon (ill. p. 91), on the other hand, represents a type of initial found primarily in Swabian and southern German manuscripts. A damaged initial on fol. 1v features scrolling leaves studded with small circles that are typical of St Florian manuscript illumination of the day.

F. S.

Extent: two parchment folios (originally one sheet, folded in two)
Format: 320 x 180 mm
Binding: black half-linen binding, added by the ÖNB in 1928

Content: fragment of the Bible (Book of Joel)
Language: Latin
Illustration: three decorated initials
Shelfmark: Vienna, ÖNB, Cod. Ser. n. 4236

Parisian Pocket Bible

France, middle of the 13th century

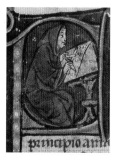

At the start of the 13th century, there appeared in Paris a handy type of Bible which proved so popular that, within just a few decades, hundreds of copies were being produced. These "pocket Bibles" played a central role in promulgating a new version of the Bible that was establishing itself between 1200 and 1230 in university circles in Paris. This version can be recognized amongst other things by its inclusion of the Prayer of Manasseh after the 2nd Book of Chronicles and of the so-called *Interpretation of Hebrew names*, an alphabetical dictionary giving the Latin meanings of the Hebrew proper names. Its production no longer lay in the hands of monastic scriptoria, but was organized by booksellers. Having had the Bibles – of which the pocket-size editions were in particular demand – copied out by scribes, these booksellers then passed many of them on to illuminators, who kept to a specific format in their illustrations, as can be seen in the two examples in the Austrian National Library: the biblical books and most of the prologues begin with initials in gold, blue, dark red, red, pink, green, white and gold. Areas of skin are rendered in a pale colour, and the faces in Codex 1151 have been given rosy cheeks (fol. 1r). Initials, figures, the internal fields of initials and foliate branches are outlined in black, while white lines and ornamentation offer a lively contrast to the dark colours. The number of initials containing pictorial fields varies from Bible to Bible: in Codices 1150 and 1151, the prologue to Genesis and the beginning of Genesis itself (ill. p. 96) are visually emphasized in this way, as is also the beginning of the Book of Proverbs in Codex 1150. Ornamental initials and *fleuronnée* initials serve to announce the beginning of the remaining books, the start of prologues and the start of new chapters.

The English philosopher and theologian Roger Bacon († 1292) bemoaned the inaccuracy of this new Bible put out by Parisian theologians and booksellers, but such criticism did not stop the pocket-size version, in particular, from selling

Detail from fol. 2r: Initial with St Jerome, author of the prologue to Genesis.

▶ **Fol. 1v:** Miniature of the Creation from the beginning of the 16th century.

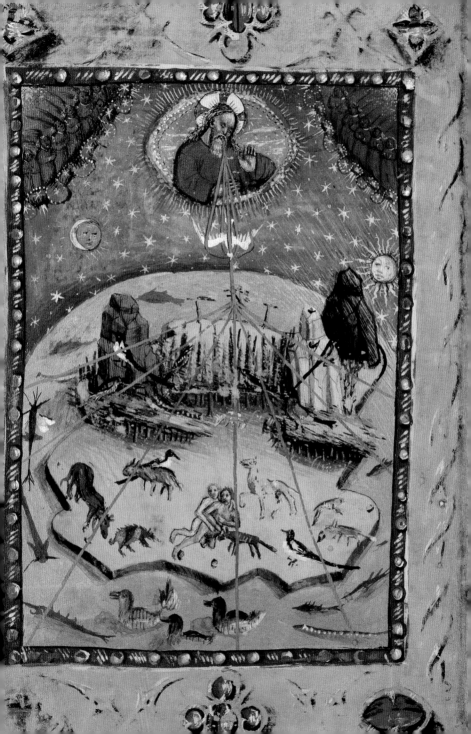

in zacharia. Quartum in puerb'
is. Quintum eque in ysaia. Qđ
multi ignorantes apocriforū delira
menta sectantur ⁊ hibereas nem
as libris auenticas pferunt. Eas
errores nō est meum exponere. Iu
dei prudentū factū dicunt. ⁊ consi
lio u'ptolomeus unū deicultor' ⁊
apud hebreos dupl'cem diuinitate
compbenderet. Qđ maxime idcirco
faciebant quia in platonica dog
ma cadere uidebatur. Deniq; ubi
cumq; sacratum aliquid scriptu
ra testatur de pre ⁊ filio ⁊ spū sco
aut aliter inter'ptati sunt aut oī
no tacuerūt. ut ⁊ regi satisface
rent. ⁊ arcanū fidei non uulgarēt.
Et nescio quis primus auctor. lxx
cellulas alexandrie mendacio suo
extruxerit. quibz diuisi eadem scrip
titarent. cum aristeus eiusdem
ptolomei uπεrασπιstes. ⁊ n̄t multo post
multo post tempore iosephus n̄
chil tale retulerint. sz una basi
lica congregatos contulisse scribāt
non pphasse. Aliud ē n̄t uatē.
aliud ē ē inter'ptem. Ibi spūs scs
uentura pdicat. hic eruditio ⁊ ū
borum copia ea que intelligit
transfert. Nisi forte putandus ē
tullius economicū xenofontiū
⁊ platonis pitagoram ⁊ demostē
tenis pphesi'm fonte afflatus rhe
torico spiritu trāstulisse. aut aliter
de eisdem libris p lxx inter'ptes
aliter per apostolos spiritus scs
testimonia texuit. ut qđ in illis
tacuer'ūt hi scriptū ē mentiti sint.
Quid g'amp'namus ueteres. Iz
nimē. Sz post pror studia priorū
domini ad possumus laboramus.
Illi inter'ptati sunt ante aduen
tum xpi. ⁊ q' nesciebant dubijs p
tulere sententijs. Nos post pas
sionem eius ⁊ resurrectione eius
n̄t tam phetia quam hystoriam
scribimus. Aliter enim audita. ali
ter uisa narrantur. Qđ melius

intelligimus. melius ⁊ pferimus.
Audi ergo emule. obtrectator asculta.
Nō dampno. nō reprehendo. poz scos fidem
cunctis illis apostolos pfero. Pudo
rum eni̅ os in xpe sonat quos; ante
pphetas inter spiritalia carisma
ta positos lego. in quibz ultimum
pene gradum inter'ptes tenent.
Quid liuore torqueris. Quid im
peritorū animos contra me con ci
tas. Sicū in trāslatione tibi uide
or errare. inter'roga hebreos. diu'sar̄
urbium magros consule. Qđ illi
habent de xpo tui codices nō hn̄t.
Aliud est si contra se postea ab apo
stolis usurpata testimonia pbaue
rint. ⁊ emendatiora sunt exempla
ria latina quā greca. greca quam
hebrea. Verū hoc ōt inuidos Nūc
te deprecor desideri bōne ut quia me
tantum opus subire fecisti. ⁊ a ge
nesi exordium capere orationibz;
iuues. qđ possim eodem spu quo
scripti sunt libri in latinum eos
transferre sermones.

I|H principio creauit
dūs cœlum ⁊ terram.
Terra autem erat inanis ⁊ va
cua. ⁊ tenebre erant sup
faciem abyssi. ⁊ spiritus dn̄i
ferebatur sup aquas. Dixit qđ
deus. fiat lux. Et facta ē lux. Et uid
dit lucem qđ ēt bona ⁊ diuisit
lucem a tenebris. Appellauitq;
lucem diem ⁊ tenebras noc
tem. factum ē uespere ⁊ ma
ne dies unus. Dixit qđ; deus.
fiat firmamentum in medio
aquarū. ⁊ diuidat aquas
ab aquis. Et fecit deus firma
mentum. diuisitq; aquas que
erant sub firmamento ab
his que erant sup firmamentū.
Et factum ē ita. vocauitq; deus
firmamentū cœlum. Et factū ē
uespere ⁊ mane dies secds. Dixit
uo deus. Congregentur aque
que sub cœlo sunt in locū unū

Fol. 5v (Genesis): The blessing of creation on the 7th day. The separation of the earth and the water. The creation of Adam.

rapidly. Who bought these tiny Bibles, and why demand for them should decline after 1300, are questions on which we can only speculate, since these Bibles rarely contain coats of arms or the names of their first owners. Having issued from the sphere of the university, they would certainly have been bought by teachers and students. Their small format must also have appealed to the monks of mendicant orders, since it meant they could carry the Bibles with them when they left the convent to go out and preach. An indication that the Bibles were indeed employed in this way lies in the fact that a number of them contain liturgical calendars for use by such orders. The early owners of pocket Bibles probably also included wealthy members of the laity, however, who used the text originally designed for theologians and priests for their own private worship, either in place of their existing psalters or in addition to them (the Book of Psalms is absent in some of these Bibles, as in the case of Codex 1150). It is therefore possible that the decline in demand for pocket Bibles was linked with the rise, towards the end of the 13th century, of more user-friendly Books of Hours, compendia of scriptural texts organized into daily devotions for ordinary people to recite at home. These Books of Hours would succeed the pocket Bible as the new and unrivalled best-seller.

Although the production of small Bibles declined after 1300, existing copies continued to be prized. In the 16th century the Bibles of Codices 1150 and 1151 were given new bindings by their owners, and an opening miniature was added to Codex 1150 (ill. p. 95). In the case of Codex 1151, it was probably the priest David Vischer, to whom the book belonged in 1565, who added the missing pagination and the information on the index tabs.

C. B.

Extent: 611 parchment folios
Format: 140 x 95 mm
Binding: worn black-velvet binding dating from the 16th century
Content: Bible (Old and New Testament, without the Book of Psalms), alphabetical dictionary giving the Latin meanings of the Hebrew names
Language: Latin

Illustration: one full-page miniature (16th century), three historiated initials, 74 ornamental initials, numerous fleuronnée initials
Provenance: In the second half of the 16th century (?) the Bible reached the Damenstift in Hall (Tyrol). In 1783, following the closure of the foundation, it passed to the Hofbibliothek in Vienna.
Shelfmark: Vienna, ÖNB, Cod. 1150

Bologna Bible

Bologna, *c.* 1240

The manuscript, which was produced in Bologna in around 1240, contains the entire Latin Vulgate with the exception of the Psalter, plus the accompanying alphabetical list of Hebrew names which was generally included in Bibles from the 1230s onwards. Added at the end, probably even before the 13th century was out, was a list of gospels and epistles for the Church year, followed by an index, in a 15th-century hand, of the books of the Bible in order.

As one of the earliest examples of the Vulgate manuscripts which issued from Bologna as from the 1240/50s onwards, the Bologna Bible is accompanied solely by ornamental illustrations. It is thereby representative of the First Bolognese style, which Robert Gibbs has aptly named the "academic manner". Codices belonging to this group were used primarily as textbooks by students, and in their modest illumination differ markedly from the luxury Bibles also being produced in Bologna in a consciously Byzantine style. Typical of the present Bible are foliate branches in body colours, which take their starting point mostly from the borders of the initial, scroll in some cases right across the page in a variety of vegetal forms and frequently contain knots, armour, drolleries and dragon-like beings, and which are later also inhabited by birds. Amongst the colours most frequently encountered are an intense blue, which is often used as a foil for other colours, a powerful orange, yellow, light green, light brown, columbine blue, grey, pink and purple.

The text and decoration, and also the sequence in which the individual books of the Bible are presented, are oriented towards French Bibles of the 1230s. The Dominican and Franciscan theological schools in Bologna in particular maintained very close links with Paris, something also reflected in the manuscripts which, as records reveal, they exchanged between them. In 1249 the Franciscan school already existing in Bologna was granted papal recognition and put on a par with

Detail from fol. 347v (Haggai [Minor Prophets]): Dragon initial at the start of the prologue to the Book of Haggai.

▶ **Fol. 4r (Genesis):** Dragon initial at the start of the Book of Genesis.



[In] principio creauit deus celum et terram. Terra autem erat inanis et uacua et tenebre erant sup[er] faciem abyssi et sp[iritu]s d[omi]ni ferebatur sup[er] aquas. Dixitq[ue] d[eu]s. Fiat lux. Et facta est lux. Et uidit d[eu]s lucem q[uod] esset bona et diuisit lucem a tenebris. Appellauitq[ue] lucem diem et tenebras noctem. Factumq[ue] est uespere et mane dies un[us]. Dixit q[uoque] d[eu]s. Fiat firmamentu[m] in medio aquar[um] et diuidat aquas ab aquis. Et fecit d[eu]s firmamentu[m]. diuisitq[ue] aquas que erant sub firmame[n]to ab hiis que erant sup[er] firmamentu[m]. Et factu[m] est ita. Vocauitq[ue] d[eu]s firmamentu[m] celu[m]. Et factum est uespere et mane dies s[e]c[un]d[u]s. Dixit u[er]o d[eu]s. Congregent[ur] aque q[ue] sub celo sunt in locu[m] unu[m] et appareat arida. factumq[ue] est ita. Et uocauit d[eu]s aridam t[er]ram co[n]gregationesq[ue] aquar[um] appellauit maria. Et uidit d[eu]s q[uod] esset bonu[m] et ait. Germinet t[er]ra herbam uirente[m] et faciente[m] seme[n] et lignu[m] po[m]iferu[m] faciens fructu[m] iuxta genus suu[m] cuius seme[n] in semetipso sit sup[er] t[er]ram. Et factu[m] est ita. Et p[ro]tulit t[er]ra herbam uirente[m] et afferente[m] seme[n] iuxta genus suu[m] lignu[m]q[ue] faciens fructu[m] et h[abe]ns unu[m]quodq[ue] seme[n]tem s[e]c[un]d[u]m speciem suam. Et uidit d[eu]s q[uod] esset bonu[m]. factu[m] est uespere et mane dies t[er]cius. Dixit aut[em] d[eu]s. Fiant luminaria in firmame[n]to celi et diuidant die[m] ac noctem. et sint in signa et t[em]p[or]a et dies et annos. vt luceant in firmame[n]to celi et illuminent t[er]ram. Et factu[m] est ita. fecitq[ue] d[eu]s duo magna luminaria. Luminare maius ut p[re]esset diei. et luminare min[us] ut p[re]esset nocti et stellas. Et posuit eas in firmame[n]to celi ut lucerent sup[er] t[er]ram. et p[re]essent diei ac nocti. et diuiderent lucem ac tenebras. Et uidit d[eu]s q[uod] esset bonu[m]. et factu[m] est uespere et mane dies q[ua]rtus. Dixit et[iam] d[eu]s. Producant aque reptile anime uiuentis et uolatile sup[er] t[er]ram.



sub firmame[n]to celi. Creauitq[ue] d[eu]s cete grandia. et om[n]em a[n]i[m]am uiuente[m] atq[ue] motabile[m] quam p[ro]duxerant aque in species suas. Et om[n]e uolatile s[e]c[un]d[u]m genus suu[m]. Et uidit d[eu]s q[uod] esset bonu[m]. Benedixitq[ue] eis dicens. Crescite et multiplicamini et replete aquas maris. Auesq[ue] multiplicent[ur] sup[er] t[er]ram. Et factu[m] est uespere et mane dies q[ui]nt[us]. Dixit q[uoque] d[eu]s. Producat t[er]ra a[n]i[m]am uiuente[m] in genere suo. iumenta et reptilia et bestias t[er]re s[e]c[un]d[u]m species suas. Factu[m]q[ue] est ita. Et fecit d[eu]s bestias t[er]re iuxta species suas et iumenta et om[n]e reptile t[er]re in genere suo. Et uidit d[eu]s q[uod] esset bonu[m]. et ait. Faciamus hoie[m] ad ymagine[m] et similitudine[m] n[ost]ram. et p[re]sit piscib[us] maris et uolatilib[us] celi et bestiis uniu[er]seq[ue] t[er]re om[n]iq[ue] reptili quod mouet[ur] in t[er]ra. Et creauit d[eu]s hoie[m] ad ymagine[m] suam. Ad ymagine[m] dei creauit illu[m]. masculu[m] et femina[m] creauit eos. Benedixitq[ue] illis d[eu]s et ait. Crescite et multiplicamini et replete t[er]ram. et subicite eam et dominamini piscib[us] maris et uolatilib[us] celi. et uniu[er]sis animantib[us] q[ue] mouent[ur] sup[er] t[er]ram. Dixitq[ue] d[eu]s. Ecce dedi uobis om[n]em herbam afferente[m] seme[n] sup[er] t[er]ram. et uniu[er]sa ligna q[ue] h[abe]nt in semetipsis seme[n]tem generis sui ut sint uobis in escam. et cunctis animantib[us] t[er]re om[n]iq[ue] uolucri celi et uniu[er]sis q[ue] mouent[ur] in t[er]ra et in quib[us] est a[n]i[m]a uiuens ut h[abe]ant ad uescendu[m]. Et factu[m] est ita. Uiditq[ue] d[eu]s cuncta q[ue] fecerat et erant ualde bona. Et factu[m] est uespere et mane dies sextus.

Igitur p[er]fecti sunt celi et t[er]ra et om[n]is ornat[us] eor[um]. Co[m]pleuitq[ue] d[eu]s die septimo opus suu[m] q[uod] fecerat et requieuit die septimo ab uniu[er]so opere q[uod] patrarat. Et benedixit diei septimo et s[anc]tificauit illu[m]. q[uia] in ipso cessauerat ab om[n]i opere suo q[uod] creauit d[eu]s ut faceret. Iste sunt generationes celi et t[er]re q[ua]n[do] create sunt. In die q[uo] fecit d[omi]n[u]s d[eu]s celu[m] et t[er]ram. et om[n]e uirgultu[m] agri ant[equam] orirent[ur] in t[er]ra. om[n]emq[ue] herbam regionis p[ri]usq[uam] germinaret. Non e[n]im pluerat d[omi]n[u]s d[eu]s sup[er] t[er]ram. et h[om]o n[on] erat q[ui] op[er]aret[ur] t[er]ram. S[ed] fons ascendebat e t[er]ra irrigans uniu[er]sam sup[er]ficiem t[er]re. formauit ig[itur] d[omi]n[u]s d[eu]s hoie[m] de limo t[er]re. et inspirauit in faciem eius spiraculu[m] uite. et factus e[st] h[om]o in anima[m] uiuente[m].

Incipit epistola sci ieronimi ad
paulinũ preſbiterũ: de oíbus diuine hiſtorie libr.

Frater ambrosius
tua mihi munuscula perferens
detulit simul & suauissimas
litteras: que a princi-
pio amiciciarum fide
probate iam fidei & ue-
teris amicicie noua preferebant. Uera
enim illa necessitudo est & xpi
glutino copulata: quam non vti-
litas rei familiaris: non presentia
tantum corporum: non subdola &
palpans adulatio: ſed dei timor & di-
uinarum scripturarum studia conci-
liant. Legimus in ueteribus hyſto-
riis quoſdam luſtraſſe puincias
nouos adiſſe populos maria tranſiſſe: vt
eos quos ex libris nouerant: coram quoque
uiderent. Sicut pythagoras memphiticos uates.
ſic plato egyptum & archita tarentinum
eandemque oram ytalie que quondam magna grecia
dicebatur: laborioſiſſime peragrauit. ut
qui athenis mgr erat & potens cuiuſque
doctrinas achademie gymnaſia perſona-
bant. fieret peregrinus atque diſcipulus
malens aliena uerecunde diſcere: quam ſua
impudenter ingerere. Deniq; cum litteras quaſi
toto orbe fugientes perſequitur: captus
a piratis & uenundatus: tyranno crude-
liſſimo paruit: ductus captiuus: uinctus
& ſeruus: tamen quia phyloſophus maior emente
se fuit. ad titum liuium lacteo elo-
quencie fonte manantem: de ultimis hiſpanie
galliarumque finibus: quoſdam veniſſe nobiles
legimus quos ad contemplationem ſui roma non
traxerat: uniuſ hoís fama perduxit. Ha-
buit illa etas inauditum omnibus seculisque cele-
brandum miraculum: ut urbem tantam
ingreſſi: aliud extra urbem quererent. Apollo-
nius ſiue ille mag; ut uulgus loquitur
ſiue phyloſophus ut pythagorici tra-
dunt: intrauit perſas: pertranſiuit cauca-
sum. albanos ſcythas maſſagetas opu-
lentiſſima indie regna penetrauit...

(secunda columna)

...tãdem latiſſimo phyſon amne tranſmiſſo
peruenit ad bragmanas: ut hyarcam in
throno ſedentem aureo & de tantali fonte poti-
tantem: inter paucos diſcipulos de natura de mori-
bus ac de cursu dierum & ſiderum audiret docentem. Inde
per elamitas babylonios chaldeos medos: aſſy-
rios parthos ſyros phenices arabes paleſti-
nos reuerſus ad alexandriam: perrexit ad ethi-
opiam ut gymnoſophiſtas & famoſiſſimam ſolis
menſam uideret in ſabulo. Inuenit ille uir ubi-
que quod diſceret: & ſemper proficiens ſemper
se melior fieret. Scripſit ſuper hoc pleniſſime octo vo-
luminibus phyloſtratus.

Quid loquar de ſeculi hominibus. cum apoſtolus
paulus uas electionis & magiſter gentium. qui de
conſcientia tanti in se hospitis loquebatur dicens: An
experimentum queritis eius qui in me loquitur xpc. poſt
damaſcum arabiamque luſtratam aſcenderit iheroſolimam
ut uideret petrum & manſerit apud eum diebus quindecim. Hoc enim myſte-
rio ebdomadis & ogdoadis futurus gentium predi-
cator inſtruendus erat. Rurſumque poſt
annos quatuordecim aſſumpto barnaba & ti-
to expoſuit cum apoſtolis euangelium: ne forte in
uacuum curreret aut cucuriſſet. Habet neſcio
quid latentis energie uiue uocis actus: & in
aures diſcipuli de auctoris ore tranſfuſa for-
cius ſonat. Unde & eſchines cum rhodi exularet & legere-
tur illa demoſthenis oratio quam aduerſus eum habue-
rat: mirantibus cunctis atque laudantibus ſuſpi-
rans ait: Quid ſi ipſum audiſſetis beſtiam ſua uerba reso-
nantem. Hec dico: ut ſi quid aliquid utilitatis ſentio-
ralem: & ut ipſum me ad uidelicet audiret: & adibi eſſet pecto-
ri tuo nec per os alterius quam uoce. quid enim forte doctri-
ſine doctore laudabile eſt. Ars quid uincat:
& quid ſit ſalutare. Qui & ex ore artificis
di dicitur: & ſi artifices explaſtica eſſet morta-
li virtute uix uiuens & quicquid eo opere: Paulus apoſto-
lus ad galathas ſcribens ita loquitur: moyſen quasi pro
alia claruit: de uiro arnauit: ſtabilis uoluit poſt-
ea tacere ſcilicet. Arma & malueritis nec in cor
natura ſit ut pontus eſt. abdidimusque mũni-
tione agitationes demonemus: nam altera
diue celoũque ſe adimus ſecũdũ Ra: cui pro-
nuntiauerunt cum uuelteri adobediendum xpc. ea pa...

(nota inferior)

Tol ſtudium legere ſtudere moyſis. Sed omni tacto uideret
alibi pſalterium inſi... rinat: ut eo/ eſi ſua belleri apellauit ut
orig; & rpſtauerit. Titulo uetus filia aureæ creature. Sup-
ter uox uelut ea uir... recubanteſ & diſ/bus uuerẽ ſo-
ſpecialiter treſtiſſet ea uocant. tante inſigni aureoꝑ t/
recet geruv· ſerẽ & altiores melinareꝰ de ſua eſt ſtupua-
pinceſ uti duo figurauit peruerſi ptendiſt... uiuadã
uis/tracineſ earn ſeptẽ & me... recurabat. ꝑ alioquã alter/
bule: & littera ſtaculo teo ubi uoce eſt cu e colibnt
requã uocta perduit famã ꝯ apolliniſẽ abob/
uedendi ingerit.

the Parisian school. At the latest between this date and *c.* 1320, well over 100 lavishly illuminated Vulgate Bibles were produced in the Emilian university town – the largest volume of such codices to be issued anywhere outside Paris in the 13th century. A production process that shared out the work of copying and illumination, and a local government that monitored the book-selling trade, guaranteed student-friendly prices – one of the reasons why Bolognese codices ended up in virtually every country in Europe, so many of them having been taken home by their owners once their studies in Italy were completed. In early Vulgate manuscripts from Bologna, the decoration remains for the most part relatively simple, employing only ornamental forms – as in the present example – or incorporating just two or three historiated initials, usually at the beginning of Genesis, the Book of Psalms and St Matthew's Gospel. Only around 1250/60 does the illustration become more elaborate, again in line with French models.

Numerous erasures in the actual biblical text of Codex 1127, and contemporaneous and later corrections and variations inserted into the margins – usually introduced by *vel* ("or") – reveal that the manuscript was copied from an earlier, revised Paris Bible. The sequence in which the individual books appear is also based on the standardized version of the Bible being promulgated in Paris from 1230 onwards. The fact that the preface to the Acts of the Apostles has been included by mistake at the end of Apocalypse goes to show, however, that the new layout was still not entirely familiar in Bologna when this manuscript was compiled.

The argument for an early dating of the manuscript to around 1240 is further supported by its decoration, with its restrained palette and omnipresent dragons. In its ornamentation and dragon figures, it offers a comparison with the legal Codex 2052, also in the Austrian National Library and datable to the 1240s (see ill. pp. 98, 99).

K.-G. P.

Extent: I + 511 + I parchment folios
Format: 180 x 133 mm
Binding: leather binding with blind tooling and decorative plait work (Upper Italy or Austria, 2nd half of the 15th century)
Content: Bible (Old and New Testament)
Language: Latin

Illustration: lombard initials with red and blue fleuronnée, 127 ornamental initials
Provenance: It has been established that the manuscript was in St Dorothy's convent in Vienna by the 15th century at the latest. Following the closure of the convent in 1786, it passed to the Hofbibliothek.
Shelfmark: Vienna, ÖNB, Cod. 1127

Magnificence and grandeur – luxury Bible manuscripts

Luxury Bible manuscripts date back to late antiquity and the earliest surviving parchment codices. Their sumptuous format was intended to reflect their importance and was tailored to their function either for private or "public", ceremonial use. At the focal point of the artistic programme stood the Bible codex, representing its own complex textual tradition whose form was determined by the size of the page, the materials used, the carefulness of the script and – here most important of all – the illustration.

Depending upon the artistic trend they embody, the illuminations in these luxury manuscripts are characterized by a delight in narrative detail and a striving for realism or – where the emphasis is different – by abstract, ornamental, decorative elements. The gamut of design options spanned by Bibles from the earliest times to the Late Gothic is very broad: from being restricted solely to first letters, the decoration may start from one initial and spread across the whole page, or may illustrate the text in pictorial cycles which unfold within separate, framed miniatures.

In pre-Romanesque times, single-volume pandects bringing together the complete holy scriptures are rare. The luxury manuscripts of late antiquity, written predominantly in Latin, Greek and Syriac, contain for the most part individual biblical books, sometimes combined into groups. The most important example of this type of manuscript is the Vienna Genesis (see pp. 54–65). Its use of purple parchment, its writing executed in gold and silver ink and its comprehensive cycle of illustrations identify it as a luxury manuscript conceived as a pictorial codex. The second famous Genesis codex from late antiquity, the Cotton Genesis (London, British Library), is indirectly represented in another manuscript housed in Vienna, the *Histoire universelle* (see pp. 280–285), and its cycle of illustrations also found an echo in the mosaics of San Marco in Venice (13th century).

Neapolitan Luxury Bible, Cod. 1191, detail from fol. 8v (Genesis): Decorative border.

▶ Wenceslas Bible, Cod. 2759, detail from fol. 2r: King Wenceslas and Queen Sophia (?), flanked by the coats of arms of the Holy Roman Empire and Bohemia. (Balaam Master)

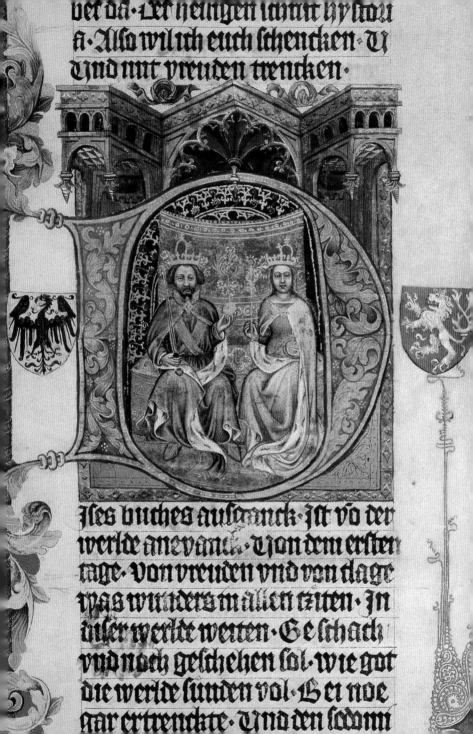

ses buches aufgranck· Ist võ der
werlde anevanck· Von dem ersten
tage· Von vreuden vnd von clage·
was wunders in allen tziten· In
diser werlde weiten· Geschach
vnd noch geschehen sol· wie got
die werlde sunden vol· Bei noe
gar ertrenckte· Vnd den sodom

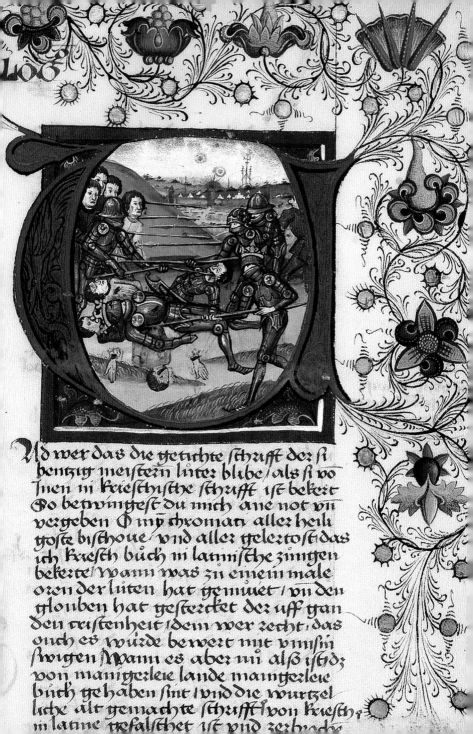

Vnd wer das die getichte schrafft der si
bentzig meistern liter blibe / als si vo
nen in kriesthische schrafft ist bekert
So betwingest du mich ane not vn
vergeben O my chroman aller heil
tgöste bischoue / vnd aller geleretost das
ich kriesth büch in latinische zungen
bekerte / Wann was zu einem male
oren der luten hat gemuet / vn den
glouben hat gesterchet der uff gan
den cristenheit / dem wer recht / das
ouch es würde bewert mit vnnsin
swigen / Wann es aber nit alsô ist dz
von mangerleie lande mangerleie
büch ge haben sint / vnd die wurtzel
liche alt gemachte schrafft von kriesth,
in latine gefalsthet ist vnd zerbroch

The next milestone in the history of luxury Bibles documented here is represented by the pandects produced in Tours abbey in western France during the Carolingian era (see pp. 78–81). The attention paid to the overall artistic design of such codices, combined in Tours with a concern for textual accuracy, may be seen against the backdrop of the Christian kingship of Charlemagne and his patronage of learning and the arts.

The imposing, almost monumental appearance of the Tours Bibles, and the design of their text and decoration, in turn provide the point of departure for a path that leads via the large-format Bibles produced in Italy from around 1050 to the so-called Giant Bibles of the Romanesque era. While the two Giant Bible fragments (see pp. 86–93) continue to show the influence of their Italian forebears, the Admont Giant Bible (see pp. 108–123), which survives almost fully intact, already reveals a largely independent, regional style, making it one of the major works of Romanesque manuscript illumination from the Salzburg area.

Sumptuously illuminated Bibles were also in fashion amongst the Cistercians, otherwise so ascetic in their attitude towards art. After Abbot Stephen Harding († 1134), one of the founders of the Cistercian Order, had one such Bible made in Cîteaux at the start of the 12th century, a number of luxury Bible manuscripts were produced by this Order. The Lilienfeld Bible presented here (pp. 124–127), which despite its "late" date remains firmly rooted in the Romanesque tradition, also aspired to the status of luxury manuscript, as evidenced by the lavish illumination of the initial *I* at the start of Genesis, which fills the whole page (ill. p. 125).

The assimilation of influences from Upper Italian manuscript illumination, coupled with the impact of the Gothic Bibles issuing from France, gave rise to new forms of decoration, as already evident in the Krems Bible (see pp. 128–137) which arose towards the end of the 13th century. The wider possibilities of Gothic manuscript illumination announce themselves in the relationship between the decorative elements and the text, as the ornamentation of the initials spills across the margins of the page and into the gaps between the columns.

Of decisive importance for the further development of Gothic Bible illumination were the revisions to the Bible undertaken at the university in Paris at the start of the 13th century, since these resulted in the first standardization of the complete Bible. The introductory initial *I* at the start of the Book of Genesis, with its portrayal of the work of Creation, could now advance – despite its relatively small format – to the status of magnificent "frontispiece" to the Holy Writ (see pp. 158–163). Illuminated initials generally marked the start of the biblical books, which were now arranged in set order, while subordinate *fleuronnée* decoration identified the beginning of each chapter.

Eberler Bible, Cod. 2769, detail from fol. 171r
Chronicles, Prologue): Depiction of a battle.

Highlighting the initials in this way was primarily intended to make it easier to find specific passages in the text. At the same time, however, such initials provided a setting for the most important biblical scenes. Over the course of the 14th century, in particular in art north of the Alps, initials increased in complexity and size, and their arabesque extensions provided room for coats of arms and even alternative worlds of miniature figures or scenes from everyday life (drolleries). South of the Alps, narrative scenes were popularly staged not only in historiated initials, but also in square miniatures (see pp. 164–175), which were often added in the lower margin.

Luxury Bibles were commissioned on both sides of the Alps by members of the royal courts. In the 14th century, moreover, the European aristocracy's desire for self-aggrandizement and its bibliophilic passion for collecting encouraged the invention of extensive pictorial programmes of the highest quality. Vast cycles of miniatures thereby interweave the history of Salvation with a history of the world in which every ruler takes his divinely ordained place. This naturally demanded new pictorial formulae, for which artists, as it has been shown, turned to chronicles of world history.

When, around 1390, work was proceeding in the imperial capital of Prague on the large German Bible for King Wenceslas IV (see pp. 138–151), the dissemination of the vernacular translations of the Bible that had arisen as part of the *Devotio moderna* movement had already been banned. Wenceslas' German-language luxury Bible might thus have become, for the first time, a statement of opposition to the Church authorities by a *Rex Romanorum*. It remained unfinished, however.

Over the course of the 15th century, commissions for luxury Bibles increasingly came from prosperous merchants and burghers (see pp. 152–157, 188–197). Although the decorative schemes employed in these codices were more modest than those of luxury Bibles destined for the aristocracy, they economized neither on materials nor on the quality of their execution and drew their inspiration from current trends in Flemish and Italian art. Even after Gutenberg started bringing out the first printed Bibles as from 1453/54, hand-written and skilfully illuminated parchment Bibles continued to be produced for many years (see pp. 188–197), and illustrations added to printed books. Only towards 1480 was the transition to Bibles produced entirely by typography more or less complete.

A. F. / M. T.

Neapolitan Luxury Bible, detail from fol. 1r:
St Jerome, dressed in a grey monk's habit,
at his desk.

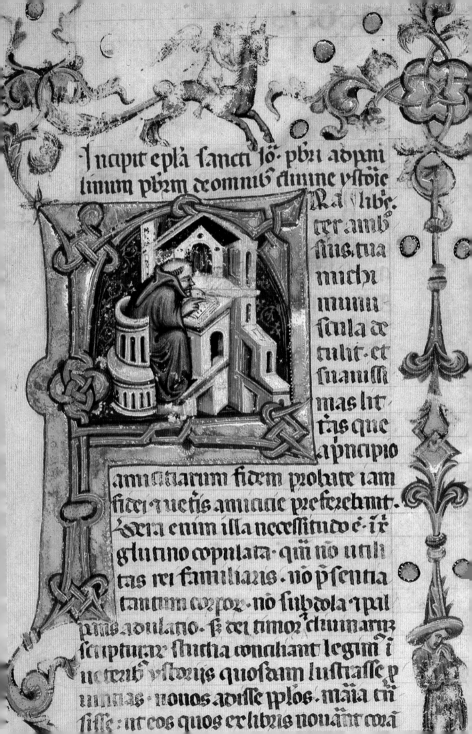

Incipit epla sancti Ioh· pbri ad Pau-
linum pbrm de omnibz diuine ystoie
libz.
ter amb
sius tua
michi
munu
scula de
tulit· et
suauissi
mas lit
ras que
a principio

amicitiarum fidem probate iam
fidei r uetis amicitie preferebant·
Vera enim illa necessitudo e· i
glutino copulata· qm no utili
tas rei familiaris· no psentia
tantum corpor· no subdola ipal
pns adulatio· s̄ dei timor diuinaruq̄
scripturae stutia conciliant legim i
ueterenb ystorys quosdam lustrasse p
uincias· nouos adisse ipsos· maria tra
sisse· ut eos quos ex libris nouarant cora

Admont Giant Bible

Salzburg, around the middle of the 12th century

As in the case of liturgical manuscripts used in services, faithful transmission of the text was a central concern of Bibles. The correction of errors that had resulted from careless transcription or the use of unauthorized sources, coupled with the desire for a modern edition of the text, often made it necessary to alter the existing version. So too in the Admont Giant Bible, in which several sets of changes can be identified. One such set of alterations was probably carried out immediately after the manuscript was first copied: entire passages of text were erased and rewritten (i.e. written over) or corrected in the margin. The same is true of the division of the Bible into individual chapters. The original divisions of the Romanesque manuscript were substituted in the 13th century for a system which can be traced back to the English theologian Stephen Langton (c. 1150/55–1228). Even in the case of such a magnificent codex as the Admont Giant Bible, the fact that such alterations impaired the aesthetic appearance of the manuscript was accepted for the sake of having a "correct" and up-to-date text.

Like other comparable Bibles of this type, the present codex was probably commissioned by a high-ranking individual or – and there are countless examples of this – by a "pool" of donors, and presented to a specific religious institution. Such commissions were frequently prompted by the founding of new monasteries and nunneries.

For whom this magnificent manuscript was originally composed has not yet been established with certainty. Hymns added in the margins have led some researchers (Mezey [1981]) to propose a Cistercian order; historical arguments speak in favour of the Cistercian abbey of Heiligenkreuz in Lower Austria. In its founda-

Detail from fol. 241v (Jonah): Historiated initial *I(onas)* in the Prologue to the Book of Jonah. Jonah is escaping from the whale.

▶ **Fol. 3v (Genesis):** The story of Creation in six pictorial fields: the Fall of Lucifer and the Creation of light (1st day of Creation). Creation of the firma-

ment (2nd day of Creation). Creation of the sun, moon and stars (4th day of Creation). Separation of the land and the seas (3rd day of Creation). Creation of the fishes and the birds (5th day of Creation). Creation of the first people and the beasts of the earth (6th day of Creation).

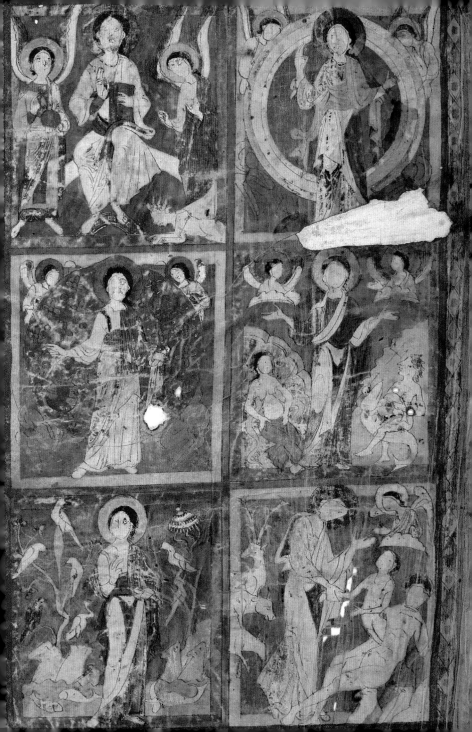

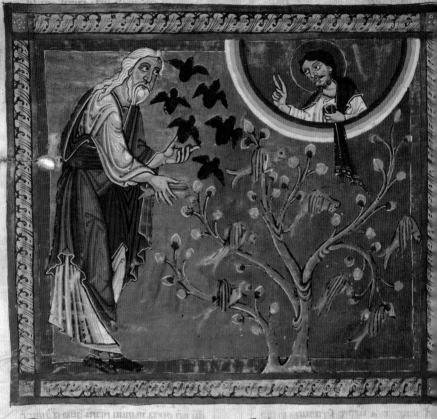

INCIPIT PROLOGVS
IOHELIS PROPP·

OBEL FILIVS
fatuel· describit terrā
xii· tribuu· eruca· brucho·
locusta· rubigine uastātib;
consumpta· post euersionē
priorif ppti effusūr̄· spm
scm sup seruos di & ancil
las· ide sup centu xx· creden
tui nomina effusūr̄· inecrna
culo syon· q̄ centu xx· ab
uno usq̄· ad̄centū paula
ti & incremēta surgentes·
eam
xv· graduū numerū effi
ciunt q̄ inpsalterio mystice
cōtinent; Expt̄ pt̄· IOHEL· pphetē;

ERDI
NI
QVI
FAC
EST
ADIO
FILIV
fatuel
Audi
hoc ſ
æatu

Fol. 236v (Joel): The vision of the locusts: Leaning slightly forward, the prophet is reaching for the insects, a swarm of brown "beetles" and green "locusts" in the shape of parrots, who are pecking at the flowers or fruits of a bush. God appears as a half-length figure in an opening in the heavens.

tion phase, this abbey maintained links with Hungary, where the manuscript was later held. On the basis of notes added to the Psalter, however, it is clear that the Bible was still employed in the Romanesque era for specific liturgical functions and was not just a treasury showpiece.

Despite the lack of certainty surrounding its first owner, it can be confidently shown that, relatively soon after its completion, the manuscript was being used in the Benedictine monastery of St Peter's in Csatár in western Hungary. There, a copy of the foundation charter, a list of relics, and records of donations to the monastery were all added to its pages. After being pawned and deposited in the neighbouring abbey of St Adrian's in Zala (Zalavár), the trail of the manuscript goes cold, and only resurfaces with certainty in the 15th century. An inscription added during this period indicates that it was the property of the Benedictine Admont Abbey.

The most striking aspect of the Bible, apart from its size, is its sumptuous illumination, characterized by initials in gold and silver and large miniatures (ill. p. 110). Almost the size of a panel painting, it recalls works of monumental painting. Inconsistencies and discrepancies in its overall decorative scheme may be the result of changes to the original aesthetic programme. The type of decoration and the style of the initials and miniatures bring the work into line with other illustrated Giant Bibles from the region of southern Germany/Austria. The Bible has been specifically linked with Salzburg book illumination of the Romanesque era, and was produced in a workshop that also accepted external commissions.

A. F.

Extent: 262 (volume 1) and 234 (volume 2) parchment folios
Format: 560 x 400 mm
Binding: Baroque leather binding by Admont Abbey (dated 1737); stamped decoration (single stamps and rollers)
Content: Bible (Old and New Testament)
Language: Latin

Illustration: more than 130 foliate initials, predominantly executed in gold and silver; canon arches; 44 miniatures
Provenance: From western Hungary, the manuscript reached the Benedictine abbey of Admont in Styria at the latest in the 15th century. In 1937 it was purchased from the monastery for the National Library.
Shelfmark: Vienna, ÖNB, Cod. Ser. n. 2701

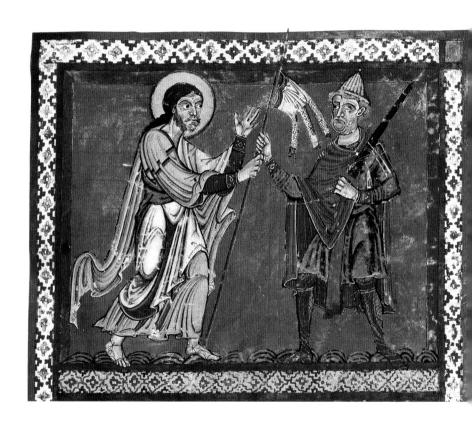

Detail from fol. 84r (Joshua): The calling of Joshua.
God presents Joshua, who is armed with a sword,
with a pennant lance.

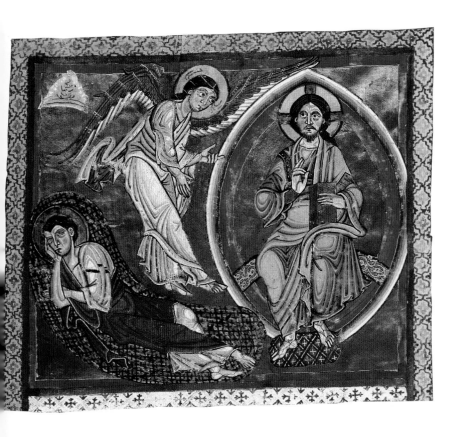

Detail from fol. 206r (Ezekiel): Ezekiel's vision: the prophet lying asleep on his bed; appearing to him are Christ, enthroned in a mandorla, and an angel.

▸ Fol. 227r (Daniel): Daniel in the lion's den: The lower field shows Daniel sitting in the lion's den amongst the lions, who are resting quietly. Arriving on the left is King Darius, anxious to release Daniel. In the separate pictorial field above, the prophet Habakkuk, guided by an angel who has hold of his hair, is bringing Daniel some food.

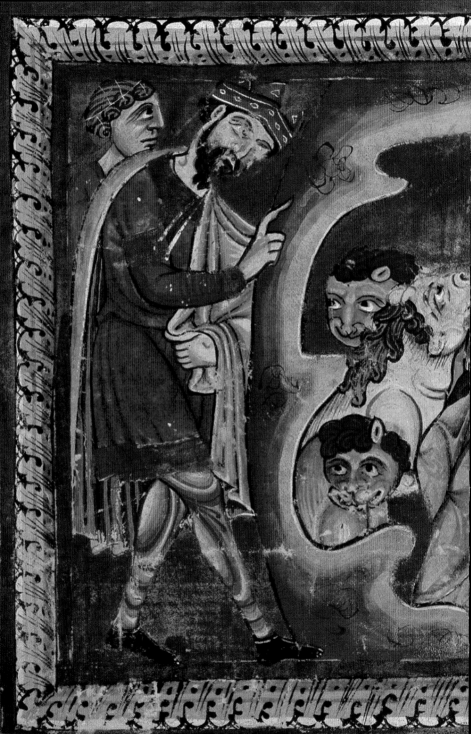

Detail from fol. 94v (Judges): The acts of Gideon. Gideon is called by God. This miniature contains two scenes: on the left, Gideon approaches God, who appears in an opening in the heavens, and is instructed to free the Israelits from the yoke of the Midianites. On the right, Gideon is seen laying a ram's fleece on the threshing floor. The wispy "clouds" signify the dew.

Detail from fol. 237r (Amos): The architecture with its gates flung ostentatiously wide is that of the city of Damascus.

▶Detail from fol. 84r (Joshua): The procession around the city of Jericho. Accompanied by blasts on the trumpet, the Ark of the Covenant is carried around the city of Jericho, portrayed on the right as a city with walls and a gate.

▶▶ Detail from fol. 109r (1 Samuel): Scenes from the life of Hannah. Above: on the left, the childless Hannah is weeping; beside her stands Peninnah, Elkanah's second wife, cradling an infant in her arms. Within an architectural surround of towers and a gable, Hannah places a young bull on the altar as a sacrifice.

▶▶▶ Detail from fol. 252v (Job): The sufferings of Job. Job, naked and covered in boils, is lying on the dung heap, his misery bewailed by two women and two friends.

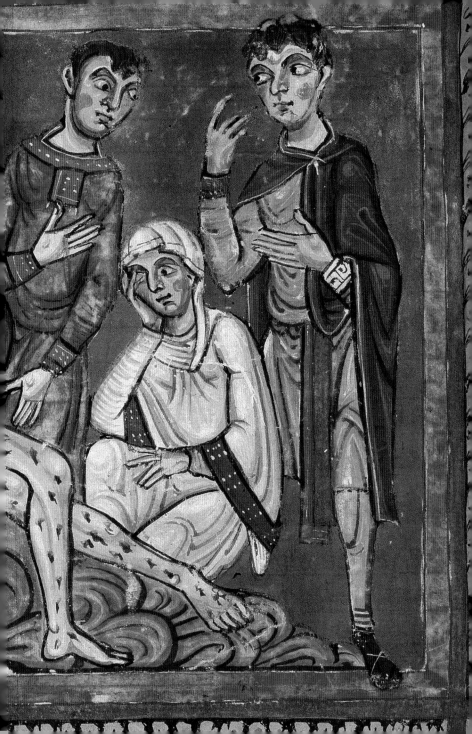

Lilienfeld Bible

Cistercian abbey of Lilienfeld (Lower Austria),
2nd quarter of the 13th century

In which library this first volume of the Bible, which was purchased by the Austrian National Library from the fine art trade, was originally housed was a question that remained for a long time unanswered. It was only with the identification of the rather unassuming library binding that light was finally shed on the production and provenance of the manuscript, which can now be confidently assigned to the Cistercian abbey of Lilienfeld in Lower Austria.

The form in which the manuscript has come down to us is symptomatic of the way in which luxury large-format Bibles were produced. The effort and co-ordination involved in obtaining the materials (parchment), copying out the text and adding the illustrations meant that the Bible "production line" frequently stopped and started. The decoration might be left unfinished (cf. the Wenceslas Bible: pp. 138–151), abandoned entirely or – as likely in the present case – resumed only after an interruption. In the library of Lilienfeld abbey, however, there survive two other large-format Bibles from the second half of the 13th century which were probably compiled to supplement the present volume.

Codex Ser. n. 2594 was produced in the early years of the abbey, which was founded in 1202. This was a period of fruitful growth, reflected in the consecration of the completed eastern section of the Gothic church in 1230. By this time, at the latest, the abbey had evidently established its own workshop of scribes and illuminators, one competent enough to embark on ambitious Bible manuscripts. The attribution of the present Bible to the Lilienfeld scriptorium is evidenced by the fact that the scribe and illuminators of the present Bible are known to have worked on other codices from the same abbey.

The script and the illustrations place the work in the period of transition from the Romanesque to the Gothic. The "classical" foliate initials that were widespread

Detail from fol. 103v (Numbers): Foliate initial *L(ocutus)*. The lower part of the initial is formed by a dragon.

▶ **Fol. 8v (Genesis):** The Creation of Adam and Eve, the Fall, and the Expulsion from Paradise; beneath, Eve at the distaff and Adam toiling in the fields.

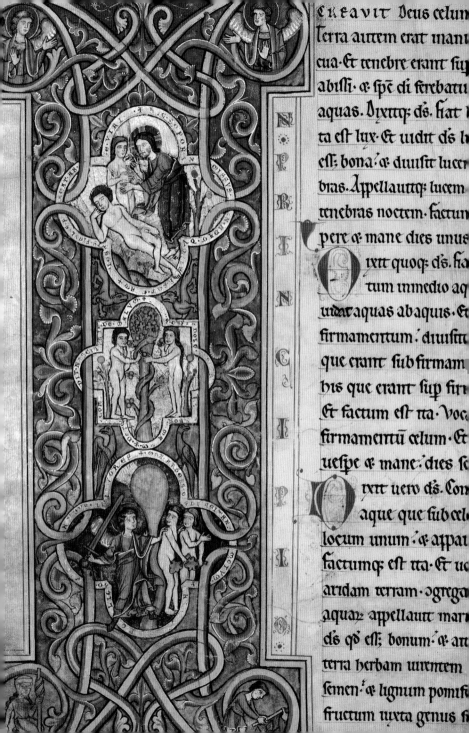

CREAVIT deus celum [et]
terra autem erat man[i]
cua. Et tenebre erant sup[er]
abissi. [et] spiritus di ferebatu[r]
aquas. Dixitque ds. fiat l[ux]
ta est lux. Et uidit ds l[ucem]
ee bona. [et] diuisit lucer[em a]
bras. Appellauitque lucem [et]
tenebras noctem. factu[m]
[es]pere [et] mane dies unus
Dixit quoque ds. fia[t firmamen]
tum inmedio aq[uarum et diui]
[d]at aquas abaquis. Et [fecit ds]
firmamentum. diuisit[que aquas]
que erant sub firmam[ento ab]
his que erant sup fir[mamentum]
Et factum est ita. Voc[auitque ds]
firmamentu celum. Et [factum est]
uespe [et] mane. dies s[ecundus]
Dixit uero ds. Con[gregentur]
aque que sub cel[o sunt in]
locum unum. [et] appa[reat arida]
factumque est ita. Et uo[cauit ds]
aridam terram. [con]grega[tionesque]
aquaq appellauit mar[ia et uidit]
ds qd ee bonum. [et] a[it germinet]
terra herbam uirentem [et facientem]
semen. [et] lignum pomif[erum faciens]
fructum iuxta genus s[uum]

EC SVNT

5

Homina filiorum isrł. qui in

Fol. 52r (Exodus): Foliate initial *H(ec sunt)*, containing a fabulous beast.

in Romanesque art and were mostly executed in pen continue to make up the large part of the illustrations. Here, a dense network of scrolling, interweaving forms develop around the body of a letter, which at times becomes barely recognizable. This ornamental carpet of stylized vegetal motifs is occasionally inhabited by mythical beasts (see ill. p. 126). These are predominantly small dragons, which are lent grotesque features by the hoods on their heads. In the majority of cases they are simply part of the decoration, since they are inserted into the initials without bearing any obvious relevance to the biblical text.

Only at the start of the manuscript does one such initial also contain a figure. Placed in front of the first book of the Old Testament (Genesis) is the letter of St Jerome (347–419) to Bishop Paulinus of Nola (c. 355–431). Jerome is depicted as a holy bishop and holds, as if they were the attributes of his authorship, a stylus and a writing tablet in the shape of a two-part diptych.

In line with a widespread tradition of Bible illumination, however, the decorative scheme concentrates upon the initial *I* at the beginning of the first book (ill. p. 125), Genesis (*In principio creavit Deus celum et terram...* – "In the beginning God created the heavens and the earth..."). Almost monumental in its effect, this *I* takes up the full height of the page and illustrates the story of Creation in an unusual choice of scenes. It depicts not the individual days of Creation, but the events that followed: the creation of Eve, the Fall, the Expulsion from Paradise and – as its consequence – Adam and Eve's atonement through their labour at the distaff and in the field.

A. F.

Extent: 214 parchment folios
Format: 410 x 290 mm
Binding: Baroque library binding by Lilienfeld abbey
Content: Bible (Old Testament: Genesis to Ruth [Octateuch])
Language: Latin

Illustration: one full-page ornamental initial at the beginning of the Book of Genesis; one figural initial drawn in pen (St Jerome); numerous foliate initials
Provenance: Cistercian abbey of Lilienfeld (Lower Austria)
Shelfmark: Vienna, ÖNB, Cod. Ser. n. 2594

Krems Bible

Krems (Lower Austria) (?),
last quarter of the 13th century and 1333/34

The first four volumes, containing the Old Testament, were
executed in the last quarter of the 13th century, and were
subsequently complemented by a fifth volume containing
the New Testament. The colophon at the end of this vol-
ume states that copying was commenced in 1333 and work
completed in 1334. The scribe gives his name as Chunradus
Sweuus (Conrad the Swabian).

The last volume of the Old Testament contains a hast-
ily-written inscription from the 15th century, identifying
the manuscript as the property of the Dominican convent in
Krems (Lower Austria), founded in 1236. It is probable that the Bible was also re-
bound at this time and furnished with heavy wooden boards covered with leather.

The illustration of the four earlier volumes embraces two types of decoration.
Subordinate sections of text, such as prologues and chapters, are introduced by
so-called *fleuronnée* initials. In this Gothic type of initial, the shape of the letter
– which was often hard to decipher amidst the dense weave of scrolling, foliate
forms that made up Romanesque initials – is once again emphasized and visually
distinguished from the surrounding decoration. The body of the letter is divided
by means of tiny gaps into two colours, usually red and blue, but remains easily
legible. It thereby stands out clearly from the surrounding linear ornamentation,
known as *fleuronnée*, which in contrast to Romanesque manuscript illumination
contains almost no naturalistic motifs.

Higher up in the decorative hierarchy are the initials executed in body col-
our and gold which make up the second type of decoration chosen to illustrate
the books of the Krems Bible. Some of these initials comprise purely decorative
designs of exuberant foliage, while others also incorporate figures, sometimes gro-
tesques. On fol. 261r of Codex 1171, for example, a dragon has clamped its jaws
around the base of the initial *I*, while a hedgehog takes a quiet walk across the

Detail from Cod. 1170, fol. 1r: Author portrait of St
Jerome as a scribe, seated with a pen and a book.

▶ **Detail from Cod. 1171, fol. 3r (1 Samuel):**
Samuel anoints King Saul.

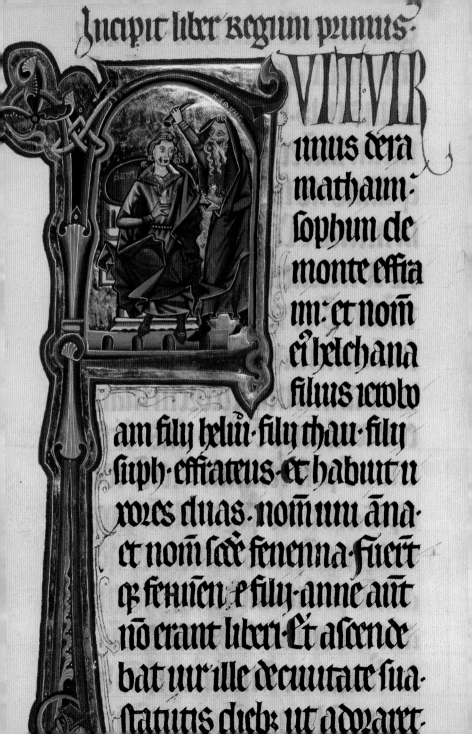

VIT VIR
unus de Ra
mathaim
sophim de
monte effra
im· et nom̄
ei helchana
filius ierobo
am fily heliu· fily thau· fily
suph· effrateus· et habuit u
xores duas· nom̄ uni āna
et nom̄ secē fenenna· fuert
q̄ fenuen· e fily· anne aut
nō erant liberi· Et ascende
bat uir· ille de ciuitate sua
statutis dieb: ut adoraret

Incipit breuit̄ ı̃ liber
Genesis Rubrica:

IN PRINCIPIO
Creauit ds̄ celum ⁊ tr̄am.
Terra aūt erat inanis ⁊ua
cua. Et tenebre sup̄ faciem
abyssi. ⁊ sp̄s dei ferebat super
aq̄s. Dixitqz ds̄ fiat lux ⁊ fc̄a
ē lux. Et uidit d̄s lucē qd̄ ēet
bona ⁊ diuisit lucē a tenebris.
Appellauitqz lucē diem et
tenebr̄s noctem ⁊ fcm̄qz est
uesp̄ ⁊ mane dies unus.
Dix̄ quoq̄z ds̄ fiat firma
mtū ı̃medio aq̄r̄um et
diuidat aq̄s ab aq̄s Et
fecit d̄s firmamtū diuis
qz aq̄s que erant subfirm
mtō abhiis q̄ erant super
firmamentum Et fcm̄ ē ita.
Vocauitqz ds̄ firmamtū
celū. ⁊ fcm̄ ē uesp̄ ⁊ mane
dies secl̄s. Dix̄ uō d̄s. Con
gḡentr̄ aque q̄ sub celo sūt
ın locū unū ⁊ appareat a
rida. ⁊ fcm̄qz ē ita. Et uoca
uit d̄s aridam tr̄am con

ggatōēs qz aq̄r̄um appellauit m
ria. Et uid̄ d̄s qd̄ ēet bonū et ait.
Germinet tr̄a hbam uirentē ⁊ faci
entē semē ⁊ lıgnū pomıfer̄z faciēs
fructū iuxta genus suū cuı semē
in semetipso sit sup̄ tr̄am. Et fcm̄ ē
ıta. Et p̄tulit tr̄a hbam uirentē et
afferentē semē iuxta gen̄ suū lig
numqz faciēs fructū ⁊ hns unū
quodqz semē secl̄m spēm suam.
Et uidit d̄s qd̄ ēet bonū ⁊ fcm̄qz est
uesp̄ ⁊ mane dies t̄cius. Dix̄ aūt
d̄s. fiant luı̃aria ı̃ firmamto celı
et diuidant die ac noctem ⁊ sint
ın signa ⁊ tempa ⁊ dies ⁊ annos.
ut luceant ı̃ firmamto celı ⁊ illu
mınēt tr̄am. Et fcm̄ ē ıta. fecıtqz d̄s
duo maḡ luminaria. Luminare
maıus ut p̄esset dieı ⁊ lumınare
mın̄ ut p̄eet nocti. Et stellas et po
suıt eas ın firmamto celı ut luce
rent sup̄ tr̄am ut p̄eēnt dieı ac no
cti ⁊ diuıderēt lucē ac tenebr̄s Et uı
dit d̄s qd̄ ēet bonū ⁊ fcm̄ ē uesp̄ et
mane dies q̄rtus. Dix̄ etıam d̄s.
Producāt aque reptıle anıme uı

Detail from Cod. 1170, fol. 9r (Genesis): Initial *I(n principio)* containing the story of Creation: (1) The Creator enthroned. (2) Separation of the light and the darkness. (3) Separation of the land and the seas. (4) Creation of the plants. (5) Creation of the sun, moon and stars. (6) Creation of the birds and beasts. (7) Creation of Adam; beneath, the Fall.

top (ill. Cod. 1171, fol. 261r). In another instance, the figure of an Atlas is holding the full weight of an elaborate initial above his head. In other of the biblical books, however, the space inside the initial is filled with historiated miniatures, i.e. small-scale illustrations that relate directly to the neighbouring text. Owing to the cramped confines in which they have to "live", such miniatures are usually reduced to single figures or essential details, as in the case of the initial showing Judith cutting off the head of Holofernes (ill. p. 132). The sole exception is the initial at the beginning of Genesis, which occupies the full height of the page, and in which the upright of the *I* illustrates the story of Creation up to the Fall in eight distinct fields, seven of them medallions (ill. p. 130).

It is interesting to observe how these decorative forms have evolved in the New Testament volume which was added some 50 years later. The *fleuronnée* initials which, in the decorative hierarchy of the first four volumes, were employed in a subordinate role and in modest garb, are here the only type of initial employed. The illustrative emphasis of the first four volumes has also diminished, and the figural elements are reduced to motifs, some of them grotesque, bearing no relevance to the text. Examples include the hybrid form of a dragon with the head of a nun and a stag hunt (Cod. 1174, fol. 37v), a motif that also frequently appears on manuscript bindings. Through its rich use of body colour and gold, however, and through the monumentalization of its initials, this fifth volume also offers a sumptuous decorative programme.

A. F.

Extent: five volumes; 1226 parchment folios in total
Format: *c.* 500 x 370 mm
Binding: Late Gothic leather blind tooled binding over wooden boards; decoration with single tools, ornament rolls and panel printed ornaments; traces of former chain fastenings
Content: Bible (Old and New Testament)
Language: Latin
Scribe: Chunradus Sweuus

Illustration: numerous fleuronnée and ornamental initials, including 15 figural initials
Provenance: A 15th-century inscription in the manuscript records it as the property of the Dominican convent in Krems. From the 16th century onwards the codex is documented in the Vienna Hofbibliothek.
Shelfmark: Vienna, ÖNB, Cod. 1170–1174

Cod. 1171, fol. 247r (Judith): Judith kills Holofernes. ▸ Detail from Cod. 1171, fol. 65r (1 Kings): Abishag in the bed of the aged King David.

tulit holocausta et pacifica et
repiciatus ē dñs terre: et cohi
bita ē plaga ab isrľ:

T REX
DAVID
Senue
rat ha
rebatꝗ
etatis pl
rimos
dies· cu
q̃ opire
tur ues

tibꝫ: ño calefiebat· Dixerunt
ꝗ ei seru sui· Queramus dño
mr̃ regi adolescentulā virgine

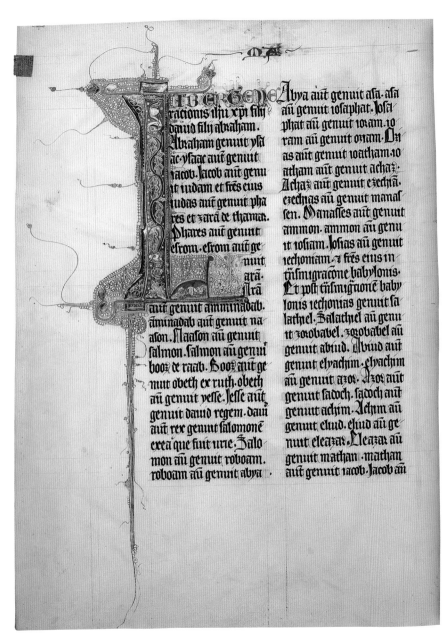

Cod. 1174, fol. 2v (St Matthew):
Initial L(*iber generationis*).

134

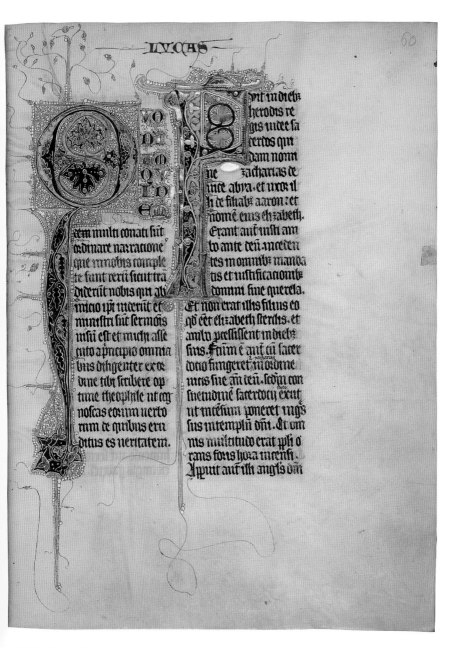

LVCAS

Quoniam quidem multi conati sunt ordinare narracioneque in nobis comple te sunt reru sicut tra diderunt nobis qui ab inicio ipsi viderunt et ministri fuit sermonis insu est et michi asse cuto a principio omnia bus diligenter ex or dine tibi scribere op time theophile ut cog noscas eorum verbo rum de quibus eru ditus es veritatem.

Fuit in dieb; herodis re gis iudee sa cerdos qui dam nomi ne zacharias de vice abya · et uxor il li de filiab; aaron : et nome eius elizabeth. Erant aut iusti am to ante deu · incede tes in omnib; manda tis et iustificacionib; domini sine querela. Et non erat illis filius eo qd eet elizabeth sterilis · et amdo processissent in diebz sius. Factum e aut cu sacer dotio fungeret in ordine uicis sue an deu · sedm con suetudine sacerdotii exiit ut incesum poneret ingres sus in templu dñi · Et om nis multitudo erat ipsi o rans foris hora incensi. Apparuit aut illi angls dñi

Cod. 1174, fol. 60r (St Luke):
Initial *Q(uoniam quidem)* and *F(uit)*.

KREMS BIBLE 135

o uolumina legrat adedificia
cione plebis·no ad auctozita
te eccliasticoz dogmat confir
manda·Siau sane lxx int
pruum magis edito placet hc
ca olum anobis emditam·
Neq cui sic noua cudum ut
uera destruam·Et cu cu dili
gentissime legit·sciat ma
gis nta sepra intelligi·q no
incui uas cussusa euacue
runt·s statim deplo puriste
comdata teste suu sapiem
seruauerut·

Parabole
salomonis
filij dauid
regisrl·ad
sciendam
sapiam·et
disciplina ad intellige
da uba pdencie et susci
piendam cruditem doct
ne iusticia et iudicium

et equitate·ut detur puul'
astucia·et adolescenti scia
et intellect·auchens sapies
sapiencioz crit·et intelliges
gubnacula possidebit·Ani
maduttee pabolam et int
ptanonem·uba sapientiu et
enigmata coz·Timoz dni
pncipiu sapie·Sapiam at
q doctrina stulti despiciut·
Auchi fili mi disciplinam
pris tui·et ne dimittas le
gem mais tue·ut addat
gra capiti tuo·et torques
collo tuo·fili mi si te lacta
uerint pectores·ne acquie
scas eis·Si dixerint neni
nobiscu insidiemur san
guini·abscondam tendi
culas cont insonte frustra
deglutiam eu sicut infern
uiuente et integru quasi
descendente in lacu·omne
subam pciosam repicm im
plebimus domos mas spo

Cod. 1172, fol. 2r (The Wisdom of Solomon): King
Solomon instructs a youth.

▶ Detail from Cod. 1174, fol. 189v (Thessalonians):
Initial A(d Thessalonicenses) from the Prologue;
initial P(aulus et Silvanus).

136 KREMS BIBLE

nos p omnia. / ipe uir et
anima et corpus sine que
rela in aduentu dm seruet
uri. Fidelis est deus qui uo
cat nos qui etia faciet. Fra
tres orate p nobis: saluta
te oms in osculo scd. Adiu
ro uos p dominu ut lega
tur epla hec omnibus sanc
tis fratribz. Gra dni nri
ihu xpi sit nobiscum. Am

A

salon
censes se
cundam
epla[m]
[script] aplus
et notu facit eis se tribz
noussimis t aduersarii
destructbe. scribens hanc
eplam ab athenis p tichi
cum dyacone t honesimu
acolitum.

PAVLVS et
siluanus et thimothe
us ecctie thessaloincen
sium in deo pre nro t
dno ihu xpo. Gras a
gere debemus deo sem
p p uobis fres ita ut
dignu est. quia super
crescit fides ura. t ha
bundat caritas uni
cuiusq urm inuicem:
ita ut et nos ipi in
nobis gloriemur. in ec
clesiis dei p patienci
a ura et fide in omnibz
psecucionibz uris et
tribulacionibz quas
sustinetis in cerem
plum iusti iudicii ut

Wenceslas Bible

Prague, around 1389/95

The first translations of the Bible into German were not sanctioned by the authorities of the Church, and in 1369 a proclamation issued by Emperor Charles IV even declared the distribution of German-language editions a heresy. This move admittedly failed to silence the ever more vociferous calls for a renewal of faith, and by time Wenceslas IV took over as head of the kingdom in 1378, the Church – and with it the Bohemian nobility – had been divided by the schism into two camps. Broad sections of the Bohemian populace had already embraced the *Devotio moderna* movement with all its reformational potential, and in this situation the young monarch saw himself as the personal guarantor of a renovation of Church and Empire. The copy he commissioned of the most modern and best German translation of the Bible is thus not simply an indication of his love of books – it is a statement of a marked change in imperial relations with the authorities of the Church.

The monarch's self-confident stance vis-à-vis the Church is reflected in an extraordinarily sumptuous decorative programme which made the Wenceslas Bible – despite being left unfinished after 2,428 pages – one of the most famous of all Bibles. Contributing not least to this programme are the monarch's own emblems, repeatedly used but difficult to interpret, which – as it now appears – marry genealogical heraldry with symbols of his personal ideals. Stated briefly, the cleansing properties of water as a symbol of renewal, and Wenceslas' ties to Bohemia and the Holy Roman Empire, are recurrent concepts which lie at the heart of the pictorial programme (see ill. pp. 139, 148).

In contrast to the script, which is written with perfect uniformity, the unfinished state of the illustrations offers us an insight into the enormous amount

Detail from Cod. 2759, fol. 160r (Numbers): In the foliate medallion, a bathing maid. (Balaam Master)

► **Cod. 2759, fol. 2v (Genesis):** The initial letter of Genesis, containing seven medallions illustrating the Creation, together with apostles, prophets, Wenceslas trapped in a letter block and bathing maid. In the borders, the coats of arms of the Holy Roman Empire and Bohemia with helmets above, drapery knots with kingfishers. (Seven Days Master)

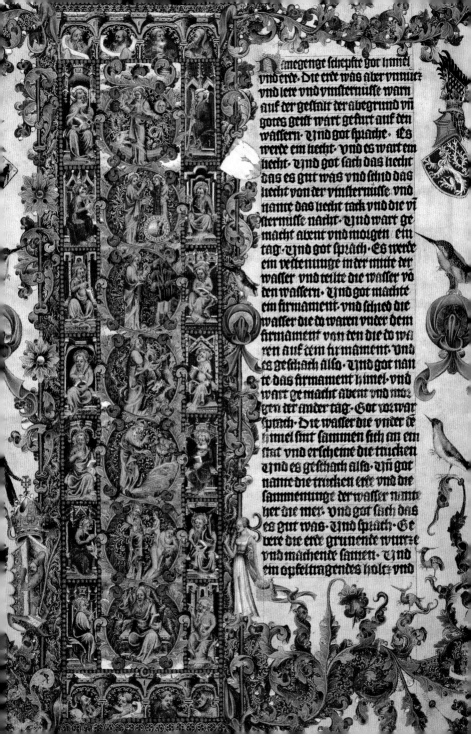

am anegenge schepfte got himel
vnd erde. Die erde was aber vnnutz
vnd lere vnd vinsternusse warn
auf der gestalt der abegrund vn
gotes geist wart gefurt auf den
wässern. Vnd got sprache. Es
werde ein liecht. vnd es wart ein
liecht. vnd got sach das liecht
das es gut was vnd schid das
liecht von der vinsternusse. vnd
nante das liecht tack vnd die vi
sternusse nacht. vnd wart ge
macht abent vnd morgen ein
tag. vnd got sprach. Es werde
ein vestenunge in der mitte der
wasser vnd teilte die wasser vo
den wassern. Vnd got machte
ein firmament vnd schied die
wasser die do waren vnder dem
firmament von den die do wa
ren auf dem firmament vnd
es geschach also. Vnd got nan
te das firmament himel. vnd
wart gemacht abent vnd mor
gen der ander tag. Got vorwar
sprach. Die wasser die vnder de
himel sint sammen sich an ein
stat vnd erscheine die trucken
vnd es geschach also. vn got
nante die trucken erde vnd die
sammenunge der wasser nante
her die mer. vnd got sach das
es gut was. Vnd sprach. Ge
were die erde grunende wurtze
vnd machende samen. Vnd
ein opfeittragendes holtz vnd

es geschach also · Und got nan
te das firmament himel · vnd
wart gemacht abent vnd mor
gen der ander tag · Got vorwar
sprach · Die wasser die vnder dē
himel sint samnen sich an ein
stat vnd erscheine die trucken
vnd es geschach also · Vñ got
nante die trucken erde vnd die
samnenunge der wasser nante
her die mer · vnd got sach das
es gut was · Und sprach · Ge
bere die erde grunende wurtze
vnd machende samen · Und
ein opfeltragendes holtz vnd

stifte das rippe. das er hette ge=
numen ans adamen in ein wip
vnd furte sie czu adamen. vnd

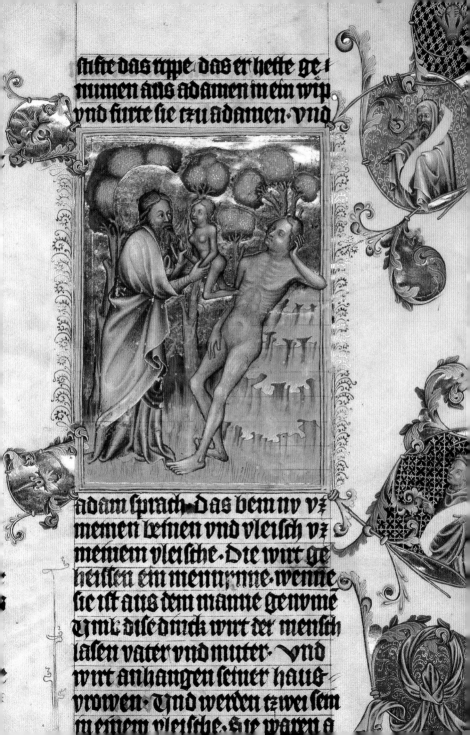

adam sprach. das bein nv vz
meinen beinen vnd vleisch vz
meinem vleische. die wirt ge=
heissen ein menurnne. wenne
sie ist aus dem manne genvmē
vn̄ vmb dise dinck wirt der mensch
lasen vater vnd muter. vnd
wirt anhangen seiner haus=
vrowen. Vnd werden tzwei sein
in einem vleische. Sie waren o

of planning and work that went into the project, which must have involved at least nine illuminators, as well as florators and assistants. How these artists were organized – whether in a single royal workshop or in several workshops supplying the court – remains unclear, since some, although not all, of the quires are the products of close collaboration. A so-called praeceptor was responsible for the overall pictorial programme, which he relayed to the artists in the form of notes in the margins, written in Latin and revealing an extremely well-founded knowledge of theology (Cod. 2761, fol. 90r). Some of the illustrators must have had a command of the German language, since their miniatures occasionally reflect the mistakes in the German translation. As Josef Krása (1971) has pointed out, stylistic links lead onto miniatures in Chronicles produced in southern Germany in the period around 1380/90. Other masters probably came to the flourishing imperial capital from neighbouring regions such as Moravia and Silesia. Together, in Prague, these artists shaped the style of the so-called Wenceslas Workshops. Since the majority of them remain anonymous, they are named after their chief works: the Seven Days Master and Balaam Master (representing the older generation), together with the Solomon Master, Ezra Master, Ruth Master, Simson Master and Morgan Master. Only two actual names have come down to us – those of N. Kuthner and a certain Frana, both of whom signed their works, probably to be sure of getting paid. By good fortune, their names were not trimmed when the manuscript was bound. Frana can in all probability be identified as the court painter Frantisek, who is named in documents.

On the basis of the chivalric epic *Willehalm* (ÖNB, Cod. Ser. n. 2643), illuminated by the same masters in 1387, work on the undated Wenceslas Bible probably proceeded from the late 1380s to around 1395.

M. T.

Extent: 1,214 parchment folios, unfinished
Format: 530–535 x 365–370 mm
Content: Old Testament (Isaiah and Jeremiah appear twice). Copy of the second-oldest German translation of the Vulgate, financed in around 1375 by Martin Rotlev, banker to Emperor Charles IV and former Kuttenberg mint master (his name is mentioned in the first prologue).
Language: Middle High German
Miniaturists: Balaam Master, Seven Days Master, Frana, Ezra Master, Simson Master, Solomon Master, Morgan Master, Ruth Master, N. Kuthner
Illustration: gold and blue fleuronnée, foliate borders with emblems, 654 miniatures, designs for a further 600 illustrations
Patron: Wenceslas IV (1361–1419), King of Bohemia and Holy Roman Emperor
Provenance: According to the second prologue, the Bible was created for King Wenceslas IV; after Wenceslas' death in 1419, the Bible became the property of Emperor Sigismund. In 1437 it was inherited by King Albert II, after whose death in 1439 it passed to Emperor Frederick III, guardian of Albert's posthumously-born son, Ladislaus Postumus; Frederick probably had the manuscript bound (in three volumes). After his death in 1493, the Bible was inherited by Emperor Maximilian, in the treasury of whose Innsbruck castle the Bible is recorded around 1500. Around 1574 it was moved to the new library in Ambras Castle, from where, in 1665, it was transferred to the Hofbibliothek in Vienna.
Shelfmark: Vienna, ÖNB, Cod. 2759–2764

◄ **Detail from Cod. 2759, fol. 4r (Genesis):** Creation of Eve. In the border, two prophets, drapery knot, W monogram. (Balaam Master)

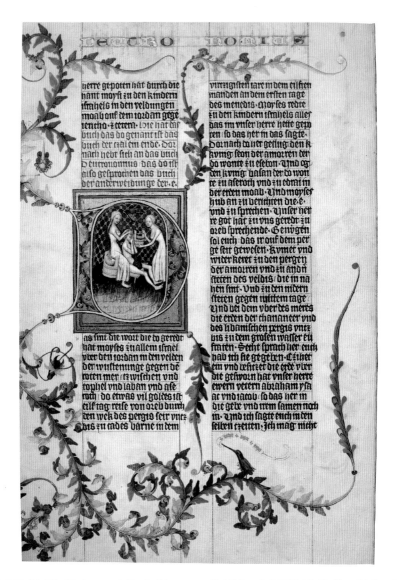

Cod. 2759, fol. 174v (Deuteronomy): Two bathing maids attend to Wenceslas. In the foliate border, a kingfisher with the royal motto *toho bzde toho* ("This one here belongs to that one there"). (Balaam Master)

▸ Detail from Cod. 2759, fol. 47v (Genesis): Joseph and his brothers rejoice at being reunited. In the foreground, a horse-drawn carriage as a gift from the Pharaoh. In the foliate medallions, two bathing maids attend to Wenceslas. (Balaam Master)

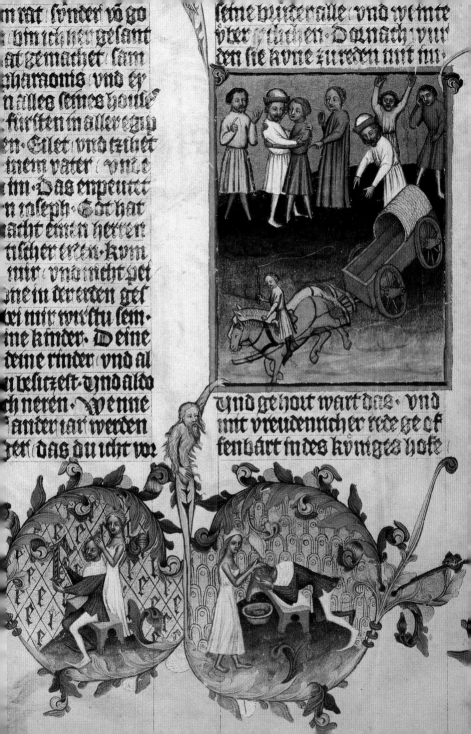

m rat synder võ go
võn ich hen gesãnt
at gemachet sãm
pharaonis vnd er
n alles seines haus
fursten in aller egip
en Silet vnd tzibet
seinem vater võ le
in Das enpeutt
n ioseph Got hat
acht eim̄ herren
 tischer erten kum
mir vnd nicht pei
ne in der erden gel
et mir wirstu sem
ne kinder D eine
deine rinder vnd al
u besitzest vnd also
ch neren Wenne
ander iar werden
er das du icht vor

seine bruder alle vnd wemte
vber sy ducken Darnach ṗ vur
den sie kune zu reden mit sm

vnd gehort wart das vnd
mit vreudenricher rede ge of
fenbart in des kungs hofe

i was aver die erde einer
zungen vnd einer spra
id do sie wanderten von
o funden sie ein velt in
i sennaar vnd wonten
· vnd der ander sprach
m nehsten · Komet hin
o mache wir tzigel vnd
ie in dem fewer · vnd sie
die tzigel für steine vnd
r kalch · vnd sprachen ·
vnd mache wir vns
vnd einen turme · des
iche bis an den himmel
er wir vnsern namen
eteilet werden in alle er
steig · aber vnser herre
resehe die stat vnd den
en do bauten die kinder
s · vnd sprach · Secht
volk ist es vnd habent
tzunge · Vnd tzu mach
n sie das angehaben ·
läsen nicht von irn ge
n vnd bis sie das mit
ken volbrengen · Ku
n darunter steige wir
vnd machen zu schan
tzungeu also das ein y
nicht vorneme die tzüge
nehsten · Vnd also teilte
er herre von der stat in
ren vnd horten auf zu
die stat · vnd darumb
o heissen ir name ha

ist die tzunge aller erden vnd
von danne zu strewte sie vnser
herre auf die gestalt aller rei
che · Ditz sint die geperunge
sems · Sem was hundert iar
alt do er geperte arphaxat tzwei
iar noch der flutte · vnd sem
lebte dornach vnd er geperte
arphaxat fünfhundert iar
vnd geperte syne vnd töchter
Dornach arphaxat lebte fünf
vnd dreissig iar vnd geperte
sale · vnd es lebte arphaxat
noch dem vnd her geperte sa
le dreihundert iar vnd geper
te syne vnd töchter · vnd sale
lebte dreissig iar vnd geper
te heber · vnd sale noch dem
vnd her geperte heber lebte
nierh undert iar vnd gepor

Cod. 2759, fol. 27r (Genesis): Jacob dreams of a ladder leading up to Heaven. In the foliate medallions, two winged *e* monograms, knots and a pail of water. (Balaam Master)

◄ Detail from Cod. 2759, fol. 10v (Genesis): The Tower of Babel. (Frana)

► Detail from Cod. 2760, fol. 33r (1 Samuel): Two wild men hold the royal jousting helmet over the head of King Wenceslas, seated on his throne. In the margins, a bathing maid with motto and Wenceslas in the letter block *W*. (Frana)

kunic dauid · ʒ cetera · Jrc hat
das buch ein ende das do ge
nant ist Ruth · Dornach so he
bit sich an das erste buch das
do genant ist zu latein regū
vnd heiſſet zu deutſche das
erſte buch der kunige · ʒ cetera·

s was ein man von ramatha
ym ſophim von dem perge ef
fraym vṅd ſein name was el

tagen so das er dem herren
opferte zu sylo · Es waren a
ber aldo tzwen sune hely des
priesters offin vnd phinees des
priesters vnsers herren · Der
tak dor vmme der qwam vnd
elkana der opferte vnd gab
fenenne seiner housvrowen
vnd allen iren sunen vnd iren
tochtern teil · aber annen gab
her teil troureclichen · wenne
annen hette her lieb · Aber
vnser herre hette vor slossen
iren pouch · Doch peinigte
sie ire gehessige vnd merte
das sterclichen in der erden
so das sie sie lesterte das vns
herre hette vor slossen iren
pouth · Vnd also tat sie alle
iar vnd reiczte sie also · wen
ne die tzeit qwam das sie
ouf tzogen zu dem house vn
sers herren · Aber iene weinte
vnd enpfink nicht speise · Do
sprach dor vmme elkana ir
man · Anna wor vmme wei

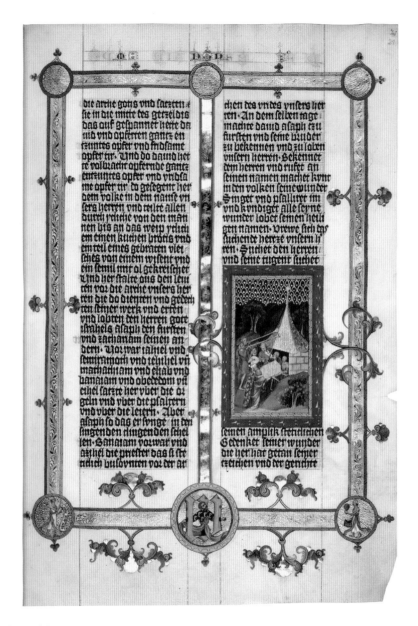

Cod. 2761, fol. 21r (1 Chronicles): King David places the Ark of the Covenant in the Tabernacle. In the borders, two bathing maids, Wenceslas in the letter block *W*. (Ezra Master)

▶ **Detail from Cod. 2760, fol. 116r (1 Kings):** The building of Solomon's Temple. In the borders, Wenceslas in the letter block *W*. (Frana)

en perde mit e
e. vnd der kv
erwelte arbeiter
ke iſrahel vnd
as dreiſſic tou
id her ſante ſie
iſchen perk tze
urch die mened
erlich alſo das
ed waren in trn
o adonam was
artzal ditz ge
uſo hette ſal o
k touſent man
den trugen vn
nt ſteynmetzen
an die probſte
ten ytliche wer
dreier touſent
udert geytend

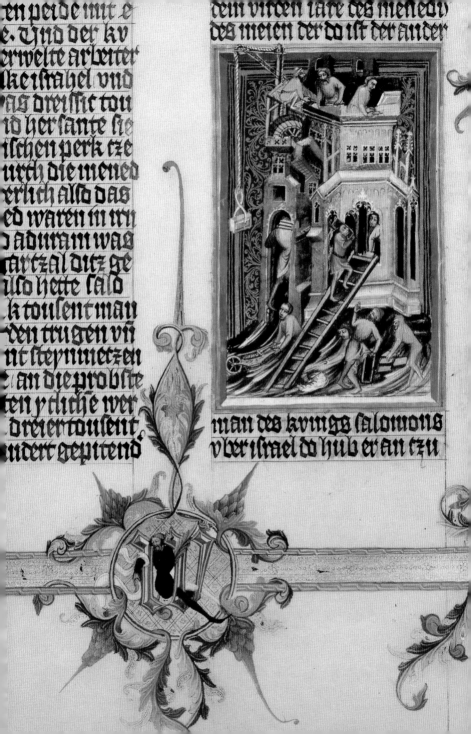

dem virden iare des menedv
des meien der do iſt der ander

man des kvnigs ſalomons
vber iſrael do hub er an tzu

Korczek Bible

Prague, 1400–1410

Per manus Martini Kathedralis dicti Korczek is how the scribe signed the second volume of his Bible, today housed in the Badische Landesbibliothek in Karlsruhe (Cod. St Blasien 2). Korczek completed the manuscript for Hanuš in 1400. Thanks to research by Karel Stejskal (1960), we know that Hanuš was cook to King Wenceslas IV and a wealthy Prague patrician. Whether Korczek was ever paid for his work, however, is doubtful, since Hanuš died in that same year of 1400. A question mark also hangs over the actual date of the Bible's magnificent illustrations. On the basis of the decoration of the opening pages, however, we may assume that Korczek's work was probably only illuminated towards 1410.

The majority of the miniatures stem from a Prague studio which evidently specialized in the production of Bibles and service books, and whose work is well documented from 1409/10 onwards. The Missal after which the master of this workshop is today called was commissioned in 1409 by Zbyněk Zajíc de Hasenburg, archbishop of Prague. Further works by the Hasenburg Master include a Bible (Prague) and a Gradual of *c.* 1410 (Lucerne), the Missal of Johann Strniště of 1410/15 (Prague), a Bible dated 1414 (Gnesen) and finally a Vesperal and Matutinal from around 1420 (Zittau). Throughout his œuvre, the artist shows himself to have been inspired by the International Gothic of the turn of the century, painting narrow-shouldered figures with doll-like heads enveloped in voluminous, cascading robes. Over the course of the ten or so years through which we can follow his work, he hardly varies his figural types at all, although a shift towards a cooler palette is noticeable. In their bright colours, the miniatures in the Korczek Bible correspond closely to those of the Hasenburg Missal of 1410. A further parallel can be seen in the filigree decoration of some initials (*fleuronnée*), which was executed by the same hand in both the Hasenburg Missal and the Korczek Bible.

A small number of illuminations in these two codices were executed by an artist working in the Franco-Flemish style. This illustrator is responsible for one

Detail from fol. 1r: Decorative border.

▸ **Fol. 1r:** St Jerome composing his prologue to Genesis. (Martyrologium Master?)

Incipit plogus
scī Jeronimi p̅b̅i
ad paulinū p̅b̅r̅m
de om̅ib⁹ tam ue-
teris q̅n noui
testamenti sacre
hystorie libris.
Rater ambrosi⁹
tua michi munu-
scula p̅ferens. de-
tulit simul z suauissimas litteras
que a p̅ncipio amiciciaz fidem p̅-
bate iam fidei z ueris amicicie noua
p̅ferebant. Vera enim illa necessitu-
do est. z xp̅i glutino copulata. quaz
nō utilitas rei familiaris. nec p̅ntia
tantum corpoz. nō subdola z palpans
adulacio. sed dm̅ timor. z diuinaz
scripturaz studia solidant. Legimus
in ueterib⁹ hystoriis. quosdam lustrasse
puincias. nouos adisse p̅plos. maria
transisse. ut eos quos ex libris noue-
rant. coram se quoq̅ uiderent. Sic pitago-
ras mephiticos uates. Sic plato egiptum
z architam tarentinū. eamq̅z oram ytalie. q̅
quondam magna grecia dicebat. laboriosissime
peragrauit. ut qui athenis magr̅ erat z potes.
cuiusq̅z doctrinas achademie gymnasia perso-
nabant. fieret peginus atq̅z disciplis. mallens
aliena uerecunde discere. qn̅ sua impudenter
ingerer. deniq̅z dum littas ē toto fugientes
orbe p̅sequitur. captus a piratis z uenundat⁹
etiam tyranno crudelissimo paruit. ductus
captiuus uinctus z seruus. Tamen qz phi-
lozophus maior emente se fuit. Ad tytum
liuium lacteo eloquencie fonte manantem. de
ultimis hyspanie galliazq̅z finib⁹ q̅sdam
uenisse legim⁹ nobiles. et quos ad spectacula
sui roma nō traxerat. unius hominis
fama p̅duxit. Habuit illa etas inauditum
omnib⁹ seculis celebrandumq̅z miraculum. ut
urbem tantam ingressi. aliud extra urbem
quererent. Apollonius siue ille magus ut uul-
gus loquitur. siue philozophus ut pitago-
rici tradunt. intrauit persas. p̅transiuit cau-
casum. albanos. scitas. massagetas. opulen-

tissima yndie regna penetrauit. z ad extre-
mum latissimo phison amne transmisso p̅-
uenit ad bragmanas. ut hyarcham in
throno sedentem aureo. et de tantali fonte
potantem. inter paucos disciplos. de natura.
de moribus. ac de cursu dierum z syderum
audiret docentem. Inde per elamitas. babi-
lonios chaldeos. medos. assyrios. parthos.
syros. phenices. arabes. palestinos. reu̅-
sus alexandriam perrexit. ethyopiam. ut
gymnosophistas z famosissimam solis
mensam uideret in sabulo. Invenit ille uir
ubiq̅z qd̅ disceret. z semper p̅ficiens. semper
se melior fieret. Scripsit hec plenissime
octo uoluminibus phylostratus. II

Quid loquar de seculi hominibus cum
Paulus vas eleccionis z magister
gentium. qui de conscientia tanti
in se hospitis loquebat. An experimentum
queritis eius qui in me loquit xp̅s. post da-
mascum. arabiamq̅z lustrata ascendit
ierusalem ut uideret petrum. z mansit apud
eum diebus quindecim. Hoc enim mysterio eb-
domadis z ogdoadis futurus gentium predica-
tor instruendus erat. Rursumq̅z post an-
nos. xiiii. assumpto barnaba z tyto expo-
suit cum aplis euangeliū. ne forte in uacuum
curreret aut cucurrisset. Habet nescio quid
latentis energie uiue uocis actus. z in au-
res disciplli de auctoris ore transfusa fort-
ius sonat. Vnde z eschineus cū rodi exularet.
z legeret illam demostenis oro. qua aduersus
eum habuerat. mirantib⁹ cunctis atq̅z lau-
dantib⁹ suspirans ait. Qd̅ si ipsam audis-
setis bestiam sua uba resonantem. III

Nec hoc dico qd̅ sit aliqd̅ in me tale
qd̅ ut possis ut uelis a me disce-
re. sed quo ardor tuus. z discendi stu-
dium etiam absq̅z nobis p̅se probari debeat.
Ingenii docile etsi sine doctore laudabile
est. Nō qd̅ inuenias. sz qd̅ queras iudicas.
Mollis cera z ad formandum facilis. etiam
si artificis z plaste cesset manus. tamen
in se est qdqid esse pt̅. Paulus aplus.
ad pedes gamaliel legem moysi z p̅phetas
se didicisse gloriatur. ut armatus spualib⁹

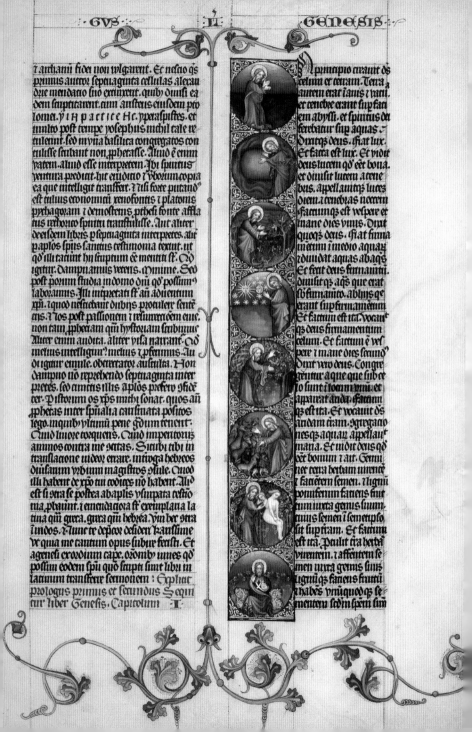

t archani fide non wlgarent. Et nescio qs
primus auctor septuaginta cellulas alexan
drie mendacio suo extruxerit. quibz diuisi ea
dem scriptitarent. cum aristeus eiusdem pto
lomei. & hi pactice Hc. yperaspistes. et
multo post tempe yosephus nichil tale re
tulerint. sed in vna basilica congregatos con
tulisse scribant non prophetasse. Aliud e enim
vatem. Aliud esse interpretem. Ibi spiritus
ventura predicit. hic eruditio & vboum copia
ea que intelligit transfert. Nisi forte putandi
est tulius economici xenofontis & platonis
pythagoram. & demostenis ptheli fonte affla
tus rethorico spiritu transtulisse. Aut aliter
de eisdem libris per septuaginta interpretes. ali
ter apostolos spus sanctus testimonia textuit. ut
qd illi tacuint hy scriptum ee mentiti sic. Non
igitur. dampnamus veteris. q minime. Sed
post pomum studia in domo dni qd possum'
laboramus. Illi interpretati sut an aduentum
xpi. & quod nesciebant dubijs protulere senten
cijs. Nos post passionem & resurrexioem eius.
non tam prophetam qm hystoriam scribimus
Aliter enim audita. aliter visa narrant. Qd
melius intelligim' melius & preferim'. Au
di igitur emule. obtrectator ausculta. Non
dampno non reprehendo septuaginta inter
pretes. sed cunctis illis apostolos prefero qsidc
ter. Pistorum os xps michi sonat. quos au
prophetas inter spiritualia carismata positos
lego. inquib' vltimum pene sedum tenent.
Cuind livore torquens. Cuind impentoriu
animos contra me vertas. Sicubi tibi in
translacione videor errare. interroga hebreos
diuersarum vrbium magistros scule. Cuod
illi habent de xpo tui codices non habent. Aliud
est si contra se postea ab apostolis ysurpata testimo
nia. probauint. & emendaciora st exemplaria la
tina qm greca. greca qm hebrea. Verum vtra
sit inios. Nunc te deprecor desideri karissime
vt quia me tantum opus subire fecisti. Et
a genesi exordium cape. orationib' iuues qd
possim eodem spu quo scripti sunt libri in
latinum transferre sermonem : Explicit
prologus primus et secundus Sequi
tur liber Genesis. Capitolum I

In principio creauit ds
celum et terram. Terra
autem erat inanis & vacua.
& tenebre erant super faci
em abyssi. et spiritus dni
ferebatur sup aquas.
Dixitq deus. fiat lux.
Et facta est lux. Et vidit
deus lucem qd eet bona.
et diuisit lucem a tene
bris. appellauitq; lucem
diem. & tenebras noctem
factumq; est vespere et
mane dies vnus. Dixit
quoq; deus. fiat firma
mentum in medio aquaz
& diuidat aquas ab aquis.
Et fecit deus firmamentu.
diuisitq; aquas que erant
sub firmamento. ab his que
erant super firmamentum.
Et factum est ita. vocauit
q; deus firmamentum
celum. Et factum e ves
pere & mane dies secund'
Dixit vero deus. Congre
gentur aque que sub ce
lo sunt in locum vnum. et
appareat arida. factum
q; est ita. Et vocauit ds
aridam terram. congrega
tionesq; aquaru appellau
it maria. Et vidit deus qd
eet bonum & ait. Germi
net terra herbam virentem
et facientem semen. & lignu
pomiferum faciens fruc
tum iuxta genus suum.
cuius semen in semetipso
sit super terram. Et factum
est ita. Protulit terra herba
virentem. & afferentem se
men iuxta genus suum.
lignumq; faciens fructu
& habens vnumquodq; se
mentem secundum speciem su

Fol. 4r (Genesis): Genesis initial with eight medallions illustrating scenes from the Creation. [Master of the Gerona Martyrologium?]

page in the Hasenburg Missal and the first three miniatures in the Korczek Bible: St Jerome, the translator of the Vulgate, who was born in Dalmatia and was thus highly venerated in Bohemia as a Slavic saint (ill. p. 153), a prophet and the Genesis initial (fol. 3v; ill. p. 154). New here are the pastel shades, the clarification of outlines and the emphasis upon physical presence. The architecture, too, is no longer merely a backdrop, but a convincingly three-dimensional component of the whole.

This illuminator must undoubtedly be seen in conjunction with one of the key works of Bohemian manuscript illumination, the Martyrologium of Gerona which was produced around 1410/15. Probably commissioned by Waclav Krollek (King Wenceslas IV's chancellor, 1416), this magnificent codex marks the transition from the Late Gothic style of the royal workshops to the Prague manuscript illumination of the 1420s.

The St Jerome miniature is so close to the style of the Martyrologium Master that Josef Krása (1971) considered it to be the work of the same artist and proposed a slightly later dating for the Korczek Bible, originally put at 1400 as recorded by the scribe. In terms of palette and figural type, and also in their repertoire of background motifs, crisply-drawn foliate forms and long-stemmed arabesques adorned with spheres, filigree decor, flowers and pounced droplets of gold, the first three illuminated pages of this Bible clearly match the style of the Master of the Gerona Martyrologium and his circle, artists who around 1410 were injecting fresh ideas into manuscript illumination.

M. T.

Extent: 230 parchment folios
Format: 505 x 355 mm
Binding: original binding of tooled and painted leather; yellow head, fore and tail edges painted with foliate arabesques
Content: Old Testament from Genesis to Psalms (Volume 1)
Language: Latin
Scribe: Martin Korczek
Miniaturists: Master of the Gerona Martyrologium (?), Master of the Hasenburg Missal

Illustration: red and blue fleuronnée initials, 30 initial miniatures at the start of each of the biblical books and Psalms
Patron: Hanuš, King Wenceslas IV's cook and councillor in Hradčány castle in Prague
Provenance: The codex appears in the inventory of the Innsbruck treasury in 1536; around 1574 it was moved to the new library in Ambras Castle and from there was transferred in 1665 to the Hofbibliothek in Vienna under the supervision of court praefect Peter Lambeck.
Shelfmark: Vienna, ÖNB, Cod. 1169

os mag
 Sui
luby de
s abeo
a eũt q'
vsq5 ad
stũ at
n suam
ĩ cũctis
tub5 pu
dẽpnab5
s est sag
es 7 pfu
vrbes su
tacõis
nec alic
ũ alti9
br vestri
enũ su
XVI.
nar ga
nasses
tiq5 st
ũt. tibi
ũ des
s ũ da
ũs tb5
io sua
vta

ioseph 7 possessio que illis fiat attribut
mansit in tribu 7 familia pris eau. Hec su
madata atq5 iudicia q prcepit dn̄s p ma
moysi ad filios isrl' i campestrib5 moab
sup yordanem 9tra yericho Explicit lib
nuerii. Incipit elezaddabarim .i. deuonom

Ec st vba
que locutus
moyses ad oe
isrl' tns yordã
i solitudie ca
pestri. 9t ma
re rubr. inte
pharan 7 tol
7 laban 7 ass
roth vbi au
e plurimu i
deim diebus

de oreb p via motis seyr vsq5 cades barne.
dragesimo anno. vndecio mese. pma die
mensis locutus e moyses ad filios isrl' oia
q prcepat ei dns vt dicer eis. Postqz pcussi
seon rege amorreor qui hitauit i esebon 7
og. regem basan qui masit i asseroth 7 edi
i tns yordane intra moab. Cepitq5 moyses e
planare lege 7 dicere. dn̄s ds nr locutus e a
nos i oreb dices. Sufficit vob qd i hoc mont
masistis. reuertimi 7 venite ad motes amorreor
7 ad cetera que ei proxima st campestria atq5 mo

◄ Detail from fol. 63r (Deuteronomy): Moses addresses the Israelites. (Master of the Hasenburg Missal)

Fol. 177v (Tobit): Tobit is blinded by bird excrement. (Master of the Hasenburg Missal)

Upper Italian Bible

Bologna or Padua, around 1250

This richly-illustrated Bible contains the Latin text of the Vulgate and may be seen as one of the earliest Upper Italian pandects in which all the books of the Bible are fully illustrated. In its text and decoration, the manuscript follows the new, standardized system in use around 1230 in Paris Bibles (se pp. 94–97). An indication of its early date lies in the fact that the chapters of the Prologue do not all begin on a new line, and also that the Prayer of Manasseh is absent. Significant, too, is the fact that it did not originally include the *Interpretatio nominum hebraicorum*, which was only added later. This alphabetically-organized *Interpretation of Hebrew Names*, which came after Apocalypse, was a common feature of Upper Italian Bibles from as early as *c.* 1240, having been introduced into Paris Bibles by Stephen Langton († 1228).

It was from the new Paris Bibles that the Vienna manuscript also adopted the iconography of its decorative programme. Examples include the lavish illustration of the initial *I* at the beginning of Genesis, in which scenes from the seven days of Creation appear in medallions, the *Tree of Jesse* initial opening St Matthew's Gospel at the start of the New Testament, and the more general use of French iconographical solutions in the illumination of historiated initials, mostly idealized portraits of the Biblical authors or important scenes from the narrative. More elaborate pictures are found, for example, in the 2nd Book of Kings (fol. 164v), portraying Ahaziah throwing himself from the building, in the 1st Book of Ezra (fol. 209r), with King Cyrus standing and Ezra writing beneath, and in the Book of Isaiah (fol. 309r), where we are shown the prophet's legendary martyrdom, sawn in two by soldiers.

The present Bible belongs to a group of manuscripts which up till now have been localized to the Padua/Venice region and which are viewed in connection with an Epistolarium written in 1259 by Giovanni da Gaibana for Padua Cathedral. Characteristic of this workshop are the Byzantine figural types with their greenish

Detail from fol. 27r (Exodus): Initial, showing the tribes of Israel. In the top half, Jacob is visually emphasized by his size and his nimbus.

▶ **Fol. 4v (Genesis):** Genesis initial incorporating representations of the seven days of Creation and an Atlas figure.

...nis pytagoram · demostenis ythe=
sorirom afflat' rethorico spū tīctus
lisset · aut alis de eisde libi p̄ lxx · īnt=
ptes · alis paples sic sc̄s testimonia
reuint · ut q̄ illi tacuerūt · hii scbm̄
ē inuiti sint · Q̄o q̄ dampnamus
ueteres? mīnime · Sz q̄ poꝛ studia · ī
domo dn̄i qꝺ possumus laboꝛam' · illa
īnpūtati q̄ ad aduentū x̄i · q̄ nescie=
bant dubiis ptilie sērentie · nec p̄
passioné z resutectem ei s̄ī tā pleni=
am q̄ hystoriam scbimi · Alit enī
audita · alis īusa narāre · scᵭ meli'
intelligimus? meli' z pfumi' · Audi
q̄ emule · obtrectatoꝛ ausculta · nō
dampno · nō tepheno · lxx · Sz cūc=
tis illis aptius pfero · p̄ xistoꝛ os · in
xp̄m sonat · quos aū aphas īre spi=
ritalia trāsuata pstlete lego · iy
quibꝰ ultimū pene gꝛadum īnterp=
tes tenēt · Quid īnuoꝛe toꝛques?
Quid īmpitoꝛum anīmos q̄ me q̄
cietis? sicubi tibi ī trāslatoē uide=
oꝛ etrare · ōinterroga ebreos · diuisa
rum urbium magꝛos ōsule · Qꝺ
illi hn̄t de xp̄o · tui codices nō hn̄t ·
Aliud ē si ōtra se pꝪ ab aplis̄ fu=
surpata testimonia pbauerūt · z
ēmendatioꝛa ē exemplaria latina q̄
greca · greca q̄ ebreа · Veꝛ h̄ ōt
īuicem · Nunc te depꝛoꝛ desideri=
tisime · ut qui tātū opꝰ me subire
fecisti · z a genesi exoꝛdium cape=
oꝛationibꝰ iuues · quo possim eo=
dem spū quo scripti sint libri
in latinum eos trāsferre sꝭmo=
nem · Explicit pꝛologus
Juāpit liber Genesis ·

IN PRINCIPIO
creauit dꝰ celū z ter=
ram · Terra aūt erat inanis
z uacua · z tenebre erāt
sup̄ saciem abyssi · z sp̄s
dei ferebatur s̄ aquas ·
Dixitꝙ̄ dꝰ · fiat lux ·
Et sca ē lux · Et uidit
dꝰ lucem q̄ eet bona ·
z diuisit lucem a tene=
bris · Appellauitꝙ̄ lu=
cem diem · z tenebras
noctem · factūꝙ̄ ē ue=
spe z mane · dies unus ·
Dixit ꝙ̄ dꝰ · fiat fir=
mamentū ī mecho aq̄ꝝ
z diuidat aqꝰ ab aq̄s ·
Et secit dꝰ firmamentū
diuisitꝙ̄ aquas que
erant sub firmamēto ·
ab his q̄ erant s̄ fir=
mamentū · Et sem̄ ē
ueste · z mane dies secd' ·
Dixit uoꝛ dꝰ · Congre=
gentur aque que s̄
celo ē ī locū unū · z
appareat arida · factū=
ꝙ̄ ē ita · Et uocauit dꝰ
aridam teꝛram · ōgre=
gationesꝙ̄ aq̄ꝝ appella=
uit maria · Et uidit
dꝰ q̄ eet bonū · z ait ·
Germinet terra herbā
uirentem z facientem
semen · z ligui pomise=
ꝝ faciens fructū iuꝯ=
genus suū · cui semē ē
semetipo sit s̄ terra ·
Et semē ē ita · Et ptu=

Fol. 105r (Judges): Samson with the donkey's jawbone.

Fol. 120r (1 Samuel): The aged Elkenah.

flesh, and a palette including vibrant orange and pictorial grounds that are in places black. Most closely related to the miniatures in the Vienna manuscript are those in a Bible in the Escorial Royal Library (Ms. d.IV.26), which probably issued from the same workshop. Dating from the 1250s (possibly a little later), the Escorial Bible is also comparable in its overall layout. Since the iconography and illustrations of the present Upper Italian Bible correspond to Vulgate manuscripts being produced in Bologna from the 1260s – an example here is Ms. Bibl. Can. Lat. 56, dated 1256, in the Bodleian Library in Oxford – it is possible that the pandect was produced in Bologna, then the most important centre of Bible production in Italy. Bologna also had its own school of theology, granted official papal recognition in 1249. Relations had always been close between the two university cities of Padua and Bologna, which lay relatively near to each other, and scribes and artists were more mobile than is generally thought. In its heyday, Bologna attracted copyists and illuminators not just from neighbouring parts of Italy, but even from England and Paris. By the same token, records from 1270, for example, show Bolognese artists migrating to Padua and other Italian centres.

Like many other codices from Upper Italy, the Vienna manuscript soon crossed the Alps. The *Interpretation of Hebrew Names*, certainly, was added in the 1st quarter of the 14th century in southern Germany or Austria. The *fleuronnée* decoration employed in this appendix corresponds somewhat to the bud-type *fleuronnée* of the Willehalm Codex dated 1320, also housed in Vienna (ÖNB, Cod. 2670).

K.-G. P.

Extent: 600 parchment folios
Format: 250 x 180 mm
Binding: Library binding from the 18th century
Content: Bible (Old and New Testament)
Language: Latin
Illustration: 82 historiated initials; 19 fleuronnée initials in the later supplement

Provenance: Soon after its completion, the main part of the manuscript reached Austria or Germany, where the final pages featuring the index were added around the middle of the 14th century. It was later housed in the Jesuit College in Vienna, after whose closure in 1773 it passed to the Vienna Hofbibliothek.
Shelfmark: Vienna, ÖNB, Cod. 1101

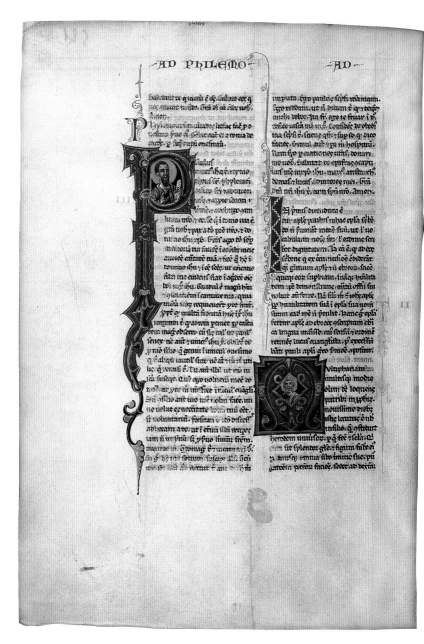

Fol. 521v (Philemon, Hebrews): Bust of the Apostle Paul.

Fol. 542r (James): James the Apostle.

Neapolitan Luxury Bible

Naples, around 1360

Lavishly illustrated with miniatures, the manuscript comprises the Latin text of the Vulgate and, added at the end, the Psalter and the *Interpretation of Hebrew Names*. It was produced around 1360 in Naples, where richly illuminated Bibles were in vogue at court, particularly during the reign of Joanna I. A total of six sumptuously illustrated Vulgate manuscripts have survived from the Naples workshop, of which the earliest (now Louvain University Library, Ms. 1) was executed for Nicola d'Alife and is signed by Naples' most important illuminator, Cristoforo Orimina. The wealth of illustrations accompanying the Vienna Bible – the coats of arms on fol. 291v and 349v and on the head, fore and tail edges have yet to be identified – were executed by altogether four miniaturists, whose hands can also be identified in other manuscripts in the group. For all their differences, three of the illuminators employ a similar style, depend more closely upon earlier French models and come close to Sienese art both in their types and their technical sophistication. The most important of them was responsible, among other things, for the initial at the start of Genesis. The illustrations by the fourth miniaturist – who carried out the lion's share of the decoration – recall, in their layout and palette, Florentine painting under the influence of Giotto. The illumination of the present Bible thus serves as a pointer to the chief sources of the new Neapolitan art of the early Trecento, a period during which artists from further afield, such as Cavallini, Giotto and Simone Martini, were recruited by King Robert of Anjou (reigned 1309–1343).

In its layout and decoration with foliate borders filled with drolleries, and also in its script and format, the present Bible is based on Bolognese luxury manuscripts of the late 13th and early 14th century. New, however, is its almost unsurpassable wealth of pictures. The text is lavishly illustrated by miniatures variously located inside initials, at the start of the biblical books and chapters and along the bottom

Detail from fol. 8v (Genesis): Border with Atlas figure.

▶ **Fol. 4r (Genesis):** Initial in Genesis showing the Creation of the heavens and the earth, the sun, moon and animals, and Adam and Eve. Two further pictorial fields show Adam and Eve being led through Paradise, and the Fall. An angel in the left-hand margin and Mary on the right together form an Annunciation, while at the top more angels, saints and drolleries surround the figure of God the Father in majesty.

scibant: nó phasse. Aliud é enim
uatem: aliud ē inpretem. Ibi spīritus
necēs prehcat: hic erudicio: et uerbi
copia: ea que intelligit transfert. ꝗ
tsi fortē putandus ē tchoꝰ: ē eho
nonuicuū renofonte: i platonis
pythagoram: i demosthenes pthē si
fontem afflatus retoico spū: tran
stulisse. Aut ꝗd de eisdem libris: ꝑ sep
tuaginta inpretes: aliter ꝑ aplos
sps scs testimonia tcerit: ut qd illi
tacuerunt: hi scriptū ēē mentiti sūt.
Quid igitur: Dampnamꝰ netes:
Minime. Sz post priorum studia: i
dominuū quod possimus labramꝰ.
Illi inpretati sunt ante aduentum xpī
i quel nesciebant dubijs pꝛotulere
sententijs. Nos post passionem a resur
rectionem eius: nō tam pham ꝙ ysto
riam scribimus. Alitꝰ enim audicta
alitꝰ uisa narrantur. Quel melius
intelligimus: melius i pꝛoferimus.
Audi igitur emule: ob trectator. A
sculta. Non dampno: nō reprhendo:
septuaginta: sz confidentꝰ amctis ill
aplos pꝛefero. Pistorum os michi
xpī sonat: quos ante iphetas inter
spiritalia karismata positos lego: i
quibus ultimū ꝑne gradum inter
pretes tenent. Quid liuore torque
ris: Quid inpitorum animos:
contra me conatis: Staubi tibi: i
translatione uidetor errare: intega
lxrbeos: diuersarum urbium ma
gistros consule. Quel illi habent
de xpī: tui codices nō hīt. Aliud est
si contra se post abaplis usurpata te
stimonia pꝛoduxerint: emendata
ora sunt exemplaria latina quam
greca: greca quam hebraa. Verum
hec contra inuidos. Nūc te pꝛecor
desidij karissime ut quia tantum
opus me subire fecisti: i a genesi ex
ordium capere: oracionibus iuues
quel possim eodem spiritu quo
scripti sunt libri: in latinum eos
transferre sermonem.

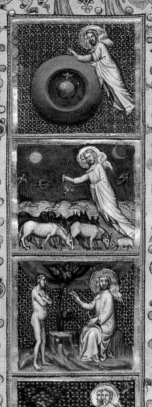

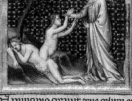

A principio creauit deus celum et
tram. Terra autem erat inanis: ua
cua. Et tenebre erant sup faciē abyssi.

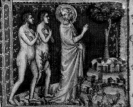

uerauit nom ei ismahel. Octoginta et
sex annoz erat abram: quando pepe-
rit ei agar ismahel. **XVII**

Postqz uero nonaginta z nouem an-
noz ee cepat: apuit ei domin.
Dixitqz ad eum. Ego dominꝰ dꝰ oīpo-
tēs: ambula coram me, z esto perfectus. ponaq̄
p̄ fedus meū int me z te: z multi-
plicabo te uehement nimis. Cecidit
abram pronus in faciem: dixitqz ei dꝰ. Ego
sum z pactum meū tecum: erisqz pater
multarum gentium. Nec ultra uocabit̄
nomē tuū abram: sed appellaberis abra-
am, q̄ patrē multarū gentium constitui
te. Faciamqz te crescere uehement nimis.
z ponam in gentibus: regesqz ex te egredi-
entur. Et statuam pactum meū int
me z te: z int semē tuum post te in gꝰa-
tionibus suis: federe sempiterno, ut sim dꝰ
tuus, z semini tuo post te. Daboqz tibi
z semini tuo tram peregrinationis tue: oēm
terram chanaan in possessionē eternam: eroq̄
deus eorum. Dixit iter deus ad abraam.
Et tu ergo custodies pactum meum:
z semen tuum post te. Circumcidet̄ ex uobis
omne masculinum: z circumcidetis car-
nem p̄putii uri: ut sit in signū federis
int me z uos. Infans octo dierum cir-
cumcidetur in uobis. Omne masculinum
uris: tam uernaculus quā emptius cir-
cumcidetur. Et quicquid nō fuerit de stirpe
ura. Eritqz pactum meū in carne ura
in fedus eternū. Masculus cuius p̄pu-
tii caro circumcisa nō fuit: delebitur illa
anima de ppło suo. q̄ pactum meū irritū fe-
cit. Dixit quoqz deus ad abraam.
Saray uxorem tuam: nō uocabis sa-
ray: sed saram. Et benedicam ei: z ex
illa dabo tibi filium. cui benedictur̄ sit,
Eritqz in nationes: z reges ploz orie-
entur ex eo. Cecidit abraham in fa-
ciem: z risit: dicens in corde suo. Putas
ne centenario nascetur filius: et sara
nonagenaria pariet? Dixitqz ad dm.
Utinam ysmahel uiuat coram te. Et
ait dominus ad abraham. Sara uxor tua
pariet tibi filium: uocabisqz nomen eius
ysaac. Et constituam pactum meū illi
in fedus sempiternū: z semini eius
post eum. Sup ysmahel quoqz exau-
diui te. Ecce benedicam eum: z augebo
z multiplicabo eum ualde. Duodecim

ances gnabit: z faciam illum in gentem
magnam. Pactum uero meū statuam ad
ysaac: quem pariet tibi sara tp̄e isto,
in anno alto. Cumqz finitus cet ser-
mo loquentis cum eo: ascendit deus
ab abraham. Tulit autē abraā, ys-
maelem filium suum: z omnes una
culos domus sue: uniuscuiusqz qz emerat,
cunctosqz mares ex omnibz uiris dom̄
sue: z circumcidit carnē p̄putii eoz
statim in ipsa die sicut preceperat ei dꝰ.
Abraham nonaginta z nouem erat an-
noz: quū circumcidit carnem p̄putii sui.
z ysmahel filius suus: tredecim annos
impleuerat tp̄e circūcisionis sue. Eadē
die circūcisus est abraham: z ysmahel
filius eius. et omnes uiri domus ill.
tam uernaculi: quam emptitii z alie-
nigene pariter circūcisi sūt. **XVIII**

Apparuit autē ei dominus in co-
nualle mambre: sedenti in ostio
tabernaculi sui: in ipso feruore diei. Cū-
qz eleuass̄ oculos: z apparuer̄ ei tres
uiri: stantes p̄pe eum. Quos cum uidis-
set: cucurrit in occursum eoz de o-
stio tabernaculi: z adorauit in terra. z dixit.
Domine si inueni grām coram oculis
tuis: ne transeas seruum tuum. Sed afferā
ram pauxillum aque: z lauentur pedes
uri: z requiescite sub arbore. Ponam
buccellam panis: z confortate cor urm.
postea transibitis. Ideo enim decli-
nastis ad seruum urm. Qui dixerunt.
fac ut locutus es. Festinauit abraā
in tabernaculum ad saram: dixitqz ei. Acce-
lera tria sata simile commisce: z fac sub-
cinericios panes. Ipse ad armentū cu-
currit: z tulit inde uitulum tenerrimū
z optimū: deditqz puero. Qui festi-
nauit z cocit illum. Tulit quoqz bu-
tyrum: z lac: z uitulum quem coxe-
rat: z posuit coram eis. Ipse uero stabat
iuxta eos sub arbore. Cumqz comedis-
sent: dixerunt ad eum. Ubi est sara
uxor tua. Ille respondit. Ecce in taberna-
culo est. Cui dixit. Reuertens ueniam
ad te tp̄e isto: uita comite: z habebit
filium sara uxor tua. Quo audito sa-
ra: risit post hostium tabernaculi. Erāt
autem ambo senes: prouectęqz etatis.
z desierant sare fieri muliebria. Que
risit occulte dicens. Postqz consenui

Fol. 9v (Genesis): Three angels appear to Abraham.

▶ Fol. 23v–24r (Genesis, Exodus): Jacob prophesies to his sons. Death of Jacob. On the right, the sons of Israel enter Egypt.

▶▶ Detail from fol. 19r (Genesis): Joseph is sold to the Ishmaelites.

of the page. Elaborate series of illustrations are contained in particular in the Biblical narrative from Genesis to the end of the 2nd Book of Kings, then again in the 1st and 2nd Book of the Maccabees, Acts of the Apostles and the Apocalypse. The other books are sparsely illustrated, some only with historiated initials. Particularly striking is the complete absence, in the Gospels, of a cycle of the Life of Jesus, as found for example in the Hamilton Bible (Berlin, Kupferstichkabinett, Ms. 78 E 3) from the same Neapolitan workshop. Apart from portraits of the Evangelists with their respective symbols, the Gospels in the Vienna Bible are illustrated by only the Tree of Jesse in Matthew (fol. 362r), John the Baptist pointing to a bust of Christ in Mark, the Crucifixion in Luke (fol. 382r) and a Throne of Grace in John.

The selection of illustrations – which is similar to those in the other Bibles produced by this workshop – is based on the pictorial cycles which were ready-to-hand in Naples. Thus the illustrations of the Apocalypse are based on the frescos in S. Maria di Donnaregina (executed after 1317) and on the so-called Erbach Panels painted in the 1330s (now Stuttgart, Staatsgalerie). The cycle of Old Testament scenes derives from the same sources as the wall paintings in the church of S. Maria Incoronata, which cannot be dated before 1368, however.

On fol. 455v the scribe gives his name as Johannes. He may possibly be identical with Magister Johannes of Ravenna, who wrote the Hamilton Bible in Berlin and a Breviary (Ms. a. III. 12) in the Escorial.

K.-G. P.

Extent: 522 parchment folios
Format: 360 x 253 mm
Binding: Vienna library binding of 1752
Content: Bible (Old and New Testament)
Language: Latin
Scribe: Johannes (colophon on fol. 455v)
Miniaturists: four anonymous miniaturists from the workshop of Cristoforo Orimina (active around 1330–1365)
Illustration: 39 large, historiated initials and 1,398 small initials, plus 184 square-framed miniatures

Provenance: The manuscript was copied and illuminated for the circle of the Neapolitan court in around 1360. The coat of arms on fol. 291v and 349v and on the head, fore and tail edges has not yet been identified. The codex has been the property of the Vienna Hofbibliothek at the latest since 1576 (shelfmark inscriptions by the praefect Hugo Blotius).
Shelfmark: Vienna, ÖNB, Cod. 1191

do t partem unam ex frib3 meis qua tuli
de manu amorrei in gladio z arcu meo.

Uenit aut iacob z
filios suos dixit. Congregamini z au-
dite. que uentura sunt uob3 in dieb3 no-
uissimis. Congregamini z audite filij
iacob. audite ifrl patrem ursm. Ruben
primogenit9 me9. z tu fortitudo mea z pn-
cipium doloris mei. prior in donis ma-
ior in impio. effusus sic aq̃. no crescas. qr
ascendisti cubile pris tui. z maculasti
stratum ei. Symeon z leui frs. uasa
iniquitatis bellantia. in consilio eor no
ueniat aia mea. z in cetu eor no sit gla
mea. qr in furore suo occiderunt uirum.
z in uoluntate sua suffoderunt murum.
Maledictus furor eor. qr ptinax. z indig-
natio eor qr dura. Diuidam eos in iacob.
z dispgam eos in ifrl. Iuda laudabunt te
frs tui. manus tua in ceruicib3 inimicor
tuor. adorabunt te filij pris tui. Catul9
leonis iuda. ad predam fili mi ascendisti.
z requiescens accubuisti ut leo. z q̃si lee-
na. Quis eum suscitabit. No auferet
sceptrum de iuda. z dux de femore ei9. do-
nec ueniat qui mittendus est. z ipse erit expe-
ctatio gentium. Ligans ad uineam pullum
suū. z ad uitem o fili mi asinam suam. La-
uabit in uino stolam suam. z sanguine u-
ue pallium suū. Pulchriores oculi ei9
uino. z dentes ei lacte candidiores. Za-
bulon in litore maris habitabit. z in statione
nauium. z pertingens usq3 ad sydonem. Ysa-
char asinus fortis. accubans ut rin9.
uidit regem quod esset bona. z terram optima.
z supposuit humerū suum portandum.

z factus est tributis seruiens. Dan iudicabit
pplm suum. sicut z alia tribus in ifrl. Fiat dan
coluber in uia. cerastes in semita. mordens
ungulas equi. ut cadat ascensor ei9 retro.
Salutare tuum expectabo dñe. Gad accinc-
tus preliabitur ante eum. z ipse accingetur re-
trorsum. Aser pinguis panis ei9. z prebebit
delicias regib3. Neptalim ceruus emissus.
z dans eloquia pulchritudinis. Filius ac-
crescens ioseph. z decorus aspectu. filie
discurrerunt super murum. Sed exasperauerunt
eum. z iurgati sunt. In inuidentes illi
habuere iacula. Sedit in forti arcus ei9.
z dissoluta sunt uincula brachior illi9.
p manus potentis iacob. Inde pastor e-
gressus est lapis ifrl. Deus patris tui erit ad-
iutor tuus. z omnipotens benedicet tibi. benedictionib3
celi desup. benedictionib3 abyssi iacentis deorsum.
benedictionib3 uberum z uulue. benedictiones
patris tui confortate sunt benedictionibus pa-
trum ei9. donec ueniret desiderium collium et-
nor. Fiant in capite ioseph. z in uertice naza-
rei inter frs suos. Beniamin lupus rapax.
mane comedet predam. z uespere diuidet spo-
lia. Et omnes hij in tribub3 ifrl xij. Hec lo-
cutus est eis pater suus. benedixitq3 singulis
benedictionib3 ppriis. z precepit eis dicens.
Ego aggregor ad pplm meum. Sepelite me
cum patribus meis in spelunca duplici. que
in agro ephron hethei. z mandrez. iuxta
mambre. que est cora abrahā. cum agro.
ab ephron hethei in possessionem sepulcri.
ibi sepelierunt eum. z saram uxorem ei9.
Ibi sepultus est ysaac cum rebecca coniuge.
ibi z lya condita iacet. XXXXX

finitisq3 mandatis quib3 filios in-
struebat. collegit pedes suos sup

24

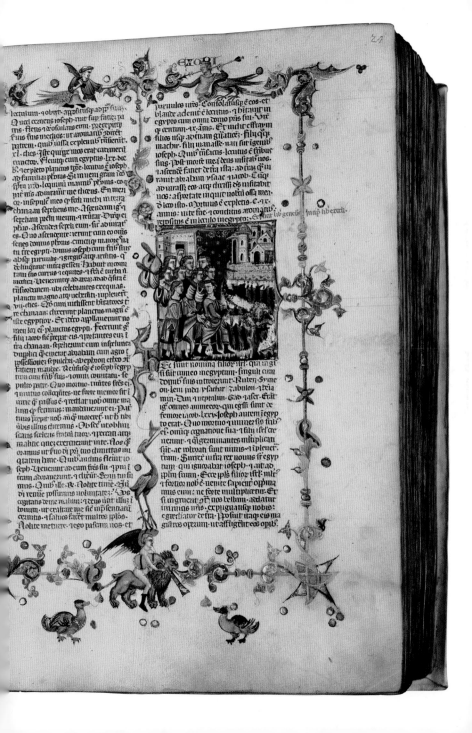

ipo eat. nec nouat. ahqo cuctis et cre
ditis. Et tu dns enim erat aun illo. q
oia opa ei dirigebat. XL

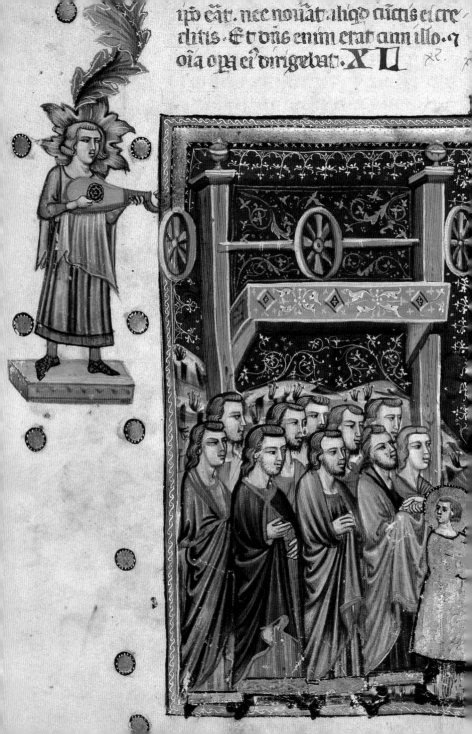

us innocens sum· Videns pistor magr̃
p̃ prudent̃ sompniū dissoluiss·ait·
Et ego uidi sompniū q̃ habein tria
canistra fanne sup caput meū·ꞇ iuno
canistro q̃ erat excelsius·putabam pꝃ
are alios omnes qui fiũt arte pistoria·
aues comedē exeo· R̃·ioseph·Hēc ē ĩ
ꝑtatio sompniū·Tria canistra: tres ad
uc dies sunt·p̃ q̃s aufeꝛ phão caput
uum·ac suspēdet te incruce·ꞇ lacera
unt uolucres carnes tuas·Et inde ĩ
as dies natalium phõnis erat·qui fac̃
ñe grande ꝫꞇuiuū pueis suis recordat̃
in t̃ epulas magr̃ pincnaꝝ·ꞇ pistoꝛ
ꝛncipis·ꞇ restituit alter ĩ locum suū·
ꞇ poꝛꝫget regi poculum·altiū suspē
dit in patibulo ut ꝫꞇectoris ꝫꞇtas phare

Detail from fol. 107r (1 Samuel): David and Goliath.
In the background, the brothers try to keep David
back.

Detail from fol. 197r (Ezra, Tobit): Tobias and his
wife Hannah distribute alms to the brothers of
his tribe. In the foreground he buries kinsmen
murdered by Sanherib.

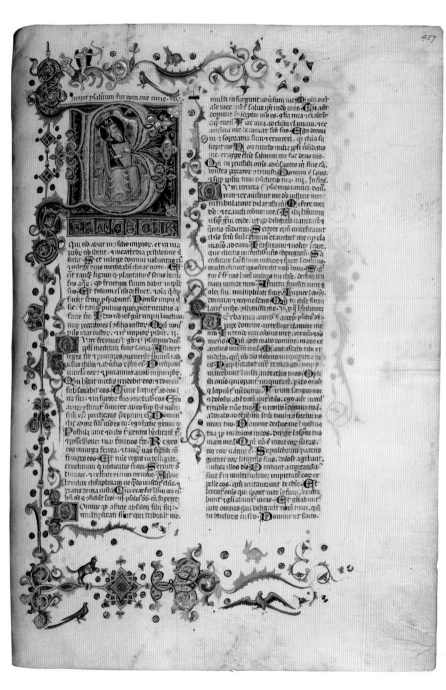

◄ **7 Fol. 457r (Psalms):** David with a psaltery accompanying Psalm 1.

Detail from fol. 444r (Acts of the Apostles): The storm at sea during Paul's journey to Rome as a prisoner (Acts 27:14–26).

Eberler Bible

Basle, 1464

Translations of scriptural texts belong amongst the very first instances of written German: the oldest surviving examples are the so-called Mondsee Fragments containing St Matthew's Gospel, dating from around 800 (Vienna, ÖNB, Cod. 3093*). Over the following centuries, further sections of the Bible were translated and began to be published as separate books, as in the case of the Psalter, which was used as a prayer book, and other books from the Old Testament.

The first complete Bibles in the German language only appeared in the 14th century and until the invention of printing and the dawn of the Reformation remained a somewhat rare phenomenon. The Eberler Bible belongs to a branch of these complete German-language Bibles which traces its descent from some of the better translations. One indication of the quality of its translation, for example, is the fact that the word order adheres relatively closely to German syntax rather than to the Latin of the original. In a striking number of places, the codex offers several possible translations or includes the original Latin word, leaving it up to the reader to decide how to interpret the text.

Matthias Eberler, who commissioned the two-volume Vienna codex, came from a wealthy Basle family. His grandfather converted from the Jewish to the Christian faith and obtained his Basle citizenship in 1393. His grandson, evidently eager to strengthen his social position, acquired himself a title and spent his inheritance on a lavish lifestyle. The reason for his decision to commission a complete German-language Bible is unknown, but was probably linked with his social ambitions and family history. The two volumes of the Eberler Bible contain illustrations by a number of illuminators, probably all based in Basle.

The prologues and biblical books all open with historiated initials. In Volume I, a single artist was responsible for the coat-of-arms page (ill. p. 177), the entire

Detail from Cod. 2769, fol. 302v (The Wisdom of Solomon, Prologue): King Solomon, who was thought to be the author of the text, in front of an interior view of the Temple of Jerusalem.

▸ Cod. 2769, fol. Iv: Beneath the coat of arms unfurls a banderole, whose inscription gives 1464 as the year in which the Bible was produced and names Matthias Eberler as its patron.

In dem iar als man zalt nij· ccc· und
lxviij· hat Mathis Swerer dis bybly
lassen machen· Des sell ruwe in
dem frede got· ꝛc·

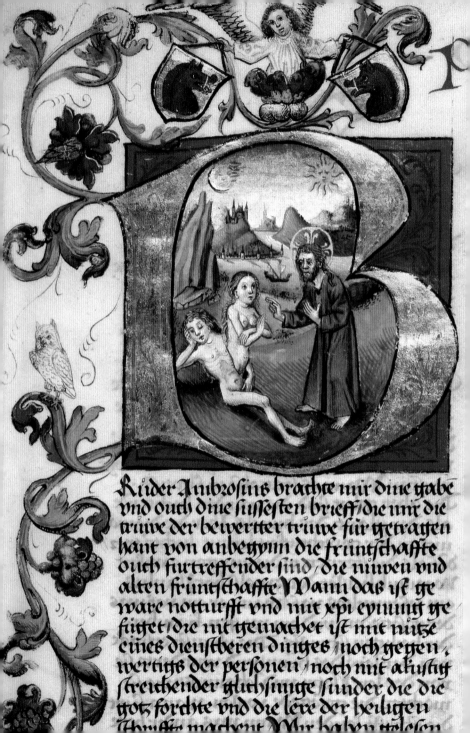

Ruder Ambrosius brachte mir dine gabe
vnd ouch dine sussesten brieff/die mir die
triuwe der bewertter triuwe fur getrazen
hant von anbeginn die fruntschaffte
ouch furtreffender sind/die niuwen vnd
alten fruntschaffte Wann das ist ge-
ware notturfft vnd mit xpi eynunng ge-
füttet/die mit gemachet ist mit nutze
eines dienstberen dinges/noch gegen-
wertigs der personen/noch mit akustif
streichender glichsinnige sünder die die
got forchte vnd die lere der heiligen

Detail from Cod. 2769, fol. 1r (Genesis, Prologue): The Creation of Eve. The sun and moon look back to the earlier separation of the light and the darkness; the landscape in the background includes a castle, a city and a ship.

decoration of fol. 1r (ill. p. 178) and the internal fields of the initials from folio 28v to 237v (ill. pp. 181, 183). His figures, convincingly realistic in their poses and gestures, are set within landscapes that recede through successive planes into a bluish distance. For his border decoration, he employs green leaves of more or less the same shape, whose curling tips end in a different colour. By contrast, a second illuminator (aided by his workshop?) uses a very varied repertoire of forms executed in bold colours, which has been convincingly traced back to earlier manuscripts preserved or illuminated in Basle (Escher [1923–25]). To this artist we can attribute the execution of the initials as from fol. 250v in the first volume and the entire decoration of the second volume. He or one of his assistants probably also completed the ornamentation of most of the initials by his colleague, plus the silver filigree on fol. Iv (ill. p. 177), since these all employ his formal repertoire.

The figures by the second artist differ strikingly from those of the first in their unusual poses, while the landscape in the distant background is rendered in paler, but not bluish, shades. A third painter was evidently responsible for the coat-of-arms page in the second volume (ill. p. 184), since the head of the donkey is shaped and modelled differently to that by the first artist (ill. p. 177). In its more limited palette and the greater uniformity of its ornament, the coat-of-arms page in the second volume also differs, moreover, from the style of the second artist, who executed the decoration on the opposite folio (ill. p. 178) and who would probably have aimed at a much better visual balance between the two pages.

C. B.

Extent: two volumes; Vol. I: II + 331 parchment folios; Vol. II: 263 parchment folios
Format: Vol. I: 400 x 290 mm; Vol. II: 385 x 280 mm
Binding: white parchment binding, dated 1756, with imperial supralibros and the initials of the Hofbibliothek and praefect Gerard van Swieten (1745–1772)
Content: Bible (Old and New Testament). Vol. I: Genesis to Koheleth [Ecclesiastes]; Vol. II: Isaiah to Apocalypse (Revelation)
Language: Middle High German
Scribe: Johann Liechtenstern of Munich

Illustration: Vol. I: one coat-of-arms page, 24 historiated initials; Vol. II: one coat-of-arms page, 28 historiated initials
Patron: Matthias Eberler, 1464
Provenance: ex libris inscriptions place the Eberler Bible in the library of the Archdukes of Tyrol in Ambras Castle (Cod. 2769, fol. IIr: MS Ambras 20; Cod. 2770, fol. 1r: MS Ambras 21). In 1665, when the Tyrolean line of the house of Hapsburg died out, the collection was inherited by next-of-kin Emperor Leopold I, and the two volumes passed into the Vienna Hofbibliothek.
Shelfmark: Vienna, ÖNB, Cod. 2769–2770

Nachdem todt Iosue do rat fragten die
sune israhel den hren vnd sprachen Wer
vart vff vor vns wider thananeum
vnd wirt ein houbt vnsers vrlieges Der
herre sprach Iudas fart vff Gehent
das lande han ich geben In sine gewalt
Vnd Iudas sprach zu symeon sinem
bruder far vff mit mir In myne lose
vnd strit mit mir wider thananeum
das ouch ich fare mit dir In dinen
teile Vnd Symeon fur mit sme Vnd Iu
das fur vff Vnd der hre trap thana
neum vnd phereseum In sin hant vn
schlugen In bezech zehen tusent man
Vnd funden adombezech in bezech In
fachten wider In vnd schlugen tha
naneum vnd phereseum Aber adom
bezech vlohe Dem iageten sie nach
vnd betriffen In vnd gestumelechten
de vnd fusse Vnd adombezech spch
Sibentzig kunig samenoten ableiben
der spise vnd myne tisch mit abgeschla
gen henden vnd fussen Als ich getan
han also hat mir got wider gethan
Vnd fürten In In iherusalem vnd do
starp er Aber die sune Iuda sturmete
an iherusalem vnd gewunnen sehnd
schlugen sie mit dem swerte vnd v
brannten sy mitenande Dornach
fürten sy aber vnd striten wider thana
neu der do wonte Indem gebirte vn
gegen dem mittellande vnd In west
lande vnd Iudas fur wider thananeu
der do wonte In ebron des name von
alte was cariatharbe vnd schluge
Hisai achima vnd cholmai vnd fur
dannant zü denen die do woneten
zü Dabir die nach dem alten na
men hiesz Cariathspher das ist ein

stat der buchstaben Vnd caleb sprch
war schlahet cariath sephe vnd so ze
storet dem gib ich axam myne tochte
ze wibe Vnd do othomel sun tenz ei
bruder caleb der die sin veste was d
stat gevieng Do grab er Im sine toch
ter ze wibe die mante sy man vff der
weise das sie hiesche von Irem vater ei
acker Vnd do sie rite vff einem esele
vnd er sufftzte Do sprach sy vater Ca
leb was ist dir Vnd sy antwürte
mir den setzen wann du mir hast ge
ben ein dürre lande gip mir ouch da
fürhte Vnd caleb grab se ouch dz fuch
mit wasser vnden vnd oben Aber d
sine matte moysen fürten vff
der stat der palmen mit den sinen
In die wusten Irs losses geten dem v
tellande azad vnd wonten mit Inn
Vnd Iudas fur enwert mit symeon
sinem bruder vnd erschlugen miteina
and thananeu der do wonte In seph
vnd der stat namen ward geheissen
Horma das ist verdapnusse Vnd
das vieng gazam mit sinen lande
vnd ostalon vnd attoron mit sinen le
den Vnd der hre was mit Iuda vn
besasz das gebirtze noch mochte nit
tilken die wone des tales wann
oberflisset waren mit gestharsech
ten wegnen Vnd si graben ebron ca
leb als moyses gesprochen hate vn
er tilkete us Ir dru sine enach Ab
die sune Benyamyn vertilketen ni
Iebuseum de wonz zu iherusalem vn
Iebusus wonte mit sinen Benyam
zu iherusalem vff disen tag Di
das husz Ioseph fur vff zu Bethel
der hre was mit sin Waann do sie b
sessen hetten ein stat die vor luza gehe
sen was do sahen sie einen menschen v
gran von der stat vnd si sprachen zu
In Zöuge vns den sigant der stat
Do wollen wir dich bethnaden vnde
In gezönte te do schlugen si die stat
mit dem swert Aber den menschen
liessen sie gan mit allem sinem gesch
lechte Vnd do er gelassen ward do
er In das lande ethim vnd büwete
ein stat vnd nante die luzam vn he
ist also vntz vff disen tag Di
manasse tilkete nit bethan vnd tha
mar mit sinen cleinen castellen vn
die wone dor vn ieblaam vnd ma
gedde mit iren cleinen castellen Vn
thananeus begonde wonen mit su

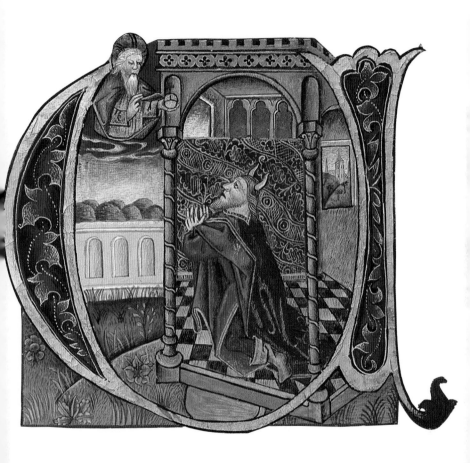

Detail from Cod. 2769, fol. 60v (Numbers): The Lord commands Moses to take a census of Israelite men able to go to war.

◄ **Cod. 2769, fol. 107v (Judges):** The Lord appoints Judah the new leader of the Israelites.

Detail from Cod. 2769, fol. 250v (Psalms, Prologue):
King David with his harp (on a separate page to
the Prologue text).

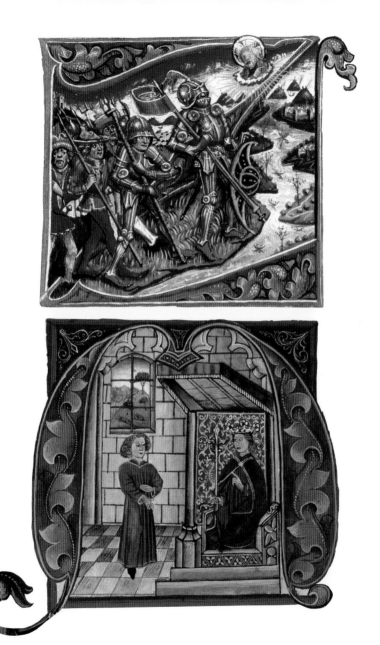

Detail from Cod. 2769, fol. 96r (Joshua, Prologue): The people of Israel about to cross the River Jordan, led by Joshua in full armour.

Detail from Cod. 2769, fol. 310v (Ecclesiastes, Prologue): King David and his son Koheleth.

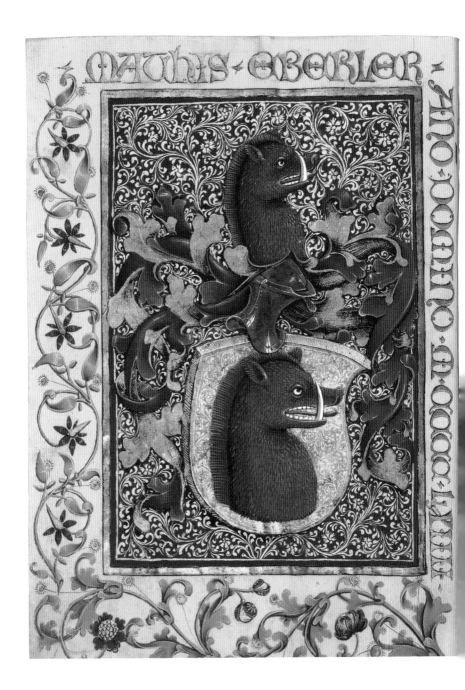

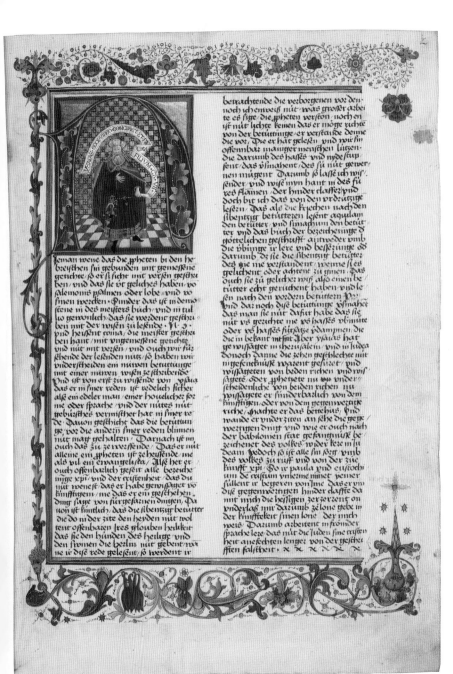

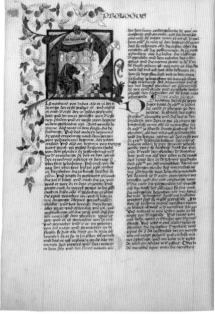

Cod. 2770, fol. 60r (Ezekiel, Prologue): The prophet Ezekiel with banderole inscribed: *PORTA HEC CLA(U)SA. CA(PITULUM) XLIIII.* "This gate [shall] be shut, Chapter 44").

◄◄ Cod. 2770, fol. 1v: Above and to the right of the coat of arms, the name of the patron and the date of the manuscript, 1464, are inscribed in gold writing.

◄ Cod. 2770, fol. 2r (Isaiah, Prologue): The prophet Isaiah with banderole inscribed *YSAIAS. ECCE VIRGO CONCIPIET ET PARIET FILIUM. CA(PITULUM) VII* ("Isaiah. Behold, a virgin shall conceive, and bear a son. Chapter 7").

Cod. 2770, fol. 144v (St Matthew, Prologue): St Matthew the Evangelist with banderole inscribed: *(LI)BER GENERACIONIS. CA(PITULUM) I* ("Book of the generation of [Jesus Christ]. Chapter 1").

► Detail from Cod. 2770, fol. 255r (Apocalypse, Prologue): St John on Patmos.

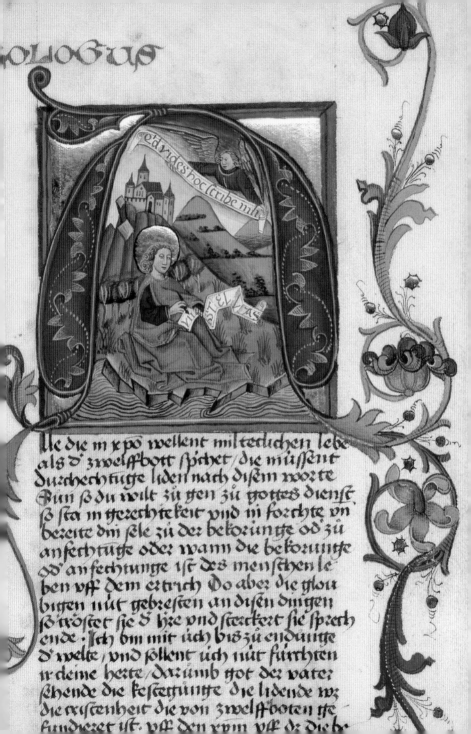

Ue die in x̄pō wellent mittediche̅ lebe̅
als d' zwelffbott spichet / die müssent
durchech tusse lide̅ nach dise̅ worte
Bun sō du wilt zū gen zū gottes dienst
sō sta in gerechtekeit vnd in forchte vn
bezeite din sele zū der bekorǖge od' zū
anfechtusse oder wann die bekorǖge
od' anfechtǖge ist des menschen le
ben vff dem ertrich do aber die glou
bigen nüt gebresten an dise̅ dingen
sō tröstet sie d' ihre vnd sterckert sie sprech
ende · Ich bin mit üch biszū endǖge
d' welte / vnd söllent üch nüt fürchten
ir deine herze / darumb got der vater
sehende die kesterǖge die lidende wz
die cristenheit die von zwelff boten ge
fundieret ist · vff den xviiij vff d' die hē

Luxury Bible by Ulrich Schreier

Salzburg (?), 1472

Illuminated by Ulrich Schreier in 1472 and written for a member of the Prasch family in Hallein, the present Vulgate is one of many Bibles produced entirely by hand even after the appearance of the first printed editions. Contrary to widespread opinion, manuscript production continued to play an important role even after the publication of the 42-line Gutenberg Bible in around 1453/54. By 1472 no fewer than another nine Latin and two German editions of the Bible had rolled off the new presses, yet it was only towards 1480 that the manuscript industry truly began to decline. The reasons for this are various, with probably the most important being the high prices charged for the new printed books, and the fact that, for reasons of economy, they omitted decorative initials (the purchaser generally had to engage an illuminator to add them later). Ulrich Schreier himself illustrated several incunabula, including a Bible more or less contemporaneous with Codex 1194, which was printed in Strasburg around 1470 and is today housed in the Austrian National Library (ÖNB, Ink. I. A. 18).

Carefully but not excessively decorated with miniatures, Codex 1194 contains 63 *fleuronnée* and 21 mostly ornamental initials. Only four of them actually illustrate the text: St Jerome in the Prologue (ill. p. 190), the seven days of Creation in Genesis (ill. p. 189), a bust of St John accompanying the 1st Epistle of John and – most unusually – the depiction of a youth sitting in a flower accompanying the Song of Songs (probably Chapter 2:1). The busts contained in initials in Psalm 26, at the beginning of the books of Isaiah, Daniel, Obadiah and Jonah, and in Habakkuk, Malachi and Galatians are without attributes and are too unspecific to be able to identify them as portraits of David, the respective prophets or St Paul. They appear to have been chosen arbitrarily and do not correspond to the iconography conventionally used in Bibles, as seen in another Vulgate by Ulrich Schreier,

Detail from fol. 271v (Baruch): Decorative border. ▸ **Detail from fol. 4r (Genesis):** The story of Creation.

Incipit liber bresith idest genesis

In principio creauit deus celum et terram terra aut erat inanis et uacua et tenebre erant super faciem abyssi et spus dei ferebat super aquas Dixitque deus fiat lux Et facta e lux Et uidit deq lucem cp esset bona et diuisit lucem ac tenebras appellauitque lucem diem et tenebras noctez factumcp e vespere et mane dies vnus Dixit quocp deus fiat firmamium in medio aquarum et diuidat aquas ab aquis Et fecit deus firmamium diuisitcp aqs que erat sub firmamuo ab aqs que erat super firmamtu Et fit e ita Vocauitcp deus firmamentum celum Et factum e vespere et mane dies secundus Dixit vo deus congregentur aque que sub celo sunt in locum vnu et appareat arida faciumcp e ita Et uocauit deus aridam terram congregaonescp aquarum appellauit maria Et uidit deus cp esset bonu et ait Ger

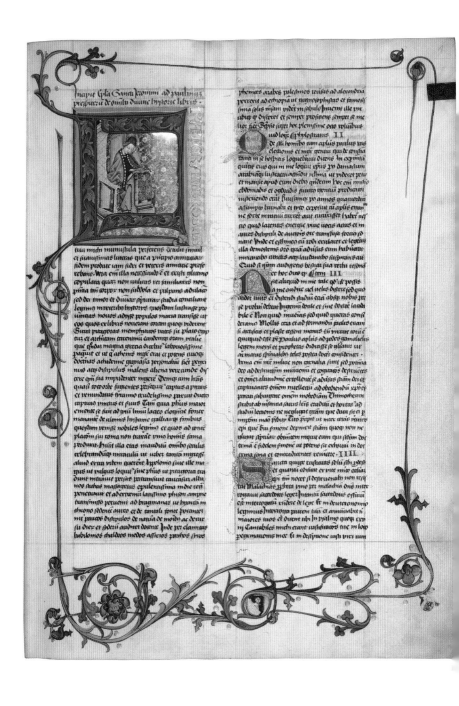

Incipit epistola Sancti Ieronimi ad Paulinum presbiterum de omnibus diuine hystorie libris.

tua michi munuscula preferens detulit simul et suauissimas litteras que a principio amicicias fidem probate iam fidei et veteris amicicie preferebant. Vera enim illa necessitudo est et cristi glutino copulata quam non vtilitas rei familiaris non presentia tantum corporum non subdola et palpans adulatio sed dei timor et diuinarum scripturarum studia conciliant. Legimus in veteribus historijs quosdam lustrasse prouincias nouos adisse populos maria transisse vt eos quos ex libris nouerant coram quoque viderent. Sicut pictagoras memphiticos vates sic plato egyptum et architam tarentinum eandemque oram ytalie que quondam magna grecia dicebatur laboriosissime peragrauit et vt qui athenis magister erat et potens cuiusque doctrinas achademie gymnasia personabant fieret peregrinus atque discipulus malens aliena verecunde discere quam sua impudenter ingerere. Denique cum litteras quasi toto orbe fugientes persequitur captus a piratis et venundatus tyranno crudelissimo paruit ductus captiuus vinctus et seruus. Tamen quia philosophus maior emente se fuit ad titum liuium lacteo eloquencie fonte manantem de vltimis hyspanie galliarumque finibus quosdam venisse nobiles legimus et quos ad contemplationem sui roma non traxerat vnius hominis fama perduxit. Habuit illa etas inauditum omnibus seculis celebrandumque miraculum vt vrbem tantam ingressi aliud extra vrbem quererent. Apollonius siue ille magus vt vulgus loquitur siue philosophus vt pitagorici tradunt intrauit persas pertransiuit caucasum albanos scithas massagetas opulentissima indie regna penetrauit et ad extremum latissimo phison amne transmisso peruenit ad bragmanas vt hyarcam in throno sedentem aureo et de tantali fonte potantem inter paucos discipulos de natura de moribus ac de siderum cursu audiret docentem. Inde per elamitas babilonios chaldeos medos assirios parthos siros

phenices arabes palestinos reuersus ad alexandriam perrexit ad ethiopiam ut gymnosophistas et famosissimam solis mensam videret in sabulo. Inuenit ille vir ubique quod disceret et semper proficiens semper se melior fieret. Scripsit super hoc plenissime octo voluminibus philostratus.

II

Quid loquar de seculi hominibus cum apostolus paulus vas electionis et magister gentium qui de conscientia tanti in se hospitis loquebatur dicens. An experimentum queritis eius qui in me loquitur cristi. Post damascum arabiasque lustratas ascenderit iherosolimam ut videret petrum et manserit apud eum diebus quindecim. Hoc enim mysterio ebdomadis et ogdoadis futurus gentium predicator instruendus erat. Rursumque post annos quatuordecim assumpto barnaba et tito exposuit cum apostolis euangelium ne forte in vacuum curreret aut cucurrisset. Habet nescio quid latentis energie viue vocis actus et in aures discipuli de auctoris ore transfusa fortius sonat. Vnde et eschines cum rhodi exularet et legeretur illa demosthenis oratio quam aduersus eum habuerat mirantibus cunctis atque laudantibus suspirans ait. Quid si ipsam audissetis bestiam sua verba resonantem.

III

Non ergo loquor de me quod sim aliquid vel fuerim sed quod tu studio discendi ad nos venire voluisti et velles discere sed quod si aliquid et ostendo studium tuum et absque nobis per se prono et flexu ingenii docile est sine doctore laudabile est. Non quid inueniam sed quid queras consideramus. Mollis cera et ad formandum facilis etiam si artifices et plastae cessent manus in virtute totius est quicquid esse potest. Paulus apostolus ad pedes gamalielis legem moysi et prophetas didicisse se gloriatur ut armatus spiritualibus telis postea diceret confidenter. Arma enim militie nostre non carnalia sunt sed potentia deo ad destructionem munitionum et cogitationes destruentes et omnem altitudinem extollentem se aduersus scientiam dei et captiuantes omnem intellectum ad obediendum cristo. Imperante iohanne omnem mediciam timotheum scribit ab infantia sacris litteris eruditum et hortatur ad studium lectionis ne negligeret gratiam que data sit ei per impositionem manus presbyterij. Tito precepit ut sancte conuersationis episcopum quem sibi sermone depinxit faceret et preueniret doctrinam quoque non negligeret stipulando obuentiones mundi cum eam que iudeorum fuit doctrinam et fidem simone ut potentior in exhortacione in doctrina sana esset et contradicentes reuinceret.

IIII

Non grandis oratio que prius tantulis solis sibi prodest. Et quantum constat ex vita mea quia nobilissimus sacerdos nihil nocet si deprecando non vtitur. Malachias quoque iuxta uno patre maladiam dominus inter rogauit sacerdotes legis etenim sacerdotes offitii est interrogari. Videre et lege in deuteronomio legimus. Interroga patrem tuum et annuntiabit tibi maiores tuos et dicent tibi. In pitagora quoque experimentales magistros michi erant. Vsitabantur tibi in loco experimentum exspecto. Si in destructione nisi vti per num

Fol. 1r: St Jerome at his desk.

illuminated in 1469 and today housed in the University Library in Graz (Cod. 48).
The remaining, predominantly non-figural initials are opulently decorated with
ornaments, flowers, grimacing faces and richly-varied tooling on a gold ground.
The foliate arabesques that issue from them are populated by stylized flowers,
a diversity of creatures such as ladybirds and birds, and also human masks and
drolleries. The *fleuronnée* employed for the subordinate initials also features the
human masks typical of Schreier.

The date of the manuscript is given both at the end of the text and in the ini-
tial on fol. 301v, which also includes the name of the artist in an illusionistically
draped banderole: *die bibell hat illuminiert der schreier*. In total, more than 60 books
and as many bindings can today be attributed to Ulrich Schreier, who worked
as a book-binder as well as a miniaturist and who not infrequently signed and
dated his works. While the beginnings of his artistic activity remain shrouded
in obscurity, we are well informed about his subsequent career. We meet him
for the first time in 1459, in Codex 5038 in the Austrian National Library. Up till
1482, Schreier was active chiefly for the Salzburg archbishop Bernhard von Rohr
(1466–1482) and for patrons in the Salzburg area. He then moved to Lower Aus-
tria, where he can be found working primarily in Vienna, Klosterneuburg and
Preßburg. Towards the end of his life he is documented in Mondsee and Linz.
His last known work is the lavishly illustrated Greiner Marktbuch (Upper Austria)
from 1489/90.

K.-G. P.

Extent: II + 419 parchment folios
Format: 375 x 280 mm
Binding: blind-tooled binding by Ulrich Schreier,
Group I
Content: Bible (Old and New Testament)
Language: Latin
Miniaturist: Ulrich Schreier (active *c.* 1450–
c. 1490)
Illustration: 21 decorated and illuminated initials,
53 fleuronnée initials

Provenance: The manuscript was probably produced
in Salzburg for a member of the Prasch family in
Hallein (coat of arms on fol. 1r), and is docu-
mented at the latest around 1700 in the Salzburg
archbishop's reference library. From there the
codex passed to the Vienna Hofbibliothek in 1806.
Shelfmark: Vienna, ÖNB, Cod. 1194

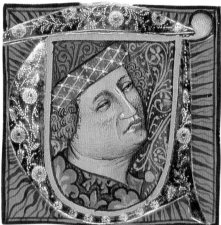

Detail from fol. 62v (Joshua): Ornamental initial.

Detail from fol. 159v (Tobit): Initial from the Book of Tobit.

▶ Fol. 200v (Proverbs): Ornamental initials from the Prologue and Book of Proverbs.

Incipit prologus Sancti Jeronimi in libros Salomonis...

Parabole salomonis filii david regis israel...

Detail from fol. 210v (Song of Songs): Bust (of the bridegroom?) behind a rose, from the Song of Songs.

Detail from fol. 306r (Jonah): Bust of a scholar from the Book of Jonah.

▸▸ **Fol. 304v–305r (Obadiah):** Ornamental initials and bust of a man in a hat from the Book of Obadiah.

In die illa deficient virgines pulchre et
adolescentes in siti qui iurant in delicto
samarie et dicunt uiuit dns deus tuus
dan et uiuit uia bersabee et cadent et non
resurgent ultra ·

VIII

Uidi dnm stantem super altare et dixit
percute cardinem et commoue-
antur superliminaria auaricia est
in capite omnium et nouissimum eorum in
gladio interficiam Non erit fuga eis fu-
giet et non saluabitur ex eis qui fugerit
Si descenderint usque ad infernum inde
manus mea educet eos et si ascenderint
usque in celum inde detraham eos et si ab-
sconditi fuerint in uertice carmeli inde
scrutans auferam eos et si celauerint se
ab oculis meis in fundo maris ibi man-
dabo serpenti et mordebit eos et si abierint
in captiuitatem coram inimicis suis
ibi mandabo gladio et occidet eos et pona
oculos meos super eos in malum et non
in bonum Et dns deus exercituum qui tan-
git terram et tabescet et lugebunt omnes
habitantes in ea et ascendet sicut riuus om-
nis et defluet sicut fluuius egypti Qui edi-
ficat in celo ascensionem suam et fasciculu
suum super terram fundauit qui uocat
aquas maris et effundit eas super faciem
terre dns nomen eius Nunquid non ut filii
ethiopium uos estis michi filii israel Nunquid
israel non ascendere feci de terra egypt et
palestinos de capadocia et syros de cyrene
Ecce oculi dni dei super regnum peccans et
conteram illud a facie terre uerumtamen
conteraz non conteram domum iacob
dicit dns Ecce enim ego mandabo et conu-
tiam in omnibus gentibus domum israel
sicut concutitur triticum in cribro et non
cadet lapillus super terram In gladio mo-
rientur omnes peccatores populi mei qui di-
cunt non appropinquabit et non ueniet
super nos malum In die illa suscitabo ta-
bernaculum dauid quod cecidit et reedifi-
cabo aperturas murorum eius et ea que cor-
ruerant instaurabo et reedificabo eum
sicut in diebus antiquis ut possideant reli-
quias idumee et omnes naciones eo q
inuocatum sit nomen meum super eos dicit
dns faciens hec Ecce dies ueniunt dicit dns
et comprehendet arator messorem
et calcator uue mittentem semen et stilla-
bunt montes dulcedinem et omnes colles
culti erunt et conuertam captiuitatem po-
puli mei israel et edificabunt ciuitates desertas
et inhabitabunt et plantabunt uineas et
bibent uinum earum et facient hortos et come-
dent fructus eorum et plantabo eos super hu-
mum suam et non euellam eos ultra de
terra sua quam dedi eis dicit dns deus tuus

Incipit prologus in abdiam prophetam·

Iacob patria-
rche esau fra-
tris esau de causa od-
repotis sui
iniqua sang-
uine sanyi-
nis memoram

acerbitate iram odio conmor-
conaris et uia de causa po-
pulum israel hoc est filios paren-
tidi esau odium inimicum po-
esau et edom appellati sunt E-
sau est de capriuitate chaldeo-
rexrem ipsarum uua dei uete-
salem ab alio regno grauiter
oppressis est ideo hoc regnum
esau predicium populum po-
per dominationem abdie qui
pauit quod non dei mortui
uentus populum siparium
De quo regno olim per diuu-
centesimo reverssimo scivo de
mouare dns filiorum edom
Nam reliqua lectione com-
rum in genere iudaii obe-
comprehendas regni dei
significat Debet abdiam hic
qui sub rege samarie ababa
iezabel pauit centum pro-
ribus qui non contaminaue-
bahal et de septem milibus
helias arguitur ignorasse e-
cio usque in hodiernum dicit
isee prophetie et baptiste tem-
basue ueneracvon habens
eia dicebant Danc herod-
filius in honore ampui rex-
inne uocauit augustam
num prophetas saluauere
propheralem et de dua
esche Tunc in samaria po-
pauciear nunc in uno orbe
Et stat stephanius corona-
sione sic hic genuine de-
nomine gloriatur quia
dni in vno sonat domino
Incipit liber Abdie prophete

Uisio abdie hec dicit
dns deus ad edom
Auditum au-
diuimus a dno et
legatum ad gentes
misit surgite et con-
surgamus aduersus eum in prelium
Ecce paruulum dedi te in gentibus
contemptibilis tu es ua-
dis tui extollit te superbia
petre exaltantem solium
in corde tuo quis detra-

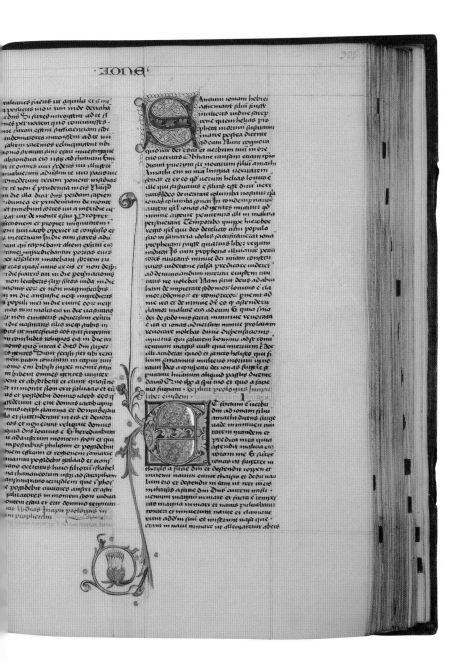

Utrecht Luxury Bible

Utrecht (Netherlands), around 1430

In the northern Netherlands towards the end of the 14th century, demand for illuminated manuscripts began to increase, first at the court of the Count of Holland, who from the second half of the 14th century resided in The Hague, and then in other towns and cities within the counties of the northern Netherlands and the bishopric of Utrecht. The increasing wealth of the inhabitants of these regions, coupled with the interest amongst the nobility, senior clergy and prosperous burghers in handsome manuscripts, provided the stimuli for the emergence of a local tradition of manuscript production and illustration.

Utrecht rapidly developed into an important centre of manuscript illumination, whose products were coveted far beyond the bishopric's bounds. Indeed, a document of 1426 from Bruges in Flanders reports of complaints by local artists about the import of illuminated manuscripts from "Utrecht and other towns" and upholds the ban on such trade. One of Utrecht's leading miniaturists during this same period – approximately 1415 to 1440 – was the illuminator of the first two volumes of the present Bible (Cod. 1199 and 1200). He is named after the Utrecht bishop Zweder van Culemborg, for whom he illuminated a Missal (Bressanone, Seminary, Ms. C. 20). This "Master of Zweder van Culemborg" frequently worked with other miniaturists; some of these were established artists in their own right, such as the Master of the Book of Hours of Catherine of Cleves (New York, Pierpont Morgan Library, Morgan 917 and 945), while others clearly worked in a derivative manner. How this collaboration was organized is a question yet to be answered, but it can be assumed that the Master of Zweder van Culemborg ran his own workshop.

The miniatures attributed to the Zweder Master in the Utrecht Bible are distinguished by a careful, highly precise manner of painting, apparent both in

Detail from Cod. 1199, fol. 120v (Joshua): God commands Joshua to cross the river Jordan with the people of Israel.

▶ Detail from Cod. 1199, fol. 5r (Genesis): The Fall. Illustrated in the marginal decoration are the Seven Days of Creation. The scribe has left space for a miniature cycle in the left-hand column (no rulings); why it was never used by the illuminator remains a mystery.

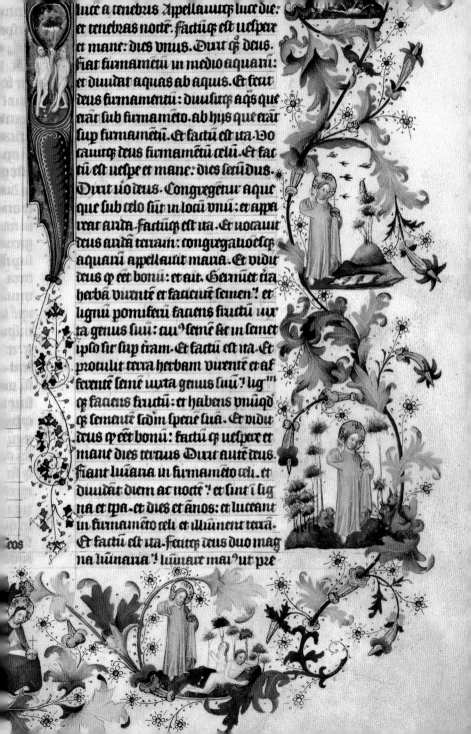

luce a tenebris Appellauitq̃ luce die:
et tenebras nocte. factuq̃ est uesper
et mane: dies unus. Dixit q̃ deus.
fiat firmamentu in medio aquarū:
et diuidat aquas ab aquis. Et fecit
deus firmamentū: diuisitq̃ aq̃s que
erat sub firmameto. ab hijs que erat
sup firmametū. Et factū est ita. Vo
cauitq̃ deus firmametū celū. Et fac
tū est uespe et mane: dies secū dus.
Dixit uo deus. Congregetur aque
que sub celo sūt in locū unū: et appe
reat arida. factuq̃ est ita. Et uocauit
deus arida terram: congregatioesq̃
aquarū appellauit maria. Et uidit
deus q̃ eet bonū: et ait. Germinet tra
herbā uirente et faciente semen·: et
lignū pomiferū faciens fructū iux
ta genus suū: cui⁹ seme sit in semet
ipso sit sup tram. Et factū est ita. Et
protulit terra herbam uirente et af
ferente seme iuxta genus suū·: ligⁿᵘ
q̃ faciens fructū: et habens unūqd
q̃ sementē sedim spere suā. Et uidit
deus q̃ eet bonū: factū q̃ uespe et
mane dies tertius Dixit aūt deus.
fiant luinaria in firmameto celi·. et
diuidat diem ac nocte·: et sint i sig
na et tpa·et dies et anos: et luceant
in firmameto celi et illumet terrā.
Et factū est ita. Fecitq̃ deus duo mag
na luinaria·: luinare mai⁹ ut pre

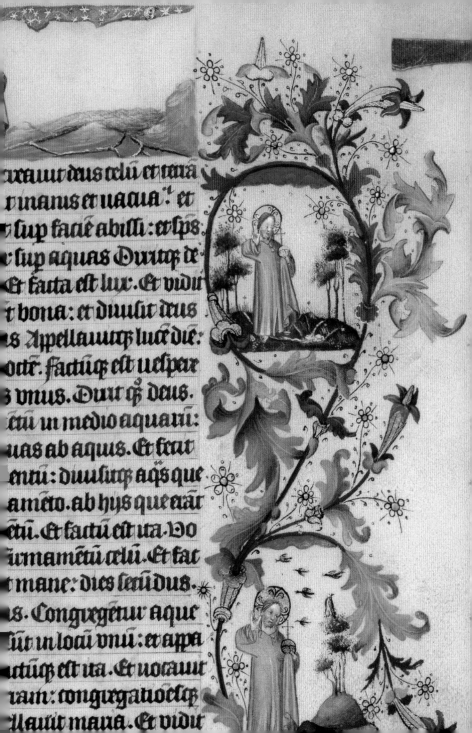

reauit deus celu et terra
r inanis et uacua⸗ et
sup facie abissi: et sps.
r sup aquas Durixtz̃ de
Et facta est lux. Et vidit
t bona: et diuisit deus
s Appellauitz̃ luce die:
octr. factitz̃ est uesper
z vnus. Dixit z̃ deus.
ctu in medio aquaru:
uas ab aquis. Et fecit
entu: diuisitz̃ aq̃s que
ameto. ab hys que erãt
ctu. Et factu est ita Vo
irmametu celu. Et fac
t mane: dies secu dus.
s. Congregetur aque
sut in locu vnu: et appa
ctitz̃ est ita. Et uocauit
ram: congregatioelz̃
lauit maria. Et vidit

Incipit epistola sancti Iheronimi presbiteri
ad paulinum de omnibus diuine
hystorie libris. Capitulum primum.

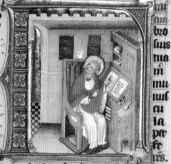

tulit simul et suauissimas litteras: que
a principio amicicias fidem probate
iam fidei et ueteris amicicie preferre
bant. Vera enim illa necessitudo est et xpi
glutino copulata: quam non utilitas
rei familiaris. non presentia tantum corpo
rum. non subdola et palpans adulatio:
sed dei timor. et diuinarum scripturarum
studia conciliant. Legimus in ueteribus
hystoriis quosdam lustrasse prouincias.
nouos adisse populos. maria transil
se: ut eos quos ex libris nouerant.
coram quoque uiderent. Sic pitagoras
memphiticos uates. sic plato egip
tum et architam tarentinum eandemque ora
italie que quondam magna grecia
dicebatur. laboriosissime peragrauit.
ut qui athenis magister erat et potens
cuiusque doctrinas achademie gymna
sia personabat. fieret peregrinus atque
discipulus: malens aliena uerecunde discere.
quam sua imprudenter ingerere. Denique cum
litteras quasi toto orbe fugientes persequitur.
captus a pyratis et uenundatus etiam

tyranno crudelissimo paruit. ductus capti
uus. uinctus et seruus. tamen quia philoso
phus maior emente se fuit. Ad titum liui
um lacteo eloquencie fonte manantem de
ultimis hispanie galliarumque finibus
quosdam uenisse nobiles legimus? et quos
ad contemplationem sui roma non trax
erat: unius hominis fama perduxit. Habuit
illa etas inauditum omnibus seculis celebra
dumque miraculum: ut urbe tanta ingres
si aliud extra urbem quererent. Apolloni
us siue ille magus ut uulgus loquitur.
siue philosophus ut pytagorici tra
dunt. intrauit persas. peransiuit caucas
sum. albanos scithas massagetas. opu
lentissima indie regna penetrauit? et
ad extremum latissimo physon amne trans
misso peruenit ad bragmanas: ut hyar
cam in throno sedentem aureo. et de tantali
fonte potantem. inter paucos discipu
los de natura de moribus. ac dierum syde
rumque cursu audiret docentem. Inde per
elamitas babilonios chaldeos me
dos assirios. parthos syros. phenices.
arabes palestinos. reuersus alexan
driam. perrexit ethyopiam: ut gimnoso
phistas et famosissimam solis mensam
uideret in sabulo. Inuenit ille uir u
bique quod disceret: et semper proficiens semper
se melior fieret. Scripsit super hoc plenis
sime octo uolumnibus phylostratus.

Quid loquar de seculi hominibus.
cum apostolus paulus uas electionis
et magister gentium. qui de consciencia tanti
in se hospitis loquebatur. an experi
mentum queritis eius qui in me loquitur
xps post damasci arabieque lustrata
ascendit iherosolimam. ut uideret petrum
et mansit apud eum diebus quindecim.
hoc enim mysterio ebdoadis et ogdoadis

Cod. 1199, fol. 1r (Genesis, Prologue): St Jerome.

the fine cross-hatching used to differentiate areas of shade and in the painstakingly worked folds of the draperies and the detailed rendering of faces and writing utensils. The desire to create a realistic atmosphere which prompted the artist to portray Jerome's rejected drafts of text, surely written without the aid of the Holy Ghost, lying discarded on the floor (ill. p. 202), did not prevent him from considering and opting for a gold ground – already a somewhat dated device even in his own day – as the appropriate setting against which to present the authors of the biblical texts and biblical events themselves. With his marginal decoration of trifoliate and tear-shaped leaves, the artist found an alternative to the thorn-leaf tendrils still being used by the illuminator of the third volume of the Utrecht Bible. This artist employs an ornamental vocabulary which, in addition to a number of motifs borrowed from the Zweder Master, includes flower pistils underlaid with gold hexagons (Cod. 1200, fol. 86v). This unusual form is found in a number of earlier manuscripts (e.g. Liège, University Library, Ms. Wittert 35, fol. 23r) attributed to the Master of the Childhood Cycle in a Book of Hours in New York (Pierpont Morgan Library, M. 866). The animation of the figures and the loose modelling of the faces also seem to point to the school of the Master of the Childhood Cycle rather than to that of the Zweder Master. The illuminator of the fourth volume copies the ornament of the Master of Zweder van Culemborg, but his miniatures fail to attain the latter's quality (ill. Cod. 1202, fol. 40r).

C. B.

Extent: four volumes; Vol. I: III + 159 parchment folios, Vol. II: II + 206 parchment folios, Vol. III: IV + 185 parchment folios, Vol. IV: III + 192 parchment folios
Format: 350–360 x 255–265 mm
Binding: Vols. I and IV: brown leather with blind-tooled lines over wooden boards (Netherlands, first half of the 15th century). Vols II and III: 19th-century parchment binding over pasteboard covers.
Content: Bible (Old and New Testament); Vol. I: St Jerome's letter to Paulinus, Genesis to Ruth; Vol. II: 1 Samuel to Koheleth [Ecclesiastes]; Vol. III: Job to Ezekiel; Vol. IV: Daniel to Revelation
Language: Latin

Miniaturists: Master of Zweder van Culemborg and two other illuminators
Illustration: Vol. I: three historiated initials, eight fleuronnée initials; Vol. II: one historiated initial, four illuminated initials, 15 fleuronnée initials; Vol. III: two historiated initials, one illuminated initial, 18 fleuronnée initials; Vol. IV: one historiated initial, two illuminated initials, 59 fleuronnée initials
Provenance: In 1665 the four-volume Bible was transferred from Ambras Castle (Innsbruck) to the Vienna Hofbibliothek (see inscriptions MS. Ambras 1, 2, 3 and 4 in the top margin of the first text page in each volume, ill. p. 176).
Shelfmark: Vienna, ÖNB, Cod. 1199–1202

Cod. 1201, fol. 72v–73r (Isaiah, Prologue): Fleuron-
née-initial: *N(emo cum prophetas)*. Martyrdom of
Isaiah.

▶ Cod. 1200, fol. 1r (1 Samuel [I Regum], Prologue):
St Jerome.

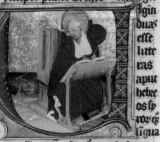

Incipit pfatio sci iheronimi in libru regu. Uiginti duas esse litteras aput hebreos sp uerbo sy lingua et caldeoru testat: que hebree n magna ex parte cofinis est. Nã et ipsi uiginti duo elementa ha bent: eodem sono sed diuersis ca racterib3. Samaritani eria pen tatentru moysi totide litteris scrip titant: figuris tantu et apicib3 disrepantes. Certus est esdram scribam legisq3 doctore post cap tam iherosolimã et instauratio ne templi sub zorobabel alias litteras repperisse quib3 nuc vti mur: cu ad illud vsq3 tepus yde samaritanoru et hebreoru karac teres fuerit. In libro quoqz nuo ru hec eadem supputatio sub le uitaru ac sacerdotu censu mista se ostendit: et nomen dni tetra gramaton in quibusda grecis voluminib3 vsqz hodie antiquis expressu litteris inuenim9 Sed et psalmi triceshm9 sextus et cen tesim9 decim9 et centesim9 vn decim9 et centesim9 octauus deci mus et centesimus qdragesim9 quartus. qn̄ q̃ diuiso scribantur metro: tame eiusdem nũ ter

uir alphabeto: et iccirco lame tationes et oratio eius. Salomo nus quoqz in fine pubia ab eo loco in quo ait mulierem forte quis inueniet. eidem alphabetis uel mutasioib3 supputant pomo qnqz littere duplices apud hebre os sũt: caph mem nun phe sade. Aliter eni p has scribut pncipia mediatatesqz vboru: aliter fines. Unde et qnqz a plerisqz libri du plices estimant: samuel mala chim dabre iamin. esdras ieni as. cu cynoch id est lamentatioib3 suis. Quomodo igit viginti du o elemeta sũt p que scribimus hebrayce omie qd loqui et eoru miniis vox humana copr̃hedit: ita viginti duo volumia supputa tur. quib3 qñ litteris et exordiis in dei doctrina tenera adhuc et lactens uir iusti erudit infancia Prinus apud eos liber vocat bresith: quem nos genesim dicim9. Secundus helesmoth: qui exodus appellatur. Tertius uate tra: id est leuiticus Qtus vage daber: que numeru vocam9 Qtus addabarim: qui deu tronomiu prenotatur. Hy sũ qnqz libri moysi: quos ppe tho rath id est legem appellant. Secun dũ pfatiu ordine faciut: et in cipiunt ab ihu filio naue. q̃ apud eos iosue bennun diat Deinde subtexut sobhtim id est iudicu libru: et in eade qpigut ruth: quia in diebz iudicu ħa narrat

Biblical exegesis from the
Church Fathers to Scholasticism

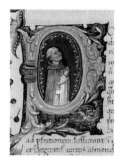

Commentaries on the Bible and biblical exegesis were perceived as a necessary response to Christianity's use of the Greek Septuagint as its "Old Testament". Why the holy scriptures should include the Septuagint – a translation of the Hebrew Bible – required particular explanation, one found in the doctrine of types. Thus individuals, facts and events in the Old Testament were understood to parallel and foreshadow their counterparts in the New Testament (cf. Luke 24:44; Acts 13:29; Romans 5:14 etc.). One such type was the Sacrifice of Isaac by Abraham, for example, which was seen to foreshadow the Crucifixion of Christ (antitype). The theory of types thereby provided one of the bases of Christian commentary and ensured that the Old Testament was a regular subject of Christian exegesis.

Information about the first Christian commentaries is sparse. Both in the East and West, these early works of exegesis were suppressed, in some cases almost completely, by the following, 4th-century generation of Church Fathers. Amongst the reasons for their suppression was the fact that, after lengthy high-level debates over dogma, many of them had since been declared heretical. One author whose writings suffered such a fate was the most important "Bible scholar" of early Christianity, Origen (c. 185–253). He was schooled in the best Hellenic tradition and was taught philosophy by Neoplatonists in Alexandria, where his education included the allegorical interpretation of ancient myths. In Caesarea he devoted himself to compiling a critical edition of the Septuagint, which he considered the prerequisite for any attempt at exegesis. Origen was opposed on a number of theological issues even during his lifetime, however, and in 542/543 was partially anathematized by Emperor Justinian, a move which probably contributed to the loss of many of his writings.

Building upon Platonic philosophy, Origen developed in his work *De principiis* (IV 2) the system of the threefold levels of meaning that was subsequently employed by almost all commentators on the Bible (and made known to the West in

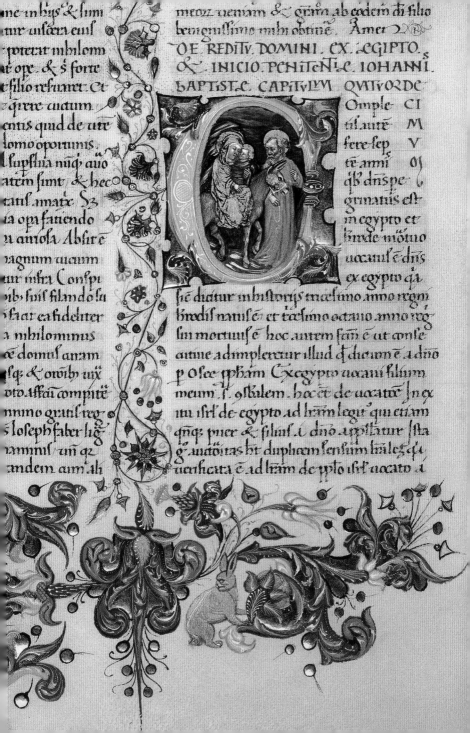

Left column:

ne in hijs & ſim
tur uiſcera cuis
poterat mihi lom
& ope. & ſ forte
filio reſumet. Et
querere cuictum
cñs quid de uir
lomo oportunis.
U ſuplina miſq̃ auo
atem ſint. & hec
catis amatr̄. Sʒ
la opis faciendo
a anioſa Abſir e
ragnum tuarum
tur nr̄a Conſpi
nibꝰ ſuis filiam d̄o ſu
ſiat ea fideliter
a nihilominus
ee domus anam
ſq̃ & omibꝰ uix
uto affai compite
mnino gratis reg
ſ loſeph faber lig
ammis. uñ qu
andem cum ali

Top of right column:

meoꝝ ueniam & graīam ab eodem d̄i filio
benigniſſimo mihi obtiñ. Amen
DE. REDITV. DOMINI. EX. EGIPTO.
& INICIO. PENITENTIE. IOHANNIS
BAPTISTE. CAPITVLVM QVITVORDE

Omple Cī
tis aut̄ M
fere ſep V
te anni oſ
qb̄ d̄ns pe
grinatis eſt
in egypto et
binde moͤtuo
uccauit e d̄ns
ex egypto qa
ſic dicitur in hiſtorijs tricelimo anno regni
brodis nanis e. et tricelimo octauo anno reg
ſin mortuus e. hoc antem ſan e ut conſe
catur adimplerectur illud q̄ dicim̄ e a d̄no
p Oſee ppham Ex egypto uocaui filium
meum. ſ. iſr̄lem. hoc e de uocatōe In ex
itu iſr̄l de egypto ad hr̄am legis. qui etiam
quiq; puer & ſilius u d̄no appellatur. ſta
g̃ auctoritas h̄t dupliceͤ ſenſum hr̄aleg̃ q̄
uerificata e ad hr̄am de ppto iſr̄l uocato a

▸ Pseudo-Joachim of Fiore, Commentary on Isaiah, Cod. 1400, fol. 21v: Family trees of the Old and New Covenant.

▸▸ St Thomas Aquinas, *Catena aurea* (on St Luke), Cod. 1391, fol. 24r: Catena commentary on St Luke, Chapter 3.

398 via the translation by Rufinus of Aquileia). These threefold levels of meaning are explained in anthropological terms as the tripartition of body, mind and spirit. According to this system, the Holy Scripture required not just a somatic (i.e. literal or grammatical; from the Greek *soma*, body) explanation, but also a psychic (moral) and pneumatic (allegorical) interpretation. Origen was thereby building upon the exegetical work of Philo (1st century AD), a Hellenized Jew also based in Alexandria, who in his Greek treatises on the Pentateuch attempted to reconcile Judaism with philosophical models. These writings were employed by Christian authors as the bases for their messianic interpretations.

As, in the 4th century, Christianity found itself tolerated, encouraged and finally the official religion, so Christian exegetic literature experienced a flowering both in the East and the West in the works of a number of theologians who had been educated in the classical tradition. Later canonized, these so-called Fathers of the Church were, in the West, Ambrose, Augustine, Pope Gregory the Great and Jerome. Also known as the Latin Doctors, these authors enjoyed an authority which equalled that of the four Evangelists.

The Church Fathers addressed their exegetic attention above all to the books of the Old Testament, which they interpreted in the standard threefold fashion. Ambrose commented on individual Psalms, Genesis and the Gospel of St Luke in ten volumes; Augustine's writings included treatises on Genesis (in three works), the Gospel of St John, and Psalms (in the Middle Ages, this *Enarrationes in Psalmos* would be his most influential commentary). Pope Gregory the Great moralized on the Book of Job, while Jerome (see pp. 212–219) was the Latin pendant to Origen. He, too, considered it vital to establish a reliable biblical text – something he was commissioned to do by Pope Damasus. This was all the more necessary in his own day as the Bible was available in a number of different translations, which made the text even harder to comprehend (see pp. 42–47). At the same time, the existing threefold system was augmented by a fourth level of meaning, the anagogic (from the Greek *anagein*, to uplift or lead up); this was an eschatological interpretation of the Holy Scripture, an exegesis that pointed to the future fulfilment of God's promises. These four models of interpretation became the foundations of medieval biblical exegesis.

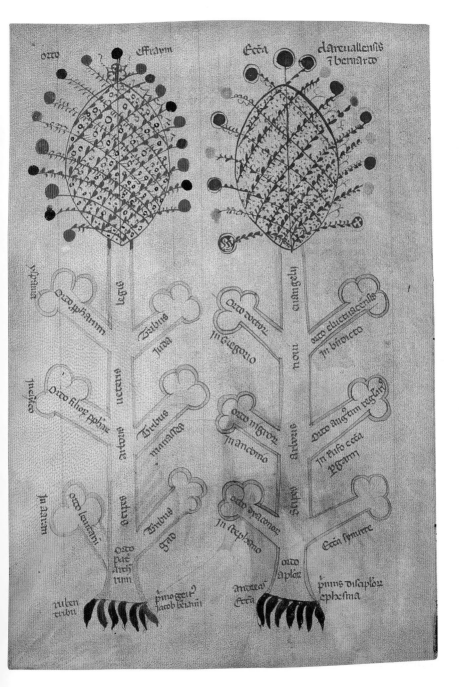

The exegetic writings of the following centuries were based on the many works by the Church Fathers, which they cited, compiled and expanded upon. Thus the Venerable Bede (*c.* 673–735; see pp. 224–227), the most important English theologian of the 7th/8th century, compiled a commentary on the Epistles of St Paul from all the works by Augustine in which the latter comments on Paul. This tradition was continued during the Carolingian Renaissance (8th/9th century), although this period also saw a number of important, independent exegetic writings such as the commentary on St Matthew by Radbert of Corbie (*c.* 790–860) and the commentary on St John by John Scot Eriugena (*c.* 810–877).

A new type of literary exegesis arose with the emergence of the cathedral schools and their teachings on the Bible in northern France (Chartres, Laon, Auxerres, Paris) from the late 11th century. Alongside these early Scholastic studies, there developed a compact method of incorporating commentary material into Bible manuscripts in the form of Glosses, which were written between the lines or in the margins. This development was part of a trend towards reducing the profusion of allegorical interpretations from the previous centuries to only the most essential annotations, in particular those pertaining to history. These annotations were once again drawn from the writings of the Church Fathers, but also from Carolingian exegetes. This type of commentary is called a *glossa* (often titled *Glossa ordinaria* or, synonymously, *Collectanea*: see Peter Lombard, pp. 242–245, *Catena aurea*: see St Thomas Aquinas, pp. 250–253, and *Postilla*: see Nicholas of Lyra, pp. 254–257). The first authors of such commentaries came from the schools of Laon (Anselm of Laon and his brother Radulf), Auxerre (Gilbert of Auxerre) and Paris (Peter Lombard). The *glossa* was always presented separately to the Bible text, whereby in the East a similar type of gloss took the form of so-called catena commentaries (from the Latin *catena*, chain), in which quotations from the Church Fathers were noted around the text in closely-linked sequence.

Also during this period, the commencement of the Crusades (from 1095) brought a new awareness of the Holy Land, which in turn resulted in the Bible and its Hebrew sources being utilized as a supply of historical information (see pp. 268–273). Scholars embarked on histories of humankind from the Creation to the time of Jesus; we might mention here Peter Comestor (see pp. 246–249) and Peter of Poitiers, who wrote a genealogy of Christ (see pp. 274–279). Commentaries on the Bible (with allegorical interpretations) conceived as books in their own right naturally continued to appear, as evidenced in particular by Honorius Augustodunensis (see pp. 232–235), Rupert of Deutz, who combines his commentaries with a theology of history (see pp. 228–231), and Joachim of Fiore (see pp. 236–241).

C. G.

ry tyberij ce
faris procu
rante potio
pylato in
deam. tetra
rcha aute
galilee he
rode. phy
lippo aute
fre eius te
trarcha y
turee ⁊ tra
chonitidis
regionis.
et lyſama
abylme te
trarcha. ſub
principibz
ſacdotum
anna ⁊ ca
ypha. fcm
eſt uibum
dni ſup Jo
hem ʒach
arie filiuʒ

Anno aut. xv. m
py tybery. ce. ſc.
Quia ei illu pdica
re uemebat. qui
er uidea quoſd
et multos et ge
tibz redepturus
erat. p rege geti
um ⁊ pricipem in
deorʒ pdicatois
eiˀ tpia deſigna
tur. Quia ar ge
tilitas colligeda
erat in romana
re publica uni p
fuiſſe deſenbit ai
dixit. Jmpiy tybe
ry cefaris. Grec.
Ooctauio ei augu
ſto monarcha aq
romani pricipes et
nome auguſti ad
eptuſ ſt. tib̄us pt
illu ad iura moar
chie ſuccedeſ. qn
tumdecimu anu.
ſuſcepti pricipat
agebat. Et in pro
phico quideʒ ſer
moe ſol uideis p
dicato. ſolu uide
orū regni deſer
bium. Viſio imgt
rſare in diebz o
gie. Joathan. ⁊ ac
hag reguʒ iuda.
ar in cuíguio qd
erat pdicendum
in umuiſo mudo.
dniuʒ deſenbur
tyberij cefaiis. qui
totus orb dnus
uidebat. Jm ſiſo
lum hi qui ſt de
getibz ceint ſalua
di. ſarus erat ſol¨
tyberij face metu
oneʒ. Sʒ qp opor
rebat ⁊ iudeos e

in deſto.
Quia ei illu pdica
re uemebat. qui
ei iudea erat. p culpa pdidie diſpgeda
in iudee regno p prteʒ ⁊ prteʒ plurim
priapabant· ſrm illd. Omc regni in ſe
ipm diuiſu deſolabit. Ecd. a. pri at
quideʒ. rij. anno tybery ceſaris iudeaʒ
miſſus pruratioes getis ſuſcepit. atʒ
ibi p decem cotinuos annos uſqʒ ad ipʒ
pene fines tybery pdurauit. ſherodes et
phylippus ⁊ lyſanias filij ſt herodˀ illiˀ
ſub quo dns natus eſt. ſinr quos ipm r
herodes archelaus fiat eorˀ. anniıs re
gnauit. Qui a iudeis apd auguſtum e
matus. apd uiemnam exilio perijt· re
gni aut iudee quo imr ualidu fiet·
ides auguſtus p tetrarchias diuidere
curauit. Grec. Et qi Joħes illu pdicau
qui ſimr rex ⁊ ſacdos ceiſter. lucas eun
gelıſta pdicationis et tpia no ſolum p
regnu. ſʒ ee p ſacdotu deſignauit. Vn
ſtdut. Sub. pria ſac. an. ⁊ carypha. Amb.
Ambo quideʒ inapete pdicatoe Joħis.
⁊. annas ⁊ caryphas priapes fue ſacdotij.
ſʒ annas illi annu. caryphas uo eu quo
dns cruce aſcedit. admiſtrabat. tribuʒ
alıʒ ın mecho potificatu pfıctıs. Veru
hı maxıme qui ad dni paſſione pımet.
ab cuıgelıſta comemorant· leg alıb namʒ
tue ſceptıs un ⁊ ambıtıoe ſeſſantıbz nlli
potificatus honoı uite ul gnıs mıto re
ddebat· ſʒ romana potate ſuma ſacdotıj
prabat· Joſephus ei reſert qp ualcuıs
gracıus annıa a ſacdotıo deturbato. vſ
maeleʒ potıfıce deſıgnauıt ſılıı baphı·
Sʒ ee huc no multo poſt abıaeıs elea
ʒarum anıame potıfıcas fılıı Sboegauıt.
poſt annıu uo ⁊ huc arcet offıcıo. ⁊ ſy
mom cuıdam camphı fılıo potıfıcatus
ſedıdıt mıſtıum. Quo no amplıˀ ⁊ ıpſe
um ı annı ſpacıo pfıctus. Joſephus caı
et caryphas nome fınt. accepıt ſucceſ
ſoreʒ. p hoc omc tpe quo dns nr in tıbˀ
docuıſſe deſenbıt· unıˀ qdıııeu ſpacıa
coartat· Ambʒ. Congg aturus aute

m. boiıı.

m. boiıı.

St Jerome,
Commentaries on the Bible

Florence, 1488

This magnificent manuscript, produced in Florence in 1488, contains St Jerome's commentaries on the Gospels of St Matthew and St Mark and on the Old Testament Book of Koheleth (Ecclesiastes). These are rounded off by shorter pseudoepigraphical and apocryphal writings: an address to bishops Heliodor and Chromatius wrongly attributed to St Jerome, the Life of the Virgin Mary and her correspondence with Bishop Ignatius of Antioch, the epistle of Prince Abgar of Edessa to Christ and the latter's reply, and an 11th-century disputation over the superiority of the Jewish, Christian or Moslem religion.

The codex formed part of the famous humanistic library created by Matthias Corvinus, King of Hungary, who made Vienna his residence between 1485 and 1490. During this period he commissioned a particular number of luxury manuscripts for his celebrated collection. Universal in its scope, his library embraced not only the Greek and Latin classics, but also the works of Church Fathers and Scholastics, as well as contemporary literature from the age of humanism.

According to an inscription by the scribe on fol. 238r, the present manuscript was completed on 19 October 1488 by one of the most important calligraphers of the Quattrocento, Sigismondo de' Sigismondi da Carpi, in a humanistic script (the so-called *Humanistica Formata*). It was probably illuminated immediately afterwards in Florence for King Matthias Corvinus, whose coat of arms and imprese (diamond ring, crowns, raven with ring) appear several times within the codex, together with a portrait of the King himself. In addition to its decorative title-page, frames and borders, the manuscript contains five large and 205 small gilt initials, and thereby represents a major work of Florentine miniature painting of the Quattrocento. Its illustrations are attributed to the brothers Gherardo and Monte di Giovanni (del Fora), who are documented as both painters and mosai-

Detail from fol. 1r: Border with putto.

▶ **Fol. IIv:** Title-page vignette of a wreath of fruits containing the insignia of Matthias Corvinus (sphere and diamond ring).

IN HOC
VOLVMINE HAEC
CONTINENTVR·DI
VVS HIERONYMVS
IN MATTEVM IN MAR
CVM IN ECCLESIAS E
ITEM QVAEDAM ALIA
OPVSCVLA·

cists. This attribution is confirmed by a comparison with other manuscripts by these two miniaturists, such as a Missal completed between 1474 and 1476 for Sant' Egidio and today housed in Florence. Both artists also worked on the Psalter executed for King Matthias Corvinus in 1488 (Florence, Biblioteca Medicea Laurenziana, ms. Plut. 15, 17).

In comparison to works by other Italian contemporaries, the miniatures by the two brothers are distinguished by their technical mastery, their naturalism, the individualization of their figures and the vibrancy of their palette. The softness of the modelling and the use of transparent layers of glaze are taken from panel painting. The works by Gherardo have always been considered the more significant and are characterized by influences from Netherlandish painting – influences which can similarly be seen in the works of one of his temporary rivals, Domenico Ghirlandaio. Which parts of the illumination were painted by which brother is not easy to distinguish, but the figural miniatures are today generally attributed to Gherardo and the ornamental miniatures to his younger brother.

Significant, too, is the red morocco binding made for King Matthias Corvinus in Ofen between 1488 and 1490. Tooled with numerous decorative motifs – interlace, stamped palmettes and circles – and gilded by hand and richly painted, it is leather-carved on its front and back cover with the crowned coat of arms of King Matthias, presented in the centre of a quatrefoil which extends upwards and downwards like an ogee arch and is decorated with arabesques. Created by the so-called Corvinus Master, its design smoothly incorporates aesthetic impulses from both Italian and oriental book-binding.

K.-G. P.

Extent: II + 239 parchment folios
Format: 355 x 240 mm
Binding: Renaissance binding (from Ofen in Hungary, between 1488 and 1490); red morocco over wood with blind tooling, hand gilding and leather carving
Author: Jerome (347–419)
Content: Commentaria in sacram scripturam (St Matthew, St Mark, Ecclesiastes)
Language: Latin
Scribe: Sigismundus de Sigismundis, comes Palatinus Ferrariensis

Miniaturists: Gherardo (1446–1497) and Monte di Giovanni (1448–c. 1532/33)
Illustration: five large and 205 small initials, one decorative title-page vignette, one decorative surround and one miniature, six decorative bars, one with a miniature
Provenance: Written for Matthias Corvinus, King of Hungary (reigned 1458–1490) in 1488 in Florence, and illuminated immediately afterwards. By 1576 the manuscript was already in the possession of the Vienna Hofbibliothek.
Shelfmark: Vienna, ÖNB, Cod. 930

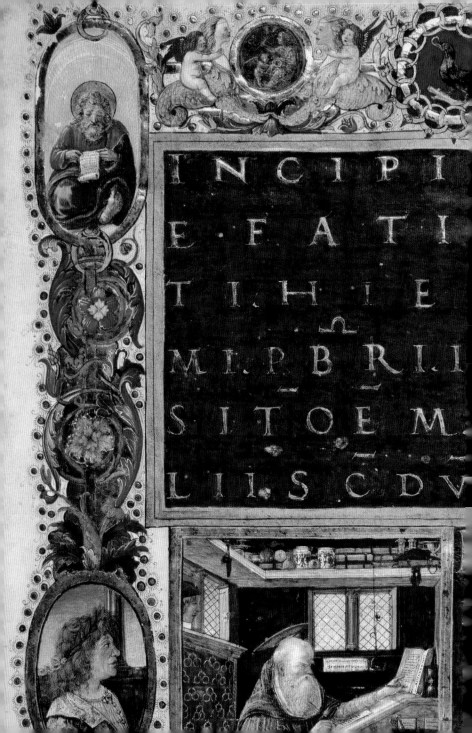

INCIPI
E·FATI
TI·HIE
♎
MI·P·BRII
SITOEM
LIISCDV

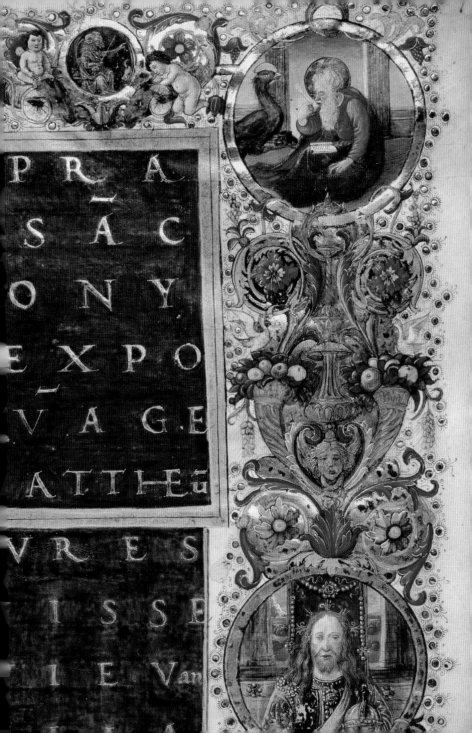

PRĀ SĀC
ONY.
EXPO
V̄ A GE
ATTHē

VRES
ISSE
IEV̄a

E M I N I M E
ante hoc ferme quinque
nium cum adhuc rome
eem. et eccliasten sancte
blesille legerem: ut eam ad
contemptum istius seculi
prouocarem et ome q̃ in
mundo cerneret. putaret
ee pro nihilo: rogatum ab
ea ut imorem comentario
li obscura q̃q̃. differerem:
ut absq̃; me posset intelligere que legebat. Itaq̃; qn
in procintu nri opis subita morte subtracta est. et no
meruimus opaula et custocuiu. talem uite nr̃e habe
consortem tantoq̃; uulnere tunc percussus obmutui:
nunc inbethleem positus. angustiori uidelicet ciui
tate et illius memorie; et uobis reddo q̃ debeo. hoc +
breuiter amonemus. q̃ nullius auctoritatem sed ue
ritatem secutus sum. sed de hebreo transfens magis me
septuaginta intpretum consuetudini coaptaui. inhis
dumtaxat. que non multum ab hebreis discrepant
Interdum aqle quoq̃. et simachi. et theodotionis re
cordatusum. ut nec nouitate nimia lectoris studiu
deterre. nec rursum contra conscientiam mea; fonte
ueritatis amisso opinionum riuulos consectarer. Ex
plicit prohemium.

erum ... colecto ... io pcesa

E R
ecctiastes.
gis iertin
bus uocatu
monem sc̃p
stissime ec
cum id. sal
idida hoc
et q̃ nunc
ecctiasten.
greco sermo
qui cetum
get quem n

possumus concionatorem. eo q̃ loquit̃
et sermo eius non specialiter ad unum.
sos gñaliter dirigat̃. Porro pacificus et
abeo q̃ inregno eius pax fuit. et cum
rit appellatus est. Nam et psalmus qua
et septuagesimus primus. dilecti et paci

Opus imperfectum in Matthaeum

St Peter's abbey, Salzburg, *c*. 790

The Gospel according to St Matthew, alongside that of St John, is the most frequent subject of commentaries upon the gospels. The *Opus imperfectum in Matthaeum* represents an incomplete commentary on St Matthew's Gospel, and was thought in the Middle Ages to have been written by John Chrysostom († 407), one of the Four Greek Doctors. It was consequently held in high regard and – as some 200 surviving manuscripts testify – was widely copied. Erasmus of Rotterdam († 1536) eventually proved that the attribution to Chrysostom was erroneous. The real author is anonymous and composed the text in the 4th or 5th century; as emerges from a number of passages in the manuscript, he was an adherent of Arianism, a doctrine that goes back to the Alexandrian priest Arius († *c*. 336). According to Arian thinking, Jesus, because he was begotten, cannot be of the same substance as God the Father, who is without origin. The Holy Spirit was considered the highest of all creatures, created by Jesus through the will of the Father, but not granted the divine status of God. This doctrine was officially condemned at the latest in 381 at the Council of Constantinople, but the *Opus imperfectum* testifies to its continuing survival.

The manuscript today preserved as Codex 1007 arose towards the end of the 8th century in St Peter's abbey in Salzburg. It was copied directly from a manuscript borrowed from the monks of Freising cathedral in Bavaria (Munich, Bayerische Staatsbibliothek, Clm 6282). The Freising exemplar also influenced the illustration of the Salzburg version. In the case of two initials, including the one placed at the start of the text (ill. p. 222), the intertwining ornamentation at the top and/or bottom of the letter is copied from the corresponding initials in the Freising manuscript.

The full-page author portrait which appears in front of the text (ill. p. 221) is an entirely Salzburg invention, however. It shows the supposed author as a standing figure holding the book in his left hand, flanked by two candelabra trees and surrounded by an ornamental frame. The miniature thereby numbers amongst

Fol. 1v: Portrait of the supposed author, John Chrysostom.

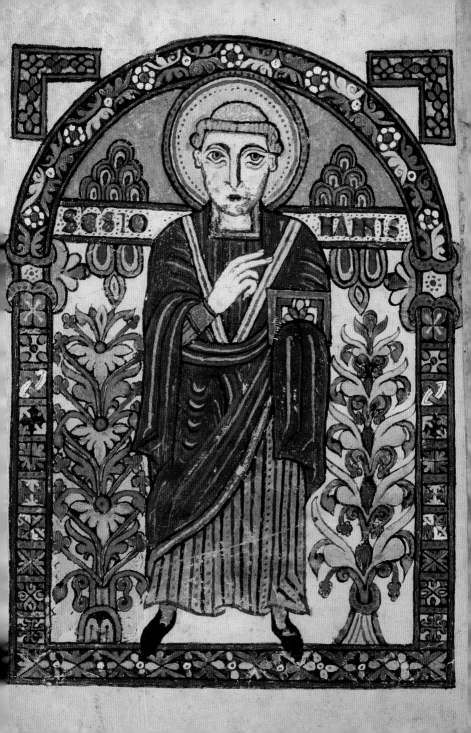

uantum quamque
gratum & utile sit
bonum ecclesias
tice pacis · Quam
flagranti et sollicito
amore querendum
& ponam · ut quisqua
insien tot exponere
possit legite inquit
fidelissimi hor tot
fres legite ut ipso
corpore absens effi
ciar in xpo uobiscum
presens in fide incipimus ergo
exponere magna debonis pro
sequar quid dicat euangelista
& factum est cum con summasset
ihs sermones istos quos superius
prolocutus quomodo dicam

INCIPIUNT
homelie
Beati Ioh
CONSTAN
tinopol
tani ·
rpos ai
NGT R

Fol. 2r: Initial *Q[uantum]* at the start of the text.

the few surviving examples in early medieval manuscript illumination of standing figures presented within an arcade-type setting, all of which go back to a pictorial type dating from late antiquity and which may derive from Ravenna; with the exception of isolated, more westerly examples, the majority of these survive in the region of Salzburg and Mondsee, Rhaetian Chur and Upper Italy. There evidently existed in this geographical area a pictorial tradition rooted deep in the past, but which can today only be glimpsed in a small number of works.

Within the sphere of Salzburg manuscript illumination, the miniature ranks amongst the earliest examples of figural illustration. The model on which it was based probably came from Upper Italy and can only have dated from a few years earlier. The linear, schematic treatment of the draperies and the denial of spatial logic demonstrate stylistic similarities with the evangelist portraits in the famous Cutbercht Gospels (Vienna, ÖNB, Cod. 1224, esp. fol. 165v), written and illustrated around 785/790 in St Peter's by Cutbercht, a scribe probably from the south of England; the most recently proposed dating of both manuscripts to the 3rd quarter of the 8th century and their supposed links with the Visigothic art of Spain are completely unfounded. Rather, the author portrait in Codex 1007 continues to reflect an insular influence which can be identified in very early Salzburg manuscript illumination but which then rapidly fades.

F. S.

Extent: 246 parchment folios
Format: 265 x 172 mm
Binding: calfskin with blind lines over wooden boards (Salzburg, 1430s)
Content: Opus imperfectum in Matthaeum
Language: Latin

Illustration: one full-page miniature, eight large initials
Provenance: In 1806 the manuscript passed from the library of Salzburg Cathedral to the Vienna Hofbibliothek.
Shelfmark: Vienna, ÖNB, Cod. 1007

The Venerable Bede,
Commentary on St Mark's Gospel

St Amand's abbey (northern France), 1st quarter of the
9th century

Bede (c. 672/673–735), who acquired his epithet of "the
Venerable" as early as the 9th century, is one of the most
important authors of the Early Middle Ages. He was educat-
ed in the monastery of St Peter's in Wearmouth, near Dur-
ham, in present-day northern England, and in 682 moved to
the newly-founded monastery of St Paul's in neighbouring
Jarrow, where he remained until his death.

His works include chronological and historical writings,
including his *Ecclesiastical History of the English People* from
the time of Caesar up to the year 731, stories of the lives
of saints, collections of poetry, sermons and letters; in addition to various essays
on mathematics, physics and music, he wrote textbooks on grammar and metre,
and above all on chronology (*De temporum ratione*) and natural science (*De natura
rerum*), which continued to be used right up to the High Middle Ages. Amongst
his theological works are numerous expositions of scriptural books, including the
Commentary on St Mark's Gospel contained in Codex 767, at least one third of
which is based on Bede's earlier commentary on the Gospel of St Luke. While
other scholars in his field tended towards a predominantly objective exegesis
of biblical texts, Bede sought to uncover and explain the hidden meaning of the
events described in the Gospel. He thereby drew upon earlier commentaries,
above all those by Ambrose, Jerome, Augustine and Gregory the Great. In order
to underline the links between his own writings and those of the four great Latin
Doctors, he employed a previously unknown system of reference, whereby he in-
serted abbreviations – *H* for Hieronymus (Jerome), for example – into the margin
beside the passages he had cited from that source. This form of cross-referencing
was subsequently adopted by numerous writers in the 8th and 9th century.

The Commentary on St Mark's Gospel by Bede, which is preserved in
Codex 767, dates from the 1st quarter of the 9th century and was produced in

Detail from fol. 15r: Text page in quattrolinear
script.

▶ **Fol. Iv:** Title page in *Scriptura Capitalis.*

IN NOM DNI
INCPRETAT
BEDANIPRBI
SVPEVANGL
MARCIEVANGLT

NITIUM EUANGELII IHV XPI FILII DI · SICUL SCRIPT̄ EST IN ESAIA PROPHETA

Conferendum hoc euangeliū mar̄ci principiu
principio mat thei quo ait · liber generationis
ihuxpi filii dauid · filii abraham · atq; exutroq;
unus dn̄s noster · ih̄s xp̄s d̄i & hominis filius est in
tellegendus; Qapteprimus euangelista filiū
hominis eum · secundus filium d̄i nominat ·
ut a minorib; paulatim ad maiora sensus noster
exsurgeret · ac per fidem & sacramenta huma
nitatis adsumptae ad agnitionem diuinae aeter
nitatis ascenderet · Apte qui h̄manā erat
generationem descripturus a filio hominis coe
pit · dauid uidelicet siue abraha̅ · de quoru̅
stirpe substantiam carnis adsūpsit ;

Apte is qui librum suum ab initio euangelicae praedi
cationis inchoab·t filium magis d̄i appellare
uoluit dn̄m nm̄ ih̄m xp̄m quin̄mirum & huma
nae · erat naturae de progenie patriar̄char̄u
siue regum ueritatem carnis suscipere · & di
uinae fuit potentiae euangeliū mundo praedi
care ; Euangelium quipp̄ e bonū nuntiū dicit ;

Quod aut̄ melius est nuntium quam paenitentia
agite ad propinquabit enim regnū caelorum ;

Hominis itaq; est humanitus nasci · d̄i uero reg
ni caelestis introitū paenitentib; praedicare ·

the abbey of St Amand's in northern France for St Peter's abbey in Salzburg. Arn, who was abbot of St Peter's and also archbishop of Salzburg (785–821), was namely also abbot of St Amand's, an office he had held from 783 (and thus even before his Salzburg appointment) and in which he continued until 808. Since St Amand's evidently had a much larger and more productive scriptorium, Arn arranged for a whole series of manuscripts to be produced there for the library of Salzburg cathedral. According to a paean in a Salzburg Book of the Dead from the 12th century (Stiftsbibliothek St Peter, Cod. a IX 7), the library's holdings are supposed to have swelled by 150 manuscripts over the course of Arn's office. Although manuscripts were also produced in Salzburg itself (see pp. 220–223), the majority were probably created in St Amand's and then dispatched to Salzburg; even after Arn's death, books continued to arrive from St Amand's right up to the late 820s. Illustration in these manuscripts, of which some 40 still survive today, appears to have played an only insignificant role, as evidenced by the initial at the start of St Mark's Gospel, for example, which although executed in colour, is lent no further ornament (ill. p. 226). More importance, on the other hand, was attached to the appearance of the script. Thus the script employed on the title-page imitates the monumental lettering of the so-called *Scriptura Capitalis* of antiquity (ill. p. 225), while the pages of the text are written in a manner designed to distinguish excerpts from the Gospel from Bede's commentary. Thus the passages from St Mark are written in a larger script and are additionally highlighted by *S*-shaped symbols in the margin; Bede's analysis then follows on in a smaller script.

F. S.

Extent: 198 parchment folios
Format: 295 x 185 mm
Binding: leather with blind lines over wooden boards (Salzburg, *c.* 1433)
Author: The Venerable Bede (*c.* 672/73–735)

Content: Commentary on St Mark's Gospel
Language: Latin
Provenance: The manuscript passed with the holdings of Salzburg cathedral library to the Vienna Hofbibliothek in 1806.
Shelfmark: Vienna, ÖNB, Cod. 767

Rupert of Deutz,
Commentary on the Apocalypse

Mondsee Benedictine monastery (Upper Austria),
3rd quarter of the 12th century

Rupert of Deutz numbers amongst the most prolific theological authors of the 1st half of the 12th century. He started out as a monk in St Laurence's abbey in Liège in present-day Belgium; in 1116 he moved to Siegburg abbey (near Cologne), where his writing career was given encouragement by Abbot Cuno, the later bishop of Regensburg. It was probably through Cuno that, in 1121, Rupert was appointed abbot of the neighbouring monastery of Deutz by Archbishop Frederick I of Cologne, an office which he held until his death in 1129.

His extensive writings include commentaries on the Song of Songs, the Minor Prophets, St John's Gospel and the Apocalypse. The present Commentary on the Apocalypse, of which 14 copies survive, was produced in Siegburg between 1117 and 1120 and is dedicated to Archbishop Frederick I of Cologne. In it, Rupert weaves a complex web of inter-relationships: he equates the seven Churches and the visions of the Revelation with the seven gifts of the Holy Spirit, for example, and establishes links between the visions and events in the Old Testament. He thereby seeks to portray the workings of the Holy Spirit in the history of salvation. He uses his interpretation of the warnings issued to the seven Churches to make critical allusions to the deplorable state of Church affairs in his own day.

The Commentary preserved as Codex 723 was copied out in the 3rd quarter of the 12th century in the Benedictine abbey of Mondsee in Upper Austria. The abbey, part of the see of the Bishop of Regensburg, at that time maintained close links with the Rhineland. The reason for this lay in the fact that Abbot Conrad I, who was appointed to Mondsee in 1127 by Bishop Cuno, himself came from Siegburg. This connection endured even after Conrad's death in 1145, as evidenced not only by imported manuscripts but also by the Rhineland influences apparent in the work of illuminators in the Mondsee scriptorium. Against this backdrop,

Detail from fol. 3r: The lion of St Mark.

▸ **Detail from fol. 1v:** Foliate initial *V(t)*, and beside it, pen drawings: Rupert of Deutz presents his work to Archbishop Frederick I of Cologne; above them, the angel of St Matthew and the lion of St Mark.

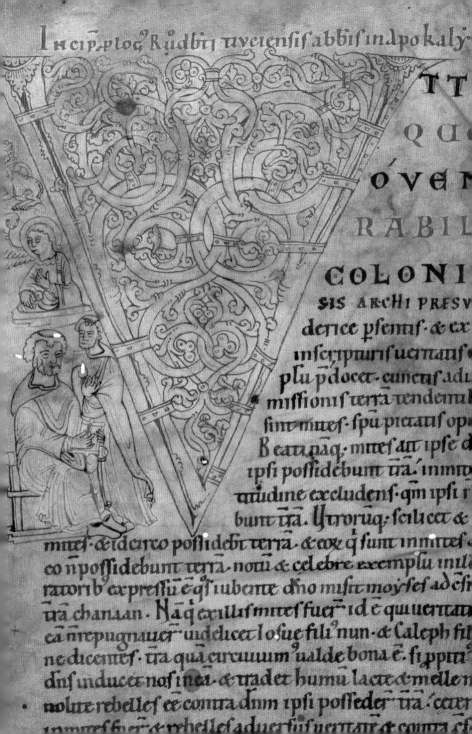

TT
Q̄
ÓVEN
RABI
COLONI
SIS ARCHI PRESV
dence p̄sentis · & ex
inscripturis uenitatis
plu p̄docet · cunctis adu
missionis terrā tendentib
sint mites · spu pietatis opa
Beati naq̄ · mites ait ipse d
ipsi possidebūt tr̄a · inm̄
titudine excludens · qm ipsi r
bunt tr̄a. Ytroruq̄; scilicet &
mites · & idcirco possidebit terra · & eox q̄ sunt in mites ·
eo n̄ possidebunt terra · notū & celebre exemplū in ta
ratorib exp̄ssū ē q̄s iubente d̄no misit moyses ad c̄s
tr̄a chanaan. Naq̄ ex illis mites fuer̄ id ē qui uenitat
cā n̄repugnauer uidelicet Iosue fili⁹ nun · & Caleph fi
ne dicentes · tr̄a quā circuiuim⁹ ualde bona ē · si p̄pti
d̄ns inducet nos in ea · & tradet humū lacte & melle
· nolite rebelles ee contra d̄nm ipsi posseder̄ tr̄a · ceter
in mites fuer̄ · & rebelles aduersus uenitate & contra c̄s

uel errore faciat legenti. S; ia gre di tuq; auc
tortnatis patrocinio freti; ppositu ingrediar
op? solum in dno do spe mea ponere bonum
uidicans. ut uidelicet ñ hic s; in futuro recipia
Explic plog? Incip expo / mercede mea.
sitio Ruodberti In apokalipsi

POKALYPSIS IHV X Capitulu; s;
GVM TOTA LIBRI SERIES GRE
ce conscripta fuerit. et de greco fonte
in latine lingue amne cucurrerit? so
la eide appellatio pulchre in
tacta pmansit / ut apd latinos
diceretur apocalypsis? qd nom poterat in reuelatione transfer
ri. uidelicet ob excellentia reru. siue mysterioz q̄ hic scripta
cophendit. Sic alleluia sic amen. hebrea uocabula ob dignitate sen
suu in greis & latinis literis pmanserunt. sic euglin in latinis codicib;
de greco reseruatu e. quo sermone oms pter matheu euglce scripser.
Itaq; apokalipsis ide reuelatio pcellens. & insensib; adorande ple
na maiestatis. l hu x inquid. id e saluatoris uncti. q̄m admodu in
psalmo scriptu e. Vnxit te ds ds tuus oleo leticie pesortib; tuis.
ltq̄ de multi nomine istu equocati s.s; hic ppam nominis hui habet
ratione qua subuingens angls cu dixisset. pariet aut filiu & uo
cabis nom ei x &c. ipse eni inquid saluu faciet pplm suu a pecca
tis eox. Ite multi x ide uncti fuer. s; hic pomb; illi unct e ut pote
in quo habitat oms plenitudo diuinitatis corporalit. illi aut
hui fuer. l scsortes siue participes. De hoc ita sentiendu e quia
sic omium. ita & reuelande hui apocalipseos potestate qua natura
ñ habebat eide iu x humanitas. dono acceptt. Vnde seqt &di
cit. X uia dedit illi ds pasa facere seruis suis. que oportet fieri cito. ;

Fol. 3r: Foliate initial A(pokalypsis), beside it a monk, a donkey (?) and the lion of St Mark.

it is very likely that Codex 723 is based on an earlier copy originating from the Rhineland, and perhaps even from Siegburg itself.

Its illustration consists of two large and eleven smaller foliate initials executed by several different hands. To the side of the two large initials are additional figural drawings in pen: at the start of the Prologue, in which Rupert addresses Archbishop Frederick I of Cologne (ill. p. 229), a penwork drawing to the left of the elaborate initial V(t tu quoque, o venerabilis Coloniensis archipresul Friderice...) shows the manuscript being presented to Frederick – probably the seated figure with the book in his hands. Rupert, with his abbot's crosier, is seen standing next to him. Drawn above the two figures are two Evangelist symbols, the angel of St Matthew and the lion of St Mark with a banderole. Harder to interpret are the pen drawings to the left of the foliate initial A(pokalypsis) at the beginning of the main text (ill. p. 230): the standing figure is either Rupert again, or the scribe Rudolf who is named in the neighbouring inscription (Rudolf scribebat, sic scriptor nomen habebat – Rudolf wrote the book, this is the name of the scribe). Other scribes by the names of Bartholomäus and Simon were also involved on the project, however, as indicated by an inscription now barely legible on fol. 238r. Unclear, too, is the significance of the animal – probably intended to be a donkey – depicted between the monk and the lion of St Mark. All other initials at the beginning of individual chapters are simple foliate initials, which in places reveal a strong Rhinelandish influence and thus bear witness to the close contacts existing with this region.

F. S.

Extent: 238 parchment folios
Format: 305 x 220 mm
Binding: russet leather with blind lines over wooden boards (Mondsee, 15th century)
Author: Rupert of Deutz
(c. 1075/80–c. 1129/30)
Title: In apocalypsim Joannis apostoli libri XII
Language: Latin

Scribe: Rudolfus, Liutold, Bartholomäus and Simon (?)
Illustration: two large foliate initials with figure drawings in pen, 11 small foliate initials
Provenance: In 1791 the manuscript passed with the holdings of Mondsee abbey library to the Vienna Hofbibliothek.
Shelfmark: Vienna, ÖNB, Cod. 723

Honorius Augustodunensis, Commentary on the Song of Songs

Scriptorium of Salzburg cathedral, *c.* 1160/65

Amongst the numerous commentaries on the Song of Songs – in the 12th century, the most frequently interpreted book of exegesis of all the books of the Bible – the *Expositio in Cantica canticorum* by Honorius Augustodunensis occupies a prominent position. The commentary, which was probably first written in Regensburg around 1150 (as a late work by its author, † 1157?), was widely copied in the southern Germany/Austria region. In addition to the present codex from the scriptorium of Salzburg cathedral, five other illuminated manuscripts dating from the period up to around 1200 still survive today, originating from Lambach (Baltimore, WAG, Ms. W 29), Benediktbeuern, Beuerberg and Tegernsee (Munich, BSB, Clm 4550, 5118, 18 125) and St Mang in Füssen (Augsburg, UB, Cod. I.2.2°13). All of them further include the *Sigillum beatae Mariae* and the *Hexaemeron* also by Honorius. Drawings are only found in the commentary on the Song of Songs, however, whose powerfully evocative imagery invited illustration.

Codex 942 contains three pen drawings at the beginning of the second, third and fourth books of the four-part commentary. They are typical examples of the Salzburg draughtsmanship flourishing under Archbishop Eberhard I (1147–1164), executed in brown and red ink and accompanied by explanatory inscriptions and captions in leonine verse. They offer the modern viewer a glimpse into the world of biblical exegesis as it was once familiar in the High Middle Ages, and which was founded on the premise of the fourfold levels of meaning (see pp. 206–211). Honorius skilfully constructs his allegorical exposition upon the number four, which he explicitly assigns to the Song of Songs. Taking as his starting point the promise in the Gospels that people from all four points of the compass will enter the kingdom of God (cf. Matthew 8:11; Luke 13:28 f.), the spousal mysticism of the Song of Solomon is interpreted, in an original fashion, as a drama about the history of salvation in four acts.

Detail from fol. 92r: Illustration of the 4th book: The Mandragora as the fourth bride.

▶ **Fol. 38v: Illustration of the 2nd book:** Procession of the daughter of the King of Babylon (filia babilonis) as the second bride.

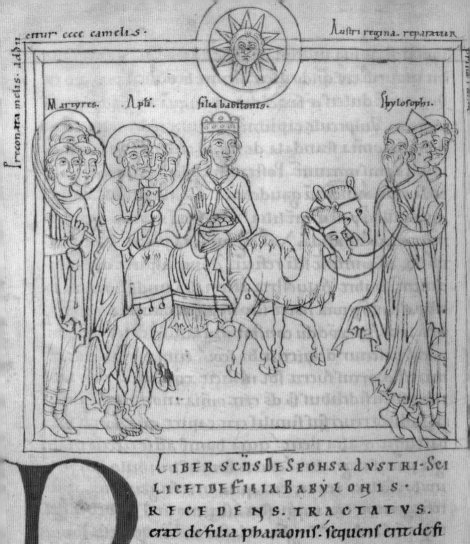

Martyres. Apłi. filia babilonis. Phylosophi.

LIBER SCĎS DE SPONSA ꝣVSTRI· SCI
LICET DE FILIA BABYLONIS·
RECEDENS. TRACTATVS.
erat de filia pharaonis· sequens erit de fi
lia babylonis. Iam legati regis p̅ regina
austri missi ueniunt. sponsā in camelis cu̅
magno comitatu adducunt quā filia pharaonis
de uineas cū suis comitibus egressa cū magno
tripudio excipit cū magno comitu̅ plausu inte̅
plum regis ducit. hanceꝗ rex regali munificentia
dotatā ad p̅paratū conuiuiu̅ introducit. scił apłi p̅
eccła gentium missi. hanc signis & p̅dicationibꝰ ad
xp̅i fide̅ conuertunt. q̅ multitudo fidelĩu̅ de iudea

mundi. Quintum bellum erit sub antix̄r q̄ incipiet a p̄dica
tione helyc & enoch. & in morte antix̄r finiet. In hoc bel
lo corruent duces regine helyas & enoch. & ois exercitus
mrm & ipse dux & capiet maloꝛ antix̄. Tc sunam tus regi
ne austri cq̄derabit. & mandragora eis associabit. Sextu
bellum erit int rege glc & rege sup bie. int anglos & hoies.
In hoc bello rex xp̄c cu uniuso exercitu anglox aduem
ens hanc babyloniā ciuitatē diaboli coburet. ipsū ho
ste cu oibꝰ suis in stagnū ignis & sulphuris pcipitabit
& sponsā suā gla & honore pacto bello coronabit & in
thalamo glc collocabit. sq̄ copulabit. qa scripsū ei tale
qualis ē patri.

Liber Tercius DE SVHAMITE.
EXPOSITIO PCEDENS RETVLIT REGINÃ AV
stri tria bella p corona gessisse. unū cra amana
aliud cra aquilone. triū cont guttas noctiū.
ac uicerice a rege coronanda uenisse. & in comitatu
lx. reginas & lxxx. cubinas & innūmeras adolescen

Fol. 79v: Illustration of the 3rd book: Procession of Sunamitis as the third bride.

Four brides appear, one in each of the four volumes making up the commentary; they symbolize the four parts of humankind, who in four epochs (*ante legem* – before the Law; *sub lege* – under the Law; *sub gratia* – under Grace; *sub Antichristo* – under the Antichrist) draw towards Christ from the four points of the compass in order to unite with him. The first bride, the "daughter of Pharaoh" who comes from the East, symbolizes the Hebrew people in the age of the patriarchs (no illustrations of this bride survive). The second bride, the "daughter of the King of Babylon" and a symbol of heathendom, is riding on a camel from the South, led by the philosophers of antiquity and followed by apostles and martyrs (ill. p. 233). The third bride, Sunamitis, who symbolizes converting Jewry, is arriving from the West in Abinadab's chariot (cf. Song of Songs 6:11; 1 Samuel 7:1; 2 Samuel 6:3), which shows the symbols of the four evangelists in its wheels (cf. Ezra 1:1–28). The priest Abinadab is leading the horses, on whose bodies appear the heads of prophets and apostles. The procession is accompanied by the Jews (ill. p. 234). The fourth bride, from the North, is the Mandragora, the human-shaped mandrake root (cf. Song of Songs 7:13), which stands for the rest of unbelieving humankind who will convert at the end of the world. She hovers above the winged head of the north wind in the shape of a naked, headless female body, held by three queens and Christ, who places upon her a christomorphic head. This act of salvation signifies victory over the Antichrist, whose horned head lies severed on the ground (ill. p. 232). Images such as these are remarkable attempts to impress upon the viewer complex theological concepts in a memorable and instructive form. The intellectual profundity of the commentary of course only reveals itself upon reading the actual text.

V. P.-A.

Extent: 131 parchment folios
Format: 300 x 205 mm
Binding: late-medieval nap-leather binding with blind lines
Author: Honorius Augustodunensis (†1157?)
Content: Expositio super Cantica canticorum, Sigillum beatae Mariae, Hexaemeron
Language: Latin
Illustration: three pen drawings

Provenance: The manuscript is documented in Vienna from the 15th century onwards: according to its donation inscription, it was bequeathed to the library of the Collegium ducale by one Philippus altarista ad celiportam (i.e. altar prebendary at the former Premonstratensian monastery abbey in the Himmelpfortgasse). Due to the disbanding of the old university library in 1756, the codex entered the Vienna Hofbibliothek.
Shelfmark: Vienna, ÖNB, Cod. 942

Pseudo-Joachim of Fiore, Commentary on Isaiah

Southern Italy, 1st half of the 14th century

Joachim of Fiore was born in *c.* 1135 in Celico (Calabria) and began his career as a notary, like his father, at the court of the Norman kings in Palermo. He then decided to turn his back on the world and embarked on a pilgrimage to the Holy Land, after which he withdrew for a while to a cave in Sicily to fast and pray. Later he entered Corazzo monastery, where he was soon elected abbot. Through his offices, Corazzo was affiliated to the Cistercian abbey of Fossanova by Pope Clement III in 1188. In nearby Petralata, meanwhile, Joachim created for himself a place of solitude and quiet in which to pursue his exegeses of the Bible. He evidently refused to obey a summons from the Cistercian general chapter of 1192, but instead founded his own monastery (S. Giovanni in Fiore), which became the starting point for the Florensian order, which was eventually amalgamated with the Cistercian order by Pius V in 1570. Joachim died on 30 March 1202 in S. Martino di Giove.

Joachim was greatly admired for his prophecies. He represented a very pronounced form of typological exegesis: between the Old and New Testament, he believed, there existed a correlation so close that the events of the New Testament were not only already foreshadowed in the Old Testament (the doctrine of type and antitype), but that by projecting these parallels forward it was also possible to make predictions about the future. He divided history into three *status*, or periods: the age of the Father, that of the Son and that of the Holy Spirit. Joachim's exegetic works were primarily concerned with determining the nature of this third age, which would last until the end of time. He foresaw this age – whose dawn was imminent – as one of a new spiritual order, characterized by a contemplative monastic life and by the recognition of the truth by all believers.

Detail from fol. 21v: Family tree of the Old Covenant.

▸ **Detail of fol. 21r:** Eagle – The number symbolism of 5 + 7 = 12, which Joachim originally linked with the eagle and which refers to the tribes of Israel, is reflected in the text above the eagle and in the number of divisions on his wings. Here, however, it applies to the Bible's different layers of meaning.

rdocium in uno xpo conueniunt · Dum quit cs sacerdos ieter
in secundum ordinem melchisedec qui sint rex et sacerdos non
cundum ordinem aaron qui solus pontifex et umbratilis exti
t non eternus ·

Qui confidunt in domino mutabunt fortitudinem assiment
mas ut aquile uolabunt et non deficient ·

▶ **Fol. 22v:** *Mysterium* (in this manuscript wrongly called *Ministerium*) ecclesiae. A misinterpretation of Joachim's *Liber figurarum*. The spiral, which in the latter symbolizes the liturgical year (seen as a parallel to the course of the history of salvation), is here misconstrued as a dragon.

▶▶ **Fol. 23v:** Dragon (cf. Revelation 12:3) with seven heads, symbolizing the seven persecutions of the Church.

▶▶▶ **Fol. 24r:** Babylon-Rome figure. This illustration, which derives from Joachim's *Liber figurarum* and whose appearance varies in the manuscripts and is difficult to interpret, symbolizes the history of the Old and the New Israel.

First, however, the Antichrist, already present in the world, had to be overcome. Joachim's typological interpretations of Christian history were spread in particular through his *Concordia novi et veteris testamenti, Expositio in Apocalypsim* and *Psalterium decem chordarum*, works whose influence on subsequent generations should not be underestimated. After Joachim's death, numerous authors – some of them writing under the pseudonym of Joachim himself, as in the case of the present commentaries on Isaiah and Jeremiah – sought to develop his ideas and adapt them to recent events and the present. Works by such pseudo-Joachims were particularly popular amongst the mendicant orders.

The present manuscript, whose text deserves closer analysis than it has yet received, contains excerpts – littered with corruptions – from the Commentary on Isaiah, plus a text known as the *Praemissiones*, so-called after the title given to it in another 14th-century manuscript. A sort of introduction (or "handbook") to the Commentary and indeed to Joachimite philosophy in general, it consists of pictures accompanied by brief commentaries and ultimately derives from the *Liber figurarum* (or preliminary studies for it) – a "book of figures" probably designed by Joachim himself in order to clarify his exegesis. The pictures are intended to make the text of the Commentary, which presupposes a familiarity with Joachim's ideas, more accessible to the reader. A number of grave misinterpretations of Joachim's drawings have found their way into the present illustrations (see ill. p. 239), however, which recent research suggests are likely to have been executed by artists working in Joachimite circles in the mid-13th century in southern Italy, rather than by artists from a Franciscan background.

M. W.

Extent: 36 parchment folios
Format: 245 x 350 mm
Binding: cerise paper binding over pasteboard (Vienna, 17th/18th century)
Author: Pseudo-Joachim of Fiore
Content: Commentary on Isaiah (excerpts) with Praemissiones (?)

Language: Latin
Illustration: 41 text illustrations
Provenance: The manuscript is documented in the possession of the Vienna Hofbibliothek from the 17th century onwards.
Shelfmark: Vienna, ÖNB, Cod. 1400

Thic de vto nonnus · Thic Josue regum · Thic liber Judicum

Thic liber numeri

Dnica quarta in qua ... · Dnica terta in qua dragesma · Dnica quinta in xl de passione d... · Dnica sexta in ...

hic incipit liber genesis

hic lev...

hic deutonom...

hic numerus

Dnica prima post ... · Dnica tercia ...

Dnica in katheng... · Dnica in katheg...

Dnica in ... · Dnica noue ... ·

Thic lib tobias · Thic liber ...

Thic lege... · Thic lib ... · Thic liber ...

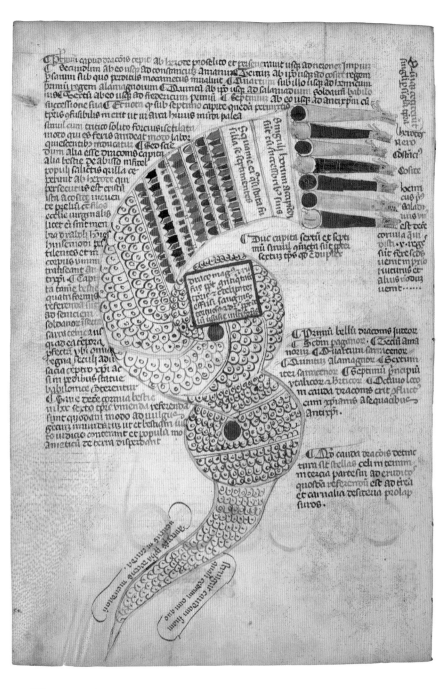

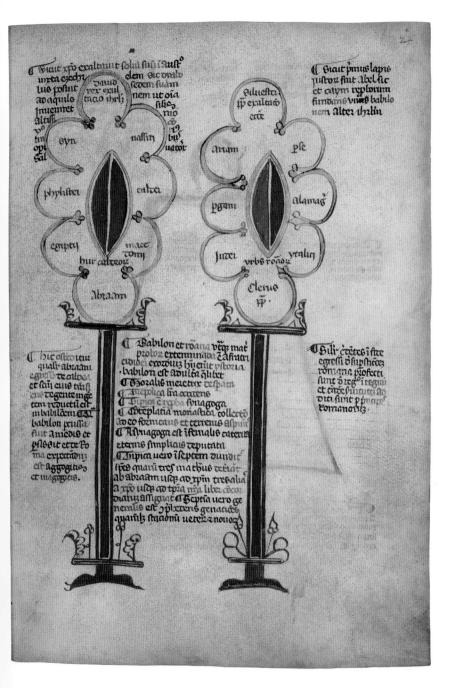

Peter Lombard,
Collectanea in epistolas Pauli

Northern France, 2nd half of the 13th century

Peter Lombard, born in Lumellogno, near Novara, in around 1095, trained in the *artes liberales* (Liberal arts) in various schools in Italy. Through the agencies of the Bishop of Lucca and his friend Bernhard of Clairvaux, he then went to study first in Reims and finally, thanks to a scholarship, in Paris. Here he made the acquaintance of Hugo of St-Victor and Peter Abelard. From 1143 or 1144 he was head of the Paris cathedral school; as a teacher, he wrote commentaries on the holy scriptures, in particular the Epistles of Paul, held discussions on theological matters and examined the teachings of the Fathers of the Church (*Sententiae patrum*). Meanwhile, he also rose up through the ecclesiastical ranks, eventually becoming bishop of Paris in 1159. He was held in such high regard in Paris that he was even consulted on matters of biblical exegesis by the Pope.

It was during his time as a professor in Paris that he wrote the expositions on the Bible of which copies still survive today. These take the form of Glosses, a type of scriptural exegesis he had encountered as a student in the commentaries of Anselm of Laon (*Glossa ordinaria*) and Gilbert of Poitiers (*Glossa media*). In addition to a commentary on the Psalms (*Glossa in Psalmos*) published in 1158/59, his writings include an analysis of the Epistles of St Paul, of which two editions are known, and the *Sentences*, a collection of writings on various theological questions taken from the Church Fathers and issued in four books (*Sententiae in IV libris distinctae*). This "work in progress" was regularly expanded – in 1153/54, for example, by the addition of the complete translation of John Damascene's *De fide orthodoxa*. Peter Lombard's *Sentences* exerted great influence as a theological textbook (still in use in the 2nd half of the 14th century) and were themselves the subject of commentaries by Albertus Magnus (1246–49), Bonaventura (1250–52) and St Thomas Aquinas (1254–56).

The present manuscript, which was transcribed – significantly, in the French region – about a century after the original was first composed, appears to be a luxury edition, as evidenced by its fine, carefully prepared parchment. A fourth of the

Detail from fol. 169r (Thessalonians): The start of St Paul's Epistle to the Thessalonians, with the initial P(aulus) opening the biblical text, and a smaller P initial in the Gloss.

PAVLVS
⁊ siluanus ⁊ timo
theus ecc̄le thessa
lonicensiū in deo
patre n̄ro ⁊ dn̄o
ihu xp̄o. Gr̄a uo
bis ⁊ pax a d̄o pr̄e
n̄ro ⁊ domino
ihu x̄. Gr̄as age
debemus d̄o sēp
p uobis fr̄s sicut
dignum ē. Q tm
sup crescit fides
ūra ⁊ habundat
caritas uniuscui

Aulus ⁊ siluanus ⁊c. Hanc epl̄am itēm scr̄
Scr̄ta enim ap̄ greco̅. quoru tribulatione: n̄
ostendens iustum d̄i iudicium: ut boni egr̄
nam. Et quia in p̄ma epl̄a. qdam dix̄: de
rectione mortuoru in. uiu̅. putabatur dies
scribit epl̄am. in qua. significat: licet ob
abolitione romani regni: de antix̄pi. apparentia ⁊ damp
strm inquietudine: scribit i̅: n̄ in stare diem dr̄i. n̄ occa
Cum enim thessalonicenses: p̄orem epl̄am legissent p̄uenis
apt̄s. morti in xp̄o: in aduentu ei̅ resur p̄imi: dein: nos
simul rapiem cum ist̄ turbati sunt: nimruq̄; p̄ti. pu
p̄untes ne dampnarent̅: cum diabolo: eo quod tarde a
ticeēt. Idcoq̄; hoc comparato: scripsit eis non iminere diem
hoc mutus̅: pomia replarentur. Vt ne diabolus b expec
illuderet corrigit ⁊ asp̄ius in quietos. Et est intentio ap̄l
ad pacientiam monere: inquietos corrige: ⁊ que obscure in
aliquatenus apire. ⁊ modus tat. P̄imum salutat. dein⁊ g̅
monet ad pacientiam: ⁊ ad constantiam. Inde asserit: qu
ueniet: ⁊ aliqua aduentus antix̄ signa: licet obscura: de
tione romani regni. ⁊ de im̅fectione antix̄pi. cura fines
sol corripiatur: obsecrat. P̄emittat a̅ salutonem: dicens
motheus. Isti tres sunt: quoz nomine scribitur h̅ p̄ti
thessalonicensiū. existentium d̄o patre. n̄ a d̄o. i. ⁊. f̅. ⁊an
gr̄a sit uob ⁊ pax a̅ d̄o patre. n̄ a d̄o. ie. ⁊ xp̄o. h̅ eo supra ⁊
dgit gr̄as d̄o: de bonis eoz. n̄ e forte de tanto bono. q
rentur: tanquam a̅ se ip̄sis b̅ fiant. q. d. qd tenentis tenete. q
debemus gr̄as age d̄o. numquā soluere possumus. ut ⁊
fr̄s semp debemus. p̄uo. age gr̄as d̄o. a quob bona sunt: ⁊
ut dignum ē ⁊ quia p magnis bonis: magne gr̄e agende s̅
quoniam fides ūra sup crescit. i. sup hoc: quod olim fun
non decrescit in tribulationib; ⁊ caritas uni cuiusq̄ uim
ur. s̅ qui diligitur diligat. alios: ⁊ mutuus ob sequiis ea
dico. ita. i. in tm crescit ut nos ip̄si apli: qui non de par
gr̄emur in ecclis d̄i. quib; de uob damus exemplu. ud
defectus de uob gr̄amur dico cor̅ maxime: p pacientia: ⁊ fide
que sunt de loco ad locum: ⁊ tribulationib; i. ⁊ tormētis quas
sustinetis. in exemplu iust̄ iudicij d̄i. i. qui tribulatione es
futuro: pacientib; ⁊ inferentib; sit dandum. Si enim
peccā in penitentib; ⁊ quod facit induratis. Ideo diē p
ē iust̄ iudicij d̄i ut intelligat. quod non parcit impi
persis ad conbustion em: qui non parcit iustis ⁊p p̄tie
persis a̅ p̄ dimitium a̅ nob: auus finis exprit qui non

P

AV
LVS
SER
VS
RIE
SV
VO
CA
VI
A
PO
STO
LVS

page is left blank on every sheet, evidently to allow room for the addition of further text.

In his layout of the biblical text, which is always written in narrower columns and in a larger script than the Gloss, and the Gloss itself, the manuscript's editor – who was probably also its copyist – displays a sophisticated eye for design. Even though he has marked out in advance, with the aid of rulings, three columns on every page (a narrow column on the far right and left for source references and text by St Paul, and a wider one in the middle for the actual commentary), he regularly breaks out of this format. Thus he allows the biblical text to project into the lines of the Gloss column, or blocks of the Gloss to project into the outerlying biblical text, in almost geometric configurations. This same device is probably also an editorial means of keeping a biblical passage and its accompanying Gloss on the same page.

In the manner in which he identifies his sources, Peter Lombard is indebted to the conventions of his time: authors are indicated by abbreviations (such as *Ag* for Augustine), but titles of works are rarely cited and more specific details of works are not given. In order to make it easier to consult, Codex 1209 is visually subdivided by its continuous, playful alternation of red and blue initials. Quotes from the Church Fathers are indicated in the text by two dots and in the margin by a (brief) reference to their source. Passages from the Bible in the Gloss and the quotations from the Church Fathers are also underlined in red ink.

C. G.

Extent: 227 parchment folios (fol. 226v–227v blank)
Format: 345 x 263 mm
Binding: Gothic leather binding over wooden boards, traces of metal
Author: Peter Lombard (c. 1095–1160)
Title: Collectanea in epistolas Pauli

Language: Latin
Illustration: 14 red and blue fleuronnée initials in the text by St Paul, 11 smaller initials in the Gloss
Provenance: In 1756 the manuscript passed to the Hofbibliothek from the former library of Vienna University.
Shelfmark: Vienna, ÖNB, Cod. 1209

Peter Comestor,
Historia scholastica

Mondsee Benedictine monastery (Upper Austria), 1462

Peter – whose epithet Comestor ("eater"; occasionally also rendered as "Manducator") refers to his appetite for books, was born around 1100. In 1147 he became dean of Troyes cathedral and later moved to the cathedral school of Notre-Dame in Paris, where he attended lectures by Peter Lombard before the latter gave up teaching following his appointment as bishop of Paris in 1158/59. After Lombard's death in 1160, Peter Comestor taught theology at the cathedral school and in 1168 was appointed chancellor. He held this office, like that of dean in Troyes, right up till his death in 1178 or 1179, although the last years of his life were spent in seclusion in the abbey of St-Victor in Paris.

Peter Comestor played not an insignificant role in ensuring that Peter Lombard's *Sentences* became a standard textbook. He wrote his own Glosses on the *Sentences*, of which only the preface still survives intact; the large part of his work, however, can only be extracted from later versions reworked by other authors. His Glosses on the four Gospels have fared only a little better; they are preserved solely in notes, known as *Reportationes*, made by students. Of the some 150 sermons, preserved in manuscript form, which are attributed to him, it is likely that only about a third actually sprang from his pen. Similarly, there is today agreement (not always unanimous) amongst modern researchers that a number of lengthier treatises, such as the *Allegoriae in epistolas Pauli*, *De spiritu et anima* and *De diligendo Deo*, should no longer be ascribed to him.

Peter Comestor achieved fame with his *Historia*, which rapidly became a standard textbook in the schools and hence acquired the adjective *scholastica* in its title. Dedicated to the Archbishop of Sens, Guillaume aux Blanches Mains, and completed between 1169 and 1173, it offers a commentary on the Old and New Testament extending from the Book of Genesis to the Ascension of Christ

Detail from fol. 194r: Lombard initial.

▶ **Fol. 193v:** End of the Old Testament section of the *Historia scholastica*; beginning of the New Testament section of the *Historia scholastica* with the initial F(*uit in diebus*).

Item primo de concepcione
precursoris domini nostri salua-
toris



...pli in mensi ponderis in honore
...manorum iudeis id est referentibus
...rit et cesarea palestine in qua
...reris stratonis in qua con̄ aduen-
...tusti cesaris portam de candido
...marmore extruxit in qua post
...melius centurio creatus est a pe-
...tro ⁊ fecit quo herodium in quo et
...sultus est | fecit ⁊ phaselum ⁊ opidu
...memoria fratris | reparauit samaria
...et sabasten dixit vbi ⁊ templum
...sari maxim̄ dedicauit · Aliud et
...mplum cta iordanis fontem candi-
...marmore cesari fecit prorsus
...quod erat ydoneus regni loco quem
...nauit honore cesaris reliquit
...imo quod xv· regni sui templum
...in magnifice decorauit nec solu
...regno suo sed in adiacentibg
...uitatibus memorialia sue libertatis
...et industrie reliquid de offensa

...Post hec herodis in filios
...rediciuit a studio filii eius et
...erat alloexander ac tenig̃ porator
...uorum vnus aristobulus filiam
...dome autem sue duxit in vxorem
...lis filia regis cappadoci idon quod
...tenciq̃ cum petre eius de successione
...regni disceptabant Ob hoc pater
...fonsus antipatru illos pronere
...itatebat in testamento quoque
...im apte declaratus fuit succes-
...ir Proinde periti fratres de
...morte patris occulte tractabant
...⁊ pencienns pater a se eos re-
...cit hij vero romam nauigauert
...et patris iniuriam deferrent
...ad cesarem ⁊c

Et sic est finis hystorie scolas-
tice veteris testamenti Anno
dm̄ m̄ cccc̄ lxij· o̅ kia an
Judica



Fuit in diebg̃ at
herodis regis
iudee anno
regni sui vno
de xxx· sacer-
dos noie zacha-
rias de vice
abia et vxore
eius aaromita
noie elizabeth
Dauid em̄ am-
pliare volens
cultu diuinu

xxiiij·or instituit summos sacerdotes
quorum vnus tn̄ maior qui dicebat
princeps sacerdotu Statuit aut
sexdecim viros de eleazar et viij de
ythamar / et hm̄ sortes dedit vni-
tuiq̃ ebdomada vicis sue habuit
at abias viij·a ebdomaz / de aug-
mine zacharias / tu in die pinacie
incensum ponet pdixit ei angelo
nascituru sibi filium de vxore
qui considerabat sterilitate vxoris
et vtriusq̃ senectute no credidit
et ob hoc obmutuit / vsq̃ ad diem
partus nome quod puer ⁊ magna
fticentia cum absinentia ei indi-
cauit Concepit aut elizabeth ⁊
occultabat se mensibus quinq̃

De concepcione saluatore nostri ihu xpi· 19

Mense aut vi·to Missus est an-
Gabriel in nazareth ad
maria desponsata ioseph cui
ea salutata dixisset ea paritura
filium altissimi Ipset quod quod
hoc fiet cum se non cognitura viz
alio nouisset nisi aliter deo disso-
neret Addidit angelg̃ non de

Imperatorie ma
iestatis est tres
in palacio habere man
siones. Auditorium
ut consistorium in q
uibus dederunt Cenacb
m in quo cibaria distri
buit. Thalamum in q
quiescit Ad huic modum imperator
rie qui impat ignis et mari min
dum ht preduituris ubi ad nutu
eius omia disponit. Vnde illud
Celum et terra ego implebo. Icdm
ht dia dns vnde dns est tra t
plonudo eius tra. iustu p thalamo
qua deliue sut ei esse tum filys ho
minud. Icdm hat dici sponsi Cacia
em scriptura p cenaclo in quo sc
surnedat ut Cibrus reddit in
ambulauid in domo dei tu gsensu
vm sat scripta. ipam sapientes
Icdm hat de pater sambias Conati
hug tres sut tres fundamti rules
tertui Hystoria findamta est aug
tres sut tres amedis ktaria effi
mera Amalies dr quddd p annul
factud ktaria chqt p mensem Iffi
mera quidue p vno ut dimidiu
diem factud est ket oblat pulitudine
de est mea qa effim dia vms est qui
vno die nasar vno die morit. Alle
goria paries sup mittens que per
factud aliud factud sigat. Atropologia
dogma culmis sup poua que pfctm
quid a nobis sit facendum i signuat
pma plamor. Gola attinuas Partia
suauisi. A fundamito loquendi
sumemq pncipiu in vno ab cpus
findamti pncipio eo iuuante qui
omi pnceps est et prnicipiu de
creacione mdi et qituor elemtor
Ih pnapis exiit verbu et vm erat
prnicipiu in quo et p qd pater

creauit mundu. Chand gm mode de
tenq empireud celu mdu de gtea
sui mundud itenq sepbilus mundu
qui a geris pan a latim de dicin est
tria phus empireud nd cognouit
Itenq sola regio sublimar. mudu de
qua het sola amndua nob nota ht
de qua prneps mudi erat forms. chq
hams de mundo qt mstorig mudi
ymagie reprutat. Vnde a dno omis
creabia dictus est et qrem qm miaro
cosmd. i morem mudu uocat em
prnreud aut ecc sepbilem mudu et
sublimare. Ichonem creauit deg et de
michilo fet hotu iis erat t plasmaut
diacione ipi illoz tum mgi legi platoz
Ih pma cauit deg celu t tra celu ide
quens et genti. i Celd empireum
et angeliud naz tcam maz omn capu
quatuor elemta i mudu sensibilem
ex hiis costantem. Cuidud celu sigei
ores pres mudi sensibile mtelligint
terra inferores t palpables Hebre q
ht Eloym qt tam singtae qua plurae
est. i dm ut dij ep hug psme vnus
deg cratoz est. Cum res dixit moyses
creauit em errores elisit platonis
ti Aristolis epiauit plato dixit tra fuisse
ab etinoidum videns ylen. et in pnu
pio tris de yle mudud factud. Arcades
dns. mudio et opificem qu de duobg
pnapys st maia t forma opatu est
sine pnapio et opat sine fine. Epi
tureg duo mare et athomos et in
pnapio natu quordm athomos ple
daunt intersed aliud in aqua alias
in aere alius in igntem Choyses vero
deum solid etind gybaunt et sine
piacenti maia mundu cauit. Creatq
est ar in pnapio sit Im pnapio serit
deus calum et tron. In pnapio a
in filio iterandu est in pnapio tris
st coeua em est mundu et temps
Sir aut solus deg etnus sic mundu
fuit

Fol. 12r: I(*mperatorie maiestatis est*) initial at the start of the *Historia scholastica*.

(the commentary on the Acts of the Apostles was added later by Peter of Poitiers (*c.* 1130–1205), from whom also stems the *Genealogia Christi* which in many manuscripts precedes the *Historia*).

The *Historia scholastica* must be seen against the backdrop of Peter's lengthy teaching career: rather than allegorical or typological explanations of the scriptures, it offers a primarily literal exegesis (see pp. 254–257) and thereby forms part of a tradition that is also found in the school of St-Victor. Hugh of St-Victor had demanded that expositions of the Bible should start at the literal and historical levels of meaning before embarking on allegorical interpretation. In his *Historia*, Peter demonstrates his interest in problems of textual criticism and unusual words, while at the same time providing a wealth of information about the individuals, events and places mentioned in the Bible, compiled from a rich fund of heathen, Christian and Jewish sources – these last obtained primarily via Andrew of St-Victor († 1175). The Jewish history related as part of the commentary becomes, from the Book of Daniel, a history of the ancient world incorporating events in Greece and Rome.

The *Historia scholastica* has survived in an unusually large number of manuscripts and was later translated into a variety of other languages, versified, cited, glossed and used as a source for sacred plays. As a reference book and textbook, it served a primarily practical purpose, which is why many *Historia* manuscripts, including the present example, do not include illustrations or lavish decoration.

M. W.

Extent: 270 sheets of paper
Format: 310 x 143 mm
Binding: late-Gothic leather binding over wooden boards; clasps and fastenings lost
Author: Peter Comestor
(*c.* 1110–1178/79)
Title: Historia scholastica

Language: Latin
Illustration: one decorated initial
Provenance: In 1791 the manuscript passed with the holdings of Mondsee abbey library to the Vienna Hofbibliothek.
Shelfmark: Vienna, ÖNB, Cod. 3727

St Thomas Aquinas, Catena aurea (on St Luke)

Bologna (?), 1468

Born around the turn of 1224/25 in Roccasecca Castle, near Aquino (Campania), as the youngest son of a family of counts, Thomas was educated at Montecassino abbey before studying at the faculty of arts in Naples. In 1244, against the wishes of his family, he joined the Dominican order. In 1245 he went to Paris to continue his studies and a few years later followed his teacher, Albertus Magnus, to Cologne. From 1252 to 1259 he himself taught at the university of Paris, then from 1259 to 1268 in Naples, Orvieto, Rome and Viterbo, before returning to Paris to resume (?) teaching from 1268 until 1272. He then returned to Italy, where in 1273 he had a mystical experience that caused him to lay down his pen for good. He died on 7 March 1274 in Fossanova (Latium), on his way to the Council of Lyon. Revered from early on as a *doctor communis*, in 1323 the celebrated theologian was elevated to the sainthood.

Thomas Aquinas is one of the most important philosophers and theologians of the Middle Ages. At the centre of his endeavours lay his desire to reconcile the tenets of Christianity and Aristotelianism. More recent research has also stressed the influence of Augustinian and (Neo)platonic ideas upon his thinking. His works are excellently structured, which makes them easy for the reader to use. Characterized by clearly formulated analyses of problems, they make a considerable contribution to the field of textual criticism.

Alongside his chief works, the *Summa contra gentiles* in four books, setting out the true Catholic faith, and the *Summa theologica*, Thomas also produced numerous commentaries on the writings of Aristotle, Peter Lombard's *Sentences* and the scriptures themselves. Falling into this last category is a commentary on the Gospels which Thomas originally titled the *Expositio continua in Matthaeum, Marcum, Lucam, Joannem*, but which later came to be known as the *Catena aurea*.

Detail from fol. 14r: *F(actum)* initial marking the catena commentary on St Luke, Chapter 2.

▶ **Detail from fol. 23v:** *A(nno)* initial marking the start of the catena commentary on St Luke, Chapter 3.

bat. Grec̄. Pficbat ergo ſm etatez
quidez corpe in uirilez ſtatum, pmoto
Sapia aut p eos qui ab eo dinina do
cebant. gra uō q̄ cum gaudio, pmoue
mur edentes in fine obtine que ab ɹ
ipo, pmiſſa ſt. Et hoc quidē apd dm
et eo q̄ aſſupta carne pinuz opus p
egit. apd hoies uō. p cōuiſionez coū
que a cultu ɹ dolor ad ſume tinitatis
notia a. Theoph. Diat aut. apd dm
et hoies. q̄ pinus ~~deu~~ decet place dō
et poſtea hoibz. Grec̄. Differēter cē
pfiat úbum in his qui ipm ſuſcipiut
ſm eū meſam ult̄ appet aut infas aut
adultus. aut pfectus. Grec̄.

A
N
no

aut quitod

ecamo impe

R Edeptons ɹ
paurſor quo tpē
úbum pdicatiois
accepit. m eo̅rato
romane rei publi
ce pncipe. ɹ unde
e regibz deſigna
tur cum diatur.

tur. ut mulier disce magr̃ que diuina sunt
studeat q̃ docere. Pᵉech Beda. ca-
tor pm̃e futur⁹
ut libuis auditõẽs
suⷮos a mũdi illece-
bus erudiẽdo sub-
stollat pruneuã in
destis trĩsigit ui-
tam. vn̄ diat. ſpu
erauⷮt crescebat.
Tⷰoⷰp. fm̃ corpalē
etatem ⁊ cõforta-
baⷮt ſpu̅. Sunl eni
cum corpe ⁊ ſpua-
le donũ crescebat.
et ſpẽ opatoẽs in
eo magꝰ ac magis
ondebant. Onꝰ. ꝩl escebat
ſpu nec in cadez pmanebat mesura q̃ ce-
pat. ſz ſp crescebat ſpẽ in co. ſp uolitas illi
ad meliora tendẽs hebat pfectus suos et
mens diunus aliq̃ cõtẽplabat. crescebat
se meõna ut pura in trⷰauro suo recodẽt.
Adⷰtut aut. ⁊ cõfortabat. Infirma cⷮ est
humana nã. Legim⁹ eni. caro infirma
cõfortanda est itaq̃ ſpu. ſpẽ ei pmpt⁹
est. multi cõfortant carne athleta dei
ſpu roborandus est. ut sapiam carnis
eludat. Vn̄ recessit fugiẽs tumultũ ur-
bui ppli freq̃tiam. ⁊ eqt ei. Et cãt pu-
er in destis. Sibi purioꝛ acrest. celũ ap-
tius. ⁊ familiarioꝛ dꝰ. ut q̃ nõduz ba-
ptismi ⁊ pdicatoms tpe aduenit. ua-
caret oⷰnibus. ⁊ cum angel̃ couersaret
appellaret dm̃ ⁊ illu audiret dm̃tem.
ecce assum. Tⷰoⷰph. ꝩl erat in destis.
ut ext m̃loriu malia am nutret. ⁊ ut
nemnẽ ueretur argue. Si ei funsset in
muido. forte funsset amacia ⁊ cõusati-
one hoim depuatus. Sunl cⷮ ut eet
fide dignus q̃ pdicatus erat ꝓpm. de-
cultabatur aut in destis donec placa-
ut dõ ipm̃ isiliîco ꝓplo dem̃are. vnꝝ
se. Vſq̃ ad diem oⷰnis sue ad ist.
Ambr. Pulchre aut tpe quo fuit i uto
ꝓpha. describit. ne marie prũtia tace-
atur. ſz q̃ silet infancie. eo q̃ prũtia ⁊
dni nris in uto roborat. qui infanti-
e impedim̃ta nesauit. Beda.

Actu̅
est
aut in diebꝰ
ill. exiit edic-
tum a cesaĩ
augusto ut ⁊
describetur u-
nuisus orb.
Hec descripti-
o prima fca ē
a pside syrie
Cyrino. Et
ibant omẽs
ut pfitentur
singuli in ci-
uitatẽ suam.
Ascẽdit at
et Joseph a
galilea de ci-
uitate naza-
reth in iudê-
am ciuitatẽ
dauid que ⁊
uocatur beth

IN Ascⷰeⷰuⷰis in car-
ne di filius sic de-
uigine natus uigi-
nitatis sibi dec-
oriidit ee gr̃issⁱ⁹.
sic pacatissimo se-
cli tp̃e peratⷰ. q̃
pacẽ qr̃e docuit.
et pacis sectatoẽs
uniuesẽ dignat. ⁊
Illiin aut potuit
maius ee pacis ĩ-
diciu. qm̃ una to-
tum orbez descri-
ptoẽ cõcludi. Cuⷰ
modatoꝛ august⁹
tanta. xq̃. annis
cⷮ tp̃e dnice nti-
tatis pace regna-
uit. ut bell̃ toto
orbe sopitis ꝓphe
psagui ad brain
umplle uideat.
vn̄ diat. Fcm̃ ē
aut in diebꝰ ill.
exⁱit edictũ a ce-
sare augusto ut
describetur uni-
usus orb. Gue cⷮ
nasar̃ tp̃e. cum
priaꝑes iudeoꝛ
defecerat ad ro-
manos priaꝑes
tⷰisilatum erat ⁊
puⷰuⷰz quibꝝ iudi
tributa soluebat
Et sic umplet ꝓ-
pha pdicⸯẽⷰs. nõ
defiⷰ dueⷰx de
iuda. nec priaꝑe
de femoribꝝ ei⁹.
donec ueniat qui
muttẽdus est. ſa-
uⷰⷰ ceⷰ cesare augu-
to. xlꝰ⁹ anni im-
pii pagⷰete. exⁱit
ab eo edictũ totⁱ
orbez cõscribi ad
tributa soluẽda

As the large number of surviving copies – both handwritten (often as luxury manuscripts) and printed – makes clear, the *Catena aurea* enjoyed extraordinary popularity both during the Middle Ages and well into Renaissance times. Compiled from the works of the Church Fathers cited in closely-linked series (hence the name *Catena* – "chain"), this commentary on the four Gospels exhibits two distinctive features: firstly, Thomas Aquinas acknowledges by name – a practice only rarely observed in the Middle Ages – the author of the quotations he has compiled; secondly he points out, in his prologue to the commentary on St Mark, that he personally arranged for works that were not yet available in Latin to be translated from the Greek. The catena commentary on St Matthew is dedicated to Pope Urban IV and must thus have been written before the latter's death in 1264; those on the Gospels of Mark, Luke and John were completed in 1268.

The commentaries on the Gospels frequently survive individually, as in the case of the present manuscript, whose eventful history can be reconstructed unusually well from inscriptions in its pages: the text was written out in 1468 (probably in Bologna) by the calligrapher Henricus Amstelredammis alias Senza paura. The elaborate binding, crafted by the so-called Corvinus Master and bearing the arms of Old Hungary and Bohemia, testifies to the fact that the manuscript formed part of the important Bibliotheca Corviniana – the library built up over decades and at enormous expense by bibliophile Matthias Corvinus († 1490), King of Hungary and Bohemia and an enthusiast of humanism. By the end of the king's life, his royal library is estimated to have comprised around 2,500 volumes and was famous throughout Europe. After his death, not least in the wake of the Turkish invasions of the 1st third of the 16th century, the collection was scattered.

M. W.

Extent: 206 parchment folios
Format: 365 x 260 mm
Binding: red morocco over wood with blind and gold tooling (original binding made for Matthias Corvinus; Buda, before 1490)
Author: St Thomas Aquinas (1224/25–1274)
Title: Catena aurea in Lucae evangelium
Language: Latin
Scribe: Henricus Amstelredammis alias Senza paura (active around 1470/80)

Illustration: 23 decorated initials
Provenance: In 1468 the manuscript was in the possession of Matthias Corvinus, King of Hungary and Bohemia; seized by the Turks in 1526 after the Battle of Mohacz; brought to Vienna by Anton Vrancsi, Bishop of Fünfkirchen, in 1557; documented in the collection of the Hofbibliothek as from 1576.
Shelfmark: Vienna, ÖNB, Cod. 1391

Nicholas of Lyra,
Postilla litteralis

Northern France, middle or 3rd quarter of the 14th century

Nicholas of Lyra, one of the most important exegetes of the late Middle Ages, wrote extensively in the prologues to his works about his aims and methods, but said very little about his own life. All the information we have about his career is derived from just a handful of sources, not all of them reliable. Born around 1270/75 in Lyre (today La-Neuve-Lyre) near Évreux in Normandy, in around 1300 he joined the Minorite order in neighbouring Verneuil and went to study at the university of Paris, where he himself then went on to teach theology. From 1319 he served as head of the Minorite province of Francia, and from 1324 as head of Burgundia province. In 1330 he resigned from all his administrative posts in order to concentrate exclusively on his teaching at the Paris university and his exegetic writings. He died in 1349 in the Minorite friary in Paris.

Modern scholarship has refuted the legend, first invented in the 15th century, that Nicholas was a converted Jew – an idea fuelled primarily by his knowledge of Hebrew, something unusual in his day, and his great admiration for rabbinical literature, in particular the writings of Rabbi Solomon ben Isaac, known as Rashi (1040–1105). Just how well Nicholas had actually mastered Hebrew was the subject of dispute even in the 15th century, and essentially remains so amongst Hebrew scholars today. Where Nicholas might have acquired his Hebrew is another question that has not yet been fully answered. A biography – written decades after his death, however – states that he attended a Jewish school. This might have been the school in Évreux, which lay not far from Lyre. In the 13th century this was a centre of Jewish exegesis, at which the so-called "great ones of Évreux" (Samuel ben Schneur and his brothers Moses and Isaac) taught.

Aside from a number of shorter works, which amongst other things address the problem of translating the Old Testament from the Hebrew, particular mention must be made of Nicholas of Lyra's commentary on the Old and New Testament, the *Postilla litteralis in universam Bibliam* (also known as *Postillae perpetuae in Vetus et Novum Testamentum*), which was written during the years 1322–31. As the word

Detail from fol. 74r: The *mare eneum* (bronze water tank for the priest) in the Temple of Solomon (cf. 1 Kings 7:23–26) as interpreted by Latin exegetes of the Bible, Rabbi Salomon and Flavius Josephus.

Hec est figura Amelli de corpore. A. Salo. hed′ Saguudo z disposito z dispositionis, columpne et basis posita quod gisti z faccis p predictis.

Fol. 73v: One of the bronze capitals moulded by Master Hiram of Tyre for the brass pillars of the Temple of Solomon (cf. 1 Kings 7:13–19) as interpreted by Rabbi Solomon.

litteralis implies, it is upon the literal meaning of the Bible that Nicholas focuses his attention – one of the several layers of meaning which, according to medieval thinking, the Bible possessed, and the one to which Nicholas attached particular importance. Although not fundamentally opposed to spiritual interpretation – in 1339 he followed his famous *Postilla litteralis* with a shorter *Postilla moralis* – he nevertheless criticized the way in which contemporary exegesis smothered the literal meaning altogether. In order to establish the actual meaning of the words, he believed, it was necessary to go back to the original text of the Bible, in other words the Hebrew version of the Old Testament. He thereby drew upon Jewish commentaries, in particular the commentary by Rashi, to assist him in his exegesis, and in so doing hoped to convince Jews, too, of the Christian nature of the Old Testament, which in his opinion refers to Christ in literal terms in several places.

Copies of the original rapidly spread and the work itself remained the subject of heated controversy even into the 1500s, as reflected in its use by other authors (including Martin Luther) and its survival in large numbers of manuscripts, translations and printed copies. Many of these reproduce not the entire *Postilla*, but shorter sections relating to individual books of the Bible, as in the case of the present manuscript.

M. W.

Extent: 306 parchment folios
Format: 312 x 215 mm
Binding: carved-leather binding over wooden boards (Vienna or Lower Austria, *c.* 1400); binding decorated with geometrical and vegetal ornament in leather-carving technique; comparable examples stem from Melk and Vienna
Author: Nicholas of Lyra (1270/75–1349)

Content: Postilla in libros Iosue, Iudicum, Ruth, Regum, Paralipomenon, Esdrae, Nehemiae, Esther, Iob, Psalmorum
Language: Latin
Illustration: initials and pen drawings
Provenance: Formerly in the possession of the Jesuit College in Vienna, after whose closure in 1773 the manuscript entered the Hofbibliothek.
Shelfmark: Vienna, ÖNB, Cod. 2158

Ludolf of Saxony,
Life of Christ

Upper Italy (Venice?), between 1433 and 1445

The *Vita Christi* by Ludolf of Saxony is one of most successful works of German mysticism. In the late Middle Ages perhaps the most widely-owned of all prayer books, it was quickly translated into many languages and was available in print as from 1470.

The name of the author, who was born around 1300 in North Germany, survives in a number of variations. In addition to Ludolf, it appears as Landulfus, Leutolphus, Litoldus, Ludoldus and Rudolf. His epithets include Alemanus, Cartusianus, Cartusiensis, de Saxonia and Natione Teutonicus. A Dominican in his youth, in 1340 Ludolf – now a doctor of theology – joined the recently founded charterhouse in Strasburg. After spending lengthy periods in Koblenz and Mainz, he settled back in Strasburg, where he died in 1377 or 1378. His chief works are his *Enarratio in Psalmos* and his *Vita Christi*, which arose between 1348 and 1368.

The text, which is divided into two parts, is not a Life of Christ in the usual sense, but a series of contemplations on the mystery of Christian salvation as a whole. It is generally followed by the Harmony of the Gospels compiled by the 12th-century theologian Zacharias of Besançon (Chrysopolitanus), together with its commentary. The contemplations are divided into reading – exposition, understanding – application and conclude with a prayer. The *Vita Christi* unites exegetic form with the style of ascetic tracts and homilies, symbolic imagery with practical application. For Ludolf, Jesus is an image of God the Father, the model and mirror of all holiness. In the life of Jesus, the Christian can find new life and, by embracing it as his model, achieve communion and fellowship with Christ. One of the keys to the enduring success of Ludolf's *Vita Christi* are his sources, which include virtually all the major patristic writings of the early Middle Ages as well as works from his own day.

The present manuscript is one of the great line of descendants from Ludolf's original text, whereby its sumptuous decoration makes it unique. It includes no less than 94 decorative bar borders, together with 93 major and 95 minor decorated

Detail from fol. 285v: Decorative border.

▶ Detail from fol. 5v: Jesus dictates the text to Ludolf of Saxony.

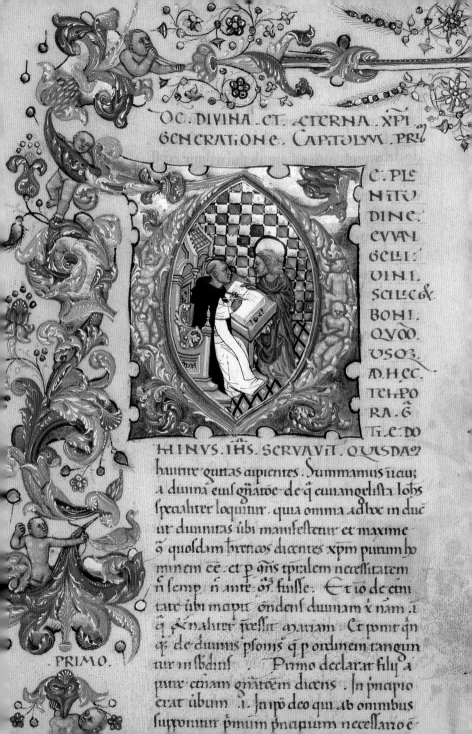

OC·DIVINA·ET·ETERNA·XPI·
GENERATIONE·CAPITULM·PRI

C·PLE
NITU
DINE·
EVAN
GELII·
VLHI·
SCILC&
BOHI·
QVOD·
VSO3
AD·HCC·
TCHPO
RA·Ē·
TĒC·DO

HINVS·IHS·SERVAVIT·QVISDAM
haurire gutas aspientes. Summamus itaq;
a diuina eius gnatoe· de q̄ euangelista lohs
specialiter loquitur· quia omnia adhoc in duc
ut diuinitas ibi manifestetur et maxime
q̄ quosdam hereticos dicentes xpm purum ho
minem ēe· et p gns tpralem necessitatem
n̄ semp· n̄ ante of fuisse· Et io de etni
tate ibi incipit· ondens diuinam x̄ nam· i·
q̄ generaliter precessit mariam· Et ponit qn
q̄ de diuinis psonis q p ordinem tangun
tur in sbciis· Primo declarat filÿ a
patre etiam gnatoem dicens· In pncipio
erat ubum· i· In pō deo qui ab omnibus
supponitur pmum pncipium necessario ē

PRIMO·

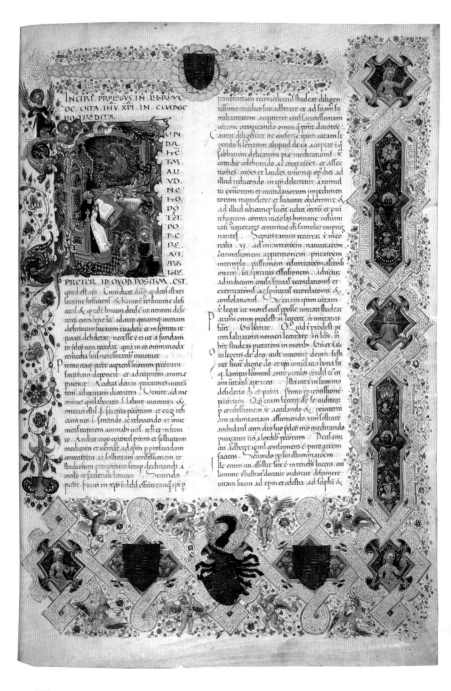

initials. The pages are in part framed by ornate foliate borders incorporating exotic flowers and inhabited by birds, naturalistic hares, roe deer, etc., as well as putti. On fol. 1r (ill. p. 260), the decoration also includes individual pictorial fields set within a pseudo-Cufic gold border and – across the top – two stylized braids. The coat of arms contained on the same page suggests that the manuscript was commissioned by the Gonzaga in Mantua some time after 1433, the year in which Emperor Sigismund awarded the family the one-headed black eagle in its arms.

The lavish illustration continues with the historiated initials which, on fol. 1r and 5v at the beginning of the manuscript, show the author at his desk in front of Christ (ill. pp. 259, 260). Subsequent initials are primarily devoted to scenes from Jesus's youth and his public ministry, supplemented by figures of monks and prophets, A companion volume to the present manuscript, containing the second part of the text, has not yet come to light and is probably lost, if indeed ever executed at all.

The illumination is the work of Cristoforo Cortese (*fl.* 1409–*c.* 1445), who was active in the first half of the 15th century chiefly in Venice, and whose only signed work is a manuscript in the Wildenstein Collection in the Musée Marmottan in Paris. Probably the most important Venetian miniaturist of his day, he absorbed influences from Bolognese, Venetian and Lombard art and fused them into a decorative programme of overwhelming, almost unsurpassable magnificence.

K.-G. P.

Extent: III + 300 parchment folios
Format: 385 x 270 mm
Binding: black leather binding over wooden boards (Italian, 2nd half of the 16th century); in the centre of the front cover, in gold letters, ALB. CAPR., on the back cover DEC. MANT., standing for Albertus Caprianus, Decanus Mantuanus (see Provenance)
Author: Ludolf of Saxony (*c.* 1300–1377/78)
Content: Vita Jesu Christi quatuor evangeliis et scriptoribus orthodoxis concinnata, Part 1
Language: Latin

Miniaturist: Cristoforo Cortese (fl. 1409–*c.* 1445)
Illustration: 94 decorative bar borders, 93 major and 95 minor historiated initials
Provenance: Executed for a member of the Gonzaga family, probably Marquis Lodovico III (1414–1478). In the 2nd half of the 16th century the manuscript was in Piedmont, in the possession of Alberto Capriano, Bishop of Alba (1590–1595), previously commendatar of San Marco in Mantua. In the library of Salzburg cathedral around 1700, the manuscript passed to the Vienna Hofbibliothek in 1806.
Shelfmark: Vienna, ÖNB, Cod. 1379

uncta sunt opatur. ſea et partem per
unigenitum filium ſuū omnia legimꝰ ſu-
iſſe opatum. Hec Auɡ. tm eundem
Auɡ. hoc ſiueium ſa euuāgelÿ quidā
placebat. iureis lïs pſcribendum et p
omnes eccłas in locis emmentiſſimis po-
nendum ēē dicebat.

Omme dſ pr ommpotens / q
coeternum et coeŋlem. et cōſta-
lem t ante omnia ſecła ieſtablr
ſilum genuiſti aim q̈ teꝗ ſpu
ſco omnia uiſibilia dc me mi-
ſum pccorem int omnia creaſti. te adoro
te laudo / te gliſico. eſto ppiciuſ mihi pccori
& ne deſpinas me opuſ manuũ tuaru
Sꝫ ſalua et adiuua me ꝑ nomen ſanctuɉ
tuum. opi manuũ tuarum dexteram
porrige. carnali fragilitati ſuccurre. qui
me feciſti reſpice inſectum tuaꝯ. qui me
formaſti reforma corruptum peccatis ut
ſecundum miam ſalueſ ammā mea. Am.

N principio aim luciſer
creatuſ eēt exerut ſe cont
deum creatorem ſuum et
i ictu oculi proiectuſ e de
excelſo coelorum in inſer-
num et obhinc cauſam
dcerunt deuſ humanuɉ
genuſ creare ut p ipm
poſſoc caſum luciſer
et ſociorum eiuſ reſtau-
rare. ꝗ uapp diabol
homini inuidenſ s inſidiabitur. &
ad pcepti tranſgreſſionem ipm induce-
nitebatur. Et addam genuſ ſpentis
s eligebat qui tunc erectuſ gradiebatur.
& caput uirgineum hebat quē h ſraudu-
lentuſ deceptor intrauit et p os eiuſ lo-

qns uerba deceptoria mulieri narram
Acceam decipienſ ſup omne genus
manum mortem induxit. Et opta-
bat nos omneſ carcerem inſerni int
de quo non poteramuſ. aliquiuſ ad-
torio eripi. ſꝫ tandem pr miarum
deus totiuſ conſolationiſ. clementer
ſperit ſtatim nre damphationiſ et
pſemetipm hbere decreuit ſup q
ſignum p oliuam dedit. quam cot-
ba induſis mariha aſſerebat. q̈ mi-
di futuram incluſiſ in limbo preten-
bat non ſolum emm iſ qui in an-
erant mia pmitebatur. ſ & tot-
do ſignum ſalutiſ i oliua dabatur.
hoc idem deus ſpiruuit nob i mul-
alÿs figuriſ. A principio autem c
dinoniſ nre. Adam in agro dam-
no iuxta ebron de terra formato
domino in paradiſum uoluptaſi
latato / ac Euam in paradiſo de cot-
dormientis ſca et pro conſorte ei p
ipiſceſ pmiſ parentib; in paradiſo a
andum et custodiendum collocat
de hinc pphgm uenit cauſam p diu-
creta ſeueritatem expulſ ſupra mi-
no deſtitit homineſ notare. id b
p occultos inſtinctuſ nec diſtulit h
errabundum ad ſententiam rei
te ſpem uenie dando prepmiſſu
uatoiſ. Et ne forte ignotam e
titudinem tanta di dignatio nre i
ſoret ineſficax i quinq; bs ſcli. et
p patriarchas iudiceſ ſacerdotes
& ſophias ab Abel iuſto uſq; ad io
baptiſtam. filÿ ſui aduentum pri
repromittere et prehonorare. nō det
ut p multa milia temporā & anne
maginiſ et uariÿs multiplicatis ortu
intelligentiaſ ntas. ad fidem eti
et Affectuſ pnimiam et uiuia deſider
ſlammare. Gn ſco. pp̄. Ceſſe
rum qrele q̈ de domuſue natū

◄ **Fol. 7v:** Christ and Satan.

► **Detail from fol. 67v:** St John the Baptist points up at God the Father in Heaven.

Fol. 35v: The Virgin and Child and two other women, accompanying the chapter on the Circumcision.

to seggregari a maıs ac militari s
fructus penitentie facere ꝟ valea
catorum meoꝛ veniam consequi et
&nam pervenire . Amen .

Uod aĩ
offm ba
n ꝓpĩ a
pauit / ſ
candin
tem m
euuani
Sut b
do au
haꝛme

gtin dicens. Non erat ille lux s. uera p
cennam et ex se naturaliter lucens et ad illu
mminandum alios luce grē p se sufficiens
ſ lux p participationem et a luce uā illa
q lucem hrat inaccessibilem illuminat
ut de ea luce uera et sole ustitie. s. ubo q
ē sba patris lux q in quo tenebre non sſ
ulle testimonium phiberet solis amd
et sancti nō sunt lux illuminās efficue
ſ lux illuminata a prima luce. Cst ⁊
lux illuminās efficue q ē lux pcenciam
et sic solus deus ē lux illuminans Cst et
lux illuminans dispositiue q ē lux p pria
pacoēm et sic scī sunt lux q illuminant
ubo et ex sam autem lux de q testimo°
phibebat erat ab eterno lux uera sine
falsitate sb umbra ⁊ sin participatone

nel in corde meo disponendo / ꝗ in boa
opa facie / ꝗ testimoniu ꝓhibeant d' me
ac bocem tuam audire credendo conde
& obediendo ope tecꝫ ꝑ imitatoeꝫ boꝛ
opm sequi et inter oues tuas a te insico
diter cognosci . Custodi etia me domine
ne vn̄ mali cogitationibus et bolunta
tibus / aut locutionibꝫ ut opibꝫ qꝛ lapidibꝫ
te a me expellam sꝫ semp te ꝑ gram i me
hitare sentiam . Amen .

VIA . VERO . SCRI
be qui putabant
se h̄re ꝑfctionem
scie . et pharisei ꝗ
simulabunt se h̄e
re / ꝑfctionem uite
dn̄m ihm i tem
plo reprehendē
no poterunt vei
entes a ierosolis i
galilea eū insecūt
in quo nimia appareꝫ malicia eorum quia de
scendentes ab irtm ciuitate sc̄a et relinqn

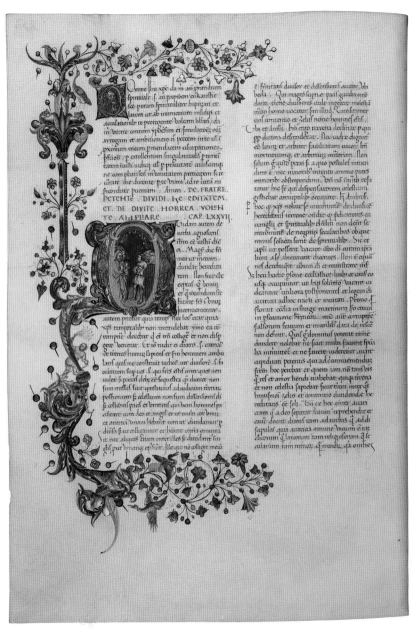

◄ **Detail from fol. 283v:** Jesus and the apostles before a group of Pharisees.

Fol. 252v: Jesus and the apostles before the Israelites.

Medieval versions of history in world chronicles and history Bibles

Although the subject of history was not expressly anchored in the academic systems of the Middle Ages, the discussion of historical concepts was encouraged by a growing awareness of the problems of chronology in liturgical practice (with regards to calculating the date of Easter, for example).

It is in this connection that we may also see the roots of manuscripts devoted to a chronological ordering of the events of the past. History in the Middle Ages was understood not as a cyclical development, but as a purposeful (teleological) series of events unfolding in linear succession, divided into ages and subdivided into epochs. Amongst the sources of inspiration for this system of chronology was the Bible. The biblical method of plotting the course of history in terms of generations (*generationes*), for example, is taken up in world chronicles and paralleled with the rules (*regna*) of heathen kings (see pp. 274–279). Another means of calculating time was the division of history into world years, starting from the Creation: according to the Vulgate, for example, the birth of Christ thus occurred in the year 3952.

Yet another, frequently adopted chronological device was the division of the history of the world into six ages (*aetates*); this system was still in use in the late 15th century and can be found in the famous Nuremberg Chronicle of 1493 by Hartmann Schedel (1440–1514). Another commonly encountered system, finally, employs a model inspired by the prophecies of Daniel and recounts the history of the world in terms of four heathen kingdoms (Babylonian, Medo-Persian, Greek and Roman). Accents are thereby also placed by decisive events such as the foundation, re-foundation and destruction of the Temple in Jerusalem and the Babylonian Captivity (deportation of the Jews; see pp. 274–279).

Histoire ancienne jusqu'à César, Cod. 2576, detail from fol. 4r (Genesis): God curses Adam and Eve after the Fall.

▸ History Bible, Cod. 2823, detail from fol. 236r (1 Kings): The Judgement of Solomon: King Solomon orders a servant to cut in half the child being claimed by two women, but the real mother begs him to spare the infant's life.

Medieval chronicles took as their starting point the chronological tables
(*chronicorum canones*) compiled by Eusebius of Caesarea (before 264/265–*c*. 339/340),
which were translated into Latin and extended by St Jerome (*c*. 347–419) and which
represented a synchronism of biblical history and ancient dynasties. Medieval
chronicles generally embraced a time span that commenced from the events of
Creation and ended at the author's day. Depending on their type, such chroni-
cles were either universal in their chronological and geographic scope (so-called
world chronicles) or more concise; their sequence was dictated by the historical
framework of the Bible, although sometimes also by events from pagan history
(see pp. 280–285).

Chronicle codices have been grouped into three different textual traditions,
each with its own narrative focus (von den Brincken [1969]). Although the manu-
scripts still extant today mostly represent a mixture of these traditions, their identi-
fication can nevertheless provide an insight into the structure and emphasis of the
text. Chronicles of the *series temporum* type, for example, are primarily laid out in
an annalistic fashion and concentrate upon the chronological sequence of historical
events; they are particularly suited to the common practice of adding to the manu-
script at a later date. They thereby differ from the *mare historiarum* type, in which
narrative diversity stands in the foreground and which also incorporates reflective
observations upon history. The third, *imago mundi* type is characterized by its
encyclopaedic scope and embraces other spheres of knowledge such as geography.

These various types of manuscript are all linked by the underlying assumption
that the events of history are determined not by humankind but by God, for the
benefit and salvation of the world. All factual events were also seen and evaluated
from this point of view. This eschatological dimension was always present, above
all when the divinely-steered nature of history was underlined by the inclusion,
at the end of such chronicles, of the Last Judgement and end of the world.

The medieval understanding of history briefly sketched here finds its most
condensed expression in the genealogical tree. The example discussed in the
following section (pp. 274–279) demonstrates – with the maximum of concision
and in the appropriate form of a scroll – the chief characteristics of such overviews
of world chronology: a synchronistic presentation of history subdivided according
to kings, dynasties and ages. While many genealogies are simply laid out as names

Jer willic be
ghinnē dand
partye vand
bybelen hoe
die yoden die
nabugodono
sor die conīc

History Bible, Cod. 2766, detail from fol. 68v
(Numbers): The scouts Joshua and Caleb tear their
clothing because the Israelites are refusing to go
on to the Promised Land.

in a series of medallions, the present example is animated by miniatures that bring
vividly to life the different epochs of the past and the concept of the history
of salvation that runs through the whole.

A narrative alternative to this pithy form of historical presentation is offered
by the *Bible historiale*, or history Bible, of which two examples are discussed here
(see pp. 286–315; see also pp. 316–329). Written in German prose and supple-
mented with apocryphal material and events from secular history, these retellings
of biblical history are accompanied by illustrations relating directly to the text.
Their chief sources include, alongside the Latin Vulgate, Peter Comestor's *Historia
scholastica* (see pp. 246–249) of around 1169–1173, Vincent of Beauvais' *Speculum
historiale* of around 1250 and the rhyming German world chronicles of the 13th
and 14th centuries. Over 100 history Bibles still survive today, the majority of
them illuminated. They vary widely as regarding their extent, text and relation-
ship to earlier copies, and on the basis of their contents were divided by Vollmer
(1912–1929) into ten groups, some of these containing further subdivisions. His-
tory Bibles were found across the entire German-speaking realm, whereby the ma-
jority of surviving examples stem from the Alsace, Swabia and the Bavaria/Austria
region. Already documented in the 1300s, the history Bible saw its greatest flower-
ing between *c.* 1440 and 1470/80.

These prose history Bibles do not contain the same volume of text as the
sources on which they were based. They concentrate upon the narration of biblical
events; edifying commentaries and theological excursions are omitted. Their
language is also simpler: the elaborate descriptions found, for example, in rhyming
chronicles are pared down to only pertinent details. Their content is thus presented
in a manner that can be understood by all. In this respect, history Bibles were
responding to the needs of a wider readership, one consisting increasingly of mem-
bers of the laity – albeit still only the wealthy and the educated. History Bibles
offered these readers the opportunity to inform themselves about the Bible and
"world history".

History Bibles gradually had to cede their role as purveyors of biblical know-
ledge to the laity to the printed editions of the Vulgate which appeared in German
translation as of the 1460s. As a paraphrasing compilation of diverse, partially non-
biblical texts, and with the Reformation about to dawn, the history Bible could

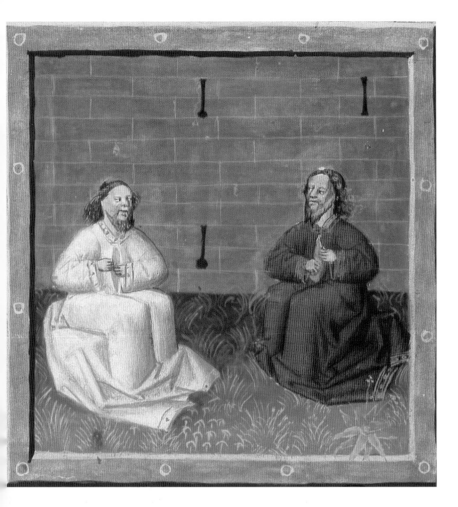

no longer compete with the Bible itself. For this reason, too, it was issued in print only rarely, and only in excerpts. "The rejection of apocryphal material by humanism and the Reformation contributed to the final disappearance of the history Bible in the 16th century." (Gerhardt [1983], p. 73)

 A. F. / K. H.

Genealogy of Christ

Upper Italy, 3rd quarter of the 15th century

The scroll, which is made up of six sheets of parchment glued together, measures almost six metres in length. It narrows at both ends into a sort of tongue which, at the top end, is pricked with holes, providing a possible clue to the manner in which the scroll was used: perhaps it was pinned up on the wall as a "teaching aid", allowing it to be studied if not at full length, then at least in sections.

The present genealogy derives its basic form from the *Compendium historiae in genealogia Christi* by Petrus Pictaviensis (*c.* 1130–1205), who was active in Paris as master and chancellor of the cathedral school. At the heart of the *Compendium* lies the so-called *Linea Christi,* an overview of biblical history from the Creation to the martyrdom of the apostles Peter and Mark. Even the earliest copies of this text began paralleling the genealogy of Christ with other genealogies, ultimately expanding the overview into a chronicle of the world. In the present example, the kings of the Babylonians, Persians and Romans on the left and the Assyrians, Egyptians, Shechemites, Syrians and Greeks on the right are named as collateral branches of the family of Christ.

The names given in the medallions are accompanied by explanatory captions, which vary greatly in their content and length from manuscript to manuscript. They draw upon various "historical" sources, the most important of which is Peter Comestor's *Historia scholastica*, completed around 1170 (see pp. 246–249).

The captions to the names are complemented by an ambitious pictorial programme, which opens with a schematic representation of the world and the story of Creation, told in six medallions (ill. p. 275). Adam and Eve, the primogenitors from whom the genealogy of Christ descends, are portrayed after their

Detail from segment 3: King David enthroned (start of the fourth age of the world).

▶ **Segment 1:** The Creator with a representation of the world composed of concentric circles: earth, water, air, fire, planets, zodiac, firmament of fixed stars. Below left and right: Adam and Eve. The story of Creation: (1) The creation of light:

the four elements arranged in bands, and above them the rays of the light. (2) God divides the waters. (3) God separates the land and the seas. (4) Creation of the stars and the vegetation. (5) Creation of the animals and birds. (6) Creation of Eve out of Adam's side. Noah building the Ark (start of the second age of the world); below right, the city of Salem (ancient name of Jerusalem).

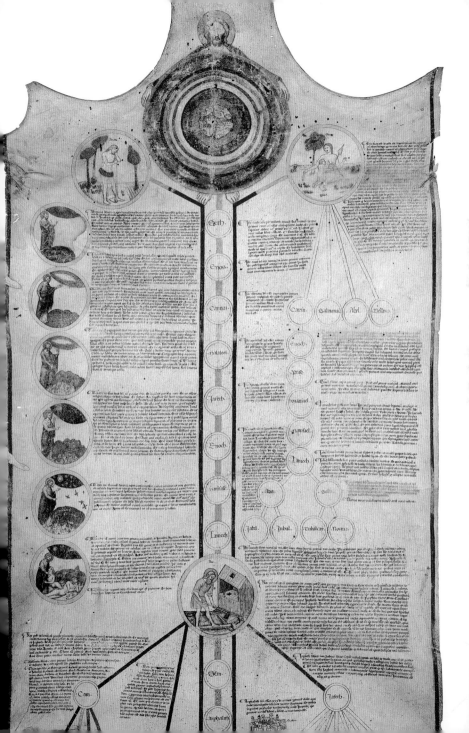

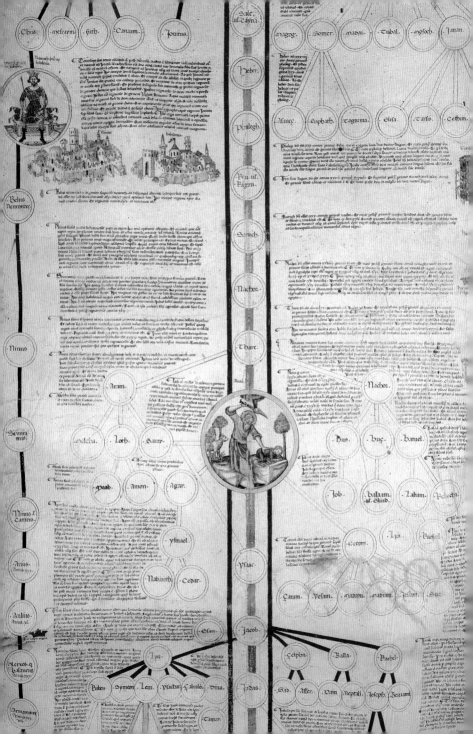

Segment 2: Nimrod, legendary ancient king of Babylon; beside him, views of Nineveh (capital of the Assyrian Empire) and Babylon. Abraham and the Sacrifice of Isaac (start of the third age of the world); below left, a crown marks the start of the genealogy of the Greeks; on the right, the city of Jerusalem and three crowns, signifying the genealogies of the Assyrians, the Egyptians and the Shechemites.

▶ **Detail from segment 6:** Birth of Christ (start of the sixth age of the world); Crucifixion with the Virgin and St John; the Resurrection of Christ.

Fall and Expulsion from Paradise. Thus they appear in the medallions beneath the circle of the world accompanied by a hoe and a distaff as the "attributes" of human toil. The genealogy of Christ unfolds in the following medallions with illustrations of Noah building the Ark, the Sacrifice of Isaac, King David on his throne and the high priest Salathiel. It concludes with three medallions depicting the Birth of Christ, the Crucifixion and the Resurrection. These scenes are not selected at random, but mark the boundaries of the six ages of the world, divided into the periods lasting from the birth of Adam to the Flood (1), from Noah to Abraham (2, ill. p. 276), from Abraham to David (3), from David to the Babylonian Captivity (4), from the Babylonian Captivity to the birth of Christ (5) and from Christ's birth to his Resurrection (6, ill. pp. 278/279).

In the collateral branches arranged parallel to the direct lineage of Christ, we find the proverbial hunter Nimrod, in his capacity as the ancient, legendary king of Babylon, and Alexander the Great as the "progenitor" of the rulers and empires born of his legacy.

In addition to these historiated medallions, the scroll contains more than twenty city views. Although seeming to vary individually in their shape and setting, they are all composed of more or less interchangeable elements. In keeping with the realism of the artist's day, these ancient cities have been transported into the 15th-century present; only occasionally do meaningful details such as the minaret in the view of Babylon find their way into them. In line with their significance in the Bible, illustrations are also devoted to the Tower of Babel and to a ground plan of Jerusalem as it looked after the return from the Babylonian Exiles.

A. F.

Extent: parchment scroll
Format: 5860 x 620 mm
Content: Genealogy of Christ
Language: Latin
Illustration: historiated medallions containing scenes from the Creation and biblical figures; numerous city views and schematic illustrations
Provenance: The scroll was purchased from a private collector in 1913.
Shelfmark: Vienna, ÖNB, Cod. Ser. n. 3394

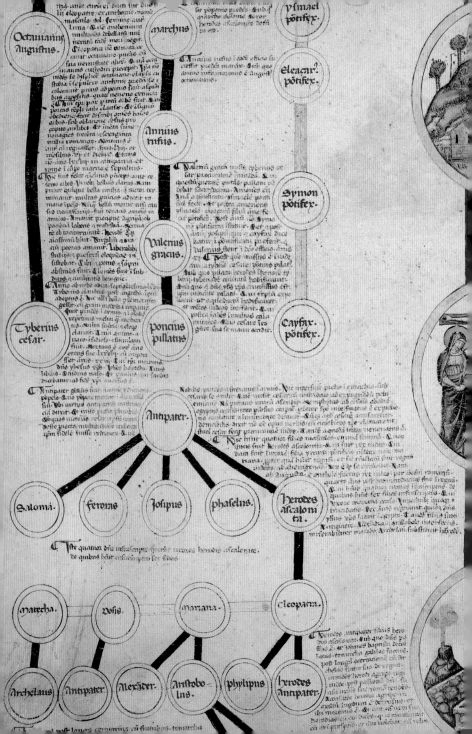

Octauianus Augustus.

marchus

ysmael pontifex

Eleacar pontifex.

Annius rufus.

Symon pontifex

Valerius gracus.

Tyberius cesar.

poncius pillatus.

Cayfax pontifex.

Antipater.

Salomā. — **feroras.** — **Josipus.** — **phaselus.** — **Herodes ascalonita.**

Matecha. — **Vosis.** — **Mariana.** — **Cleopatra.**

Archelaus. — **Antipater.** — **Alexander.** — **Aristobolus.** — **phylipus.** — **herodes Antipater.**

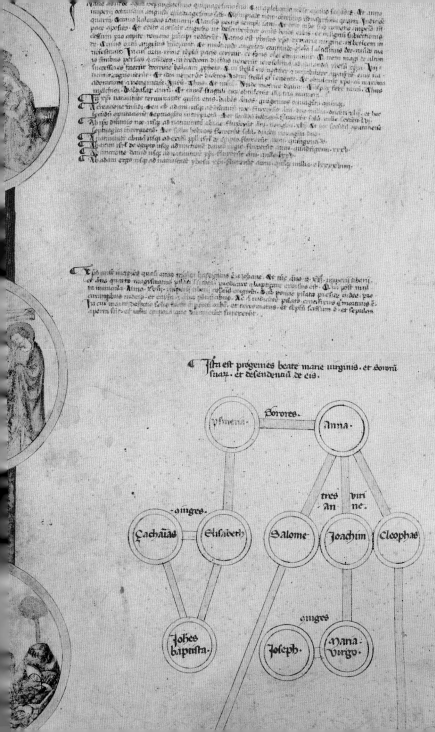

¶ Ista est progenies beate marie uirginis. et sororū
suaγ. et discendenaū de eis.

Ysmeria — Sorores. — Anna

tres viri
Anne ne

·omnes· — Zacharias — Elisabeth — Salome — Joachim — Cleophas

omnes

Johes
baptista — Joseph — Maria
Virgo

Histoire ancienne jusqu'à César (Histoire universelle)

Venetia, 2nd quarter of the 14th century

Medieval world chronicles offer a "universal" view of history that perceives biblical stories in the same overall context as secular events, myths and legends. Often lavishly decorated and written in the vernacular, such chronicles were aimed at a lay public and were both educational and entertaining. The *Histoire ancienne jusqu'à César*, which originated within court circles in northern France, was one of the most popular works of this genre. It was written in the early 13th century for a chatelain of Lille by the name of Roger (IV) and represents the earliest surviving world chronicle in French. It was widely distributed in the Middle Ages, as evidenced by more than 70 copies from France, Acre (Palestine) and Italy, together with two revised versions in French and several Italian translations. The text contains Genesis and other Old Testament stories about Judith and Esther, together with pagan tales from the Orient and Greek and Roman antiquity. Its rich collection of prose texts, some of them furnished with a prologue and moralizing interpolations in verse form, is influenced not just by major theological treatises such as the *Historia adversum paganos* by Orosius (c. 418) and Peter Comestor's *Historia scholastica* (see pp. 246–249), but also by various classical epics and more recent vernacular romances.

The present codex represents one of the copies of the *Histoire ancienne* produced in Italy in the late Dugento and Trecento in response to a widespread interest in French literature. Dante described the *langue d'oïl*, the old language of northern France, as the language of vulgar prose, citing as an example a Bible compiled with the deeds of the Trojans and Romans (*De vulgari eloquentia* I,X,2). He was undoubtedly referring to an *Histoire ancienne*.

Codex 2576 contains a number of linguistic peculiarities which seem to point to the fact that the manuscript was produced in Venetia. This argument is supported by the illustrations, which were initially thought to be Provençal but which

Detail from fol. 32v (Genesis): Jacob visits his aged father Isaac in Mamre.

▶ **Detail from fol. 9v (Genesis):** Building of the Tower of Babel. The figure of God borne by angels appears in front of the tower, probably as an abbreviated illustration of the Babylonian confusion of tongues.

lle fience q̃ grꝛe dieu cudoiet eſtruier ꙅcon
tendꝛe Encoꝛe adonꝗz neſtoit parle par tꝛ
lemode cuns ſol lengage Seignoꝛꙅ ceſtoit
ebrieus ꭍli nif parolent encoꝛe que deuant
ceneadonꝗz quant cele tour fu comice na
noit encoꝛe eſte ois nettoues ꝗ un ſol legage
oans parcelle tour furet les tꝛanxoꙅ ꙅledui
ſe parole pmes troues ꙅ parlees ſi poꝛeſtraon
comb ꙅenꝗl maineie. Coment lilengue
Quant nꝛe ſir dieu qui furent troue
ꙅ toute creatuꝛe. auoit oꝛdenes ꙅ faite aſſi
nolente mꝛ le gnt oꝛgoil ꙅlegnt ontrage
decelle ient ꝗ ne recreioient mie il abaiſſa
loꝛ oꝛgoil ꙅloꝛ folles audaces e mit petite
emine Car qnt latour fu amont menee
con ielenos adeſcite nꝛe ſir loꝛ enuoia ſi

Fol. 3r (Genesis): Initial with the Creator giving a gesture of blessing. In the lower margin, two scenes from the Creation of Eve: God removes one of Adam's ribs while he sleeps and then breathes life into Eve.

are now generally considered to be Venetian dating from the mid-14th century (or slightly earlier). The numerous miniatures, which unfold across the lower margin of the page and are not framed, illustrate a variety of subjects in an unequal series of scenes. More than half of the entire pictorial programme is devoted to Genesis, which is accompanied by a cycle of 24 miniatures. These are followed by secular illustrations, such as "chivalrous" scenes of knights in battle in accordance with the conventions of medieval epics. Codex 2576 thereby exhibits almost no connection with the iconography of other copies of the *Histoire ancienne*. Its distinctive illustrations are based instead on different sources, which in the case of the Genesis cycle can be traced specifically to Venice. Many of its scenes are indebted to the pictorial vocabulary of the Cotton Genesis of late antiquity, and to the 13th-century mosaics on the porch of San Marco depending on it directly. This intensive assimilation of the pictorial sources of late antiquity can be seen, for example, in the inclusion of small, moving figures in rear view, which appear closely related to the illusionistic style of the *Vienna Genesis* (see pp. 54–65). There is nothing rare about such borrowings in Venetian manuscript illumination of the Trecento (see, for example, the *Roman de Troie* in Madrid, Bibl. Nac., Ms. 17 805; *c.* 1340/50). Early Bibles were evidently available in Venice and, as the present codex makes clear, continued to exert a powerful influence upon Venetian art centuries after their origin.

V. P.-A.

Extent: 155 leaves of parchment
Format: approx. 335 x 255 mm
Binding: ornamental roll binding of Johann Benedikt Gentilotti, prefect of the Vienna Hofbibliothek (1705–1723), dated 1720
Content: Histoire ancienne jusqu'à César (also known as Histoire universelle)
Language: French

Illustration: 46 miniatures; eight historiated and nine non-historiated initials; fleuronnée lombard initials. The initials from fol. 111v onwards frequently include decorative bar borders incorporating animals and figures drawn in pen.
Provenance: In 1665 the codex passed to the Vienna Hofbibliothek from Ambras Castle, near Innsbruck.
Shelfmark: Vienna, ÖNB, Cod. 2576

hgnaue émesopotanne⁊latl qͥas feme ⁊ se
ne teueut sur demagͤnation⁊aluy oes dousan
sens tu coz deliures ⁊ hezer urraront ēs le sa
me con li demanda abraam sō sire Lors sapare
hezer sans nule demorance por luy tosd meti
la noue ⁊ biē sakies qͥl men a ·x· kameaus ēsa
gͤne ⁊ aueuc les serͤgens qͥl les casoyent ⁊ bien
pent li serͤgēs langies ⁊ li kameaus deriches ar
⁊ denobles tells ⁊ oͫ adone sauoit pͤser ens en c
cōtre argent ⁊ or ⁊ dras desoye ⁊ se ᵱ yseon ē ar
⁊ core ⁊ dečes coses meisme mͭ porta il ases a
luy Car il sauoit que poi auoit ē celle tere ua
⁊ autre rikeses Car bien sakies qͥ ·x· cameaus ᵱ
porter mͭ gͤt fais ⁊ gͤt somes Et bien sakies
noir estoit on que ehezer uenͥst qͥl su amour pͤ

ne betha ehezer

◄ **Detail from fol. 23v (Genesis):** Eliezer and Rebekah at the well rendered in Venetian style with an acanthus capital.

Fol. 37r (Genesis): Pharaoh's cup-bearer dreams of the vine whose grapes he squeezes into a cup. Pharaoh's baker dreams of the three bread baskets which are emptied by birds.

History Bible

Urach (Swabia), 1463

The present German-language history Bible represents the only surviving copy of what Vollmer has identified as version Ic of the text (see Introduction). It relates the history of the world from the Creation to the destruction of Jerusalem (AD 70), incorporating along the way events from secular history, in particular from the life of Alexander the Great. It is thereby based on version Ia of the original text, here expanded and modified in structure, using as a chief source a 14th-century world chronicle by one Henry of Munich.

Codex 2823 differs from the second history Bible discussed in this chapter, Codex 2766 (see pp. 302–315), in its format, which measures only about half the size, in its use of paper instead of parchment as a material, and in its "modest" illumination with pen drawings in just a few different colours rather than with miniatures and initials in body colour and gold. Its illustrations also reflect an entirely different artistic concept. This manuscript conforms, in fact, to a type of book which was not only faster and cheaper to produce and which could therefore be afforded by a broader section of the population, but which also took into account the requirements of its readers, most of whom were members of the laity.

The illustrations in the present codex reveal the same reduction to essentials that characterizes the text of history Bibles in general (see Introduction). The portrayal of events is pared down to only what is absolutely necessary; narrative details that do not directly serve to convey the meaning of the scene are omitted, and no attempt is made to describe the setting in any depth: nothing is to distract the viewer from the central message of the picture. Hence there is also no attempt at dramatic staging or colouristic "effects". Instead, those individuals and objects important to the scene are brought together in simple compositions that are easy to understand and remember. They are clearly characterized so that their respective

Detail from fol. 37r (Genesis): Abraham's servant, who has returned to his master's homeland to seek a wife for Abraham's son, Isaac, meets Rebekah at the well outside the town.

▶ **Detail from fol. 65v (Genesis):** Joseph is pulled by his brothers out of the well into which they had thrown him naked, and is sold to Midianite merchants.

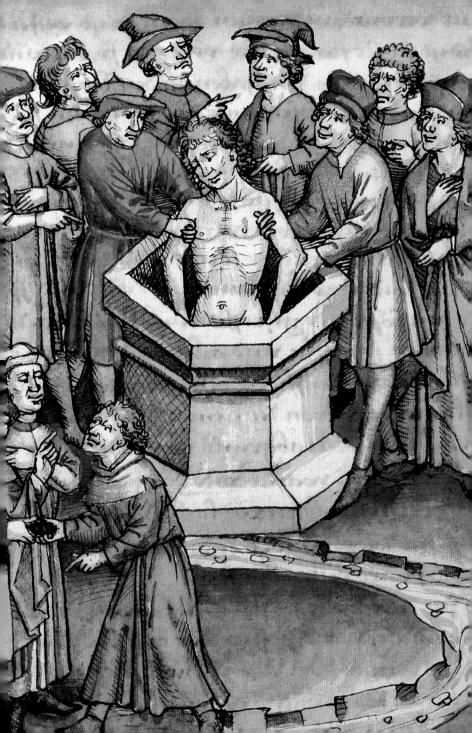

Fol. 1r (Genesis): A summary of the story of Creation up to the creation of man, including the creation of the angels.

▸ **Fol. 1v–2r:** Lucifer and his supporters are flung into the jaws of Hell by other angels. The two pictures on fol. 1r and 1v appear in front of the text, which begins on fol. 2r with a plain lombard initial instead of the usual decorative initial.

roles within the scene can be immediately discerned. It is the artist's intention that the entire composition should be grasped quickly and easily. This is encouraged by the repetition of individual elements and compositions that the reader can soon learn to recognize, and by pictures which summarize a story in a single, condensed image rather than in a series of separate scenes as employed in world chronicles.

The captions written above or below the illustrations play an essential role when it comes to recognizing the scenes portrayed. Thus clearly identified, the pictures take on a new autonomy vis-à-vis the text. This allows them to be extracted from their traditional location within the column of text and placed on a separate page – in some cases at a considerable distance from the passage they accompany. The illustrations are quite clearly intended to be contemplated "for themselves". In this way they provided the educated lay reader with easy access to the history of salvation. It should thereby be noted that, both in the individual drawings and the choice of scenes illustrated, there emerge certain thematic emphases that remain to be defined.

The production of this history Bible is unusually well documented: it is dated 1463 on fol. 412v, and its copyist can perhaps be identified by his initials (regarding his previous, probably inaccurate identification, see Scribe below). Furthermore, an account drawn up on fol. 417v also provides details of the names and/or place of work of the other individuals involved in the production of the codex (see Binding, Illustration). At the same time, this list of expenses provides information about the cost of the materials and the respective wages of the artists and craftsmen.

K. H.

Extent: III + 417 sheets of paper
Format: approx. 290 x 205–210 mm
Binding: red leather over wooden boards, blind lines on the front and back cover, traces of two clasps; original binding, 1463 or shortly afterwards, made by Renbold, a bookbinder in Urach
Content: history Bible
Language: German (Swabian dialect)
Scribe: On the grounds that the manuscript originated from the collection of the Zimmern family, the scribe, who has signed his initials on fol. 412v, has been identified with Gabriel Sattler-Lindennast from Pfullendorf, who copied several books for Johann Werner von Zimmern the Elder. Since the scribe's initials should probably be read as B. S. and not as G. S., however, this identification is likely to be incorrect.

Illustration: lombard initials and rubrication by one Stefan Sesselschreiber (perhaps the same as "Stephan Schriber" from Urach); 116 mostly full-page coloured pen drawings by an artist from Urach, with captions in red ink.
Provenance: The manuscript was probably produced for Johann Werner von Zimmern the Elder (1454–1495) or for his father Werner (c. 1423–1483); whichever the case, in 1576 it was presented to Archduke Ferdinand II (1529–1595) by Wilhelm von Zimmern (1549–1594) and passed from the Zimmern collection to the library at Ambras Castle. In 1665 it was transferred to the Vienna Hofbibliothek by praefect Peter Lambeck.
Shelfmark: Vienna, ÖNB, Cod. 2823

Hie stossend die Engel lucifern in die helle

Als got in siner maiestat vnd kraft schwe
bet vnd alle ding in siner wißhait hette
vnd bracht sie in liechten schin zů gnauden vn̄
beschůff den himel wúnieglichen mit sonne mo
nen vnd sterne̅ Da mit zieret er sie in hocher ere
vnd beschůff dar in nún kör die engel dienen got
vnd wonen by im vnd sind boten vnd etlich engel
sind im näher sie senden die andern in botschafft
wise So sind etlich gewaltiger dan̄ die andern
vnd wie vil die engel zů dem metschen botschaft
werben so schawen sie sich doch nit von got vnd se
hen mit freiden vnd sie her wider vnd lebend in alle
zitte Es wissend och die engel zů kúnfftige ding
die sehen sie in gottes augen vnd verkúnden sie de̅
mentschen nauch gottes gebott Vnd hait och ain
etlicher mentsch ain engel der sin hüttet vnd bring
et sin gebett vnd allmůsen vnd was er gůttes tůt
fúr got Die hösten ertzengel das ist gabriel raph
ahel vnd michahel Sant gabriel haisset gottes
sterckin So ist raphahel gottes ertzny Sant micha
hel ist by got nähe vnd hait in got zů probst ge
macht in hocher kraft úber das paradis So sind
sust vil tusent engel vor got der namen wir nit
wissent

Do got die engeln beschůff in den himmeln wú
nenglich gar schön vnd liecht do vor luaset úber
alle engel schar der aller schönst vnd clarest deß

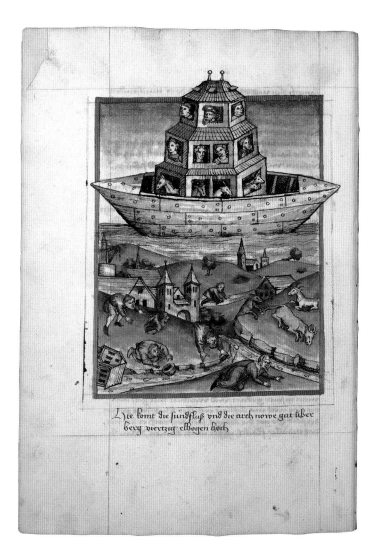

Lie kont die fundfluß vnd die arch nowe gat über
berg viertzig ellbogen hoch

Fol. 18v (Genesis): The waters of the Flood cover the earth, drowning people and animals; Noah's Ark floats over the hilltops.

► **Detail from fol. 31v (Genesis):** The Destruction of Sodom and Gomorrah and the Saving of Lot: as Lot and his family flee from the burning city, his wife looks back, against divine instructions, and turns into a pillar; Lot and his two daughters carry on.

►► **Detail from fol. 91r (Exodus):** A summary of the Egyptian plagues: visited by a plague of frogs and mosquitoes, Pharaoh calls for Moses.

◄ **Detail from fol. 97v (Exodus):** The Crossing of the Red Sea: while the Israelites, who have passed through the Red Sea without getting their feet wet, continue on their way, the Egyptians pursuing them are drowned as the waters flood back.

◄◄ **Detail from fol. 102v (Exodus):** God delivers his Commandments to Moses on Mount Sinai, at whose foot the Israelites have assembled.

Fol. 181r (1 Samuel): David and Goliath: David swings his catapult in the direction of the enormous Philistine, who is here equipped with a staff, the usual attribute of giants.

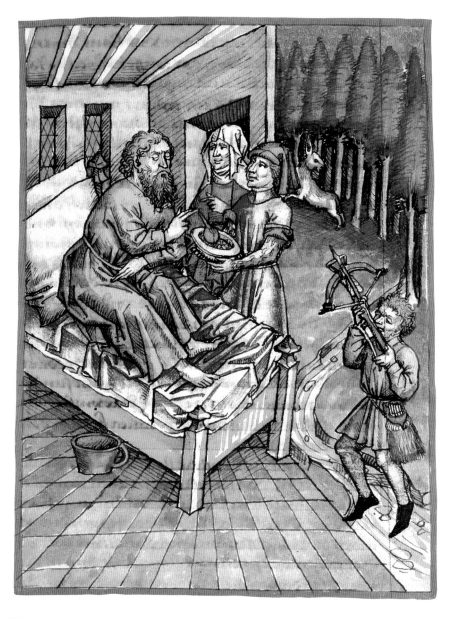

Fol. 42r (Genesis): The blind Isaac gives his younger son Jacob the blessing due to the first-born, while the elder Esau is out hunting game for his father.

▶ **Detail from fol. 341r (Judith):** Holding the severed head of Holofernes, Judith arrives at the gate of her native town of Bethulia, whose inhabitants greet her with astonishment.

History Bible
Vienna (?), *c.* 1470 (?)

The text of Codex 2766 preserves what Vollmer (see Introduction) has classified as version IIIb of the German-language history Bible, which starts from the Creation and continues up to just before the life of Charlemagne (747–814). The author has thereby reworked the Old Testament version IIIa, a German extract from Peter Comestor's *Historia scholastica* (see pp. 246–249), by expanding or replacing the biblical stories, by introducing episodes from secular history such as the founding of Rome, and – most significantly – by adding a New Testament section focusing primarily on the history of the emperors and popes. The primary source for these additions was a 14th-century world chronicle by Henry of Munich, from whom the division of history into six ages is also derived. The present version IIIb also survives in six other manuscripts, all produced in Austria in the 3rd quarter of the 15th century.

Both in its technique and choice of material, and in the form taken by its illustrations, the present history Bible bears little relation to the "modern" editions of the same text which were being produced with simpler, more economic means and aimed at a much broader lay public, as represented by the history Bible discussed earlier in this section (pp. 286–301). Like other codices in group IIIb – some of which boast an even greater number of illustrations, even if few surpass the dimensions of the present manuscript, whose format and use of parchment clearly identify it as a de luxe edition – it takes up the tradition of chronicles written in rhyme. This deliberate revival of an "old-fashioned" style of manuscript undoubtedly reflected the wishes of the patron.

In line with tradition, the text in Codex 2766 is subdivided by decorative initials and illustrated with relatively small, framed miniatures. These are dotted about within the columns of text, always near the passages to which they relate.

Detail from fol. 54v (Exodus): God delivers his Commandments to Moses on Mount Sinai.

▶ **Detail from fol. 5v (Genesis):** God creates the sun and the moon (4th day of Creation).

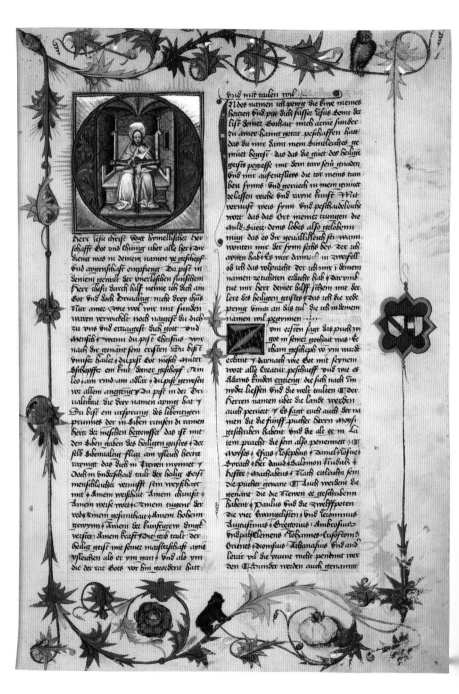

Herr Jesu Crest Got hymellischer her
schafft Got vnd chunig uber alle ewr
dienet mit in deinem namen ye geschepf
vnd aygenschafft empfieng Du pist in
deinem gewalt der vnerloschen sünstchen
Herr Jhesu durch hilf neime ich dich am
Got vnd doch driualtig nicht drey thus
flur amen wie wol wir mit sünden
mitten verwickelt noch naygest du dich
zu vns vnd erzaugest dich wol vnd
mensch wann du pist christus wir
nach dir genant sein cristen Du pist
vnser hailer du pist Got mensch vnter
tschöpffer ein lint deiner geschöpf Ein
leo am vnd an adler du pist gewesen
wir allem angeweng du pist in der dru
ualtikait die drey namen ammet hat
Du bist ein vrsprung des lebentigen
prunnes der in siben rinnen di namen
heit der mesellen betewffet das ist mit
den siben gaben des heiligen geistes das
selb sibenualtig flies am ysleich hertze
raynigt das dich in trewen mynnet
Doch in underschaid tails der heilig geist
menschleiche vernufft sein weyßhait
mit amem weißhait amem chunst ir
amem weis met amem tugent der
red amem gesinthait amem hoher
gewym amem der kunstigen dinst
verseer amem kraft die gab tails der
heilig geist mit seiner maisterschafft ayne
ysleichen als er yn wan vnd als ym
die der rat Gots vor im geordent hatt

vnd mit tailen wil

In des namen ich petew die line meines
hertzen vnd pitt dich faisse Jhesus deine der
list deiner Gothait mich arme sünder
zu amer hant getat beschaffen hatt
das du mir sam mein himlreiches ge
müet berest das das gut des heiligen
geists gemesse mit dem taw sein gnaden
vnd mir auffentslies die tot mein tun
ben synne vnd geruch in mein gemüet
zelassen reiche vnd ayne kunst Mit
vernufft weis synn vnd beschaudeleuche
wort das das ort meiner zungen die
auß suez dein des lobes also zelobem
müt das es die gewalliklich sei wann
wonten mir der form seits bey der ich
ayren hab Es wir armen in zweifell
ob ich das warhaet der rechen i deinem
namen zerichten erdacht hab darvmb
tue mir herr deiner hilff sichem mir die
lere des heiligen geistes das ich die rede
pring himts an die teil die ich in deinem
namen wil petremen

Um ersten sagt das puch vm
got in seiner gothait wie be
erkant y darnach wie Got mit seynem
wort alle creatur beschüeff vnd wie es
Adams kinden ergieng die sich nach im
wider liessen vnd die welt tailten Der
herren namen über die landt werden
auch periert y Es sagt euch auch der na
men die die fünff pücher herren moysi
geschriben habent vnd die als ee in La
tein pracht Sie sein also zenemmet
Moyses Esias Josephus Daniel Josue
Syrach der dauid Salomon Juditch
Hester Machabeus Nach erlesteln sein
die pücher genant Auch werden die
genant die die Newen e geschriben
habent Paulus vnd die zwelffpoten
die vier zwaniglisten vnd Jeronimus
Augustinus Gregorius Ambrosius
vnd pabst Clemens Johannes Crisostom
Oriens Dionisius Athanasius vnd and
lerar vil die ytzunt nicht penennt wer
den Die andern werden auch genannt

Fol. 1r: Opening page with a decorative foliate border inhabited by animals and vegetal masks; in the right-hand margin, the arms of the first owner, yet to be identified. At the start of the text, an ornamental initial depicting the Holy Trinity in the image of the Throne of Grace.

This form of illustration guarantees that words and image are grasped at the same time, with the role of the picture being to express the content of the text in another "language". Thus we are dealing here with narrative representations in which the episodes in the text are staged in clear and lively scenes, even infused with a certain drama, whereby colour is also used as a means of expression.

To what extent the illustrations in this manuscript are dependent upon the iconography typically employed in earlier world chronicles, and to what extent they adopt the abbreviated manner characteristic of the history Bible as a genre (see pp. 286–301), are questions that have yet to be addressed. Quite different aims, however, inspired the exquisite distant landscapes which form the background to many of the present miniatures, and which can sometimes contain secondary scenes and even genre-like motifs painted on a truly miniature scale (e.g. ill. pp. 306, 314). The illumination of Codex 2766 has also yet to be examined more closely from a stylistic point of view. It was evidently executed by at least five different artists, some of whom can be grouped in the vicinity of the Lehrbüchermeister (Master of the Textbooks) active in Vienna in the 1450s–60s. It is on the basis of this link that the manuscript has been provisionally classified; in order to confirm its origins, however, it would be helpful not only to identify the first owner and scribe, but also to undertake an in-depth analysis of the various individual styles represented within the illuminations.

K. H.

Extent: 258 sheets of parchment
Format: 475 x 340–345 mm
Binding: Vienna, after 1713, Étienne Boyet the Younger; dark blue leather over pasteboard with a linear frame and the arms of Prince Eugene of Savoy (1663–1736) in gold tooling on the front and back cover; also on the back cover, an entwined double E
Content: history Bible
Language: German (Bavarian-Austrian dialect)
Scribe: The text was copied by the notary Kuntz Kwermrewter, who placed his signet and name in the lower margin of fol. 52v.

Illustration: 58 decorated initials, two of them historiated, at the beginning of the six ages of the world, the books of the Bible and their subdivisions; the majority terminate in foliate arabesques occasionally inhabited by animals; 222 framed miniatures illustrate the text.
Provenance: The manuscript's first owner has yet to be traced; the two coats of arms on fol. 1r may help to establish his identity. In 1738 the manuscript passed to the Hofbibliothek from the collection of Prince Eugene of Savoy.
Shelfmark: Vienna, ÖNB, Cod. 2766

mannes suen vnd vnsiz ist noch am
der ist der Iungist vnd ist do hamm pei
vnsem vater peliben / do sprach zo
schü das ist auch das ich sag das ir
speher seit mann es ist vnmüglich
das am man der senen got mit ge-
tzauzen mag wer er sei od wo er sei
Als ir sprecht ir seit ebraisch volk
vnd mügit ewrn got mit getzauzen
Als vil gelükchs hiet vnd das er sam
leüche kinder hiet man es ist den
trossen kunnigen gar sellsam · Die
doch wissen wen sie anpeten das sie
als vil suen haben darumb sag ich
euch bei der warhait des kunigs pha-
raonis das ir all von dem lande mit
komet hintz das ewr künigster pruder
her kumpt / darumb sent am aus
euch der yn pring wann Joseph
wacht sie hieten mit dem brueder
auch vnpilleich gefarn / darnach gab
ma sie gepunden das ma ir drei tag
hütte dem dritten tag fuezt er sei aus
der bannknütz vnd pehielt den aynen
Symeon die andn lies er varen ·

do klagten sie vndemand vn sprachen
wir leide pilleich wan wir haben ge-
fundt an vnsm pruder vnd weste mt
das er ir sprach weshuend wann er hat
wr / gewelt durch einen tulmiatschen
do schuef Joseph mit seine dienern das
sie yn ir seck fulten vnd legte einem

yrslewhem sein gelt in sin sakch oben
auf die speis · ¶ vnd do furen sie
vnd kome tzu dem vater vnd sayten
yn alles das yn widerfarn was vnd
do sie ir sakch aufpunten vnd das korn ·

aus schütte do vand yrslewh sein gelt
in seine sakch vnd do erschraktien sie
all · do sprach der vater Ir habt mich ye
raubt meiner kind Joseph ist mit hie
Symeon leit gefangen / benyamyn
sol ich auch do hin senden / das übel
vnd das vngelükch ist mir khomen
Do sprach Ruben · vater emphilch mir
benyamyn vnd ist das ich yn nicht
widerpring / so versticke mem paid
suen · vnd do sprach der vater dem
suen der kumpt nicht mit euch ·

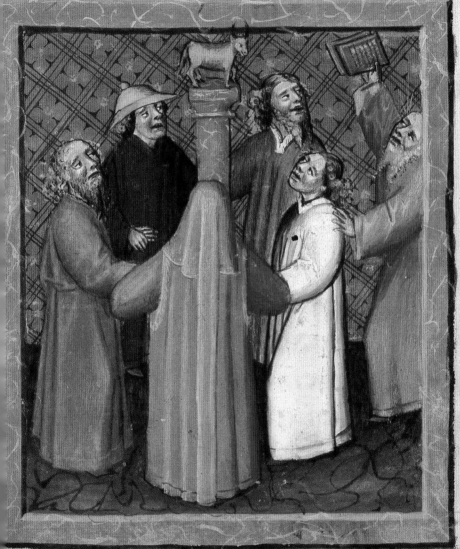

vnd das gold das doron kichom
rant er tzepuluer vnd strewte
s in das wasser vnd hab es dem

Fol. 207r (Jeremiah): Ornamental initial at the start of the Book of Jeremiah with a portrait of the seated prophet, holding a banderole in his right hand as a symbol of his prophecies.

▶ **Fol. 231v:** Ornamental initial marking the start of the sixth age of the world, which dawns with the birth of Christ; above, a representation of the Holy Trinity in the shape of three identical enthroned figures.

vnd den ersten das ist den prelat
vnd den vndertan vnd sie mugen
nur mehr empflehen wan wer
fleucht den hilt das meht vn ist
das das er in der helle grut dann
da vindet yn darnach mein gewalt
oder ob er sich preget in die liefst
dannen wil ich yn fueren vnd
fleucht er dem an des mers grut
da wil ich meinen trakchen hyn
senden der yn da totet Glosa Nu
spricht der prophet vo der kunst
vnsers herren Ihesu cristi auf erde
secht es kumpt noch d tag das süs
sikeit wirt fliessen vo den perren
Glos die perg bezaichet an der stat
de himel vn werde alle tal gepawt
Glos die tal das sein diemutige hrtz
vn ich wil mein volk widerbringen
vnd wil nus müest nus das das
werde gepawet vnd wil mein
wolkk pflantzen in tr erblant
Glosa Vnser erblant ist der schön
himel Also das sie da vo nymmer
mer werden gesthauden noch ver
stossen Amen Amen Amen

Hie endet sich die alt ee vnd sind
aus die finf alter der werlt
Das erst alter der werlt was von
Adam vntz Noe do waren vgan
gen tzmaltausend tzrahundert
vnd xlv iar das ander was von
Noe auf Abraham do man hin
Newnhundert vnd xlv iar das
dritt was von Abraham auf da
uid do waren hm Newnhundert
vnd siben vnd viertzig iar das
vierd was vpn dauiden auf der
Iuden vanckhnüss do waren hm
vierhundert vnd lxxx iar das
funft was von der Iuden vanck
nüss vntz her do sind vergangen
sfünfhundert vnd lxxx iar
So sein vergangen von Adam
vntz her fünf tausend tzwuhim

Nu hebt sich an die New ee vnt
der gepurd Ihesu cristi vnd ist das
sechst alter der werlt das wert auf
den Anticrest

Prologus
Kunig Da
uid behielt
gotes gepot
darumb ge
lobt ym got
das sein same
das reich ewigkleich besitzen solt
Hie ist tzu merkhen das die ge
hauss die dauid vo got empfange
het ewigkleich besten wie doch das
was das das der Iude zestort
was wann alles geslächt das vo
herren dauid chom die wurden
all fürsten doch lebten ettleuch i
sünden darumb wurden sie vo
dem kümreich entsetzet dannoch
bestunden gotes wort wann die
hoch gelobt Iunkfrau Maria ein
tochter Ioachym vnd sant Anne
die da geporn was von dem küni
mgkkleichen geslächt hin dauids
aus der Iesus xprystus geporen
ist warer got vnd mesch vnruckt

Detail from fol. 113r (2 Samuel): Ahithophel hangs himself because his advice, which would have brought ruin upon King David, was ignored.

▶ **Detail from fol. 143r (Isaiah):** The prophet Isaiah is sawn in two.

Durch des weissagen gepet willen
¶ Epiphanus schreibt do der kunig
sennacherib von Egipto tzoch do er
sich fuer Jerusalem legte Do legt
er sich zu dem weier Siloe darumb
das das her da wasser hiet wann

Details from fol. 70r (Numbers): Aaron and the
princes of the tribes of Israel discover that Aaron's
staff has sprouted and blossomed. When Moses
strikes the rock with his staff, water flows out of it.

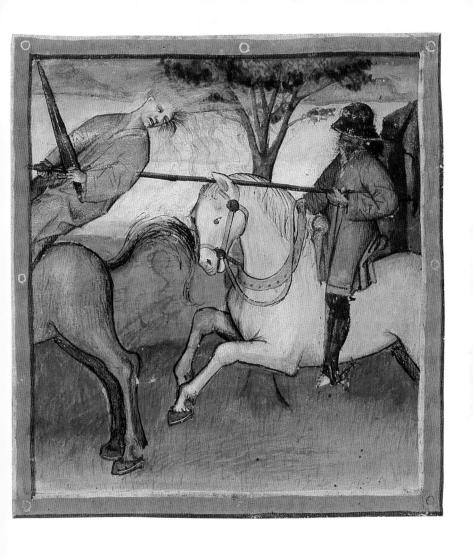

Detail from fol. 113r (2 Samuel): Absalom, David's
son, remains hanging from a tree, his hair caught
in its branches, and is killed by Joab.

Vnd do fie moifen ftraffen do fprach
moyfes fuecht ein micht warm got
hat es alfo gefchickt das er hewt fecht
fein groffe wunder wan er mit heut
fur ew rechten vnd das volk das er nit
feht das feiht ir nymer mer

das waffer veft als ein maur an
paiden feitten vnd do das volk
von Egipto das fach do wanten fie
fie waren von den frmen komen

Do ruefft moyfes hincz got der
antwurt was weeffeft du
hincz mir hed auf die gerten vnd
reck dein hant auf das mere vnd
tail es das das volk w yfrahel truken
fuere do hub fich der engell auff
der ir gelait was vnd ftund zwifch
en dem volk Egipto vnd w yfrahel
vnd das gewulkchen was den von
Egipto vinfter Aber dem wolk von
yfrahel leucht es vnd do moyfes fein
hant auf hueb do kom ein groffer
wint vnd macht das mer truken
vnd tailt fich in zwai tail Alfo das
ein yfleich geflacht durch fcherten
Do rueft moyfes einem yfleich
en gefchlacht vnd pat fie das fie ym
nach wolten warm er uberfuer
Vnd do fich huben Symeon
vnd auch Leui peforgten das fie
an das mere furen So wolt ym
Iudas von erft nach vnd do mit
verdienet er das ym das reich
wart Darnach fueren fie alle
durch das mere vnd do wart

vnd do fie fehn fahen uberfarn do
zugen fie nach vnd was mete
tzeit do fah got uber das volk von
Egipto micht mit feiner zuere vnd
famt yn mit feiner ful von fewr
gewolkchen vnd laidleuchen verzen
zorn vnd plekigten do erfchracken
fie vnd fprachen vnr fullen fliehen
das volk von yfrahel warm er got
richt fur few do kom das volk
von yfrahel an das lant gezten yn
vnd do das volk von Egipto alfo in
angften was do reket moyfes fein
hant auf das mer von gotes gepot
vnd do flos das mer reift in feinen
lauf als ee vnd uberziah das volk
von Egipto Alfo das er kainer aus
kom do nam das volk von yfrahel
alle ir waffen do macht moyfes
einen gefangk vnd lobt got vm fprch
wir fullen got fingen vnd yn loben
wan er lobleich an vns getan hat
do belaib das volk von yfrahel hy
ben tag pei dem geftat des meres
vnd komen alftag zu ſr geftat des

Fol. 51r (Exodus): The Crossing of the Red Sea:
God shows his people the way – by means of clouds
in the daytime, and at night with a pillar of fire.

▶ **Detail from fol. 228r (Jonah):** Jonah is thrown out
of the boat by the oarsmen and is swallowed by
a big fish.

History Bible of
Evert van Soudenbalch

Utrecht (northern Netherlands), *c.* 1460

In terms of the scope, lavishness and meticulousness of its artistic decoration and the quality and originality of its miniatures and decoration, the Soudenbalch Bible is undoubtedly the most outstanding of all the Middle-Netherlandish history Bibles still surviving today. It represents a copy of the first Netherlandish translation of the Bible, which was made in the southern Netherlands probably around 1360/61 (Deschamps [1972]). A masterpiece of Dutch manuscript illumination, its inclusion of the arms of the Utrecht canon Evert van Soudenbalch allows it to be confidently localized to Utrecht. The pictorial cycles in this Bible signify a turning-point in the history of Bible illumination insofar as they show the artists beginning to emancipate themselves from the traditional conventions of biblical illustration. Instead, they take the inspiration for their pictures directly from the biblical text in its vernacular form. These first attempts to establish a direct, personal relationship with the material of the Bible pave the way for the emergence of a "freely inventive" narrative style which would reach its high point in Rembrandt's unremitting, unorthodox interpretations of biblical events. The illuminators are often concerned less with portraying the external scene than – for the first time – with conveying the psychological dimension of the events taking place. This is something specifically Dutch. In one example in the present Bible, Daniel is seen being led into the lion's den on King Darius' orders. Darius is portrayed not giving a gesture of command, but rather as a passive ruler being coerced by two villains. In this way the Master of Evert van Soudenbalch illustrates Darius' unwillingness, as described in the Bible, to throw Daniel to the lions (fol. 247v).

Part of the explanation for the divergence in the present Bible from canonic iconography lies in the fact that the illustrations are inspired not by the Vulgate

Detail from Cod. 2772, fol. 189v: Decorative border.

▸ **Cod. 2771, fol. 9r:** Right-hand side of the double-page diptych: The celestial sphere with the planets and signs of the zodiac; above, God the Father enthroned in the choir of a church; around the choir and the sphere, worshipping angels. (Master of Evert van Soudenbalch)

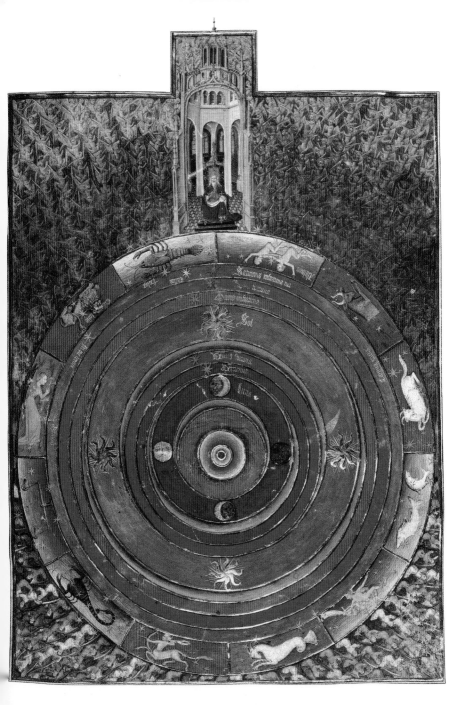

but by the commentaries of the *Historia scholastica* and by the prologues to the biblical books written specifically for this Bible. In the first volume, a number of the pictures are inspired by passages of text that had never before been selected for illustration, with the result that the illustrations include a series of iconographically unique compositions, such as the Burial of Cambyses (Cod. 2771, fol. 265r). Furthermore, there is no clear division between the books of the Old Testament and those of the New Testament (in Codex 2772 the New Testament is followed by the books of the Maccabees and the Book of Psalms).

In seeking to explain the emergence of this new approach to biblical illumination, we must also consider the religious climate prevailing in the northern Netherlands, which was strongly influenced by the *Devotio moderna* movement and its calls for religious renewal. This movement had begun in the Netherlands and by the end of the 14th century had spread across the whole of Europe, finding

Cod. 2771, fol. 49v (Genesis and Exodus): Jacob's Blessing. The burial of Joseph. The Israelites working in bondage to the Egyptians (making mud bricks). (Master of Evert van Soudenbalch)

Cod. 2771, fol. 129v (Deuteronomy): God shows Moses the Promised Land from the top of Mount Nebo. The burial of Moses (two scenes in one miniature). (Master of Evert van Soudenbalch)

In den begin sciep god
hemel ende eerde. Maer
die eerde was onnut
en ydel en donckerhe-
den waren op dat aen-
sichte des afgronts.
En gods geest wart
gedragen bouen den
wateren Scolastica

In den begin was
twoert en dat
woert wast beginne
In den welken en by
den welken die vader
die werlt sciep. Dyt
woert was sijn ewige soen. men heyt
die werelt in vier manyeren. Eerst so
heytmen den geesteliken hemel die wer-
relt om sijn suuerheyt. ende sulke tijt
dese begripelike werelt. en die griecse
heten die werelt pan. En die latijnse
hetense omen dat is al. Wat die philo-
sophi en kenden den geesteliken hemel
niet. en sulke tijt heetmen die werelt
dat lantscap alleen dat onder der ma-
nen loep is. Want dese werelt heuet
alleen in die dier die wi kennen en
hier of is geseit. die pnice der werrelt
dats die diuel en sal daer niet werden
verdreuen. En sullke tijt so heetmen die
menschen die werlt. Want hi heeft in
hem alle die gelikenisse der werelt en
daer om is hi vanden heer inde ewange
lio geheten alle. en die griecken heten den
mensche microcosmū dat is die mynre
werlt. Die geestelike werelt en die begri-
pelike werelt en dat lantscap onder die
mane dat sciep god
lijperlick. dat is hy
maecter van niet.
maer den mensche
niet properlicken
want hi blassame
reden. En daer in
is betekent sijn
hoge wesen om
dat hi mit voirsie
nicheiden gemaket was. Ende vander
scepping vanden eersten drien werelde
seyt moyses. In den begin sciep god he-
mel en eerde. hi sciep den hemel dats
te verstaen en dat daer in was scildich
te sijn dats den geestelijken hemel en

Die geestelike wer-
elt of die geestelike
hemel dat heetmen
in latijn empyrtū
dats die hemel daer
god en sijn liene
moeder in sitte. En
daer die neghe cho-
ren der heiliger en-
gelen in sitten

nde het gescie
de na dien
dat saul doot
was dat da
uid weder ke
rede vā ame
lechs geslech
te en dat hi
twe dage ge
duerde mi sy
teleth En ten
derden dage

openbaerde een man comende wt sauls
getelde mit gescoerden cledere en mit
gemul op thoeft gespreyt En doe hi tot
dauid comen was so viel hi op syn aen
sichte en aenbeden. En dauid seide tot he
waen coemstu. En hi seide he. Ic bijn ge
vlogen wten getelden van ysrl. Ende da
uid seide tot hem wat woerde datter ge
siet is segt my. Hi seide tvolc vloech va
den stride en hoe veel vande volke syn
daer geuallen en doot gebleuen. mer
saul en ionathas syn dier doot gebleue
En dauid seide totte iongelinc die dier
boetscapte waer bi weetstu dat saul ende
syn sonen doot syn. En die iongelit die

hoeft was en die a
en ic hebse gebmet
pe pōden segt
ghen dat de
sone van ydumea.
so gaf hem syn vad
teysxene die hi pla
dragen soude tot d
de dauids vrient
daer na viel hi oe
reden en is met co
hiete van ydumea
lech. want die va
ydumea. want a
soen die ezaus zon
nde dauid
cledere en
manne en
weenden en sy scir
auonde op saul en
op sheren volc en
datsi mitte zwerd
dauid seide totte io
scapt hadde. waer
bin eens toecomel
amelechs soen. En
om en ontsaechst
steken om shere e
En dauid riep ene
seide coempt voer
en die sloechen ei
de tot hem. want
di seluen gesproke
consacreerde coni
nede dit geween o
syn soen. En hi geb
van ysrl ten botfte
rechter boer gestre
ls dauid ve
bleuen wat
hi datne die kijnd
als mder rechter b
boecx so en heefst

a particular reception in Germany and Bohemia. The new kind of narrative style and the departure from traditional iconography are encountered in the work of all six illuminators engaged on the present Bible, and most clearly of all in the miniatures by the Master of Evert van Soudenbalch. Colour also plays a particular role for all the artists, be it in the vibrant palette employed by the Master of Evert van Soudenbalch in his figures and settings, or in the gloomy, matt palette adopted by the Master of the Cirrus Clouds.

It is probable that the six illuminators were all employed in the same workshop, as they also collaborated on other codices (on a Book of Hours in Brussels, Bibl. Royale, ms. II 7619, for example, and another in Liège, Univ. Bibl., ms. Wittert 13). A single editor was in charge of the overall pictorial programme of the Bible. Some of his instructions to the artists have survived in the lower margin, and have clearly been closely adhered to by the illuminators. The present history Bible is undated, but can be assigned together with other works by the Soudenbalch Master – one of them dated 1460 (the Brussels Book of Hours) – to around 1460.

U. J.

Extent: 343 and 261 parchment folios
Format: 395 x 293 (Cod. 2771) and 395 x 288 mm (Cod. 2772)
Binding: bindings of blue morocco by Etienne Boyet the Younger, Vienna, after 1713.
Content: copy of the "first history Bible in Middle Netherlandish"; in addition to the books of the Bible, also secular texts (e.g. the history of Alexander, excerpts from Flavius Josephus' De Cyro and The Jewish War, including the description of the destruction of Jerusalem); extracts from Peter Comestor's Historia scholastica as a commentary on the biblical texts; own prologues to the individual books of the Bible.
Language: Middle Netherlandish
Miniaturists: The hands of altogether six illuminators have been identified in the two volumes: Master A (represented by one full-page miniature, Cod. 2771, fol. 8v), Master of Evert van Souden-

balch (chief master of the 1st volume), Master of the Cirrus Clouds (represented in both volumes), Master of Gysbrecht de Brederode (one miniature in Cod. 2771, f. 243v; mostly represented in Cod. 2772), Master E and Master F (a small part of Cod. 2772)
Illustrations: Cod. 2771: 134 miniatures; 27 decorated initials; numerous fleuronnée initials. Cod. 2772: 110 column-width miniatures; 23 historiated and 33 ornamental initials; eight smaller historiated initials; numerous fleuronnée initials.
Patron: The Bible was commissioned by Evert van Soudenbalch, canon of Utrecht cathedral from 1445–1503 (donor portrait in the block of Creation miniatures.)
Provenance: The manuscript passed into the possession of Prince Eugene of Savoy (1663–1736) and was acquired by the Hofbibliothek in 1738.
Shelfmark: Vienna, ÖNB, Cod. 2771–2772

Detail from Cod. 2771, fol. 165r (1 Samuel): Samuel
cuts Agag into pieces before the Lord. (Master of
Evert van Soudenbalch)

Detail from Cod. 2771, fol. 166v (1 Samuel): David
kills Goliath. (Master of Evert van Soudenbalch)

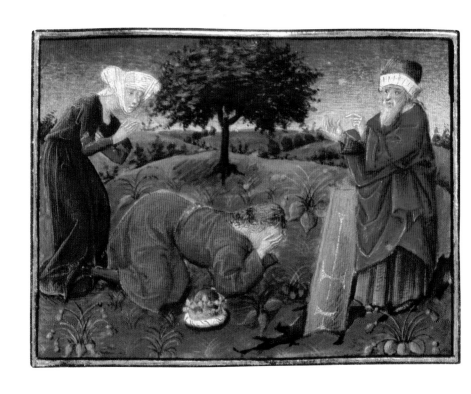

Detail from Cod. 2771, fol. 173r (1 Samuel): Saul
visits the medium of Endor; the prophet Samuel
appears and prophesies that Saul and his sons will
die the next day. (Master of Evert van Souden-
balch)

Detail from Cod. 2771, fol. 218v (2 Kings): Queen
Jezebel is torn apart by two dogs and trampled
by two horses. (Master of Evert van Soudenbalch)

▸ **Cod. 2772, fol. 10r:** The symbols of the four Evan-
gelists as the title-page to the concordance
of the four Gospels; below: bridal couple.
(Master of Gysbrecht de Brederode)

Sancte iohannes ewangel

Sancte marcus ewangelist

Sancte lucas ewangel

Sancte matheus ewangel

hier beghint dat prologus opte ewangelie

V si wi come
totten nywe
testament en
hier na volge
die ewange
lien · Aer om
dat wi dye
geesten van
den hystorie
volge willen
so sullen wi
hier bescrive

die ewangelien diemen heet concordan

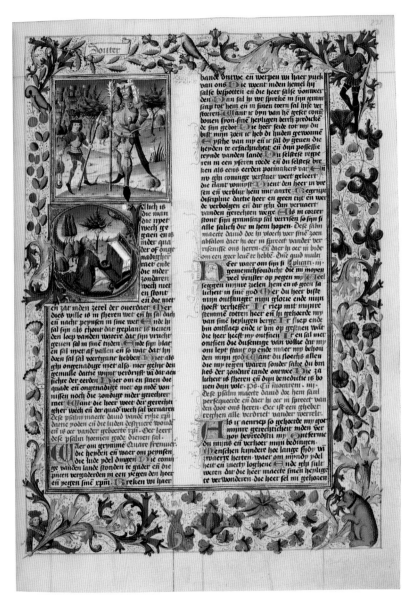

Cod. 2772, fol. 231r (Psalms): David and Goliath, title-page to the Book of Psalms. Historiated initial underneath: King David kneeling before an altar. (Master of the Cirrus Clouds)

► Detail from Cod. 2772, fol. 198v (Josephus Flavius, *Jewish Antiquities* XIII–XVI): The queen gives a command to a messenger (left-hand foreground). Aristobulos' mother in prison (right-hand background). (Master of the Cirrus Clouds)

ajer dat zeuende jaer dattie voeden
an quam. En jan toech vande poert
ptolomeus doode syn moeder en syn
en hi vloech tot senonen den conic p
phien diemen heet coelia en toena·
Hier na beleyde antyochus ponticue
En om dese zake dede jan hyrcaen o
vande acht coffers die omtrint dau
stonden· En hi nam daer wt meer d
talente· En hi gaf antyocho· iij·c tale
hi van yerosolima trecken soude· En
hi die murmuracie vinden wolke v
woude dat hi dat graft ondaen hadde
kede hi mitten anderen gelde binne ye
teerste hospitale va armen· Dese jar
samarien en slechtet· aier daer na v
herodes en hietse sebasten· En doe jan
iaer die dingen alte wel geregiert ha
sterf hi en hi liet vijf sonen na hem d
aristobolu den eerst geboren en anti
mit drien minderen broeders· En om
ment van he lude tamelic en was o
te regeeren so sette hi boue judea he e
en syn wijf die alte wijs was. Hoe de

segge. hier om leyde aristodie gewapede man
in een duwiere die ond die eerde was diem hiet
purgastroton daer antigonus oū lyde soude dat si
en doot slaen soude waert dat hi gewapēt qme
En aristobel riep den bode tot hē en beual he dat
hi sine broed seide dat hi met gewapēt en quame
aj die conigin verwan den bode mit ghifte dat
hi hem segge soude dat hi gewapēt quame
wāt die conic begeerde te zien in sijn scoen wapene

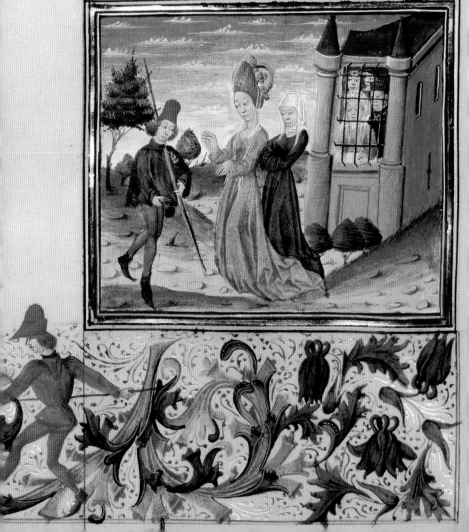

The juxtaposition of the Old and New Testaments in typological picture Bibles

Typology is the name given to a method of biblical interpretation which sees a meaningful connection between specific events or figures in the Old Testament and similar events or the figure of Christ in the New Testament. The Old Testament element is thereby understood as the prefiguration, or type, of its New Testament counterpart, which represents its fulfilment, or antitype (Schrenk [1995]). This typological "method" was necessitated by the (Christian) view that the Old Testament occupied a firm place in the history of salvation through its references to the New Testament.

The foundations of typological exegesis in literature and the arts were first laid down in the early years of Christianity. Typology subsequently saw a significant flowering in the picture Bibles of the late Middle Ages: in addition to the manuscripts discussed here, further important codices of this kind include Ulrich von Lilienfeld's *Concordantia caritatis* (arose after 1350) and the Marian-oriented *Defensorium inviolatae virginitatis beatae Mariae* by Franz von Retz (†1427).

In Codices 2554 and 1179 (see pp. 336–347), the Österreichische Nationalbibliothek owns the oldest surviving examples of a type of Bible known as a *Bible moralisée*, a luxury manuscript in which scenes from the Bible are paired, in large-scale pictorial programmes, with an interpretation of their meaning. To assist the reader in understanding the connection between the pictures, brief captions identify the individuals and events portrayed. The connection between biblical passage and interpretation is generally established by the phrase "signifies that". For example, in Codex 2554, the fact that Saul forbids his people to eat or drink until

Biblia pauperum, Cod. 1198, detail from fol. 9v: 33rd picture group (above): Moses receives the Tablets of the Law from God.

▶ Bible moralisée, Cod. 2554, detail from fol. 37r (1 Samuel): (1) Samuel rebukes the sons of Israel; below: Christ rebukes the Jews. (2) The Israelites bring iron into the country and make weapons; below: the wicked students go to Bologna to study

law. (3) Saul forbids his people to eat or drink until the battle is over; below: the good princes and prelates forbid the Christians to turn to worldly things before they have conquered the devil. (4) Saul is victorious over the Saracens, but his son licks a stick with honey on it; below: the good Christians are victorious over God's enemies, but the wicked turn to worldly things.

the end of the battle signifies that the good princes and prelates forbid the Christians to turn to worldly things before they have defeated the devil (ill. p. 331; lower left-hand pair of medallions). Since most commentaries in these books adopted the same or a similar moral slant, they became known as *Bibles moralisées*, "moralizing Bibles" – a term which appears in a 15th-century copy of the text of one such Bible. Other methods of exegesis are also employed, however, including typology, and the miniatures permit associations that go beyond the explanations in the captions.

A total of seven fully-illustrated *Bibles moralisées* have survived into the present, six of which arose between *c.* 1220 and 1480 in Paris; the seventh, produced in England, is a copy of one of these other six. It is very probable that these manuscripts (with the exception of the English copy) were executed for members of the French royal family: a number of invoices relating to the *Bible moralisée* ms. fr. 167 in the Bibliothèque Nationale de France, Paris, name the French king John the Good (1319–1364) as patron. Housed in the Pierpont Morgan Library in New York is the final sheet of the copy belonging to Toledo cathedral, showing a queen and king enthroned above a monk and an illuminator who are both working on a *Bible moralisée*. The clearest evidence that these Bibles were produced for royalty is provided by the final sheet of Codex 1179 in Vienna, which shows a king holding up an open *Bible moralisée* (ill. p. 34).

Another typological work highlighting the unity of the Old and New Testaments, this time in a condensed form following the life of Christ, is the *Biblia pauperum*. The term is misleading: this intellectually sophisticated "Bible of the Poor" was certainly not intended for an uneducated class of *pauperes* (poor) or *illitterati* (illiterate), but for an educated, clerical circle of users. The oldest surviving manuscripts of the genre, dating from the first half of the 14th century, originate from the Bavaria/Austria region and probably arose within a Benedictine or Augustinian context; their prototype is thought to have appeared at the latest around the middle of the 13th century. More than eighty examples of the *Biblia pauperum* are still extant, not just as – in the majority of cases – illustrated manuscripts, but also as block books and later printed versions. Together they testify to the enduring popularity of the so-called "Bibles of the Poor" and document the longevity of typology well past the Middle Ages. The typological comparisons they offer may arise out of biblical events or be symbolic or theological in nature. The fact that such comparisons are frequently only superficial reflects an intellectual watering-down that is characteristic of the late phase of typological picture cycles. In the case of the *Biblia pauperum*, it can be explained to a certain degree by the systematic layout, in which Old Testament types and prophesies are always arranged in the same fashion around a central New Testament scene. An insight into the comprehensive scope of the themes is offered by the present Codex 1198 (see pp. 356–361), here reproduced almost in its entirety.

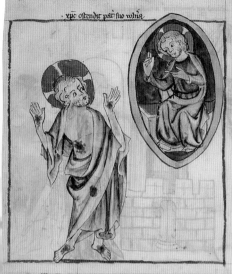

xpc oſtendit pat̃ ſuo vlña · anripater miles · Iuliuſ cesar

Cap̃m·ccxxviij·

J̃ p̃cedẽtc̃ ca·audimuſ qñ·nr̃a·mediat̃e
comu audiuꝰ cħri̓ſ ſoliꝰ Anguſtuſ cẽ mr̃a defcꝰ arc
ſtc̃ audiam̃ cħm·v̓·p̃ nob pr̃ ſuo oñdr̃ vlña
z m̃ oſtendit filio ſuo pectꝰ et vbera
z it̃ nr·x⁰ deſcẽdit q̃ noſ de celo ad nſr̃u
z tã traſcendit i celũ vt orat·p̃ nob uſqꝫ iſp̃timu
z ideo ſi peccauim̃ deſpare̾ non debem̃
cħ fidelem Aduocatū apud deũ hem̃
A aut x⁰ vulnium cicatreſ pr̃ moſtre noleba̾
h oc z olm̃ p̃ qdam figã oñ̃ium erat
A ntipꝫ mileſ ſtrenꝰ v̓latꝰ fuit tp̃atori Julio
M mſidel z iur̃ã finiſ romano impio
z q̃ ille ſe e̾uenſ nudꝰ co̾a tpr̃atore ſtaba̾
z ei cicatreſ vlñu co̾a oib̃ ſ oſtendeba̾
N irmꝫ nõ opuſ cẽ vb ſe e̾purgare
e̾ ti cicatreſ vidrem̃ euꝰ fidelitate adamite
Q̃ milcſ cesar euꝰ euenſacoem̃ app̃baba̾
z eū fidelem militẽ z ſtrennū aſſir̃nbant
P̃ uilc·v̓·v̓figuȑat·ſuit p̃ iſtu antip̃em̃
z xp̃e ſepꝫ p̃ nob ſtat añ ſuū pr̃em̃
z cicatreſ ſuꝰ oſtendt̃ ſe miliꝫ ſtrñuū fuiſſe
z mãdatū pr̃i cuiꝰ taqꝫ fidel mileſ ipleuiſſe
cħ q̃ dt̃ tã fidelẽ militẽ nõ ceſſat honoȑare
z ꝓctiqꝫ petierit pat̃ z ſibi daȑe
Q̃ nr̃a fidel ſtr̃nuuſ mileſ xp̃e eȑat

h oc i cicatrib̃ ſuiſ z co̾tanſ veſtib̃ app̃eba̾
d A euſ iduūcia eȑant ſanguinolenta
s ſicut ſunt vitaſ calcãtiu veſtimẽta
A q̃ a̾ceba̾ ſerti̓ tṙe iduūcia euꝰ eſſꝫ rubra
s ſeu iroziculari vitaſ calcanciū
M tũdr̃ q̃ torcular paſſioniſ ip̃e ſol̃ calcaꝫ
e de gib̃ genti̓b̃ vir·ſecū non fuiſſe̾
s nõ dixr̃ q̃ de oib̃ gẽtib̃ vir ſecū nõ fiaꝫ
e tũ vnica vȝo·v·m̃·ſecū pim̃ſtraȑi
M ileſ iſte ſeȝ ſc̃ã more Alm̃anico
v bi m̃ cȑeda̾ milari ſolꝫ dari colaph̃ i collo
s milc̃iſtre·v̓·nõ recepit tũ colaph̃ vnũ
s ſ collapbox z alapaꝫ qi ih̃m tũ nũm̃
e x̃pti̓ cuiꝰ eȑant aſſimil cauſeſ·d̃ie palmaȑu
e aꝑuiſ p̃clui iſ p̃ugnabat eȑat mõ tauiariaꝫ
A Aſta eſ·v̓·loŋ·z militꝫ lancea
e eona d̃ Accutiſſimiſ ſpiniſ eȑat z p̃ galca
s igr̃uū ſeu ornameñtū galce fuit tabla regali
B Alreuſ cuiꝰ eȑat ligauita z fimelſ
M Actiblm̃ cruciſ ꝑbeba̾ p̃ clypeo z ſcuto
ꝓ rõ calcaȑib̃ vtiꝰ i clauo fȑeo vno
A euca ſua qᵒ totũ coꝑꝰ ſuiſ tegeba̾
e e̾an cuiſ ꝙa qi flagellacõe cõt̃ ſcurieba̾
s laduiſ ſuiſ eȑat ſc̃ã docena q̃ dɾceba̾
e z ch̃rõt̃ea̾ manuit diuaſ clauoſ fȑeoſ hebaȝ

An early example of a *Biblia pauperum*, it adheres to a strict visual programme comprising 34 uniformly structured picture groups laid out over 17 pages (ill. pp. 356–361). If we compare this to the *Biblia pauperum* housed in the Österreichische Nationalbibliothek as Codex 370, it becomes clear how the linear arrangement of the pictures there leads to a considerable vagueness in the typological relations (ill. pp. 348–355).

Surviving, lastly, in at least 350 to 400 Latin and vernacular manuscripts as well as numerous printed copies, is the most widely distributed typological work of the late Middle Ages, the *Speculum humanae salvationis*. Although fewer than half of these manuscripts are illuminated, the "Mirror of Salvation" must have been conceived with illustrations right from the beginnung, probably in the long, 45-chapter version represented here by Codex Series nova 2612, an early example of the genre (ill. pp. 362–371). Its simple, memorable pictures and detailed texts address themselves to a broad public drawn from both the clergy and the laity. The origins of the *Speculum* remain obscure. Initially thought to be a work by the Strasburg-based Dominican Ludolf of Saxony (see pp. 258–267) dating from 1324, it is now increasingly assumed to be an Italian work of the late 13th or early 14th century. Astonishingly, the first examples emerge more or less simultaneously from about 1320/30 in Italy (Bologna) and southern Germany, whereby certain details establish a link with the Dominican order – the vision of a Dominican, for example (ill. p. 370).

Typology in the *Speculum* becomes the starting-point for a broader contemplation of the mystery of the Divine Plan from the beginning to the end of the world. As suggested by its title, it seeks to hold up to man a mirror that will reveal the connections running through the history of salvation in order to save his soul. In addition to Christ, the Virgin Mary now also plays a prominent role: as the counterpart to the Man of Sorrows, who is showing his wounds to his Father, we find the Mother of God baring her bosom to her Son – both symbolic images of *intercessio*, the intercession with God on behalf of humankind (ill. pp. 333, 335). Strikingly, the Dominican receiving the stigmata in the vision mentioned above is also shown with the Virgin's sword in his heart, symbolizing her pain at the loss of her son (ill. p. 370). The underlying concept here is that of *compassio*, the compassion aroused by contemplating the Passion. Such devotional images, which in the *Speculum* accompany the traditional scenes from the New Testament, announce a new quality in typology, one inconceivable without the influence of contemporary mysticism.

A. F. / C. B. / V. P.-A.

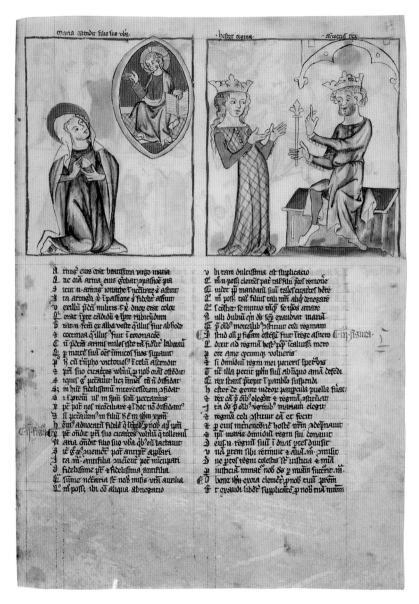

Speculum humanae salvationis, Cod. Ser. n. 2612, fol. 41v–42r: 39th chapter: *Christ shows God the Father his wounds* (symbolic image of intercession). Antipater shows Julius Caesar his scars to refute the accusation that he is a disloyal and ineffective soldier (after Peter Comestor, *Historia scholastica*). This page: the *Virgin Mary* bares her bosom to her Son (and thereby intercedes, like Christ, for humanity). Esther intercedes with Ahasuerus for her people.

Bibles moralisées

Paris, 1st half of the 13th century

Codices 2554 and 1179 in the Austrian National Library are the oldest surviving examples of a type of commentary on the Old and New Testaments known as the *Bible moralisée*. Not a very common genre, the *Bible moralisée* offers interpretations of the Christian scriptures, conveyed in a particularly sumptuous and attractive format. Neither manuscript gives the name of its first owner, but the circle of possible patrons for such lavish manuscripts, whose concept, text and iconography were entirely new and whose design was modified and expanded upon in every subsequent copy, was surely very limited. The commission for codices 2554 and 1179 is most likely to have come from a member of the French royal family in the 1st half of the 13th century. Support for this argument is offered, in the case of Codex 1179, by the penultimate medallion on the right-hand side of fol. 246r (ill. p. 34): it shows a king on his throne, holding a sceptre with fleur-de-lys in his left hand and the open *Bible moralisée* in his right. The inscription accompanying this medallion in the right-hand margin was erased by a later hand, and it is no longer possible to make out a name. Since the manuscript can be dated, on grounds of its style and content, to the period between 1220 and 1230, the king in question might be Philippe Auguste II († 1223) or his son Louis VIII († 1226). Louis IX was still a minor when his father died and it is more likely that he would have been portrayed without a beard. The original owner of Codex 2554, which unlike Codex 1179 is written in French, not Latin, is popularly imagined to have been Blanche of Castile, who married Louis VIII in 1200. After her husband's death, she took over the running of government for a few years on behalf of her son, Louis IX, and died in 1252. Unfortunately, the end of the manuscript, which might originally have contained a reference to the owner, is today missing, as are a number of other pages.

The manuscripts arose just a few years apart and were each illuminated by a team of artists, some of whom contributed to both Bibles. Which of the two can lay claim to the title of first *Bible moralisée* remains a matter of dispute. Those who argue

Detail from Cod. 2554, fol. 10r (Genesis): Christ's arrival in Hell.

▶ **Cod. 2554, fol. 1v (Genesis):** God as the Creator of the world.

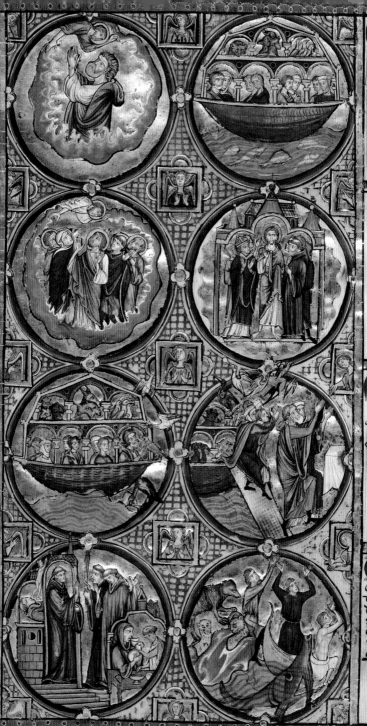

Ci sau
en la n
le comn
dames te
trois fil
nie.

Ce qe dame
dex rauist
enoch en la
nue senefie re
sucrist qi en
meine les su
ens z rauist
en la celestial
compagne.

Ce qe sau
de z con
me senefie
crist qi se
o sa mer
les suen
re eglise.

Li enuoie floc
un colon foil pa
sauon sil tanoial
terre feme zal
nettrunt puis z
puisen cu una
ure zal tanuit le
pies enboez z pui
is fen oia a un co
bel z al salist lui
une charugne.
lors enuoia un
colon z al tant la
terre feme et
aporta un raim
doliue en sa bo
che...

Ci a da
cesse li
euel reti
floc senifie
o tot sa m
z reut ge
den de ce
getre de c

Ce qi enuoia tot
les oiseaus senefie
le bon prelac qi en
uoefos les deceples
por preechier li
meaus colons bon
fiel bon doistrurer
qi muert en cloistre
li colons qi reuint
es pies enboez se
nefie le bon moi
ne qi s enesue
e boe non ruet
arrier. Li corbeau
se nefie le mauue
voine qi s aresie
z la charugne
demoire.

Ce qe de
la guer
celui peril
tot cell
deu e van
peril qe il
enterre o
mer z de
gerre.

Cod. 2554, detail from fol. 3r (Genesis): (1) God gathers up Enoch; below: Christ gathers his own into the company of heaven. (2) Noah saves himself and his family in the Ark; below: Christ saves his own in the holy Church. (3) Noah sends out birds to look for dry land; below: the good prelate sends his disciples out to preach. (4) God has saved Noah from danger; below: God saves the faithful from dangers.

that Codex 1179 came after Codex 2554 point out, by way of supporting evidence, that its page layout is easier for the viewer or reader to follow and was adopted by later *Bibles moralisées*. The medallions are grouped in vertical pairs: a scene from the Old Testament on top, and below it a second scene interpreting its meaning. In Codex 2554, the second pair of medallions does not follow beneath the first but beside it, so that the direction in which the page is read is different. In Codex 1179 and in later *Bibles moralisées*, the captions inserted between the two columns of medallions ensure that the viewer's eye is guided from the top to the bottom. The second pair of medallions is now found beneath the first one and not beside it (compare ill. p. 338 with ill. p. 346).

Who designed the impressive pictorial programme is unknown. A theologian who understood something of the methods of biblical exegesis was undoubtedly involved. In most cases, the texts beside the medallions are closely related to the scenes portrayed, although less so in Revelation, where the medallions are accompanied by lengthy passages from the scriptures (on fol. 246 f., for example, (1) is accompanied by Apc 22:6–15, (2) by Apc 22:16–17 and (3) by Apc 22:18–21). These extracts from the Bible combine with the illustrations to weave an even more complex web of inter-relationships. In the following section we shall confine ourselves simply to identifying the figures and symbols in the medallions; for a proposed interpretation of their meaning, see Tammen (2002). There are nevertheless inconsistencies within the programme for which no other source demonstrating the same flawed knowledge of the Bible has yet been found (for example ill. p. 346, where the commentary beside the medallions misinterprets the events illustrated, which in fact tell the story of Ruth 1:6 ff.; the captions below are based on the erroneous commentary).

Extent: 130 parchment folios
Format: 344 x 260 mm
Content: Bible moralisée (commentaries on the books of Genesis, Exodus, Leviticus, Numbers, Deuteronomy, Joshua, Judges, Ruth, 1 and 2 Samuel, 1 and 2 Kings); the page order was altered by mistake when the binding was replaced
Language: French
Illustration: one full-page miniature, 129 pages each containing eight miniatures in medallions
Patron: Blanche of Castille (?)
Provenance: Codex 2554 arose in the 1st half of the 13th century in Paris and was probably commissioned by a member of the French royal family. In the 16th century, an additional page was inserted, bearing the arms of the Mercy, Luxembourg, Beaupart, Beauvau-Craon, Lenoncourt and La Mark families, all of whom were based in the Lotharingian Luxemburg area. To which particular member of these families the manuscript might have belonged has yet to be determined. The codex later reached the Damenstift in Hall (Tyrol), following whose closure it passed to the Hofbibliothek in 1783, together with the convent's other holdings.
Shelfmark: Vienna, ÖNB, Cod. 2554

There is still a great deal of research to be done into the thought underpinning *Bibles moralisées*. Relatively easy to understand, on the other hand, is the typological relationship between the two medallions making up each pair, whereby the Old Testament scene in the first medallion serves to prefigure the second, New Testament scene. An example of this is illustrated in the pair of medallions in the lower right-hand corner of fol. 5r in Codex 2554 (ill. pp. 342/343): in the upper of the two medallions, we see Abraham approaching an altar in the mountains, where he is to sacrifice his son Isaac at God's command. Isaac is carrying on his back the wood needed for the sacrificial fire. The artist has portrayed the bundle of wood in the shape of a cross, in order to make clear the parallels between the Sacrifice of Isaac and the Crucifixion of Christ in the medallion underneath. The caption to the lower medallion explains: "That Isaac is carrying the wood for the sacrifice signifies Jesus Christ, who is carrying his Cross for his Crucifixion."

In addition to such typological illustrations, there are many which attempt to infer from the stories in the Old Testament lessons about the right way to behave, and thus to unlock the moral message of the holy scriptures. Relatively frequently, these take the form of instructions about correct learning and teaching, and about problems such as usury, greed and the threat posed to the Church by unbelievers.

Extent: 246 parchment folios
Format: 430 x 300 mm
Binding: dark blue morocco over pasteboard, hand gilded, bearing the arms of Prince Eugene of Savoy (Vienna, Étienne Boyet the Younger, after 1713). Content: Bible moralisée (commentaries on the books of Genesis, Exodus, Leviticus, Numbers, Deuteronomy, Joshua, Judges, Ruth, 1 and 2 Samuel, 1 and 2 Kings, Nehemiah, Job, Daniel, Tobias, Judith, Esther, 1 and 2 Maccabees, Apocalypse)
Language: Latin
Illustration: one full-page miniature, 242 pages each containing eight miniatures in medallions, on fol. 42r and 52r one ornamental initial and four medallions, on fol. 162r one ornamental initial and two medallions

Patron: King Philippe Auguste II († 1223) or his son Louis VIII († 1226)
Provenance: It is fairly certain that the Bible was produced for a member of the French royal family in the 1st half of the 13th century in Paris. A coat of arms incorporating a double-headed eagle and a heart-shaped shield divided into red and white fields on fol. 1r and 246v have not yet been identified with certainty. The manuscript was later owned by Prince Eugene of Savoy (1663–1736). In 1738 Emperor Charles VI acquired parts of the Prince's collection, including the present Bible moralisée, from his heiress Victoria of Savoy, Duchess of Sachsen-Hildburghausen (or Saxe-Hilburghausen). In 1809 the manuscript was taken to Paris. Since 1914/15 it has been housed in the Vienna Hofbibliothek.
Shelfmark: Vienna, ÖNB, Cod. 1179

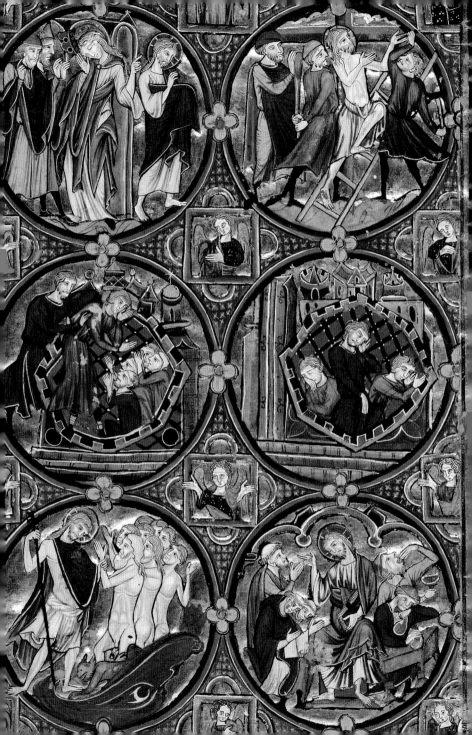

Il dist der
a abraham
q̃ il face sac̃
fice de son
fil ꞇ abraham
dist a son fil
prencele busche
ꞇ alomes en la
montaigne.
ꞇ cil si fist.

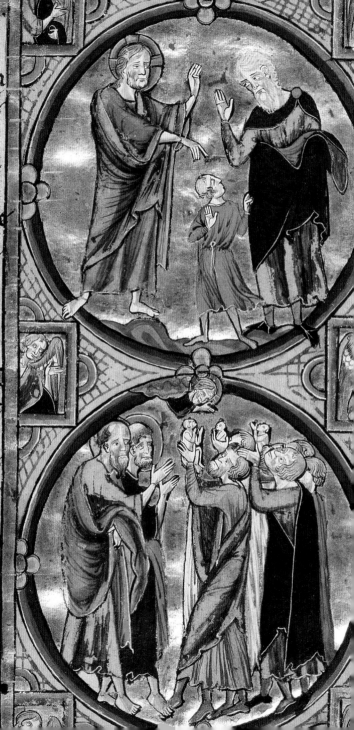

Deus qui dist
a abrahã
qil feist sacrefie
ment de son fil
senefie le iᷓ mes
ages ⁊ iᷓ e su crist qͥ
uient ꞇ amone
ten tas boeus
restien eq̃ il sa
ent offrande de
ns cors ꞇ de lor
mes a deu.

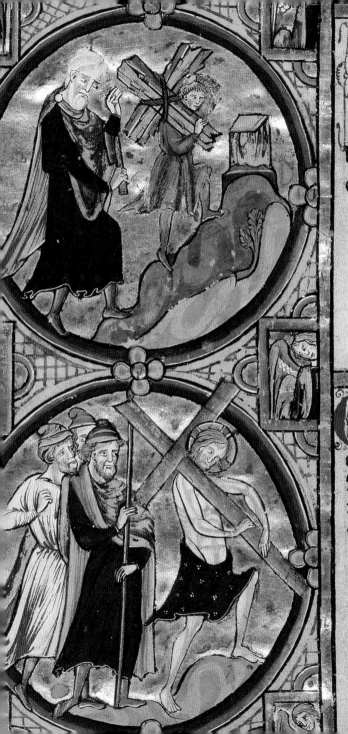

I li fenuet a[b]
ham en la
montaign[e]
z fef filz de
lui qi porte la b[ûch]e a facrefice f[ir]

E qe yfaac
porta la bû[s]che a facrefier[e]
fenefie refucrift [qe]
porta fa croiz a
fon crucefierne

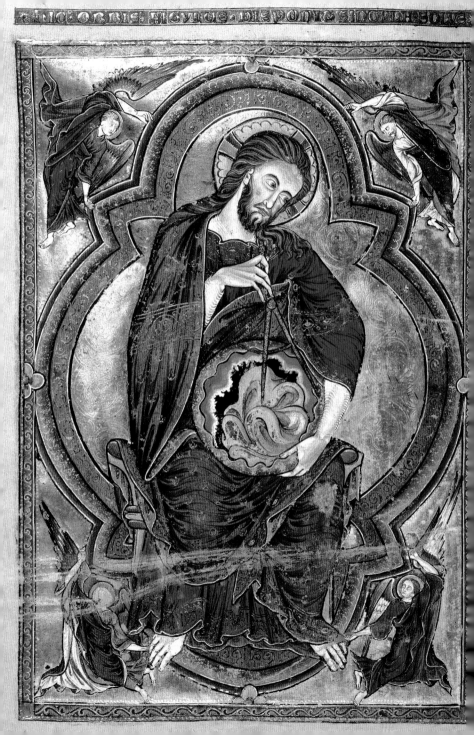

◄ **Cod. 1179, fol. 1v (Genesis):** God as the Creator of the world.

► **Cod. 1179, fol. 83v (Ruth):** (1) Ruth and her daughters, of whom one follows her while the other turns away; below: some follow the holy Church, others turn away. (2) Ruth enters a town, and the inhabitants go to their windows to look at the beautiful woman; below: the holy Church entered the world and was looked at and venerated by many. (3) A woman gathers ears of corn left behind; below: the holy Church gathers those left behind by the Apostles. (4) The lord finally gave the woman sovereignty over the reapers and the corn; below: Christ gave the holy Church care of the Christians and Apostles.

In the top left-hand medallion on fol. 22*v of Codex 2554, for example, the Israelites have gone against Moses' instructions and have kept some of their manna overnight. The terse observation in the Bible that "it bred worms and stank" (Exodus 16:20) has been dramatized in the *Bible moralisée* into a scene of worms and snakes slithering out of the chests of manna and attacking the Israelites, as revealed by the caption beside it. The text next to the medallion underneath explains: "That the sons of Israel want to take out the manna they had put aside, and worms come out, signifies the bad students who open their desks too late, and devils come out and bite their tongues; and the usurers, who watch over their money so well, will be defeated by the earthly lords."

Clues to the approximate date of these two early *Bibles moralisées* are provided by a number of more specific references to contemporary life. On fol. 37r in Codex 2554, in the second medallion from the top on the right-hand side, we can identify students who are leaving their teachers in Paris to go and study law in Bologna – something which confuses and muddles them, as the accompanying text admonishes (ill. p. 331). The study of civil law in Paris was forbidden in 1219 by a bull of Pope Honorius III; the problem described here must thus have arisen in the years following this date. An approximate *terminus ante quem* can also be deduced from the lack of references to the two mendicant orders who were gaining in importance and who had established houses in Paris by 1229. By contrast, several references to these mendicant monks appear in another *Bible moralisée* commenced by the illuminators of the Vienna codices, and today housed in Toledo cathedral.

Little is known about the illuminators themselves. The bottom right-hand medallion on fol. 246r in Cod. 1179 shows a painter working on a *Bible moralisée* (ill. p. 34). His clothes are those of a layman, from which we can deduce that this picture Bible was not produced in a monastic scriptorium. Both Vienna codices open with a full-page miniature of the Creator (ill. pp. 337 and 344). These miniatures rank amongst the masterpieces of 13th-century painting and are attributed to the main master of these early *Bibles moralisées*, who was probably also in overall charge of the illumination and contributed several pages of medallions. Whether the other artists were members of his workshop or were engaged specifically for the project has yet to be determined.

C. B.

▶ **Detail from Cod. 1179, fol. 246r (Apocalypse):** John addresses the closing words of Revelation to the clerics and laymen standing beside him. Christ appears in the clouds above; below: a priest excommunicates the unbelievers, the first of whom holds a banderole reading *iudei heretici falsi decretiste* (Jews, heretics, false canon lawyers).

testor ego
mm audi
ti ba ꝓpbie
siquis ap
ertradie
ret sup il
ꝭs plagas
smlaꝛous
quis di
mit de u
ꝓpberieb
xet ꝺꝭs ꝑar
us deliꝟ
z de cuuta
icta z dehe
escripta
m libꝛoıꝼ
z quitel
nuum ꝑ
istorum
uicrioa
eñ vein
ne ihesu
adomini
hu xpisti
mmbus
amen.

Biblia pauperum
Krumau picture Bible

Southern Bohemia, in the region of Krumau (Český Krumlov),
shortly before 1350

The most striking feature of the present *Biblia pauperum*
is the fact that the elements within each picture group are
arranged in a line and extend without a break across both
pages of the open book. At the beginning and end of the
codex they are laid out in two rows and in the middle sec-
tion in three rows per page. Captions relating to the figures
and scenes immediately below are written in the narrow
gaps at the top of the page and separating each row.
The *Biblia pauperum* preserved in Codex 370 is the only
one of its kind whose layout is not centred around a New
Testament antitype. Through their arrangement in succession, all the components
of a picture group are lent equal value in formal terms. The usual sequence of
Prophet – 1st type (Old Testament scene) – Prophet – Antitype (New Testament
scene; titled in italics in the captions to ill. pp. 348–355 below) – Prophet – 2nd type
(Old Testament scene) – Prophet is interrupted in a number of groups, either by
the omission of prophets or even scenes. The Latin inscriptions appearing above
the pictures also follow the linear layout of the illustrations. They give the names
of the prophets and brief captions to the pictures. Banderoles accompanying the
prophets contain quotations from their prophecies, although from fol. 14v onwards
they have not been filled in. The lengthier captions and commentaries that usually
form part of the repertoire of a *Biblia pauperum* are entirely absent.

Whereas all other "Bibles of the Poor" focus on just one or two picture groups
on each page (see pp. 356–361), the illustrators of Codex 370 have made no at-
tempt to keep each page a self-contained whole. Thus it is often necessary to turn
the page while reading a picture group, and even halfway through a scene. The
typological correlations that are established by the formal layout are thereby con-
fused in Codex 370 by the linear arrangement, and it becomes evident that this
sequential method of composition is irreconcilable with the concept of typology.

Detail from fol. 15r: Part of the 17th picture group:
Solomon. Absalom conspires against David. (Hand
II)

▶ **Fol. 9r:** Part of the 10th picture group: Prophet.
Temptation in Paradise. Isaiah. Part of the 11th
picture group: David. *Transfiguration of Christ.*
(Hand I)

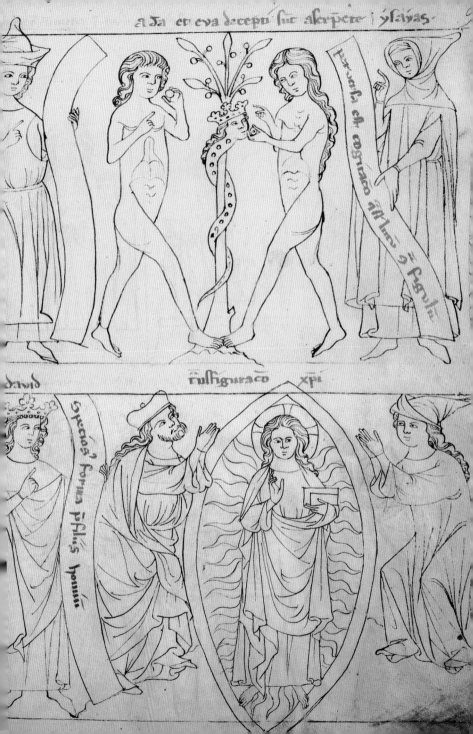

ada ev eva decepti sut aserpete ysaias

parnasa est cognicao assumes q pignula

tusfiguraco xpi

david

species forma psilis homuis

Fol. 1v-2r: 1st picture group: David. Gideon dressed as a knight, the fleece beside him on the ground. Isaiah. *The Annunciation*. Ezekiel. Cursing of the serpent. Jeremiah. Part of the 2nd picture group: Daniel. Moses before the Burning Bush. Isaiah. *The Nativity*. (Hand I)

▶ **Fol. 6v-7r:** Part of the 7th picture group: Queen Athaliah orders the royal children to be killed. Isaiah. 8th picture group: David. (1st type is missing.) Isaiah.

The Holy Family Returns from Egypt. Zechariah. The return of Jacob with his family and herds. (Hand I)

▶▶ **Fol. 7v-8r:** Part of the 8th picture group: Hosea. 9th picture group: Isaiah. The passage through the Red Sea. David. *Baptism of Christ*. Ezekiel. Prophet. The spies bring back the bunch of grapes from the Promised Land. Zechariah. 1st part of the 10th picture group: Job. David. *Temptation of Christ*. Jeremiah. (Hand I)

The originally centrally-weighted pictorial system, which arose at the latest in the middle of the 13th century and reflected Scholastic ideas, has now been overtaken by a more modern, contemporary style of pictorial narrative.

The manuscript was illustrated by three artists (Hands I, II and III), who probably came from a mural workshop in the vicinity of Krumau. The relationship between Hand I – an older master – and Hand II – a younger artist – was probably that of teacher– pupil/assistant. They illustrated the *Biblia pauperum* together. (The somewhat weaker Hand III is stylistically similar to Hand II, but only worked on the captions.) Both the elder Master I and the younger Master II reveal extremely close stylistic links with the wall paintings in the former Hospitallers' church in Strakonice, where figures and scenes (for example, the paintings of the Passion) are laid out in rows one above the other.

The best drawings were executed by the elder master. His illustrations are based on an early style of 1320/1330: his figures appear to have no joints and to be inscribed within a sweeping flow of movement. They fill the entire height of the elongated pictorial plane in which they appear. Their solidity is emphasized by the wide sweep of their long draperies (cf. the line of apostles in Strakonice). About half of the *Biblia pauperum* illustrations and many of the captions to the saints were executed by the younger master, Hand II, who is anchored in the contemporary style of around 1350. The neutrality typical of the scenes by the first master is here lost as the setting is rendered more concrete through the inclusion of architectural and landscape details. This striving towards a greater realism contributes substantially towards bringing the illustrations to life, in particular the various scenes from the lives of the saints. Trends of this kind can be identified in Bohemian painting as a whole around the middle of the 14th century and are a valuable source of information about the medieval world.

U. J.

Extent: 172 parchment folios
Format: 350 x 250 mm
Binding: modern parchment binding over thick cardboard, made in 1966 when the facsimile edition was prepared (prior to this, 18th-century parchment binding)
Content: Biblia pauperum, two parables, 30 legends, 21 of them legends of saints (with an emphasis on Bohemian saints such as Wenceslas, Ludmilla, Vitus and Procopius) and nine of the Virgin
Language: Latin
Miniaturists: three artists (Hands I, II, III) from a mural workshop in the Krumau region
Illustration: The present manuscript is a true picture book; in other words, the illustrations – drawings in brown and black ink - entirely dominate every page. The codex thereby consists of individual scenes in continuous succession, in most cases across a double-page spread; three full-page drawings.
Provenance: The manuscript was in all probability intended for one of the Rosenberg family (members of the Bohemian aristocracy whose estates lay predominantly in southern Bohemia, where Krumau formed the political and cultural centre from the 14th century onwards). When Catherine of Rosenberg founded the Minorite monastery in 1350, the already completed picture codex was presented to its new library. Following the closure of the monastery under Joseph II in 1782, the codex passed from the Krumau Jesuit convent to the Hofbibliothek.
Shelfmark: Vienna, ÖNB, Cod. 370

Vlh

Qui regnaturus est non ex me principes extiterunt

Penettur ad ierusalem et c

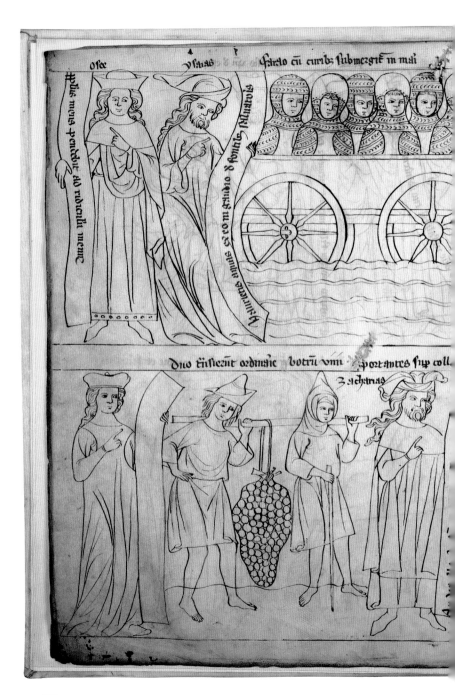

Osee

Ysaias

Farao cū currib; submergit in mari

Welis mens pendebit ad ridicula mente

Haurietis aquas sct ō gaudio ē fonte saluatoris

Duo ēferent ordinate botrū vnū portantes sup coll.

Zacharias

354

baptzat xpe Sechel

Temptat xpt adyabulo Geremias

Biblia pauperum

Klosterneuburg, *c*. 1330/31

Codex 1198 ranks amongst the oldest and finest examples of an illustrated *Biblia pauperum* – a typological work which holds up, in captioned illustrations, the parallels between the Old and New Testament and thereby serves as a sort of "teaching aid". The present manuscript dates from the early years of the genre and adheres, characteristically, to a strict visual programme, whose layout is especially fitted for books, comprising 34 uniformly structured picture groups with accompanying captions. Starting on a verso page, four self-contained but thematically related picture groups are laid out per double-page. At the centre of each picture group is a scene from the New Testament (the so-called antitype; titled in italics in the captions to ill. pp. 356–359), extending from the Annunciation to the Life of Christ and ending with the Death of the Virgin. Assigned to these are two prefigurations from the Old Testament (the so-called types) and the busts of four half-length figures of prophets. Two extended prose lessons, tituli in verse, prophecies on banderoles held by prophets and additional titles accompanying the figures and scenes help to illustrate the typological significance of the whole. Text and image in combination propose parallels, on various levels, between Old and New Testament events and between their symbolic and theological meanings, most frequently in the memorable form of "rhyming" situations.

Within the manuscripts of the so-called "Austrian family", Codex 1198 is closely linked to the *Biblia pauperum* produced in St Florian's abbey (Stiftsbibliothek, Cod. III, 207) around 1310, when manuscript illumination at this Augustinian abbey in Upper Austria was at its height. Both manuscripts probably derive from the same St Florian prototype. The illuminator demonstrates a masterly ability to translate, within the pre-set framework, the eurhythmic style of the original

Detail from fol. 1v: 1st picture group (above): Cursing of the serpent (a virgin in the treetop treads on the serpent's head). Prophets Isaiah and Ezekiel.

▶ **Fol. 2r:** 3rd picture group (above): Abner guides the Israelites to David. Adoration of the Magi. The Queen of Sheba pays homage to Solomon. 4th picture group (below): purification sacrifice (Leviticus). *Presentation of Christ*. Hannah brings Samuel to Eli the priest.

Egitur insecundo libro Regum qd abner ynceps milicie
Saulis. Venit ad dauid mirlin ut ad eum reduceret
ppls totum isrl qui adhuc sequebatur domū saulis quod
bn pfigurabat aduentū magoz ad xpm venientiū qui eū
mysticis munib; honorabant

Plebs notat hic gentes xpo uniuz cupientes. Hec ad
dauid Sapia patris i filia eius

Abn dauid

Auctor iudei eruus et grecus. Epyphania dni.

Micheas

Egitur inicio libro Regum quod regina Saba venit
ad saloem mirlin cū magnis muniub; cū honorand
Hec quidem regina gentiū erat que significabat bn
gentes que dnm de longinquo cum munib; venerabant
Adorare dnm nrm ihm xpm

Oma de Saba venient Salon Regina Sab
venientem

Balaam

Receptū enī legis erat quod mlis parentes puez pmo
genitū ipm redimere debebat oue pauper au que ouem
habe non possunt duos turtures ul columbas offerre de
bant p pio. Ihc psua purificatione qz glosa dgo adiplet
quibus purificari non indiguit.
Sicut fecundus vires sic nostra mundus. Cuiul debuit ypo

Egitur inūmo libro Regum qz quado Anna mat
samuelis ipm samuelē ablactauit tunc obtulit
eum sacdoti Hely insulo intali fasciculo que oblatio
bn pfigurabat oblationē domini intemplo facta symeo
ni sacerdoti legis agebatur. Templo te xpe pns natus notat iste

Dns inuplo sancto suo Purificaco Venite ad templū sctm suū dni

Lux ego veno i utilatibule Lux isrl mansurus non venturus

dauid Anna Hely sacerdos

Esau · Rebecca · Iacob · David

Ysaias · Sunem · David

fuga xpi in egyptum

Jeremias · Abdias

Osee · moyses · Aaron · Saul

vadit in egyptum

templum dagon · dagon

Zacharias · Amos

Fol. 2v: 5th picture group (above): Rebekah advises Jacob to flee from Esau. *The Flight to Egypt.* David flees from Saul's soldiers. 6th picture group (below): Moses before Aaron and the Golden Calf. *An idol falls in the presence of the Christ Child.* Fall of the idol of Dagon in the temple.

▸ **Fol. 3v–4r:** 9th picture group (above): Passage through the Red Sea. *Baptism of Christ.* The spies with the bunch of grapes from the Promised Land.

10th picture group (below): Esau sells his birth-right to Jacob. *Temptation of Christ.* The temptation of Adam and Eve by the serpent. 11th picture group (above): Abraham and the three angels. *Transfiguration of Christ.* Nebuchadnezzar and the three young men in the fiery furnace. 12th picture group (below): Nathan rebukes David. *The Penitence of Mary Magdalene (Supper at Simeon's house).* Moses heals the leprous Miriam.

influenced by western Gothic into a more individual and progressive language. Characteristic of his achievement are faces wearing at times forceful expressions, and items of furniture drawn in perspective (fol. 6r). Unusually, the finely shaded, pastel colouring was only added after the manuscript had been bound and just extends to the first few pages.

Art-historical research has convincingly localized the illuminator to the region of Lower Austria. It is even possible to narrow this down to the Augustinian abbey at Klosterneuburg, near Vienna, since the present codex not only shows stylistic links with the local manuscript illumination, but must have been made during the redesign of the "Verdun Altar" in 1330/31, when the ambo of Nicholas of Verdun was modified into a winged altarpiece with six additional enamel plaques and four large tempera paintings. The innovative style of these important Klosterneu-burg panels, with their specific mixture of elements from the art of north-western Europe and Trecento Italy, leads to the progressive "realism" of the illuminator of the *Biblia pauperum*. On the other hand, it appears that pictures from a *Biblia pauperum* of the same type as Codex 1198 (if not from this very codex itself) were used as models for part of the new enamels. Such correlations seem to prove the fact that both works were produced in the same place and at the same time. The iconography of the present *Biblia pauperum* is also reflected in a somewhat later fragmentary typological cycle in the stained glass of St Stephen's in Vienna. Even these few remaining examples from the Vienna region can give an impression of the importance the *Biblia pauperum* assumed in the late Middle Ages as a vehicle of typological instruction.

V. P.-A.

Extent: nine parchment folios
Format: approx. 365 x 255 mm
Binding: parchment binding of Gerard van Swieten, prefect of the Vienna Hofbibliothek (1745–1772), dated 1753
Content: Biblia pauperum
Language: Latin

Illustration: 17 pages with ink drawings, incompletely coloured
Provenance: The manuscript is documented in the Vienna Hofbibliothek probably under the prefect Hugo Blotius (1576) and certainly under his follower Sebastian Tengnagel (1608–1636).
Shelfmark: Vienna, ÖNB, Cod. 1198

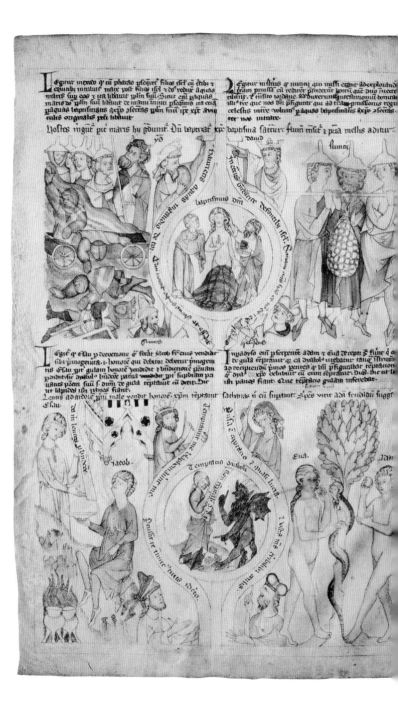

Legitur in exodo qͥ cu pharaone yseqͥren̄ filios isͩl cu celib̄ z eqͥmb; mctauit mare post filios isͩl z dn̄s reduxit aquas maris sup eos z ita lidauit pplm suu. Sicut enim paquas maris dn̄s pplm suu librauit de manu inimici pleyam: ita crͤ paquas baptismatis xͥpiano sectas pplm suu ipe xͥps ab inimicis originalis pm lidauit.

Legitur in lib̄ nume qͥ misͤt duos viros exploran̄ dam pmissa cu redux̄t pferentes portu que dn̄s suc cedit. z i tͥstes reddunt. Ad duxerunt in ethinonii botruͥ iste vere que nos uͣi pfigurant qui ad trͤiͣ pͤnicͥonis regni celestis inire volunt pͤ aquas baptismatis xͥpo psectatͥ nos inimint.

Hostes in guͤ pͤt maris huͥ gͣdunt. Du̇ teͤpͤrat tͤͣ

baptisma fit aͤ ꝼlun inuͤt z pͤia melius aditur david

Armiḡ

In deus bͤedͤicte defunctis isͩl

baptismus dn̄

rͤomꝰ

Legit̄ qͥ esau pͤ deuocͤone qͥ ꝼecͤt Jacob fᷠ euͤs vendidit sibi primogenitͣ. i. honore qͥ deͤtͤ: debetͤ pᷓmͤigenͤ tis esau qͥ guͤlam honore vendidit z violͤicͤone primͣ pͤdidit: sic dyabolͨ bͤedictͤ patͤia vendidit ipͤt supͤbiͤ pͤ luxuͥa pͤm suu s̄ dn̄m ͤ guͤla teptauit cu dixit. Dic ut lapides isti panes fiant.

Legͨ ad aͤuore piͤi male vendit honore xͥpm teptauit Esau.

In pͤadiso enͤ pͤserpente adͣm z euͣ de cͤpit ꝼ fuint qͥ de gula tͤptauit qͥ ea dyabolꝰ victͤ tͤ́q istͤmͤtͤ ad recipiendu pͤnes pͤnes qͥ uͤi pͤfiguͤabat teptacͤone qͥ dyͣa xͥpo exͤhͤbuit cu eum tͤptauit. Dicͤs die ut lͤib panes fiant. Q̇ue teptacͤone guͤlam inferebat sathanas no eu supͤauit. Sͤps vicͤit adͣm ꝼ eudu̇ suggͤt

Jacob

Temptacͤo dyaboli

Eua

Adͤ

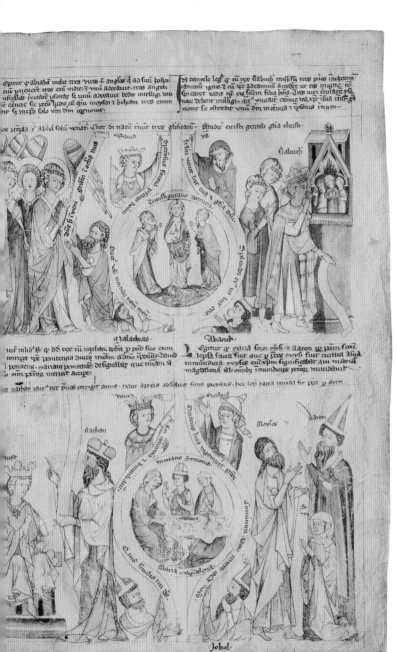

Egitur q̃ abiaba widt tres viros f̃ angtes q̃ ad suũ hoſpi
tiũ pueneret tres cnũ vidit. τ vnũ adozauit. tres angeli
uſitrctarunt ſinnatare pſonŭe ſ̃ vnũ adozauit dedit intelligi tun
e cenate ſic τ pres horũ cũ qm moyſen τ helyam tres cnũ
uit ſ̃ mũdo ſolũ vin dm cognouit.

Jn danyele lego q̃ cũ rex ſlabuch miſiſſet tres pucos inaximu
camniũ ignes τ cũ rex adramuũ acrederet ve eos ingne cõ
ſiũ eſſet vidit cũ eis ſilem ſuo bonũ tres viri cuitate pſa
maz velint indigni quũ vnitate cenũe ſed rpi ſua cuiſtgũ
eone ſe oſtendit vnũ dm cũ mad τ ipſoꝛũ tnuũ

ſ̃ aceptla e̅ abhi ſolũ venit. Ceer dt natit cuut tres glificatũ
Dauid Spenoliis ſunce fm venit hc eũ τ ξ̃a dm
Transfiguracoe dmuũ ſlabuch

Malachias Abacuk

Jmaf inlits q̃ q̃ dd vex cũ nathan vba p pres ſuo cum
coruigt ipᷓe pnutencia ductg mūã adno ꝗeaut. Dauid
j pnitens. mariam pnutenẽ deſignabat que mūã A
ſim prꝛoꝛ merutt accep

Nathan Ezechiel Moyſes Aaron

Joheel

BIBLIA PAUPERUM 361

Speculum humanae salvationis

Lake Constance region (?), 1330s (probably 1336)

Sacra Scriptura est tamquam mollis cera... – "The Holy Scripture is like soft wax that assumes the form of the seal pressed upon it"; thus runs the preface to the *Speculum humanae salvationis*. The chief subject of this "mirror of human salvation" are the redemptive works of Christ, which are interpreted with a host of typological-allegorical references. The reader is called upon to immerse himself in the mystery of the history of salvation "with the eyes of the heart" (*oculis cordis*). The codex addresses itself both to the clergy and the laity: it aims to instruct the educated (*litterati*) through its texts and the illiterate (*rudes*) through its pictures.

The *Speculum humanae salvationis* was a very popular type of devotional book in the late Middle Ages and the present Codex Series nova 2612 belongs to the earliest examples of the genre. Extending to exactly 100 pages, comprising 45 illustrated chapters and a preface without illustrations, it adheres in its careful layout to a rigorous overall system. The first 42 chapters each occupy one double-page spread and contain 100 rhyming lines, divided into four columns and illustrated by four pictures. Chapters 1 and 2 trace the divine plan of salvation from the Fall of Lucifer to Noah's Ark. Chapters 3 to 42 are structured typologically and show, on the left, scenes from the lives of Christ and the Virgin (titled in italics in the captions to ill. pp. 362–370) and symbolic images (of the Passion, intercession etc.), spanning the period from the Annunciation of the Birth of Mary to the last things. These are followed on the right by three types taken either from the Old Testament or from heathen secular or natural history. The manuscript concludes with three devotions, twice the length of the earlier chapters, on the seven stations of the Cross and the seven sorrows and seven joys of the Virgin Mary, each devotion illustrated by a picture of a vision and seven "stations of salvation". Overall, the *Speculum* has already shifted away from the rigid form of typology

Detail from fol. 31r: The ostrich frees its young from the glass jar with the blood of the worm (after Peter Comestor, *Historia scholastica*, referring to Christ, who burst open Hell with his blood; 28th chapter).

▸ **Detail from fol. 20v:** 18th chapter: *Judas betrays Jesus with a kiss.*

A pcedēti· ea· audiui° dm̄i· x· hostes suoꝛ ꝓstituit·
Cont· audiã° dm̄i· judas· ī colo eū salutauit·
udas tradicoꝛ saluatoꝛis nr̄i· ded̄ judeis osc̄li siḡ°
ꝗnꝗn̄ sup· modū mīus· et malismīm·
sc̄m n· s̄p ꝓsueuit· eē siḡnū dilecōis
oc· ꝗnꝗs· judas· ꝓmutauit· ī siḡnū· ꝛdicōnis·
 sta· ꝗnꝗa· salutaco ꝗ inꝗ· tā· dolose· siuit· ꝑpetta

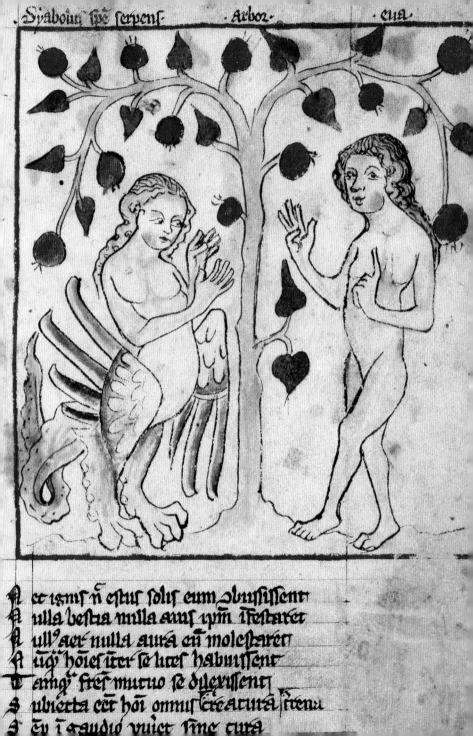

A et ignis non estur solis eum obnisissent
A nulla bestia nulla auis ipm infestaret
A ull' aer nulla aura eu molestaret
A utqz hoïes inter se lites habuissent
T emq' fres mutuo se dilexissent
S ubiecta eet hoï omnis creatura serena
S eu in gaudio uiuet sine cura

Detail from fol. 4r: 1st chapter: The serpent (in the shape of a siren) tempts Eve. First part of the eight-scene pictorial cycle illustrating Genesis.

▶ Fol. 17v–18r: 15th chapter: *Christ's entry into Jerusalem*. Jeremiah laments the destruction of Jerusalem. David, with the decapitated head of Goliath, is greeted by the rejoicing Israelites (King Saul amongst them). Heliodorus is trampled and beaten.

still found, for example, in the *Biblia pauperum* (see pp. 348–361). The method is not longer employed primarily to prove the unity of the Old and New Testament, but has become part of a larger whole serving spiritual edification.

The manuscript was previously thought to be an example of Upper or Lower Austrian work from the year 1336, but this has recently been called into question (Roland [1997]). Its dubious dating – deduced from the number *XXXVI* in an erased inscription by the scribe on fol. 51r – is nevertheless plausible and marries well with the drawings, whose style points to the 1330s and bears, for example, comparison with the Passion altarpiece in Klosterneuburg and the commentary on the Gospels in Schaffhausen (Stadtbibliothek, Codex 8; Schmidt [1962]). Despite these Austrian connections, other evidence suggests that the manuscript may have been produced in south-west Germany: the text *Von den 15 Wundern in der Geburtsnacht Christi* ("Of the 15 miracles on the night of Christ's birth") added at a later date on fol. 1r, is written in an Alemannic dialect and points westwards, also regarding its content (probably to the circle around the so-called Engelberg Preacher). The pictorial programme, meanwhile, reveals clear parallels with the *Speculum humanae salvationis* of approximately the same date from the Premonstratensian monastery of Weissenau in Upper Swabia (Kremsmünster, Stiftsbibliothek, CC 243).Moreover, there are stylistic arguments in favour of southern Germany: in addition to examples cited in the literature (such as the Biel panels in the Schweizerisches Landesmuseum in Zurich), mention should be made of a Psalter from the diocese of Constance, whose figural style approaches the present drawings in its soft and powerful modelling (Manchester, John Rylands Lib., Ms. 95). This all suggests that the present codex may be an import from the Lake Constance region. Its points of comparison with Austrian works are thereby not self-contradictory, but testify to the many western influences also in this region.

V. P.-A.

Extent: 51 parchment folios, paper flyleaf at front and back
Format: approx. 280 x 200 mm (irregular)
Binding: half leather binding with blind lines and blind stamping from the 1st half of the 16th century
Content: Speculum humanae salvationis
Language: Latin

Illustration: 192 coloured pen drawings – four per double-page spread – within 48 folios; three later penwork sketches
Provenance: Documented in Ambras Castle near Innsbruck in an inventory of 1613, the manuscript passed to the Kunsthistorisches Museum and in 1936 passed to the National Library.
Shelfmark: Vienna, ÖNB, Cod. Ser. n. 2612

·x· vides ciuitatē ihrm fleu[it] · Cū laudib᷒ suscipiebat · Vedentes z emetes d replo erecit · Semeas lamētans

Cxv̄ᵐ Capᵐ	
	z sauli mille z dauid x mīlia attribuebant
	D aud dūm nr̄m ihm vpm p̄signabat
	Cᵒ soluā z dȳaboli aduersarium nr̄m supauit
	ꝶ ste verus dauid z vᵒ mᵈ die palmaꝝ
	h onorat᷒ fuit mᵗliplr̄ z occisꝰ turbat᷒
Cᵗ figª	Cᵒ dam osānā filio dauid Acclamabant
	Cᵒ dam vn̄ict᷒ q̄ venit ĩ noīe dn̄i p̄sonabāt
	Cᵒ dam regē isr̄l eum asserebant
	Cᵒ dam cū saluatoꝛe mūdi venieb̄t
	Cᵒ dam cū flouib᷒ q̄d eū palmis occīerūt
	Cᵒ dam vestimēta sua ĩ via p̄sternebant
	Ᵽ istoꝝ ihrm visio pacis trestātᵗ
	Ᵽ q̄ fidelis aĩa similr̄ designatur
	ꝶ hac saluatoꝛe nr̄ in hora q̄e z ventꝰ
	x nos ei ĩ occursum p̄ zciderā dēm᷒ ſtē
Cᵗⁱ figª	Cᵒ autē dn̄o clamosꝰ vocalr̄ deantam᷒
	Cᵒ ñ ĩ p̄fessione p̄ca nrm̄ eū q̄eramᵘs ᵗveram
	Ᵽ amos palmaꝝ ad laudē dī maīb᷒ p̄tamus
	Cᵒ ñ cōr mā in ſatꝼcōne disciplīe castigam᷒
	v estim᷒a nr̄a ĩ via ad honorē dy p̄st̄num᷒
	Cᵒ ñ iꝑala nr̄a erogam᷒ xp̄o plaꝝ᷒bus
	Cᵒ ñ flouib᷒ dño occurrim᷒ z honoram᷒
	Cᵒ ñ miē aꝑd᷒ẓ duisuᵄ virtut᷒ nos ornam᷒
	Cᵒ yp̄m ihm q̄ venit ĩ noīe dn̄i b̄dicim᷒
	Cᵒ ñ p̄ bn̄ficiis nob᷒ deuote z etes dicim᷒

egem eu et dnm nrm ee pteftamur
Quia oia opa cum timore dni z reuencia opari
Jtco notadu qp ihc flagellatoz fimiliter fe
cutus z ueneres flagellado dni ihu cuerti
menfas puit nummulariozu z effudit es cozu
tam z ipfi erant ufurarii z cohibfoz phifcoz
ec aut flagellaco dni iam retracta
lim fuit in Eliodoro pfigurata
qr in filencio mifit pincipe fuu Eliodoru
z uenit in xtrm z fpoliaturus ibi dni templum
fed audiit iufter i templu manu armata
tanti a eu uindicta dei eft puocata
z impumitus aftuf qda equis horribil'
qi fedebat fup eu armat' erat z tribilis
quu aut Eliodoro uioces caledes inmifit
ipfum decienf fremebat ad trram collifit
fiuit fup ellu duo robuftiffimi Adolefcetes
Eliodoz flagellis ufqz ad morte pcutietes
fco pctus eques z duo adolefcetes diffcuerut
Eliodoz rogu mortui flagellat reliquerut
Ohate qp eo fumo pontifice oras rogauit
rediens ad domu fuu filentiu dixit
z hic rex aliquo hofte cui' morte affertat
Iiit ad Iophada templu ierofolis murtati
Eliodoz flagellat'. fint qp tpliciter dri fpoliacdem

uidei fpoliati fuiut qp ufure pallacdem
hyfem n pafiuit i templo cohibebat z nummularios
uolenribus offerre mutuo dabat dinarios
qp ipi legem ufurati accipe no debebat
oliuia. tñ. z minutiftla qua recipiebat
licus uuas nuces poma. vocabat collura
migdola pullos canferes colliuat z fymbla
icqz ufura fraudulent' fub pallio tegebat
ec uba dni i ezechiele fcpta no aduedebat
furā z oem habudaucia no accipiat
fciet carifimi h ubu dilige i memo tecedatis
pleceo uolet xpiam hodie i ecca fumt
qu fraudulenter fidem z ufure pallacdem faciut
mutui no dant puite z pfi dilconem
z ipi mila uel fuura fauore nl pmocdem
u pcetant d'me ubi illud dni no pdatares
utciu dare mch mde fperantes
Aliel dnus de templo fuo celefti expellet
z radice qoz de tra uiuecit euellet
z rudeam qp templu dni z dmu etiu ueniat
z uiolum a dno flagello peuo flagellari
Ueliquam z ufura z oem fpem ufure
exceppellam a dno de templo ipe fuure
bone ihu doce nos qp oia totali cuftodire
z mecham i templo ghe tue cinali itroire am

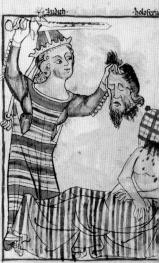

CXXIIᵘ Capᵐ

In precedēti cᵃ audiuiᵐ qm̄ xp̄c vicit diāᵐ p̄ passioñe
Cōr audiamᵘ qm̄ m̄ vicit eūdem p̄ passioñe
Diū que xp̄c in suā passioñe tollerabat
h et m̄ p̄ nimā cōpassionem portabat
C lauū qui tr̄sierūt pedes filū suū ⁊ manᵘ
p̄ cōpassioñe tr̄sierūt sp̄itissime m̄ris pectᵘ
Z antea que s̄t filū suī mortem pfor̄abat
Y cōpassioñe cor m̄ris uiuētis penetruit
A culeᵘ sp̄ie qui caput xp̄c pupūḡit
p̄ cōpassioñe cor genitrꝭ eiᵘ wl̄nauit
G ladiᵘ accūtissimᵘ l̄ḡ qd̄ xp̄c audiuit
p̄ cōpassioñe ūn̄a m̄ m̄am p̄ūsiuit
Z sic xp̄c sup̄auit diāᵐ p̄ suā passioñe
Ita ⁊ sup̄auit cū m̄ p̄ nimā cōpassioñe

Figura A rms passionꝭ xp̄c cū se armauit
F n̄ ᵱ dīaᵐ ad pugnāᵐ se p̄arauit
I tā m̄ p̄figat p̄ iudith q̄ str̄uit olofin
A ma ip̄a se oppos̄uit diāᵐ p̄incipi inferni
I udith id̄uit se uest̄iū iocūditatꝭ
⁊ cr̄ali caput suū m̄t ⁊ pedes scādalꝭ
M aria uestiuit se tunica filū suū cōsutilꝭ
⁊ sup̄ id̄uit se pallio derisionꝭ ex̄ duplā
V n̄ erat albᵘ ⁊ quoꝫ xp̄c ab herode deriđbat̄
A liud cocc̄neū ⁊ rubicūdū iq̄ amictuᵘ il̄udbat̄
⁊ b̄n̄ cū pallio albo ⁊ rubicūdo iⁿduebat̄

Q ma dilc̄a eiᵘ filiᵘ c̄ādꝯ ⁊ rubicūdᵘ v̄cat̄uᵘ
T ota eiᵘ passio ꝯpart̄ fasc̄lo mirre
Q̄ mari debꝫ m̄r ul̄a diligentꝯ amme
Q es aūt pensalitatē xp̄c cū diligēt̄ collegꝭ
⁊ ꝯpassioñe ⁊ fasc̄lm̄ mirre ex ip̄s ꝯpon̄
h sic fasc̄lū ⁊ clypeo m̄r ul̄a suā collocauꝭ
cū tali armata ꝯ host̄e nr̄m dimicauit
I n uasc̄lo mirre erat sim̄l ōm colligata
Q uc dulc̄imo filio suo i passioñe sim̄l ill̄ata
L adiū fustes l̄acere ⁊ arma quꝭ capiebat
⁊ uctis ardentis ⁊ fasc̄le qᵘꝫ toⁱtᵘ t̄rebat̄
T risticia pauor tr̄emor ⁊ t̄na cr̄ucio
⁊ uxor p̄touⁱme ꝯ engli afforatᵘ
A ud tⁱbus occrⁱt ꝯ uno uerbo ōs pⁱstⁱt
⁊ rest̄ruit eⁱ uires se capⁱēdū mⁱserauⁱt
S̄ pⁱmicoⁱ signā ⁊ osculⁱ maligⁱmū
S olosa salutacᵒ ⁊ respōsū xp̄c benigmū
C rudel xp̄c captⁱuacꝰ ⁊ victo̅x lı̄gacⁱo
A urⁱc̄le rec̄rc̄o ⁊ discⁱpl̄or̄ fugacⁱo
S ādoma rel̄c̄to adil̄co suo rosie
V xulcacꝰ ul̄dox ⁊ iⁿrogacꝰ anime
A lapa serⁱí ꝯfⁱers ⁊ mal̄e xp̄c rⁱsⁱo
T rⁱma negacⁱo petrⁱ ⁊ eⁱusꝯ ᵘisⁱo
Q ōm uⁱducⁱ crⁱam qᵘꝫ dixⁱt ⁊ ⁊ accūsat̄
A ñas Caypphas herodes / pⁱꝯ pylatᵘ

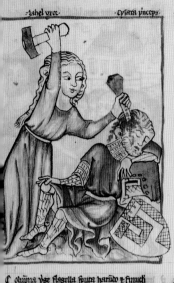
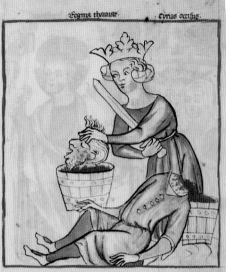

C oluŋna uꝛge flagella ſputa haꝛudo ⁊ ꝼunicli
C tuꝛ clauu laſcꝛa mallei coꝛona ⁊ tabla tituli
A lape colaphi obpꝛoꝛia blaſphemia ⁊ deriſio
v claꝛu oꝛloꝛ aptha·x·⁊ veſtiuuꝛ diuiſio
S oꝛſ ſup tunicã ⁊ hodiſ albu idumiꞇu
T ribunal indicꞇs loco manuu ⁊ ꞅꝑmeu veſtiꞇ
A oŋmiu uꝛoꝛ ꝓ pilau ⁊ libaꞇo barrab kiꝛd
I miliꞇus·clamoꝛ iudeoꝛ ⁊ gciaru ceſſioꝛ
iuſ·x·Accerablin ⁊ Acceꞇu felle amaranꞇu
 ꝓaꞇo·x·clamoꝛ laeꞇme ⁊ larroni acceptaꞇo
A rudo cu ꝼpongea ꝓopuſſo ⁊ vmu miꞇiaꞇu
O ıa·uerba·x·iudaꝛ ⁊ diſꞇꝛipu ibus ꝓmedaꞇo
F yꝑmaꞇo·x·laꞇeꝛa lōgim cu iŋuiſ illuiaꞇoꞇ
S fluxio ſanguis ⁊ aque ceŋuꝛio cu ſua ꝓteſtaꞇoꝛe
O vſomaꞇo ſal eꞇre moꝛ ꞅꝺuſio neli ⁊ petraꝛ cꞅraꝛ
S uma ꝓꞇis templi apico ſepleꞇu ꝼetoꝛ ⁊ moꝛ caluaꝛ
T riginta argenꞇei quib ꝫᵐ eꝛat redem ꞇuſ
S eſpaꞇo iude qui noꞁ eſ ꞅagꞇe·x·redepꞇus
h uꝼ ⁊ aluꞇ·x·penaluꝛanb²·oꝭ·uꝛgo ſe armaꞇuꝛ
⁊ taꝗ ꝗꝺiſnaꞇiꝛ mꞇrã ꞇiꝛm hoſte diee ⁊ꝓculcau
T uc impleꞇa ſꞇ tipa ꝗmoꞁꞇꞇe olim ꝼiguꝛe
S quedam aptha·t tam ꞅacre ꝼcriptuꝛe
S uꝙ aſpidem ⁊ baſiliſci tiꝰ q̃·ambulab
L coŋe ⁊dꞇoꞇoꝛe·ꞇ·ꞇathanã ꞇeulcabis
⁊ tu ſath iŋſidiab calleꝺꝺo cuꝰ hoꝛoes ꞇꝑꝼuaꝺꝺo

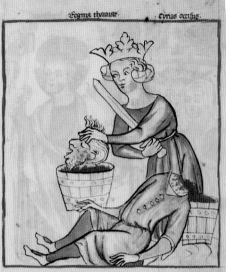

A pã ꞇteꞇeꞇ capuꞇ tuu ꝓpaſſioꞇe te ꞅuꝓaꝺꝺo
S ꞅꞇuꝺ olim iabel uꝛoꝛ abeꞇꞇuuci ꝓꝼiꝼnamaꞇuꝛ C iiꞇ ꝼiguꝛa
L ue cyꞅaꝛã alliꞇ ꝑ ꞇympã clauo ꝼꞇeo ꝓꝼiŋꞇuꞇ
C yꞅaꝛã eꝛaꞇ ꝑŋnceps milicie ꝗabiŋ regis
⁊ uaſtauiꞇ iſꝛl ꝼilioſ uiolencia iꞇꞅeꞇus eis
S anꞇo a iabel clauo ⁊ ꞇiꞇa·ꞇ·ꝓꞇoꞇꞇꞇus
⁊ iꝓiſ iꞇꞅꞇiꞇuꞇus abeiuꞇ ꞇeſꞇacoib ⁊ libaꞇus
S ic·m·clauo ꝼce cꝛucis hoſꞇe ꞇ ꞇm ꞅuꝑauiꞇ
⁊ cu Apoꞇeſꞇaꞇe q̃ ꞅup noſ huiꞇ liberauiꞇ C iiꞇ ꝼiguꝛa
R egma thamaꝛ eꞇiam maꝛia ꝼꝼiꝼ uꝛaꞇ
L ue uiꝛu cꝛudeliſſimu homiꞇaꝺ decollauiꞇ
L u ꞇm aſꞇuꝛabaꞇ ad boim iꞇꞅꞇoꞇe
L u noꞁ poꞇuiꞇ ꞅaꞇuaꝛi ꝑ huaꞇ ꞅãꞇuſ effuſioꞇe
S mub²⁊ꝺuoꞇauiꞇ ꝑ oꞇa regna iꞇꞅ adeuꞇ
S ulli ꝓcebaꞇ oꝺem q̃ poꞇuiꞇ ꞅãꞇe ꞅiꝺebaꞇ
T andem regma thamiꝛ ipm capieꞇ ꝺcollauiꞇ
⁊ capuꞇ ꞇ urnam ꞇ melo pleno ꞅanꞇe huaꞇuꞇ
S acia miꞇ ꞇe ꞅanꞇ⁊e huano q̃ i iꞇꞇ ꞅiꝛuꝼ
h mꞇa ꞇua muꝼ ꞅaciaꝛi poꞇuiſꞇi
S iꝛ dꝛaꝗ qui ab iꞇꞇio homiꞇaꝺa eꝛaꞇ
S uꞁ hoꝛu daꝼꞇaꞇoꞇe ꞅaciaꝛi poꞇiaꝛ
S⁊ regma celi ipm ꝑ paſſioꞇe ꝼilu ꞅuꝓauiꞇ
⁊ cꞇu daꝼꞇaꞇoꞇe q̃ noꞁ ꝑauaꝛ ipm ꞅaciauiꞇ
C bone ihu ꝼac noſ ꞇuo aꝺiuꞇoꝛio·ꞇ·dꝛaꝗ ꞅuꝓaꝛe
v ꞇieꞇui meaꝛu ꞇecu ꞇ꞉ua gꝛa uiꞇaꝛe

◄ **Fol. 32v–33r: 30th chapter:** *The Virgin Mary conquers the devil with the weapons of Christ (the instruments of the Passion).* Judith cuts off Holofernes' head. Jael kills Sisera. Tamar kills Cyrus and throws his head into a bucket full of human blood (after Peter Comestor, *Historia scholastica*, referring to Mary's victory over the murderer of men).

Detail from fol. 47v–48r: 44th (here 45th) chapter: Devotion on the seven sorrows of the Virgin Mary. Part 1: Vision of a Dominican receiving the stigmata and the Virgin's sword (the same figure is here shown twice). First sorrow: Presentation of Christ in the Temple. Second sorrow: the Flight to Egypt. Third sorrow: the twelve-year-old Jesus in the Temple.

► **Detail from fol. 35r:** Jonah is spat out by the whale (symbol for the Resurrection of Christ; 32nd chapter).

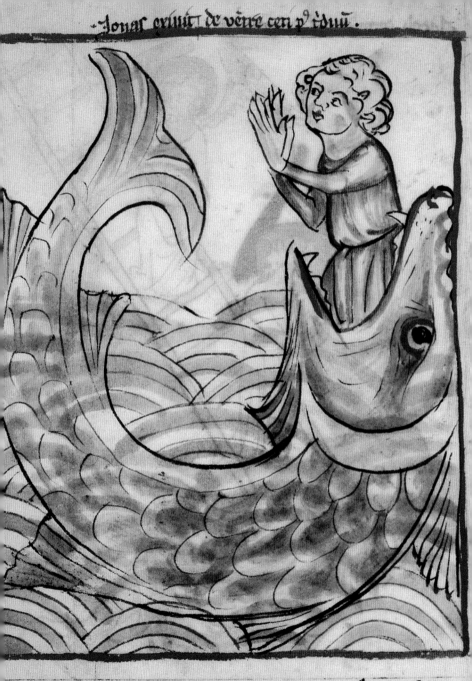

no̅ e̅ putandu̅ q[uod] i̅ parascaue cor[pus] surrexer[un]t
illa die sepulta solu̅ apta fuerint

Bible manuscripts of the Jewish and Eastern Orthodox faiths

When, in around 281/280 BC under King Ptolemy II of Egypt, the Hebrew Bible was translated into Greek – much to the displeasure of the Jews, as recent research has shown (Collins [2000]) – the foundation was laid for the spread of the text that the Christians would soon claim as their "Old Testament". As the Greek Septuagint, the Old Testament was now available to a readership that went beyond Jewish circles. In the early days of Christianity, the Jews also continued to use the Septuagint, until a rabbinical initiative in around AD 100 resulted in the laying down of a definitive Hebrew canon, after which all further distribution of the Greek translation amongst Jews was prohibited. The earliest extant Hebrew Bibles preserved in complete parchment codices, however, date only from the 9th/10th century. The first fragments of the Septuagint from the first decades of the Christian era may therefore be of both Jewish and Christian provenance.

It may be a reflection of the general distaste amongst the early Christians for pagan ostentation, and also of the danger inherent in owning a Bible in an era of continuing persecution, that luxury Bible manuscripts are only documented from the 4th century onwards (John Chrysostom, *In Ioannem* 32 [31], p. 3) and that the first surviving fragments of such a Greek Bible – the Cotton Genesis – date from the 5th/6th century. The *Vienna Genesis* from the 6th century has survived almost in its entirety (pp. 54–65). Further luxury codices with biblical illuminations issued from the workshops that flourished in the major centres of the Byzantine East, such as Constantinople and Antioch. As, over the course of the 7th century, the Byzantine Empire lost its Syrian-Palestinian and Egyptian territories to the Persians and the Arabs, the parting of the ways that had already taken place theologically some time ago finally became an actual split. National (Coptic and Syriac) versions of the Bible now established themselves increasingly firmly in these ar-

Mahmûd ibn Ramadân, Rosary of Tidings, Cod. A. F. 50, detail from fol. 8r: Solomon.

▶ **Slavonic Liturgical Apostolos, Cod. slav. 6, detail from fol. 215v:** Paul the Apostle seated, above him Jesus Christ, to the right and left a crowd of people.

ҀĨОСТО҇ ПА҇ВЄ

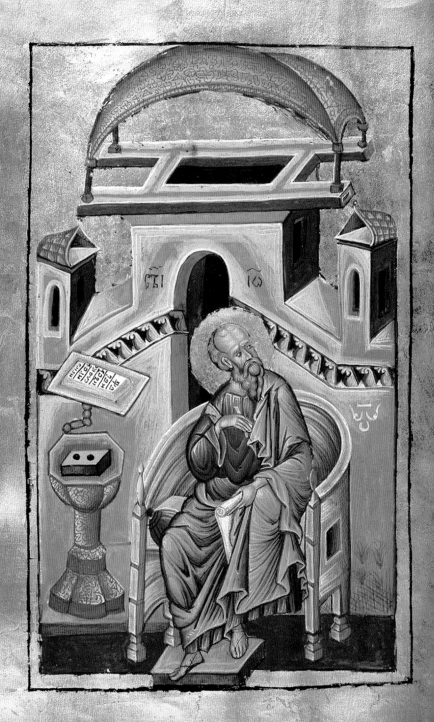

eas. The number of artists calculated to have worked on the *Vienna Genesis*, for example, is indirect evidence that treasures of this kind must have been produced in relatively large numbers. Yet few traces remain of the manuscript tradition of this era. An impression of these magnificent codices can be gleaned from the works of the Macedonian Renaissance of the 9th and 10th century, which consciously look back to earlier codices from late antiquity. Examples include the Joshua Roll preserved in the Vatican Library and the Niketas Bible, named after its patron (see also pp. 382–387).

According to the Acts of the Apostles (11:26), it was in Antioch (in Syria) that the disciples of Christ were first called Christians (*Christianoi*). Antioch subsequently became a centre for some of the most important theologians of the day, and also developed a leading school of biblical exegesis (which regularly ran into conflict with Alexandria). Tatian (2nd century AD) is recorded as having completed the first Syriac translation of the Bible, the *Diatessaron*, a compilation of Gospel texts presented in the chronological order of the life of Christ. The four Gospels (as well as Acts and the Epistles of Paul) were also translated in the conventional, "separate" order the (*Vetus Syra*). In the 5th century (at the latest), a new translation was then undertaken which became known as the Peshitta (the "simple"). The production of lavish Bible manuscripts began very early on: the Rabbula Codex, a Gospel book, was completed by the scribe Rabbula in St John's monastery in Zagba, Mesopotamia, in AD 586, and contains the canon tables devised by Eusebius, accompanied by numerous miniatures in the margins, and seven full-page biblical illustrations. The first illuminated complete Bible (today surviving only in fragments), the so-called Syriac Bible of Paris (6th/7th century), contains title miniatures and author portraits.

After King Tiridates IV adopted Christianity as Armenia's state religion in around 313, the need for a vernacular Bible quickly became apparent. The foundations were laid by Mesrop Mashtots in 406 with the creation of the Armenian alphabet; only now could the Holy Scripture be translated into Armenian (a project completed in 435). The oldest illustrations from an Armenian (?) Bible have survived almost by chance, on sheets bound within one of the most beautiful of all Armenian manuscripts, the Echmiadzin Gospel Book of 989, to which a five-part ivory diptych, probably from the 6th century, was later also added. Themselves dated to around the 6th century, parallel to illustrations in early Greek and

Slavonic Liturgical Apostolos, fol. 189v (St John): St John the Evangelist seated with a scroll in his left hand and a stylus in his right; desk with writing utensils and a piece of writing.

▶ **Greek Gospel Book, Cod. theol. gr. 240, fol. 255v (St John):** St John the Evangelist standing with open book in hand; imaginary symbols are visible in the codex. The miniature has been bound as a separate sheet, and is drawn on a thin gilded sheet, glued onto the page.

Syriac Bibles, these sheets contain four full-page illustrations relating to Luke (fol. 228r/v) and Matthew (fol. 229r/v). The colophon in the Echmiadzin Gospel Book notes that the codex is a copy of a very old original.

The conversion of the Ethiopian kingdom of Aksum to Christianity was begun in the 4th century by the prisoners Frumentius and Aedesius, who were employed at court amongst other things as tutors to the royal princes. In the 5th century, Syrian Christians continued the missionary work. Theologically, the Ethiopian Church was oriented towards the Coptic Church in the north, where its bishops were also ordained. The Bible was translated into Ge'ez (later the liturgical language) soon after Christianization, but its text is today difficult to reconstruct: the earliest extant (Gospel book) codices date from the 10th/11th century (and the majority only from the 13th/14th century), and between these and the first Ge'ez translation undoubtedly lie various revisions and alterations. Ethiopia's geographical and political isolation led to the development of an independent iconography (see pp. 420–425).

Christian missionary activity amongst the Slavs began immediately after their arrival in the Balkans (6th/7th century). Following initial missions arriving primarily from the West, the brothers Constantine (better known under his monastic name of Cyril) and Methodios made a lasting impact, at first in Moravia, where they were invited to teach by King Ratislav towards the end of 862 (or 863). In order to spread their message, they invented the Glagolitic alphabet, based on Greek (and soon replaced by a modified Cyrillic), and thereby laid the foundations for the production of Slavonic manuscripts, of which the earliest extant examples date from the 10th/11th century (initially Gospel books and Psalters). These codices reflect the influence of Byzantine manuscripts as well as other sources in their artistic design. Muslim conquests in the Near East and Egypt from the 7th century onwards steadily weakened the link between Christianity and the Byzantine Empire. Alongside national languages, Arabic – as the language of communication and soon the vernacular – now assumed a central role in the transmission of the Holy Scripture, as evidenced by numerous bilingual and even trilingual Bible manuscripts. Recent research suggests that the Gospels were translated into Arabic from the middle of the 7th century; the oldest fragments of Arabic Bible manuscripts date from the 9th–11th century (the majority from St Catherine's monastery on Mount Sinai).

C. G.

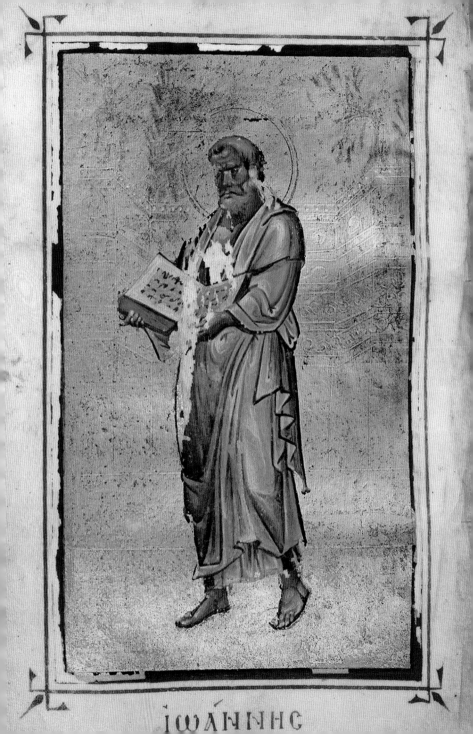

ΙѠΆΝΝΗС

Hebrew Pentateuch
with Haphtaroth

North-eastern Spain (?), final third of the 15th century

This small-format parchment Bible codex contains the Torah (the five books of Moses) and the Haphtaroth, i.e. the passages from the Prophets which are read out after the Torah reading in the synagogue. The Haphtaroth are usually thematically related to the passage from the Torah that they follow. The use of readings from the Prophets probably arose in the wake of the religious edict issued by King Antiochus I (168–165 BC), under which reading the Torah was forbidden. In order to get round this ban, a passage from the Prophets was read out during prayers instead – a practice that continued even after the edict had been lifted. The present codex thus contains only the texts used in the synagogue service, and is not a full Bible. Since, in the Jewish liturgy, such texts always had to be read from the Torah scroll, this handy codex is most likely to have served as a private "prayer book" in which the readings could be followed during the service.

The book, like many Hebrew manuscripts, has not survived intact. It is missing the beginning of Genesis, for example, which only starts from Chapter 10:25, and the end of the Haphtaroth is also incomplete. For a long time, the codex probably had no binding. Its illustration and script (vocalized square Sephardic script) indicate that the manuscript was produced in Spain in the final third of the 15th century, when Jewish culture on the Iberian peninsula was flourishing. It was probably in the wake of the expulsion of the Jews from Spain in 1492 that – as later inscriptions suggest – the codex travelled, via several owners, to Moravia. It eventually reached the Vienna Hofbibliothek in 1877, as part of a group of Hebrew manuscripts purchased for the library from Hirsch Lipschütz.

The illustration in the manuscript is purely ornamental and features none of the display scripts otherwise typical within this cultural sphere. This omission may point to the involvement of non-Jewish artists, who were frequently employed to illustrate Hebrew codices. At the start of the individual pericopes, the parashah symbols are in most cases highlighted by means of lozenge-shaped decorative frames incorporating quatrefoils and *fleuronnée* forms in red ink. The chief

Fol. 187v (Deuteronomy): End of Deuteronomy (Debarim), with ornamental panel in front of the Haphtaroth.

בְּמֹתוֹ לֹא כָהֲתָה עֵינוֹ וְלֹא נָס לֵחֹה וַיִּבְכּוּ בְנֵי יִשְׂרָאֵל אֶת
מֹשֶׁה בְּעַרְבֹת מוֹאָב שְׁלֹשִׁים יוֹם וַיִּתְּמוּ יְמֵי בְכִי אֵבֶל
מֹשֶׁה וִיהוֹשֻׁעַ בִּן נוּן מָלֵא רוּחַ חָכְמָה כִּי סָמַךְ מֹשֶׁה אֶת
יָדָיו עָלָיו וַיִּשְׁמְעוּ אֵלָיו בְּנֵי יִשְׂרָאֵל וַיַּעֲשׂוּ כַּאֲשֶׁר צִוָּה
יְהוָה אֶת מֹשֶׁה וְלֹא קָם נָבִיא עוֹד בְּיִשְׂרָאֵל כְּמֹשֶׁה אֲשֶׁר
יְדָעוֹ יְהוָה פָּנִים אֶל פָּנִים לְכָל הָאֹתֹת וְהַמּוֹפְתִים אֲשֶׁר
שְׁלָחוֹ יְהוָה לַעֲשׂוֹת בְּאֶרֶץ מִצְרַיִם לְפַרְעֹה וּלְכָל עֲבָדָיו
וּלְכָל אַרְצוֹ וּלְכֹל הַיָּד הַחֲזָקָה וּלְכֹל הַמּוֹרָא הַגָּדוֹל
אֲשֶׁר עָשָׂה מֹשֶׁה לְעֵינֵי כָּל יִשְׂרָאֵל

חֲזַק

וְאֵלֶּה שְׁמוֹת בְּנֵי יִשְׂרָאֵל הַבָּאִים מִצְרָיְמָה אֵת יַעֲקֹב
אִישׁ וּבֵיתוֹ בָּאוּ: רְאוּבֵן שִׁמְעוֹן לֵוִי וִיהוּדָה: יִשָּׂשכָר
זְבוּלֻן וּבִנְיָמִן: דָּן וְנַפְתָּלִי גָּד וְאָשֵׁר: וַיְהִי כָּל־נֶפֶשׁ
יֹצְאֵי יֶרֶךְ־יַעֲקֹב שִׁבְעִים נָפֶשׁ וְיוֹסֵף הָיָה בְמִצְרָיִם:
וַיָּמָת יוֹסֵף וְכָל־אֶחָיו וְכֹל הַדּוֹר הַהוּא: וּבְנֵי יִשְׂרָאֵל
פָּרוּ וַיִּשְׁרְצוּ וַיִּרְבּוּ וַיַּעַצְמוּ בִּמְאֹד מְאֹד וַתִּמָּלֵא הָאָרֶץ
אֹתָם: וַיָּקָם מֶלֶךְ־חָדָשׁ עַל־מִצְרָיִם
אֲשֶׁר לֹא־יָדַע אֶת־יוֹסֵף: וַיֹּאמֶר אֶל־עַמּוֹ הִנֵּה עַם בְּנֵי

illustrations in the manuscript, however, are the five decorative panels placed in front of the individual books of the Bible and at the start of the Haphtaroth (ill. pp. 379, 380). Presented within an outer and in some cases elaborate frame, most of these panels centre upon a symmetrical floral motif, around which scrolling foliate tendrils, interspersed with semi-stylized, ornamental flowers and leaves, unfold in a gentle, flowing arrangement. The flowers are often executed in a wash style which frequently allows the whitish parchment ground to shine through. The pistils are always emphasized with a dot of burnished gold leaf. The floral motifs are occasionally joined by acanthus shoots. The ornamentation also continues partly beyond the edges of the frame in a sort of border, usually only employing a more abbreviated manner of decoration.

The illustration of Codex hebr. 211 cites developments in Flemish manuscript illumination which were taken up in Spain at the latest around 1430. Among the first to embrace these new trends were the Hebrew Bible in the Pierpont Morgan Library, Ms. Glazier 48, executed between 1422 and 1458, and the so-called Duke of Alba Bible (Ms. 399, Duke of Alba Library, Madrid), which was written in Toledo between 1422 and 1430. Whereas the assimilation of Flemish influence in the Duke of Alba Bible is still in its early stages, the forms of Cod. hebr. 211 reflect a later stage of development, as also found in the illustration of the *Compendi Historial* by Domenech Jaume, written between 1454 and 1455 in Catalonia (auctioned as Lot 38 by H. P. Kraus in 1974).

K.-G. P.

Extent: 247 parchment folios
Format: 173 x 120 mm
Binding: 19th-century half-leather binding with green marbled pasteboard
Content: Pentateuch, Haphtaroth
Language: Hebrew
Illustration: five decorative fields, fleuronnée accompanying the parashah symbols

Provenance: Several undated ownership inscriptions by a Meir Ben Isaak, Josef bar Isaak of Trest (= Triesch in south-west Moravia) and a Meir bar Neriah in Prerau (= Prěrov in Moravia); later in the possession of Hirsch Lipschütz, from whom the manuscript was purchased on 24 February 1877 for the Vienna Hofbibliothek.
Shelfmark: Vienna, ÖNB, Cod. hebr. 211

Greek Gospel Book

Constantinople (?), *c.* 1000

The patronage of the arts by the Macedonian dynasty of Eastern Roman Emperors (867–1056) contributed to a cultural flowering which has become known as the Macedonian Renaissance. For manuscript illumination, it spelled the end of the woeful iconoclasm of the 8th and early 9th century, when the illustration of codices with images of God and the saints was forbidden and illuminated manuscripts were destroyed, as the records of the Second Council of Nicaea of 787 testify. The era from which the present manuscript dates is also one that saw the introduction of minuscule as a codex script (it makes its earliest dated appearance in 835). Over the following years, majuscule was increasingly suppressed and only survived as a display script, as seen here in the headings at the start of each Gospel, which are designed in a particularly artificial manner with foliate and decorative elements within ornamental "arches" (see ill. p. 387).

The fact that manuscripts of the 9th and 10th century look back in their illumination to earlier sources is evidence that defenders of icons must have managed to keep safe at least some of their most magnificent codices containing images of God and the saints. These include the Joshua Roll, the only luxury manuscript of the Book of Joshua surviving in the form of a scroll (Cod. Vat. Pal. gr. 431), the Niketas Bible (today divided between Turin, Copenhagen and Florence), and the present manuscript – all dating from the 10th century.

The miniatures in Codex theologicus graecus 240 perpetuate the illusionistic tradition of late antiquity, in particular in the clearly-defined anatomy of the figures, who adopt poses from classical statuary (their arms draped in the manner of rhetoricians) and whose robes clearly reveal the proportions of their limbs (see ill. p. 383). The illustrations are thereby the products of a first-class workshop, as evidenced, too, by the care with which they have been executed. The miniatures

Detail from fol. 256r (St John): Beginning of St John's Gospel with a decorative arch; the title ("Gospel according to John") written in display majuscule.

▶ **Fol. 97v (St Mark):** St Mark the Evangelist standing with codex in hand. The miniature has been bound as a separate sheet, and is drawn on a thin gilded sheet, glued onto the page.

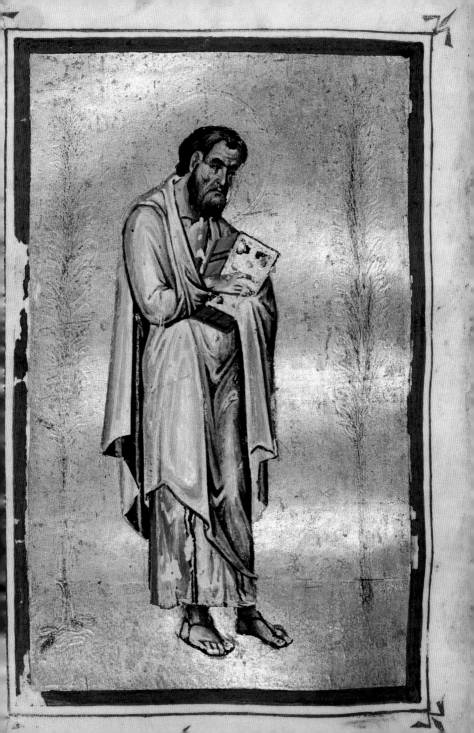

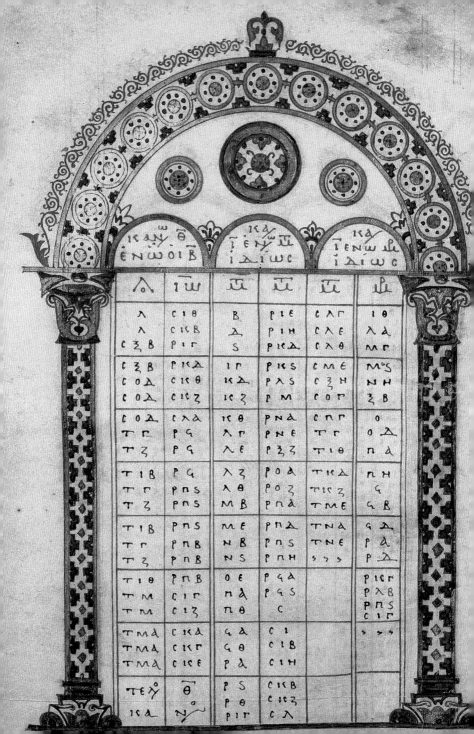

Fol. 6v: 9th canon table and first half of the 10th canon table.

▶ **Fol. 8v–9r (St Matthew):** St Matthew the Evangelist standing with book in hand. The miniature has been bound as a separate sheet, and is drawn on a thin gilded sheet, glued onto the page. Beginning of St Matthew's Gospel with a decorative arch; the title ("Gospel according to Matthew") written in display majuscule.

of the Evangelists were each executed separate from the main manuscript, in a production stage that may have taken place in parallel to the work of the copyist, but was nevertheless entirely distinct from it. The artist began by drawing the Evangelists – not seated in the usual manner, but standing – on a wafer-thin sheet of metal foil, which was probably a more suitable ground for paint. He also managed to achieve a subtle differentiation between the foreground and background by employing two shades of gold. The entire sheet was then glued into the frame created for it on the parchment folio. This painted frame was then extended to overlap the edges of the wafer-thin sheet by a few millimetres, so that the sheet could no longer be recognized as such and the miniature appeared as if it had been executed within the frame. In creating his designs, the artist not only introduced spatial depth via the colour of the gold, but also used scoring (to depict the architecture) and shaving (for the trees). A luxury object such as Codex theologicus graecus 240 is, as might be expected, just one of many products from a single workshop in Constantinople (?). It has been assigned on stylistic grounds to a group of other manuscripts which are characterized by their inclusion of a gold ciborium as a decorative arch, for example at the start of the Gospels.

When the imperial legate Ogier Ghislain de Busbecq came to Constantinople between 1555 and 1562, he purchased a large number of manuscripts, including the present example, which today makes up one of the two mainstays of the Hofbibliothek's collection of Greek manuscripts. Codices such as these were probably plundered by the Turks from parts of the newly-conquered Byzantine Empire, with a view to selling them in Constantinople to western visitors.

C. G.

Extent: 331 parchment folios
Format: 203–212 x 150–158 mm
Binding: Vienna Hofbibliothek leather binding of 1755 (re-bound under praefect Gerard van Swieten)
Content: four Gospels (with Eusebius' letter to Karpianos and canon tables)
Language: Greek
Illustration: four full-page miniatures on a gilded ground

Provenance: The codex was acquired in Constantinople between 1555 and 1562 from the imperial ambassador Ogier Ghislain de Busbecq. It is first documented in the Vienna Hofbibliothek under its second praefect, Sebastian Tengnagel (1608–1636).
Shelfmark: Vienna, ÖNB, Cod. theol. gr. 240

ΜΑΤΘΑΙΟC

ΕΥΑΓΓΕ- ΛΙΟΝ ΚΑ- ΤΑ ΜΑΤ- ΘΑΙΟΝ

ἱβλος γενέσεως
ἰη(σο)ῦ χ(ριστο)ῦ υἱοῦ δα(υὶ)δ υἱ-
οῦ ἀβραάμ·
ἀβραὰμ ἐγέννη-
σε τὸν ἰσαάκ·
ἰσαὰκ δὲ ἐγέννη-
σε τὸν ἰακώβ·
ἰακὼβ δὲ ἐγέννη-
σε τὸν ἰούδαν &
τοὺς ἀδελφοὺς αὐ-
τοῦ· ἰούδας δὲ ἐγέννη-
σε τὸν φαρὲς καὶ τὸν

ζαρὰ ἐκ τῆς θάμαρ·
φαρὲς δὲ ἐγέννη-
σε τὸν ἑσρώμ·
ἑσρὼμ δὲ ἐγέννη-
σε τὸν ἀράμ·
ἀρὰμ δὲ ἐγέννησε
τὸν ἀμιναδάβ·
ἀμιναδὰβ δὲ ἐγέν-
νησε τὸν ναασσών·
ναασσὼν δὲ ἐγέννη-
σε τὸν σαλμών·
σαλμὼν δὲ ἐγέννη-
σε τὸν βοὸζ ἐκ
τῆς ῥαχάβ·
βοὸζ δὲ ἐγέννησε
τὸν ὠβὴδ ἐκ τῆς
ῥούθ·
ὠβὴδ δὲ ἐγέννησε

Greek Gospels
and Praxapostolos

Constantinople, middle to 2nd half of the 12th century

After a constant succession of emperors and fresh (and in part continuing) threats from the Normans, Seljuk Turks and Petchenegs, the 12th century under the rule of the Comnenian (1081–1185) and Angelos dynasties (1185–1204) was a period of cultural flowering in the Byzantine Empire. It was also a period of confrontation with the West, precipitated by the Crusades which led, on 13 April 1204, to the conquest of Constantinople by the Latins. The aesthetic minuscule script had by now passed its peak, and even though biblical and liturgical manuscripts continued to look back to "classical forms", a decline in standards became increasingly apparent.

It is against this backdrop that we must view the production of the present manuscript, which probably arose not in Grottaferrata in northern Italy, as was previously thought, but in a Constantinople workshop (Spatharakis [1999], p. 279). This luxury codex is distinguished by an unusual preface: a representation of the Trinity accompanied underneath by a text setting out, in two columns, pairs of Trinitarian opposites (*one* God – *three* persons, *one* nature – *three* hypostases etc.; ill. p. 389). This representation finds a parallel in a fresco based on orthodox rites in the monastery of Grottaferrata, although this fresco, which dates from around 1200, is probably not directly connected with the manuscript.

Facing this so-called *Paternitas* type of Trinity picture (God with Christ on his lap and the dove as a symbol of the Holy Ghost in Christ's hand, after St John 1:18; ill. p. 389) is the Nicene Creed as it was affirmed at the Council of Constantinople (fol. 1*r; ill. p. 388), containing the sentence that split the Eastern and Western Churches: namely, that the Holy Ghost proceeds (only) from the Father

Detail from fol. 1*r: Nicene Creed as it was affirmed at the Council of Constantinople, with the depiction of a man raising his arms towards the Trinity on the opposite page.

▶ Detail from fol. 1v: Representation of the Trinity (God the Father with Christ on his lap and the dove in Christ's hand), surrounded by an angelic host (cf. Daniel 7:9).

▶▶ Fol. 13v: St Matthew beside a desk copying (!) the beginning of his Gospel from another open manuscript ("Book of the Lineage of Jesus Christ, the Son of David").

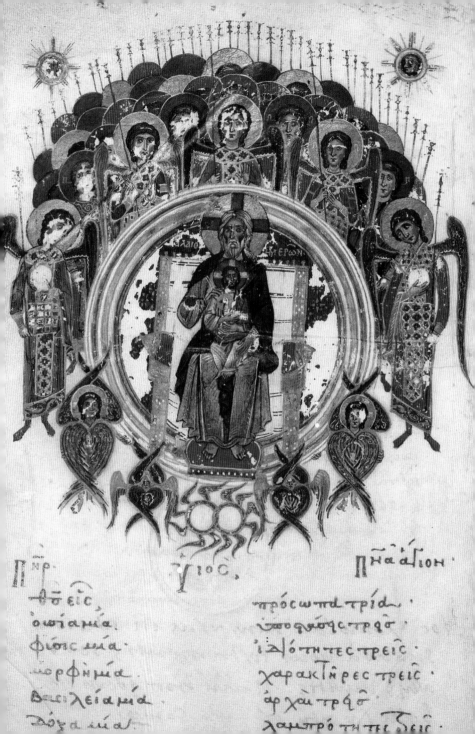

Π͞Ρ͞Σ Ἅ͞ΓΙΟΣ Π͞Ν͞Α ἉΓΙΟΝ

θ͞ς εἷς, πρόσωπα τρία·
οὐσία μία, ὑπόστασεις τρεῖς·
φύσις μία· ἰδ(ι)ότητες τρεῖς·
μορφὴ μία· χαρακτῆρες τρεῖς·
βασιλεία μία· ἀρχαὶ τρ(εῖ)ς·
δόξα μία· λαμπρότητες τρεῖς·

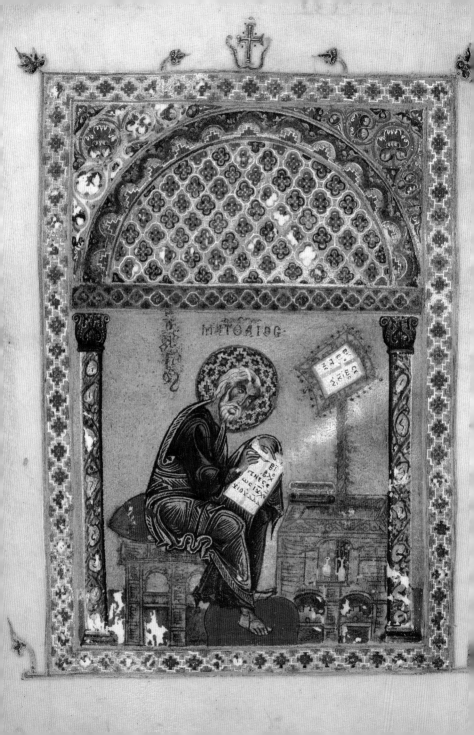

(and not also from the Son). Its prominent position at the beginning of the manuscript – in front of the magnificent canon tables (ill. p. 392) – lends it a programmatic emphasis which, in view of the constant conflict with the West, particularly in the 12th century, may perhaps be understood as a deliberate statement. As indicated by God's description as "The Ancient of days", the miniature itself is based on Daniel 7:9, where in the account of Daniel's dream the white-haired "Ancient of days" is also described, seated on a throne surrounded by countless beings. Fittingly for Christian exegesis, the Old Testament passage goes on to speak of a Son of man, who approaches the Ancient of days on the clouds of heaven. The manuscript belongs to a group of codices containing a characteristic illustration of an Evangelist with a "whispering dove" (here in front of St Luke's Gospel; fol. 117v) and which can now be localized to Constantinople. A division of labour within the workshop is clearly apparent: the miniaturist worked independently of the copyist and executed his Evangelist portraits on thicker sheets of parchment, which were then bound at the start of the Gospels they accompanied. Noteworthy is the fact that this manuscript passed into Western hands early on. Latin notes in the margin relating to the Trinitarian opposites can be dated to the 13th century; in the 14th century, the codex was used by Radulphus de Rivo, deacon of Tongeren church in Belgium, who had been taught in Greek by the Greek archbishop Simeon of Thebes while in Rome around 1380. The codex subsequently had a number of owners in Belgium. Erasmus of Rotterdam, who records at the start of the manuscript (fol. 1r, and again in Greek on fol. 181v) that he consulted the codex for his second edition of the New Testament on 1 July 1519, offers the following verdict on the text: "This exemplar ... I used ... alongside many others. For although the codex is beautifully written, it is not, as I have observed, well corrected, which shows that no one has consulted it."

C. G.

Extent: 454 parchment folios
Format: 245–250 x 175 mm
Binding: 17th-century black leather binding over wooden boards with blind lines and gold tooling on the back (probably made for the Dominican Martin Harney, a previous owner), gilt edges
Content: Gospels and Praxapostolos
Language: Greek
Illustration: half-page representation of the Trinity surrounded by a choir of angels; Creed miniature, canon tables; full-page miniatures of the four Evangelists; decorative bars and decorative initials at the beginning of the texts (decorative bar cut out on fol. 183r)

Provenance: The first owner is named as Radulphus or Rolandus de Rivo († 1401/1403 Rome), who came from Belgium. The manuscript subsequently had a number of different Belgian owners (St Mary's abbey in Corssendonck, near Turnhout; Erasmus of Rotterdam, 1519; financial commissioner van den Wouvere). After belonging to another owner named in an inscription as Martin Harney, a Dominican monk, the codex reached the Dominican abbey in Brussels. From there it passed into the possession of Prince Eugene of Savoy (1663–1736); it has formed part of the Vienna Hofbibliothek collection since 1738.
Shelfmark: Vienna, ÖNB, Cod. suppl. gr. 52

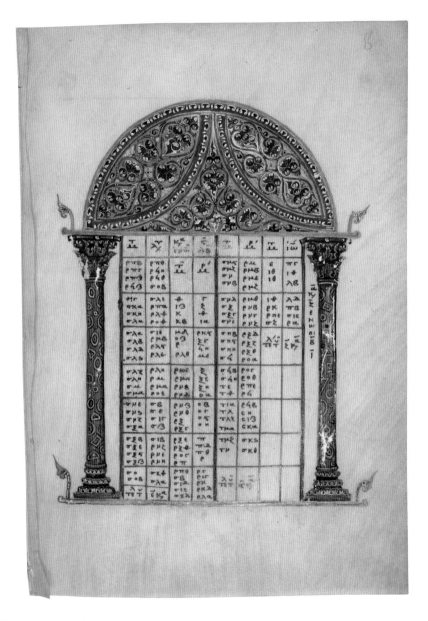

Fol. 8r: 5th canon table (end of the 5th canon, 6th and 7th canon).

▶ **Fol. 182v:** St John, his head inclined towards God's hand, dictates the opening of his Gospel to his scribe Prochoros ("In the beginning was the Word, and the [Word] ...").

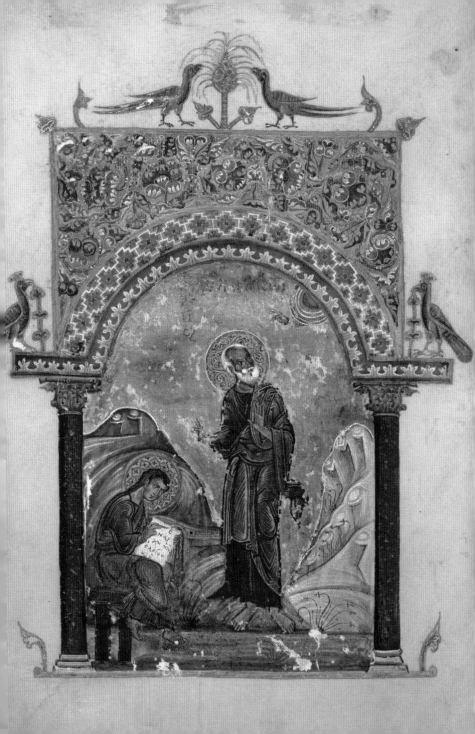

Slavonic Liturgical Apostolos

Dragomirna abbey (Romania, Moldavia region), 1610

Codex slavicus 6, a sumptuous and richly illuminated manuscript from the year 1610, originates from the Moldavian abbey of Dragomirna, which lies some seven miles north of Suceava in present-day Romania and was founded at the beginning of the 17th century by Archbishop Anastasie Crimca († 1627?), Metropolitan of Suceava. It was in fact the same Anastasie Crimca who donated the codex to the abbey, in memory of his parents Ion and Cîrstina Crimca, as can be deduced from a note (fol. 311v) and a dedication (fol. 314v). The manuscript was housed in the Church of the Holy Ghost attached to the abbey and probably completed around 1609. The subsequent history of the manuscript can be traced with the help of another inscription (fol. 11v–15r): following the destruction of Dragomirna by the Zaporog Cossacks in 1653, the codex was stolen and was only returned to the abbey after a ransom had been paid with money put up by the boyar Toma Cantacuzino. It is highly probable that the codex entered the Vienna Hofbibliothek at the beginning of the 18th century. Today it numbers amongst the oldest holdings in the library's Slavica collection.

A leading role in the story of this manuscript is played by the figure of Archbishop Anastasie Crimca, as he was not only the founder of Dragomirna abbey and the donor of the codex, but also its scribe and illuminator. The lower miniature on fol. 75r shows him kneeling in prayer and holding in his hand a scroll bearing a prayer to Jesus Christ. Opposite him in the right-hand half of the scene is a representation (according to the caption) of Dragomirna abbey with the figure of a nun, possibly his mother Cîrstina. The text on the left, beside the donor's self-portrait, gives his name and position.

Codex slavicus 6 is written in semi-uncial (*Poluustav*) on very soft and smooth parchment, and contains a wealth of miniatures and miniature-like illustrations which follow the tradition of Byzantine manuscript illumination. Particular men-

Detail from fol. 110v (Jude): Jude the Apostle seated.

▸ **Detail from fol. 172r:** St Michael the Archangel as horseman of the Apocalypse, above him to the right a youthful Jesus Christ.

ТАЖЕ ЗАПОВѢ ДАВЬ НЕ СЪГРѢШАТИ ·
НЖ КАѦТИСМ СЪ ГРѢШАЖЦIИ НАⷧ ·
СЪ БГОДАРЕНIЕ АⷧЬ ·

СIКОНТАВЛѢ
ПОСЛА
НIЕ

ГРОЗНЫ ИСКАНIЙ
СТРАШНЫ ИНБНЫ
И ЛЬВОЕВОДА · ПРѢ
ТАТЕ ПРТЛУ ВЕЛИ
ЬСТВIА СЛАВЫ ТВОЕⷶ ·

АР̃ МИХАⷷ

I҃С Х҃С

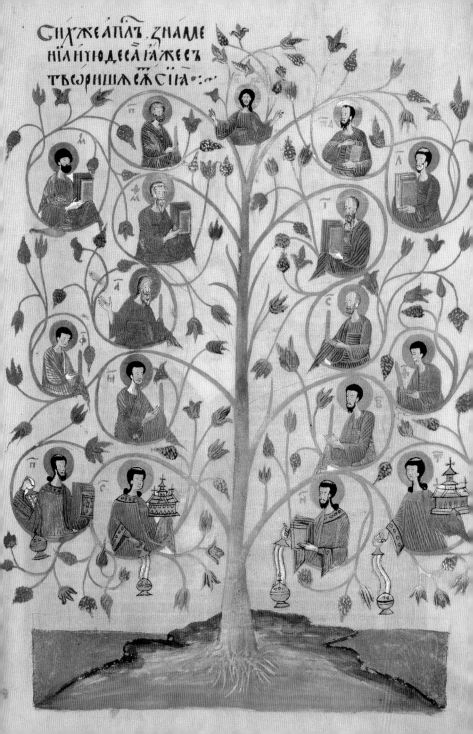

Fol. 4r: Golden tree, based on genealogical trees, with portraits of Jesus Christ (top centre), the four Evangelists and the Apostles.

▸ **Detail from fol. 75r:** Representation of the Old-Testament Holy Trinity, served by Abraham (left) and Sarah (right), against an architectural and landscape background.

tion should be made of the icon-like full-page miniatures of St Luke the Evangelist and the Apostles (St Luke: ill. p. 16; fol. 75v; St John: ill. p. 400; fol. 215v; fol. 262v) and scenes from the New Testament, including for example the Annunciation (fol. 270r), Christ's entry into Jerusalem (ill. p. 401) and the Crucifixion group (fol. 292v).

Especially magnificent is a miniature portraying Archangel Michael mounted on horseback (ill. p. 395). The crowned commander of the heavenly hosts is riding a white horse towards the left and at the same time blowing a horn. Conquering a demon at his feet with his lance, he holds up in his left hand a Gospel book and a censer. Above him to the right appears the young Jesus Christ, and beside him to the left a number of lines of text naming his attributes in prayer form.

The starts of the Acts of the Apostles and the various Epistles (fol. 5r; 76r; 100r, ill. p. 400; 144r) are announced by decorative fields filled with interlace patterning and executed chiefly in gold, red, blue, green and orange. The elaborate titles are written almost exclusively in gold.

Recent research (Costea [1992]) has shown that the present manuscript, together with two others dating from 1609 (Codex slavicus 22 and 436, which today are both in Bucharest), forms part of a group of codices which issued from the scriptorium at Dragomirna abbey between 1609 and 1616, and which arose on the initiative or within the circle of Archbishop Anastasie Crimca.

M. P.

Extent: 317 parchment folios
Format: 355 x 235 mm
Binding: Byzantine leather binding with elaborate blind tooling over wooden boards
Content: Acts of the Apostles, Epistles of the Apostles (both divided into pericopes), prefaced by an essay by Epiphanius of Salamis (*c.* 310/320–403) on the lives, deaths and acts of the Apostles and concluding with a liturgical appendix
Language: Church-Slavonic Bulgarian edition
Scribe: Archbishop Anastasie Crimca, Metropolitan of Suceava (1627?)
Miniaturist: see Scribe

Illustration: Titles in gold script; initials, decorative borders, decorative fields filled with interlace patterning, numerous small and full-page miniatures against an architectural and landscape background.
Provenance: The Apostolos was written and illuminated by Archbishop Anastasie Crimca in 1610 and donated to Dragomirna abbey (16.3.1610). Housed in Vienna probably since the beginning of the 18th century, it is one of the oldest Slavonic codices in the Austrian National Library collection.
Shelfmark: Vienna, ÖNB, Cod. slav. 6

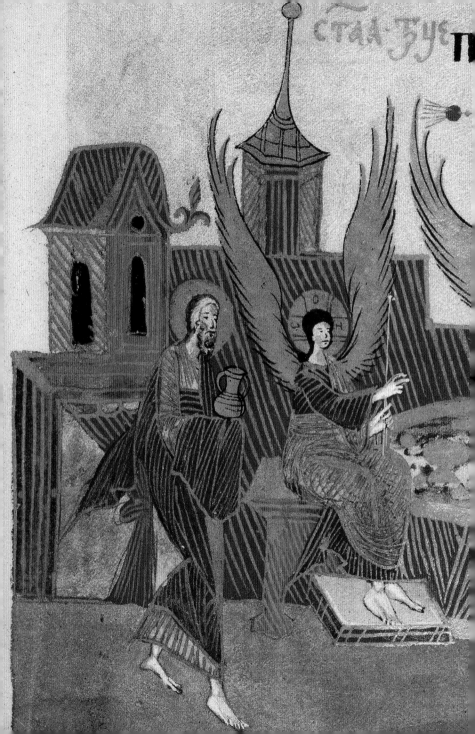

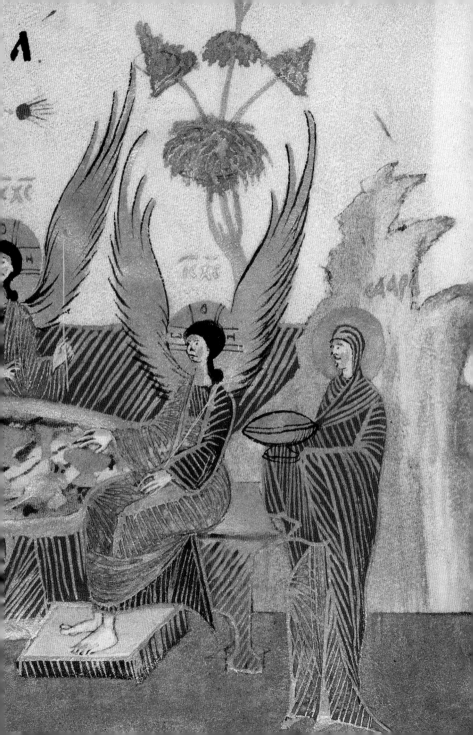

Fol. 99v–100r (1 John): John the Apostle seated in a cave, above him the Holy Ghost as a white dove, in front of him an open book containing the first sentence of his 1ˢᵗ Epistle. Start of the 1ˢᵗ Epistle of John.

▸ **Fol. 292r:** Entry into Jerusalem: Jesus on a donkey in the centre of the picture, riding towards the right; behind him the apostles, on the right a crowd of people bearing palms. Landscape background and representation of the city of Jerusalem.

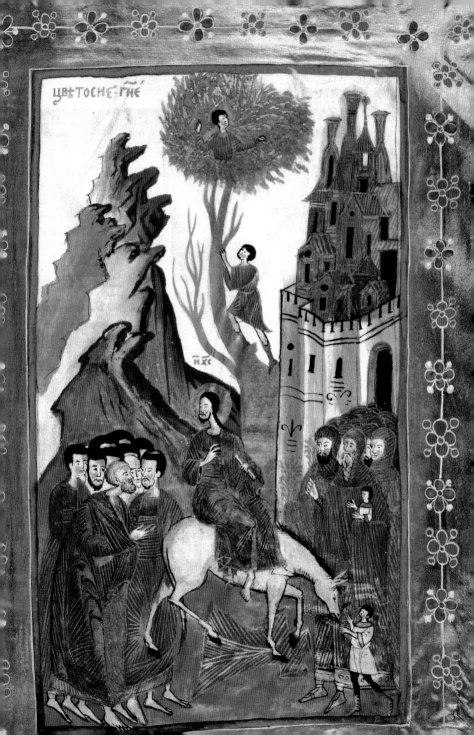

ноученїоу · въдѫщѧбытнꙗвлена
въннхжеꙍстѫпатьнѣцнꙍꙁвѣры
нлоутнꙗженнстобытнбрашно ·
нкъꙁꙑвѣстньвьꙗлоꙋглюбопернлан
стѫбанїгаꙗкоснкръннꙗѣжша · оꙋ
кланѣтнсѧ · оннꙗженнвⷰцїнхвⷪа
лѧщесѧ · прѣстѫпншавⷣрѫ · н
іконецъ · ікⷯоⷡпотрⷨѣбаⷮенлаⷮ

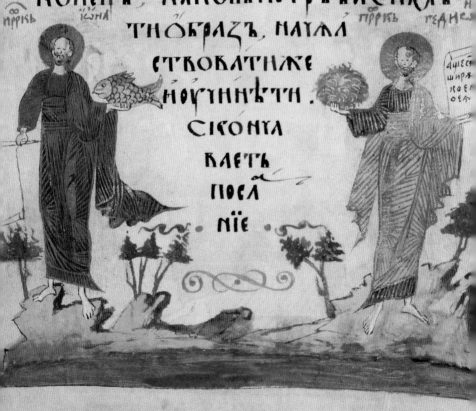

тнобразъ · наⷱла
ствоватнже
ноутннѣтн ·

сіꙉонⷱа
клеⷮ
посⷧ
нїе ·

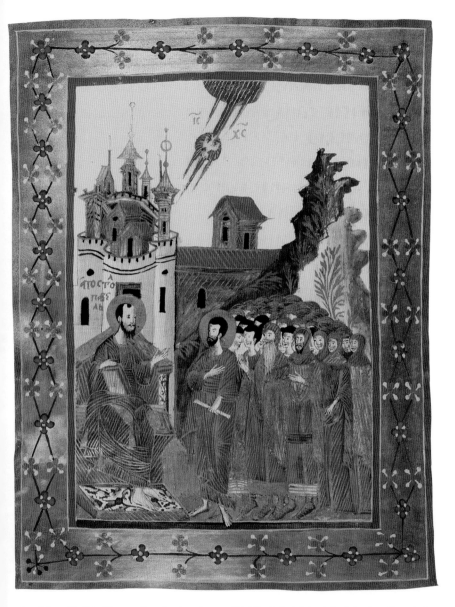

◂ **Detail from fol. 246r:** The prophets Jonah and Gideon.

Fol. 143v (1 Corinthians): Paul the Apostle seated in the lower left-hand corner of the picture and preaching to a crowd, above him the Holy Ghost as a white dove, in the background a city and landscape.

Slavonic Liturgical Gospel Book

Bistrita abbey (Romania, Moldavia region), 1502

The present Gospel book ranks amongst the finest manuscripts in the Slavica collection of the Austrian National Library in Vienna. It was commissioned by Prince Stephen III, the Great, of Moldavia, who presented it to the Bulgarian monastery of Zographou on Mount Athos in 1502 – for the salvation of his soul and of those of his wife Maria and son Bogdan, as a dedication on fol. 245r informs us (ill. p. 409).

The manuscript arose during an era of great political change in south-eastern Europe. The Ottoman Turks had been pursuing their relentless expansion since the middle of the 14th century, conquering the Bulgarian Kingdom (1393), the Byzantine Empire (1453) and the Despotate of Serbia (1459), and were in the process of seizing the territories of the Hungarian throne.

Within this situation, only the principality of Moldavia, under the rule of Stephen III, succeeded in repulsing Ottoman invaders in the period between 1474 and 1501. In recognition of this achievement, the Pope awarded Stephen the epithet *Athleta Christi* ("fighter for Christ").

The Moldavian dynasty of princes had in the past founded and funded churches and monasteries both at home and abroad, and from the middle of the 15th century onwards, in emulation of the rulers of Bulgaria, Serbia and Byzantium, gave particular support to the monastery of Zographou. Stephen III followed this example: as well as building numerous churches and abbeys, he also donated generous sums of money to Zographou monastery, paid for new buildings to be erected and presented it with at least four manuscripts, three dating from 1463, 1475, 1492 (which today are all in Moscow) and the present codex.

At the instigation of Bartholomäus Kopitar (1780–1844), curator of the Hofbibliothek in Vienna, and with the agreement of the abbots, the present Gospel book and eleven other Slavonic codices from the monasteries of Hilandar and Zographou on holy Mount Athos were brought to Vienna in December 1826 for

Detail from fol. 190r (St John): Decorated page with interlace patterning and animal motifs (white doves).

▶ **Detail from fol. 120v (St Luke):** St Luke the Evangelist seated and writing on a scroll with writing utensils.

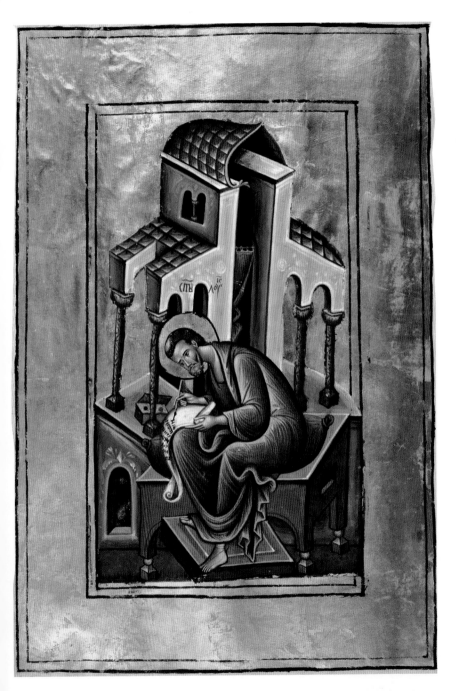

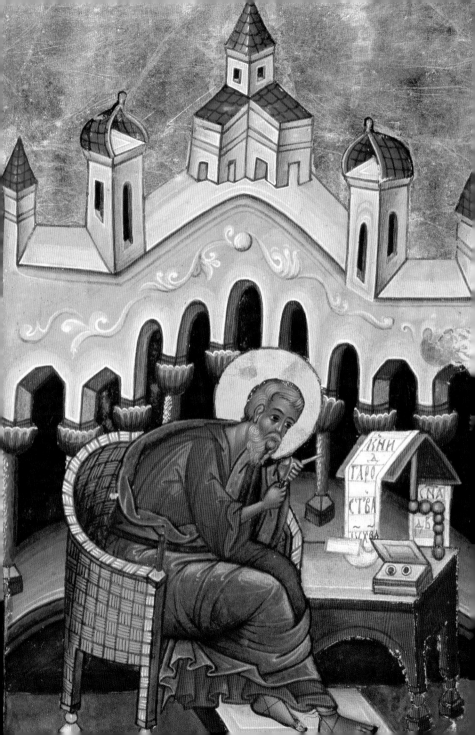

Fol. 5v (St Matthew): St Matthew the Evangelist seated and sharpening his stylus, with desk and writing utensils.

closer study. Having established their artistic and historical value, they were subsequently purchased for the library with the benevolent assistance of Emperor Franz I (1768–1835) and State Chancellor Klemens von Metternich (1773–1859). This luxury manuscript is written in semi-uncial (*Poluustav*) on very fine parchment. Its captivating illustrations stand clearly in the tradition of Byzantine manuscript illumination (cf. the full-page miniatures of the four Evangelists). While the portraits of St Mark (ill. p. 408) and St Luke (ill. p. 405) correspond to probably the most common compositional type of the "writing Evangelist", the portrait of St John uses the type of the "meditating Evangelist" (ill. p. 374) and that of St Matthew "the Evangelist sharpening his stylus" (ill. pp. 25, 406). All four are depicted like icons against a gold ground.

The portraits of the Evangelists in each case precede the start of their respective Gospels. The opening of the Gospel texts themselves are announced by large decorative fields filled with interlace patterning. The palette they employ is in three cases chiefly blue, green, red and gold (fol. 6r; fol. 73r; fol. 190r) and in one case (fol. 121r) only gold. The dedication at the end of the manuscript is also worthy of attention (fol. 245r, ill. pp. 409. It is written in gold ink and shows, clockwise from the right, the moon, an aurochs (the Moldavian heraldic animal), the prince's coat of arms and the sun.

On the basis of its illustration and calligraphy, Codex slavicus 7 has been assigned to a group of Gospels which can be dated to the 16th century and localized to the region of Serbia/Romania.

M. P.

Extent: 258 parchment folios
Format: 335 x 235 mm
Binding: 19th-century half-leather binding
Content: four Gospels (divided into pericopes) with preface by Theophylaktos of Ohrid (*c.* 1050–after 1126) and an appendix on the liturgical readings
Language: Church-Slavonic Bulgarian edition
Scribe: Philippos the monk
Illustration: gold sub-titles, decorative bars, decorative fields containing interlace patterning and animal motifs, four full-page miniatures of the Evangelists, dedication with decorative frame and representations of the moon, heraldic animal, coat of arms and sun
Patron: Stephen III, the Great ("tefan cel Mare), Prince of Moldavia 1457–1504
Provenance: The Gospels were dedicated by Stephen III to Zographou monastery on Mount Athos. In 1827 they were purchased by Bartholomäus Kopitar for the manuscript collection of the Hofbibliothek in Vienna.
Shelfmark: Vienna, ÖNB, Cod. slav. 7

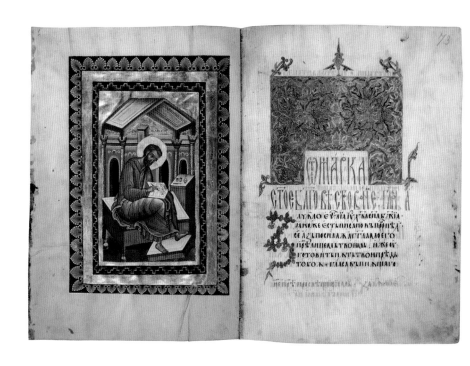

Fol. 72v–73r (St Mark): St Mark the Evangelist seated and writing at a desk with writing utensils. Decorated page at the start of St Mark's Gospel.

▸ **Fol. 245r:** Dedication in gold ink; moon, aurochs and sun in gold, family coat of arms in blue, green and gold.

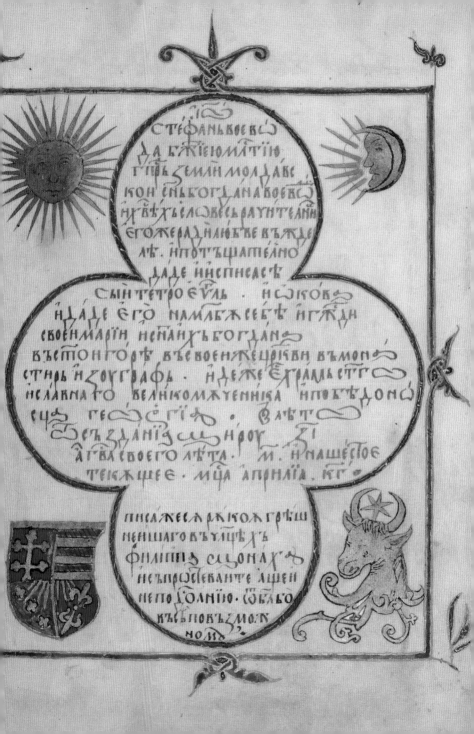

СТЄФАНЬ ВОЄВ(С)
ДА БЖІЄЮ МАТІЮ
ГПЬ ЗЄМЛИ МОЛДАВС
КОН ЄНЬ БОГДАНА ВОЄВ(С)
И ВЪХЬ ЄЛОВЄСЬ РАИТЄЛИ
ЄГОЖЄ РАДИ ЛЮБЄ ВЪЖДЄ
ЛѢ. И ПОТЪЩАТЄЙНО
ДАДЄ И ИСПИСАСѢ

СЫН ТЄТРОЄУЛЬ . И СЇЮ КОВЬ
И ДАДЄ ЄГО НАМ ЛѢЖ СЄБѢ И ГДЖИ
СВОЄН МАРІИ, И СПАНЪ БОГДАНЪ
ВЪ СТОН ГОРѢ ВЪ СВОЄН МЖЄ ЦРКВИ ВЪ МОНА
СТИНЬ И ЗОУГРАФЬ . И ДЄЖЄ ЄГ ХРАМЬ ЄСТ
И СЛАВНАГО ВЄЛИКОМЖЄННИКА И ПОБѢДОНО
ЄЦЄ ГЄОРГІА . ВЪ ЛѢТ
Ѕ ЗЬ З ДАНІЄ ЩИ РОУ ЗІ
А ГВА СВОЄГО ЛѢТА . М . И НАШЄ СТОЄ
ТЄ КЖЩЄЄ . МЦА АПРИЛЇА . КГ.

ПИСА ЖЄ СА Р КОА ГРѢШ
НЄНШАГО ВЪ ЇЄРЄХЬ
ФИЛИППЬ СЩОНАХЬ
НЄ ПРОСÊ ВАНТЄ АЩЄ И
НЄ ПО ДОЛНЇЮ . СЪ БЛÇО
КЪ ПОКЪ ЗМОЮ
НОМЬ

Syriac Gospel Book

Vienna, 1554

Within the Syriac-speaking sphere in the 2nd century, the four Gospels were read chiefly in the form of the *Diatessaron*, the concordance of the Gospels compiled by Tatian (2nd half of the 2nd century) and today surviving only in quotations. It was not long, however, before Syriac translations of each of the four Gospels were also prepared, themselves drawing upon the *Diatessaron*. In the process of transcription over the course of time, these translations underwent revision and alteration. The translation preserved in the present Gospel book became known in the 10th century as the Peshitta (i.e. the "simple" translation, in contrast to others much harder to read), and was originally prepared in the 5th century, again on the basis of earlier versions. It spread rapidly, supplanted the *Diatessaron* and was soon adopted by all Syrian churches. It remains today the standard New Testament text for Syrian Christians and is read in the liturgy. The present codex contains the Peshitta translation of the Gospels.

The manuscript is written in *Serto*, one of the three Syriac styles of script, which evolved from the 6th century onwards in the West-Syrian (Syrian Orthodox) Church and was employed in manuscripts from the 8th century onwards. Since only the consonants are written, systems of indicating the vowels were developed as from the early Middle Ages. The present codex employs the old system of diacritical points and in addition is almost completely vocalized with vowel signs of both the western and eastern Syrian systems, written somewhat thinner and almost always in black.

When Codex syriacus 1 was bound, three sheets of paper were included at the front and back of the manuscript to protect the inner book. On the first two parchment folios and one third of one paper page are a dedication to Emperor Ferdinand I included in a lengthy Latin colophon, in which the scribe, Moses of Mar-

Detail from fol. 159v (St John):
End of St John's Gospel.

Fol. 1v (St Matthew): "With the power of our Lord Jesus Christ we start to write the text of the ho(ly) Gospels; first the Gospel according to St Matthew, which he recited in Hebrew in the land of Palestine." Beginning of St Matthew's Gospel.

Fol. Iv: Ornamental page, sentence in the shape of a cross: "Through you we defeat our enemies and in your name we crush those who hate us."

din, sets out the aim of the undertaking and the transcription. The Bible text is introduced on fol. 1r by an ornamental page (ill. p. 412), which contains the following sentence in gold ink in the shape of a cross: "Through you we defeat our enemies and in your name we crush those who hate us." This is followed by the four Gospels. In line with earlier editions of the Peshitta, the pericope about the woman caught in adultery (John 7:53 – 8:11; fol. 137v) is absent. On fol. 39r the scribe notes in the margin that, in the context of Matthew 24:40, the text of Luke 17:34 "is missing". The codex otherwise contains no observations on the texts of the Synoptic Gospels. The Gospels are divided into the usual chapters and into the sections traditional in Syrian Bibles, and are only sparsely illustrated (ornament on fol. 75v; 96r).

The Gospels are followed by two Syriac colophons bordered in red, and one in Latin (fol. 160r). In Syriac, the scribe introduces himself as Moses of Mardin, son of the priest Isaac, and as a "Jacobite" from the village of Qalūq, and asks the reader to pray for him and his family. He goes on to record that he wrote the text "in Vienna" (*b-by'n'*) in the time of "Ferdinandus, the Roman King". He includes wishes of prosperity and victory for Ferdinand "and his brother Karolus, the King of Spain". He completed the manuscript on 28 Tammuz 1554 (in Latin on fol. IIIr, 10 August 1554). The scribe's name, year and dedication are repeated in the Latin colophon. The codex probably served as the basis for a first printed edition and as such for the first book to be printed in Syriac script in Vienna (1555, Johann Albert Widmannstad).

C. L.

Extent: 160 + II parchment folios, 6 sheets of paper
Format: 92 x 75 mm
Binding: brown leather binding over thin wooden boards with roller-stamped and plate-stamped decoration (Vienna [?], 16th century), pounced gold edges, clasps lost, on the front cover plate-stamped representation of an allegory of FIDES surrounded by foliate decor, on the back cover Crucifixion with the Virgin and St John, SATISFACTI beneath
Content: Gospel book
Language: Syriac (and Latin)
Scribe: Moses of Mardin, son of Isaac the priest, from the village of Qalūq near Mardin (documented in Rome in 1549 as the scribe of a Roman Missal in Syriac lettering [British Library, Harl. 5512]; †1592 or shortly afterwards)
Illustration: ornamental design given to the beginnings of sections within the text; beginning and end of each Gospel written in outlined gold script; beginning of each Gospel also announced by three-sided ornamental border with interlace patterning; decorative page at the very front featuring a cross in interlace patterning with inscription (see below).
Provenance: According to the dedication on fol. IIIv-Vr, the manuscript was intended for Emperor Ferdinand I (1503–1564).
Shelfmark: Vienna, ÖNB, Cod. syr. 1

Armenian Gospel Book

Village of K'arahat in the region of Ganjak (Azerbaijan), *c*.1680

Armenia was the first kingdom to declare Christianity its official state religion (in around AD 313), and the Bible played a correspondingly central role in its manuscript production and illumination. The emergence of Armenian manuscripts as an independent genre only became possible, however, following the creation of a new alphabet under Mesrop Mashtots in 406. The subsequent translation of the Holy Scripture was completed in 435. The Erkat'agir ("iron script") majuscule employed in early manuscripts gave way, from the 10th century onwards (until about the 16th century) to a Bolorgir minuscule ("round script"), which is also employed as a traditionalism in Codex armenicus 29.

For the Armenians, their Bible enjoyed the status of a holy relic, and they devoted particular care not just to its production, but also to its protection and preservation. Should a manuscript fall into foreign hands in the wake of military conquest, every effort would be made to pay the costly ransom demanded for its return. The great importance attached to the Bible is also indicated by the communal storage of medieval manuscripts in the Matenadaran book-depository in Yerevan – a literary horde which was severely depleted as a result of pillaging by the Seljuk Turks, Mongols, Persians and Ottomans, so that today only some 28,000 manuscripts survive.

Armenia's vicissitudinous position as a buffer state between Byzantium and Persia, and subsequently between Arab, Seljuk and Ottoman territory and Persia, also left its mark upon manuscript illumination, amongst other things in its assimilation of foreign styles, such as the Byzantine influence which is clearly apparent in Armenian codices of the 11th century.

Detail from P. 213 [fol. 107r, St Luke]: Beginning of St Luke's Gospel with lavish majuscule (Erkat'agir) in the shape of an animal.

▸ **P. 287* [fol. 194r, St John]:** Beginning of St John's Gospel with decorative arch, decorative element in the margin and lavish majuscule (Erkat'agir) initial in the shape of a bird.

▸▸ **P. 105 [fol. 53r, St Mark]:** Beginning of St Mark's Gospel with decorative arch, decorative elements in the margin and lavish majuscule (Erkat'agir) initial in a zoomorphic shape.

▸▸▸ **P. 148-149 [fol. 74v-75r, St Matthew]:** Part of St Mark's Gospel with decorative initials and marginal decorations (with numerals) to subdivide the text; Gospel concordance in the lower margin.

.

բառ
մարկոսի։

The constant repression under which they lived prompted many Armenians to emigrate – to Cilicia, for example, where they founded the kingdom of Little Armenia (1199–1375) with its own admirable tradition of manuscript illumination – and to establish a diaspora of communities, chiefly in eastern Europe. New cultural centres of Armenian manuscript production (and printing) were thereby established (amongst them, from 1717, the Armenian-Catholic Mechitharist congregation of San Lazzaro in Venice). Even within Armenia itself, however, the production of sumptuous Bible manuscripts did not entirely cease, as the present codex from the 2nd half of the 17th century clearly demonstrates. The manuscript employs a range of traditional elements of Armenian Gospel-book illumination: these include the decorative arches at the start of each Gospel, which are in each case followed by a title line in ornamental Erkat' agir, whose opening initial is given a zoomorphic shape (see ill. p. 416). At the beginning of St Luke's Gospel (fol. 106r–107r), the title line is also written in a "bird script", insofar as each letter presents itself in the form of a bird.

The circumstances in which the codex was produced are recorded – as is common in Armenian manuscripts – in the (in places highly detailed) colophon at the back, generally called the Hišatakaran (memorial). In the present case, it names Shah Suleiman I of Persia and Katholikos Siměon of Albania (today Azerbaijan). It should be noted in this context that the date of the manuscript coincides with efforts by the Armenians to free themselves from Ottoman sovereignty: from around 1678 until 1711, the Armenian diplomat Israel Ori travelled throughout Europe and Russia seeking the backing of Emperor Leopold I, Tsar Peter the Great and Pope Clemens XI for Armenia's campaign against Turkish and Persian rule.

M. K. K. / G. P. / C. G.

Extent: 264 sheets of oriental paper
Format: 180 x 118 mm
Binding: dark-brown leather binding over wooden boards, with additional flap to protect the fore edge; probably decorated in two phases: the blind stamping with quatrefoil flowers and plaitwork forming a cross on the front cover were executed first; later, the front and back covers were densely studded with metal (?) bosses, of which only circular imprints and the holes still remain. Patterned fabric is glued to the inside covers.
Content: four Gospels with Gospel concordance and introductions to the Gospels.
Language: Armenian (Grabar)
Scribe: Grigor, a priest, and Palason, a deacon Illustration: decorative arch at the start of the Gospels, numerous calligraphic initials, some

assuming the bird shape typical of Armenian manuscripts; decorations in light blue, orange, green, red, pink and gold in the margins dividing the chapters.
Provenance: According to the colophon, the manuscript was written in the time of Shah Suleiman I (1667–1694, of the Persian Safavid dynasty) and Katholikos Siměon of Aghwan (Caucasian Albania, today Azerbaijan); numerous dated entries from the 1st half of the 19th century (1813–1851) on the blank pages at the end of the manuscript (fol. 262r–264v) mention, amongst others, a Nersēs, Movsēs (son of Nersēs), a Menas, a Łukas and a Karapet (?) as owners. The codex was purchased for the National Library in 1927.
Shelfmark: Vienna, ÖNB, Cod. arm. 29

Ethiopic Gospel Book

Ethiopia, around 1700

አተ፡ኡወ፡ለዩ፡ዳፂ፡ተ፡ወ፡ለዩ፡ኡ፡ዐበር፡
ኡ፡ዐበር፡ዋም፡ወ፡ለዩ፡ኡ፡ለ፡ኡ፡ለ፡ኡ፡ተ፡ዐ፡ዩ፡ኡ
ለዩ፡ለ፡ለ፡ዐ፡ቡ፡ተ፡በ፡ወ፡ዩ፡ዳ፡ቡ፡ተ፡ቡ፡ዩ፡ወ፡ለ፡ዩ
ዩ፡ዩ፡ወ፡ኡ፡ወ፡ኡ፡ዩ፡ዐ፡ለ፡ዩ፡ዐ፡ቡ፡ዩ፡ዩ፡ወ፡ለ፡ዩ
ኡ፡ዩ፡ወ፡ኡ፡ለ፡ዩ፡ኡ፡ዩ፡ወ፡ተ፡ኡ፡ወ፡ጐ፡ተ፡ወ፡ኡ፡ላ
ለ፡ዩ፡ኡ፡ቡ፡ር፡ዩ፡ቀ፡ወ፡ኡ፡ኡ፡ር፡ዩ፡ኡ፡ወ፡ለ
ር፡ተ፡ዮ፡ወ፡ለ፡ር፡ዩ፡ኡ፡ወ፡ለ፡ዩ፡ኡ፡ዩ፡ኡ፡ዩ
ወ፡ኡ፡ዩ፡ኡ፡በ፡ዩ፡ኡ፡ወ፡ለ፡ዩ፡ኡ፡ኡ፡ዩ፡ዩ፡ወ
ዩ፡ዩ፡ወ፡ለ፡ዩ፡ሐ፡ለ፡ዩ፡ኡ፡ዩ፡ወ፡ዐ፡ለ፡ዩ፡ኡ
ር፡ዩ፡ኡ፡ዩ፡ኡ፡ዩ፡ኡ፡ኡ፡ወ፡ዩ፡ር፡ኡ፡ዩ፡ኡ
ኡ፡ዩ፡ለ፡ዩ፡ኡ፡ዩ፡ኡ፡ዩ፡ተ፡ዩ፡ወ፡ዩ፡ኡ፡ዩ፡ኡ
ዩ፡ለ፡ዩ፡ዮ፡ዩ፡ወ፡ኡ፡ለ፡ዩ፡ዩ፡ኡ፡ወ፡ዩ፡ኡ፡ዩ፡ዩ
ኡ፡ዩ፡ዮ፡ዩ፡ተ፡ተ፡ዩ፡ወ፡ኡ፡ዩ፡ኡ፡ለ፡በ፡ዩ፡ዩ

This luxury Ethiopic manuscript can be confidently dated to the end of the 17th or beginning of the 18th century, on the evidence of its fully-developed Gwelḥ script, the style of its miniatures and the royal names mentioned in later notes, which indicate that the manuscript must have been completed by 1755.

The codex is written in Ge'ez, which remains even today the liturgical language of the Ethiopian Church, which became independent of Alexandria in 1959. In contrast to almost all other Semitic languages, Ethiopic is written from left to right and uses no cursive characters.

Christianity reached Ethiopia in the middle of the 4th century with the baptism of King 'Ezānā. Through the influence of nine monks driven out of Syria, Ethiopia quickly embraced the doctrine of Miaphysitism; the translation of Christian texts into Ge'ez probably began soon afterwards. Although none of the Ethiopic codices still extant today dates from earlier than the 10th century, it can be assumed that the Gospels were the first to be translated, probably from the Greek, in around 500. Surviving texts also reveal strong Syrian and in particular Arabic influences, brought to Ethiopia via Coptic manuscripts and incorporated over the course of time.

The manuscript was commissioned by one Adarā Krəstos (fol. 15r); according to the dedication on fol. 22v, he and his father presented the Gospel book to the monastery of Anṭonyos, whose precise location has yet to be established.

The opening pages of the manuscript contain ten full-page miniatures, two of which portray scenes from the Old Testament that held particular significance for the Ethiopian Church. The first picture (ill. p. 424) shows King Solomon on his throne beneath an Ethiopian ceremonial parasol. Through the person of King Solomon, Ethiopia could also lay claim to its part in Old Testament history,

Detail from fol. 23r (St Matthew): Beginning of St Matthew's Gospel.

▶ **Fol. 3v:** Moses receives the two Tablets of the Law from the hand of God reaching down from a cloud; the inscription in Ethiopic reads "Moses the Prophet".

መ፡ ሊ፡ ነ በ ይ፡

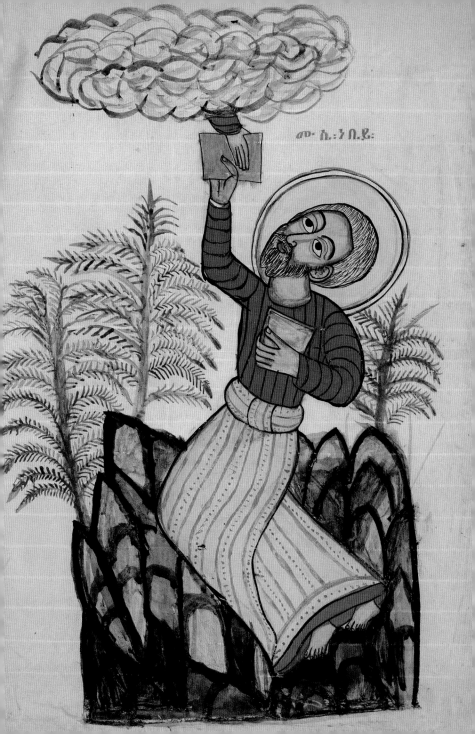

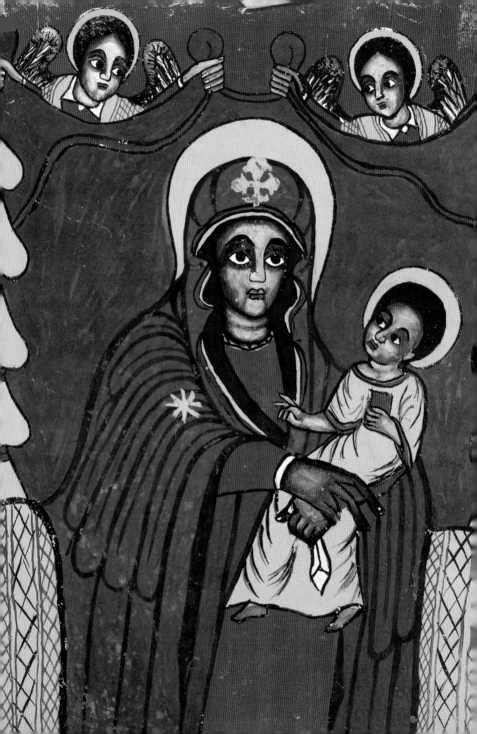

Detail from fol. 10r: The Virgin and Child; above, two angels holding a curtain.

since Solomon's union with the Queen of Sheba produced a son, Menelek. He in turn became the first King of Ethiopia, from whom the Solomonean dynasty which ruled, with interruptions, until 1974, claimed its descent. The next scene (ill. p. 421) – Moses receiving the two Tablets of the Law – is also very closely connected with Ethiopia, because according to tradition the Ark of the Covenant (*tābot*) was brought out of Jerusalem by the companions of King Menelek. It continues to be housed even today in the city of Aksum, the former royal residence, and bears the six additions to the Ten Commandments from Matthew 25 scored into its reverse side by Jesus himself. Every Ethiopian church possesses a copy of this *tābot*, which is carried on the priest's head in a ceremonial procession around the church during Mass.

It is rare in Ethiopia to find the whole New Testament in a single codex; the Gospels usually stand alone. Typical of many Ethiopic Gospel books are prefacing texts, which are here visually distinguished by their smaller script and greater number of lines. An introduction into the nature, use and order of the Gospels is followed by the letter written by Eusebius of Caesarea to Carpianos, the Eusebian canon tables, here highlighted with graphic means but not set within a decorative framework, as otherwise often commonly found, and finally the Gospels themselves.

In the Ethiopic liturgy, after the prayers and Scripture readings, the Gospel is presented to all the faithful to be kissed; Codex aethiopicus 25, however, shows almost no traces of use and appears to have only been employed in the monastery. The only inscriptions added to its pages are notes at the front and back relating to inventories of church utensils.

S. P.

Extent: 138 parchment folios; fols. 123–132 are bound upside down and in the wrong order.
Format: 320 x 365 mm
Binding: probably the original, dark-brown leather binding over wooden boards; blind-tooled decoration with a cross in the centre; multiple rectangular frames with plaitwork and lozenge patterning; fabric covering glued onto inside covers
Content: Gospel book with prefaces
Language: Ge'ez (Ethiopic)

Illustration: ten full-page miniatures
Patron: Adarā Krəstos
Provenance: Adarā Krəstos donated the manuscript to Anṗonyos monastery; it then passed into the possession of Sir Robert Napier (1810–1890), victor in the Battle of Maqdalā in 1868, who brought many Ethiopic manuscripts back with him to Europe. The codex entered the Hofbibliothek in 1868 (?).
Shelfmark: Vienna, ÖNB, Cod. aeth. 25

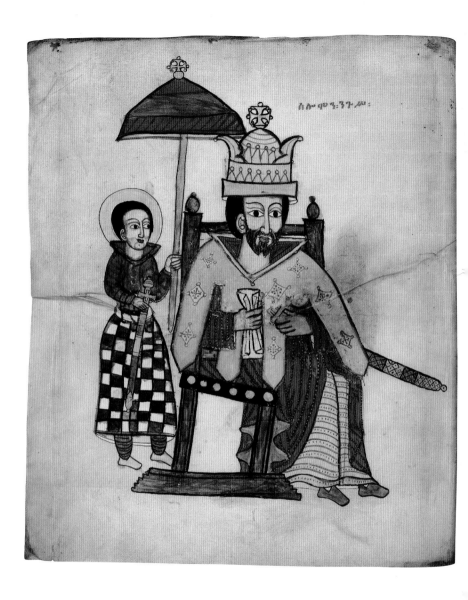

ሰለሞ፡ንጉ፦ንጉሥ፡ሥ።

Fol. 2v: King Solomon seated on his throne with a cloth in his right hand and a sword in his left; beside him, a servant with a ceremonial parasol and sword; the inscription in Ethiopic reads "King Solomon".

▶ **Detail from fol. 9r:** St John the Evangelist with an eagle. In his hands, pen and paper; above him, a cloud with the hand of God; in front of him, writing utensils.

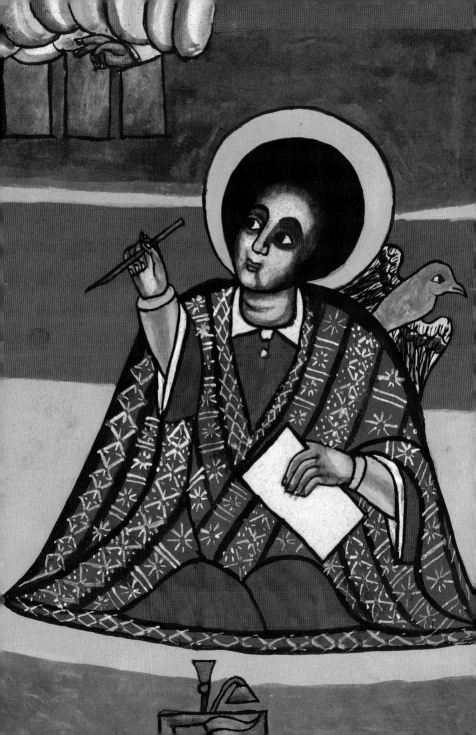

Arabic Gospel Book

Egypt (?), 14th/15th century (?)

As several extant manuscripts from the 8th and 9th century (by Christian reckon-
ing) demonstrate, translations of the Bible into Arabic go back a very long way.
Although no translations survive from the pre-Islamic era, some (non-Islamic) his-
torians of religion have raised the question of whether such translations might have
been known to Muhammad and his contemporaries, in view of the fact that
a whole series of "biblical" figures are encountered in the Koran. According
to Islamic belief, these figures are prophets and those guided on the right path, and
both books, Bible and Koran, were revealed by the same God: "Who revealed the
Book which Musa [Moses] brought, a light and guidance to men?" (The Cattle, 6.91)
Hence parallels between the two revelations pose no problem for Muslim believ-
ers and thus also do not represent proof that Arabic translations of the Bible may
already have existed in Muhammad's lifetime. There is no doubt, however, that
the pre-Islamic Arabs were familiar, through their daily contact with neighbouring
Christian and Jewish communities, with the beliefs and legends of their religions.

With the spread of Islam, Arabic became the language of everyday speech in
many parts of the Near East and suppressed the vernacular languages that had pre-
viously been spoken. This gave rise to a growing need for an Arabic version
of the Holy Scripture, as many people could no longer read or understand it in their
"old" language. In a number of these Near-Eastern countries, including Egypt, the
written tradition went back considerably further than that of the Arab peninsula,
so the conditions required to meet this need were already in place. There thus
arose a whole series of complete and partial translations of biblical texts from the
Hebrew, Greek, Coptic and Syriac, and later also from the Latin.

The Arabic Gospel book from the estate of Sebastian Tengnagel contains, in
addition to the four Gospels, an anonymous preface on the spiritual benefits of the
text, its authors and its divisions. This is followed by the canon tables first drawn
up by Eusebius of Caesarea (ill. p. 427), in which corresponding passages in the
various Gospels are cross-referenced. As in the Byzantine tradition, each Gospel

Fol. 10v: 6th and 7th canon tables.

مثى مرقس	مثى مرقس	مثى مرقس	مثى مرقس

كمل القانون السادس تلوه القانون السابع بسلام الرب

مثى يوحنا	مثى يوحنا	مثى يوحنا	مثى يوحنا

كمل القانون السابع

اكثر خطأ من كل الجليليين اذ اصابتهم هذه الاوجاع

لا اقول لكم ان لم تتوبوا كلكم فانتم تهلكون كلكم هكذا

واوليك الثمانية عشر الذين سقط عليهم البرج

فى سيلوحا و قتلهم اتظنون انهم اكثر جرمًا من

جميع الناس الذين يسكنون بادو شليم كلا واقول

لكم انكم ان لم تتوبوا جميعكم تهلكون هكذا

وقال لهم هذا المثل شجرة تين كانت لواحد مغروسة

فى كرمه جآء طلب فيها ثمرة فلما لم يجد قال

للكرام هذا ذ لت سنين اتى واطلب عثرة فى هذه

الشجره ولا اجد اقطعها لبلا تبطل الارض فلجابه

وقال له يا رب دعها فى هذه السنه لا فلحها واصلحها

لعلها اثمرت فى السنه الاتيه فان هى اثمرت والا

اقطعها : الفصل الحادى والخمسون

وفيما هو يعلم فى احد المجامع فى السبت واذا امراه

معها روح مرض منذ نمان عشرة سنة وكانت

محنبيه لا تقدر ان تستقيم البته فنظر اليها يسوع

Detail from fol. 141r (St Luke): Page from St Luke's Gospel (Luke 13:2–13:11) with marginal glosses in Arabic and interlinear glosses (Latin translation of Arabic words) in Sebastian Tengnagel's hand.

is accompanied by a brief introduction about its content and author. References to the Coptic, Syriac and Greek versions of the text are included in (red) Arabic glosses in the margins. Tengnagel also added the Latin Bible chapter numbers in the margin.

Sebastian Tengnagel, head of the Hofbibliothek from 1608 until his death in 1636, was a passionate Orientalist. His extensive private library, which he bequeathed to the Hofbibliothek and which he personally inventoried in two catalogues, included alongside 80 Hebrew manuscripts 100 "oriental" codices. Like many of the books in his collection, they served as a learning aid and as subject matter for his primarily lexical study of oriental languages: "I am fired with an incredible enthusiasm for the Arabic, Persian and Turkish languages and I am trying to procure the means to further my education in them from every quarter", he writes in a letter to a fellow librarian. Many of the manuscripts from his collection bear glosses in his characteristic handwriting, including the present Gospel book, which he probably read in tandem with a Latin version, writing the corresponding Latin phrase above any Arabic words that were unfamiliar to him (see ill. p. 428).

S. R.-D.

Extent: 217 sheets of oriental (cotton) paper
Format: 260 x 175 mm
Binding: Late medieval limp parchment binding
Content: Al-arba'a al-anâgil al-muqaddasa ("The four holy Gospels")
Language: Arabic

Provenance: The manuscript was purchased by prefect Sebastian Tengnagel (1608–1636) for 10 florins for his private library and bequeathed to the Hofbibliothek in his will.
Shelfmark: Vienna, ÖNB, Cod. A. F. 97

Mahmûd ibn Ramadân,
Rosary of Tidings

Istanbul (Turkey), around 1674

The Ottomans, like so many other European potentates of antiquity, the Middle Ages and the Renaissance, sought to underpin (and legitimize) their claims to power through genealogies which traced their descent from famous rulers or even gods. The fabled prince Oghuz, ancestor of the Oghuz people, was descended in a direct line – so legend had it – from Noah's son, Japhet; and so Ertugrul, the father of the first Ottoman sultan and head of a Turkish line, also belonged to this same people of Oghuz. This was seen as clear proof that the Ottoman dynasty was at least the equal of other ruling families, such as the descendants of Genghis Khan.

There thus arose a whole series of genealogical tables, some of them in codex form, others in the form of scrolls (see pp. 274–279), which – starting from Adam and Eve – illustrate not only the lineage of the Turkish sultans, but also numerous other Arab, Persian and Turkish dynasties. Some of these genealogical tables are without illustrations and consist "only" of medallions containing names (albeit usually in a beautiful calligraphy); others are richly decorated with miniatures of the "main characters", as in the case of the present luxury manuscript from the 17th century.

The protagonists include the patriarchs and prophets of the Old Testament and figures from the New Testament, who are also mentioned in the Koran: "And We gave to him [Abraham] Ishaq [Isaac] and Yaquob [Jacob]; each did We guide, and Nuh [Noah] did We guide before, and of his descendants, Dawood [David] and Sulaiman [Solomon] and Ayub [Job] and Yusuf [Joseph] and Musa [Moses] and Haroun [Aaron]; ... And Zakiriya [Zechariah] and Yahya [John] and Isa [Jesus] and Ilyas [Elijah]; every one was of the good ... This is Allah's guidance, He guides thereby whom He pleases of His servants" (The Cattle, 6.84–88). Medallions containing miniatures and the names of all these "biblical" figures are found

Detail from fol. 5r: Enoch and his son.

▶ **Detail from fol. 1v:** Vignette in blue and gold with vegetal and floral ornament and the title Subhat al-ahbâr ("Rosary of Tidings").

سپاس علی الاطلاق و ستایش با استحقاق اول باری خلایق قدیم حضرتنه

اولسونکه وجود عالم لل عالم وجود انک بحر جُودندن بر قطره در وشهُود نور ظهور

انک ظهور نور شهُود دن بر لمحه در بر مبد عد دکه بر کلمۀ کن ایله بونجه بیك كلمات حقایق نتنی

ام الكتابدۀ لوح فطرت اوزره او زرۀ تصویر بیوردی وجود انک کلمۀ جامعه و هم صحیفۀ کامله

قلوب عالم نسخه سندن انتخاب ایدوب لطیف دوزدیکه اجنده صور جمله معانی و کلما

سبع المثانی تجرید بیوردی بر نخت ر عد دکه محض اصطفا و خلوص اجتبا یله حضرت آدم صفی

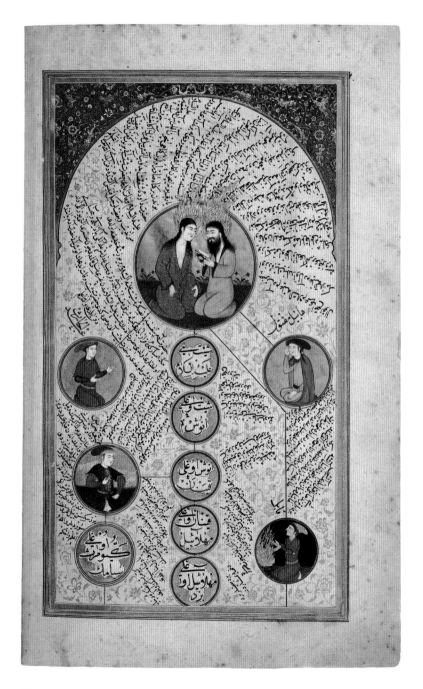

Fol. 4v: Adam and Eve; below them to the left, Abd al-Hârith, according to Islamic legend one of their sons, and Gayûmard, ancestral father of the legendary Persian kings. On the right, Abel, and beneath him Cain. The medallions in a vertical row down the centre contain the names of Seth and his descendants.

▸ **Detail from fol. 8r: left:** Alexander the Great, Jesus; right, Zechariah, John the Baptist.

in the present Ottoman genealogy, along with portraits of Muhammad, the last and greatest of the prophets of Islam, who is portrayed in traditional fashion with his face veiled, and Alexander the Great – this hero, too, is mentioned in the Koran (fol 8r). The information provided in the accompanying texts is based either on legend or, in the case of later, historically-documented individuals, on their lives.

The manuscript contains just one female portrait, the miniature of Eve (ill. p. 432); depictions of the Virgin, as found in another Ottoman genealogy (Vienna, ÖNB, Cod. A. F. 17), are entirely absent. The only reference to the Virgin is found in a small text medallion beside the miniature of Jesus, which reads: "Jesus, son of Mary" (ill. pp. 434/435). Medallions decorated in gold bear the names of the daughters of the Prophet Muhammad.

The illustrations of the figures obey certain formulae: thus the prophets are identified by a nimbus of gold flame and Muhammad and his direct descendants by green turbans. The Persian kings are frequently depicted as soldiers with bracers and weapons (fol. 5r); the fratricidal Cain is portrayed as a fire worshipper (ill. p. 432, below right). The attributes of "biblical" figures are at times familiar to the Christian viewer: Jesus is shown as bare-headed, with long hair and simple robes, holding a book (ill. pp. 434/435); Noah probably has a Koran lectern in front of him; the Ark is visible in the background (fol. 5r).

The genealogy was probably executed by dervish Mahmûd ibn Ramadân and dedicated to Sultan Suleiman the Magnificent († 1566). The present manuscript continues the genealogy up to Mehmed IV (deposed in 1687). The closing pages each show two to four large portrait medallions of Ottoman sultans; hidden at the foot of Sultan Mehmed's throne on the last page is the artist's signature: Hasan from Istanbul.

S. R.-D.

Extent: 17 sheets of oriental paper
Format: 300 x 185 mm
Binding: 17th-century Turkish binding, brown kidskin with gold-tooled medallion
Author: Mahmûd ibn Ramadân (16th century)
Content: Subhat al-ahbâr ("Rosary of Tidings")
Language: Turkish
Miniaturist: Hasan al-Istanbûlî (17th century)

Illustration: title-page vignette, 102 portrait miniatures, name medallions, page backgrounds of floral patterns in gold, decorative bars, calligraphy, full-page representations of animals and plants
Provenance: The manuscript was brought back as booty from the Turkish wars and passed into the possession of Prince Eugene of Savoy (1663–1736); it entered the Hofbibliothek in 1737.
Shelfmark: Vienna, ÖNB, Cod. A. F. 50

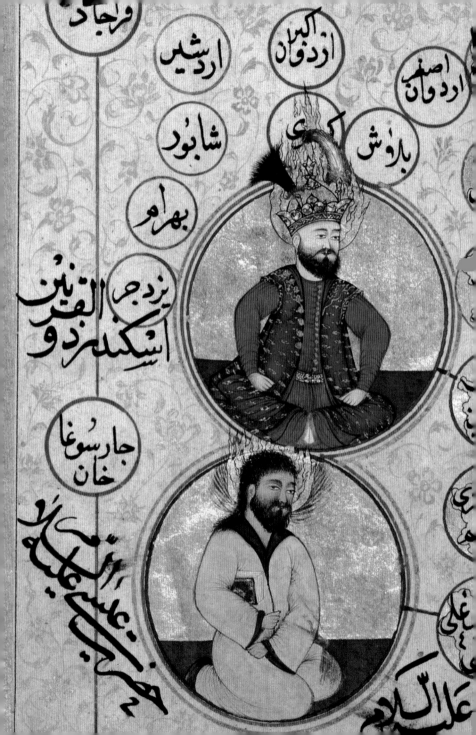

وجاد

اردشیر

اکبان ازدوان

اصفهی اردوان

شابور

باوش اکی

بهرام

یزدجرد القرنین اسکندرذو

جارسوغا خان

نجاشئ ملك

برسطو

المد اوغلى
مردوس
فهرس اوغلى
طيمو شب
ايره اوغلى
غالب اوغلى
سينف
غالق اوغلى

صلخ اوغلى
زكريا السلام
حصور عليه

ايره اوغلى

برجيس
يونس
شمعون

◄ **Detail from fol. 17r:** Fabulous beast and plants.

Fol. 16v: Closing chapter with a short biography of Sultan Mehmed IV. The title of the chapter is inscribed in gold calligraphy within a semicircle at the top of the page. The calligraphic verse at the bottom of the page requests God's succour for the Sultan.

Index of manuscripts
and monuments

Bold type indicates a main
description, italic type indicates
the introductory chapters.

AUGSBURG
Universitätsbibliothek,
Cod. I.2.2°13: 232

BALTIMORE
Walters Art Gallery, Ms. W
29: 232

BAMBERG
Staatsbibliothek, Ms. patr. 5, *27*

BERLIN
Kupferstichkabinett, Ms. 78 E 3
(Hamilton Bible): 167

BREMEN
Staats- und Universitätsbiblio-
thek, Ms. 216: *17, 31*

BRESSANONE (BRIXEN)
Biblioteca del Seminario
Maggiore, Ms. C. 20: 198

BRUSSELS
Bibliothèque Royale, ms. II
7619: 321

ESCORIAL
Real Biblioteca
Ms. d.IV.26: 161
Ms. a.III.12: 167

FLORENCE
Biblioteca Medicea Laurenzi-
ana, Ms. Plut. 1, 56 (Rabbula
Codex): *375*
Ms. Plut. 15, 17: 215
Museo Nazionale, Missale
di Sant' Egidio (without
shelfmark): 215

GERONA
Catedral de Santa María,
Archivo, Cod. 52: *47*

GNESEN
Dombibliothek, "Bibel von 1414"
(lost): 152

GRAZ
Universitätsbibliothek,
Cod. 48: 191

GREIN
Greiner Marktbuch: 191

GROTTAFERRATA
Santa Maria: 388

HEILIGENKREUZ
Stiftbibliothek, Cod. C7 rechts: *47*

KARLSRUHE
Badische Landesbibliothek,
Cod. St Blasien 2 (Korczek
Bible, vol. 2): 152

KLAGENFURT
Kärntner Landesarchiv,
Cod. 6/4: 86

KLOSTERNEUBURG
Augustiner-Chorherrenstift,
Verdun Altar: 359

KREMSMÜNSTER
Stiftsbibliothek, CC 243: 365

LIÈGE
Bibliothèque de l'Université
Ms. Wittert 13: 321
Ms. Wittert 35: 203

LINZ
Oberösterreichisches Landes-
archiv, Buchdeckelfunde,
Nr. 1: 90

LONDON
British Library, Ms. Cotton
Otho B VI (Cotton Genesis):
54, *102*, 283, *372*

LOUVAIN
Universiteitsbibliotheek,
Ms. 1: 164

LUCERNE
Zentralbibliothek,
PMsc. 19/fol.: 152

MADRID
Biblioteca Nacional, Ms. 17 805:
283
Fundación de la Casa de Alba,
Ms. 399: 381

MANCHESTER
John Rylands Library., Ms. 95:
365

MUNICH
Bayerische Staatsbibliothek
Clm 6282: 220
Clm 4550: 232
Clm 5118: 232
Clm 13 031: *28, 32*
Clm 15 905: 89
Clm 18 125: 232

NAPLES
S. Maria di Donnaregina: 167
S. Maria Incoronata: 167

NEW YORK
Pierpont Morgan Library
M. 866: 203
M. 917 and 945 (Book of Hours
of Catherine of Cleves): 198
Glazier 48: 381

OXFORD
Bodleian Library, Ms. Bibl. Can.
Lat. 56: 161

Concordance
of biblical books

(based on the Vulgate)

**Vetus Testamentum –
Old Testament**
Gn – Genesis – Genesis
Ex – Exodus – Exodus
Lv – Leviticus – Leviticus
Nm – Numeri – Numbers
Dt – Deuteronomium –
Deuteronomy
Ios – Iosue – Joshua
Idc – Iudicum – Judges
Rt – Ruth – Ruth
I Rg – I Regum – 1 Samuel
II Rg – II Regum – 2 Samuel
III Rg – III Regum – 1 Kings
IV Rg – IV Regum – 2 Kings
I Par – I Paralipomenon –
1 Chronicles
II Par – II Paralipomenon –
2 Chronicles
I Esr – I Esra – Ezra
II Esr – II Esra – Nehemiah
III Esr – III Esra – Nehemiah
IV Esr – IV Esra – Nehemiah
Tb – Tobias – Tobit
Idt – Iudith – Judith
Est – Esther – Esther
Iob – Iob – Job
Ps – Psalmi – Psalms
Prv – Proverbia – Proverbs
Ecl – Ecclesiastes – Ecclesiastes
Ct – Canticum canticorum –
Song of Songs
Sap – Sapientia – The Wisdom
of Solomon
Sir – Jesus Sirach (Ecclesiaticus)
– Ecclesiasticus
Is – Isaias – Isaiah
Ier – Ieremias – Jeremiah
Lam – Lamentationes Ieremiae –
Lamentations of Jeremiah
Bar – Baruch – Baruch
Ez – Ezechiel – Ezekiel
Dn – Daniel – Daniel
Os – Osea – Hosea
Ioel – Ioel – Joel
Am – Amos – Amos

Abd – Abdias – Obadiah
Ion – Ionas – Jonah
Mi – Micha – Micah
Na – Naum – Nahum
Hab – Habacuc – Habakkuk
So – Sophonias – Zephaniah
Agg – Aggai – Haggai
Za – Zacharias – Zechariah
Mal – Malachi – Malachi
I Mcc – I Maccabeorum –
1 Maccabees
II Mcc – II Maccabeorum –
2 Maccabees

**Novum Testamentum –
New Testament**
Mt – Matthaeus – Matthew
Mc – Marcus – Mark
Lc – Lucas – Luke
Io – Iohannes – John
Act – Acta apostolorum – Acts
Rm – (Epistula Pauli) ad
Romanos – Romans
I Cor – (Ep. Pauli) ad Corinthios
I – 1 Corinthians
II Cor – (Ep. Pauli) ad Corinthios
II – 2 Corinthians
Gal – (Ep. Pauli) ad Galatas –
Galatians
Eph – (Ep. Pauli) ad Ephesios –
Ephesians
Phil – (Ep. Pauli) ad Philippenses
– Philippians
Col – (Ep. Pauli) ad Colossenses
– Colossians
I Th – (Ep. Pauli)
ad Thessalonicenses I –
1 Thessalonians
II Th – (Ep. Pauli)
ad Thessalonicenses II –
2 Thessalonians
I Tim – (Ep. Pauli)
ad Timotheum I – 1 Timothy
II Tim – (Ep. Pauli)
ad Timotheum II – 2 Timothy
I Tit – (Ep. Pauli) ad Titum – Titus

Phlm – (Ep. Pauli)
ad Philemonem – Philemon
Hbr – (Ep. Pauli) ad Hebraeos –
Hebrews
Laod – (Ep. Pauli) ad Laodicens-
es – Laodiceans
Iac – (Epistula) Iacobi – James
I Pt – (Epistula) I Petri – 1 Peter
II Pt – (Epistula) II Petri –
2 Peter
II Io – (Epistula) I Iohannis –
1 John
II Io – (Epistula) II Iohannis –
2 John
III Io – (Epistula) III Iohannis –
3 John
Iud – (Epistula) Iudae – Jude
Apc – Apocalypsis – Apocalypse
(Revelation)

▶ **Slavonic Liturgical Apostolos,
Co. slav. 6, fol. 292v:** Crucifixion
group: the grieving Virgin Mary
to the left of the Cross, above
her Archangel Gabriel, the griev-
ing apostle John to the right of
the Cross, above him Archangel
Michael, in the centre Jesus
Christ on the Cross.

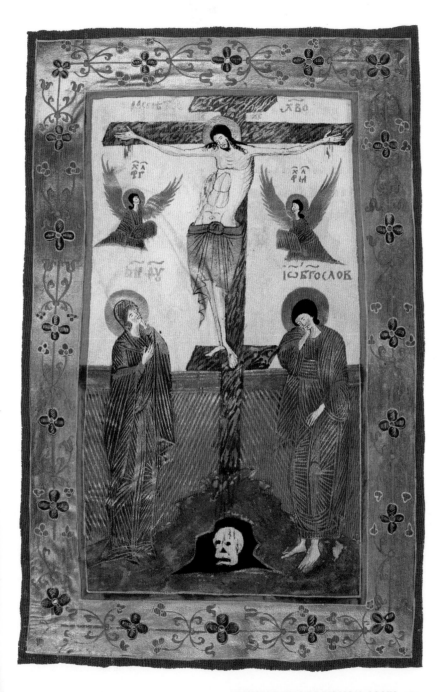

Bibliography

Abbreviated forms

AYRES = L. M. AYRES,
A Fragment of a Romanesque
Bible in Vienna (ÖNB, Cod.
ser. nov. 4236) and its Salzburg
Affiliations. *Zeitschrift für Kunstgeschichte* 42 (1982), pp. 130–144
BIRKFELLNER = G. Birkfellner,
Glagolitische und kyrillische
Handschriften in Österreich
(*Österr. Akad. der Wiss., Phil.-hist. Kl., Schriften der Balkankomm., Linguist. Abt. XXIII*).
Vienna 1975
BISCHOFF = B. Bischoff, Die
südostdeutschen Schreibschulen und Bibliotheken in der
Karolingerzeit, Part II: Die
vorwiegend österreichischen
Diözesen. Wiesbaden 1980
BUBERL–GERSTINGER =
P. BUBERL, H. GERSTINGER, Die
byzantinischen Handschriften
II (*Beschreibendes Verzeichnis
der illuminierten Handschriften in
Österreich*, new series, vol. 4/2).
Leipzig 1938
CAHN = W. CAHN, Die Bibel in
der Romanik. Munich 1982
DE HAMEL = C. DE HAMEL,
The Book. A History of the
Bible. London 2001
EUW–PLOTZEK = A. V. EUW
and J. M. PLOTZEK, Bibel, in:
ibid., Die Handschriften der
Sammlung Ludwig, vol. 1.
Cologne 1979
FILLITZ = H. FILLITZ (ed.),
Geschichte der Bildenden Kunst
in Österreich, vol. I: Früh- und
Hochmittelalter. Munich, New
York 1998
FINGERNAGEL–ROLAND = A.
FINGERNAGEL and M. ROLAND,
Mitteleuropäische Schulen I
(ca. 1250–1350) (*Österr. Akad.*

*der Wiss., Phil.-hist. Kl., Denkschriften 245. Veröff. der Komm.
für Schrift- und Buchw. des Mittelalt., Reihe I: Die illuminierten
Handschriften und Inkunabeln
der Österreichischen Nationalbibliothek*, vol. 10). Vienna 1997
FINGERNAGEL–SIMADER = A.
FINGERNAGEL and F. SIMADER,
Ergänzungen und Nachträge
zum Katalog der deutschen
romanischen Handschriften.
Online catalogue, Vienna (since
2001): http://www.onb.ac.at/sa
mmlungen/hschrift/kataloge/er
gaenzungen/ergaenzungen.htm
FRITZSCHE = G. FRITZSCHE,
Die Entwicklung des "Wiener
Realismus" in der Wiener
Malerei, 1331 bis Mitte des
14. Jahrhunderts (*Dissertationen
zur Kunstgeschichte* 18). Vienna,
Cologne, Graz 1983
HERMANN 1 = H. J. HERMANN,
Die frühmittelalterlichen
Handschriften des Abendlandes
(*Beschreibendes Verzeichnis der
illuminierten Handschriften in
Österreich*, new series, vol. 1).
Leipzig 1923
HERMANN 2 = H. J. HERMANN,
Die deutschen romanischen
Handschriften (*Beschreibendes
Verzeichnis der illuminierten
Handschriften in Österreich*, new
series, vol. 2). Leipzig 1926
HERMANN 3 = H. J. HERMANN,
Die romanischen Handschriften
des Abendlandes mit Ausnahme
der deutschen Handschriften
(*Beschreibendes Verzeichnis der
illuminierten Handschriften in
Österreich*, new series, vol. 3).
Leipzig 1927
HERMANN 5/3 = H. J. HERMANN, Die italienischen Hand-

schriften des Duecento und Trecento 1. Bis zur Mitte des XIV.
Jahrhunderts (*Beschreibendes
Verzeichnis der illuminierten
Handschriften in Österreich*, new
series, vol. 5/3). Leipzig 1928
HERMANN 6/1 = H. J. HERMANN, Die Handschriften
und Inkunabeln der italienischen Renaissance. 1. Oberitalien: Genua, Lombardei, Emilia,
Romagna (*Beschreibendes
Verzeichnis der illuminierten
Handschriften in Österreich*, new
series, vol. 6/1). Leipzig 1930
HERMANN 6/2 = H. J. HERMANN, Die Handschriften und
Inkunabeln der italienischen
Renaissance. 2. Oberitalien:
Venetien (*Beschreibendes
Verzeichnis der illuminierten
Handschriften in Österreich*, new
series, vol. 6/2). Leipzig 1931
HERMANN 6/3 = H. J. HERMANN, Die Handschriften und
Inkunabeln der italienischen
Renaissance. 3. Mittelitalien: Toskana, Umbrien, Rom
(*Beschreibendes Verzeichnis der
illuminierten Handschriften in
Österreich*, new series, vol. 6/3).
Leipzig 1932
HERMANN 7/2 = H. J. HERMANN, Die westeuropäischen
Handschriften und Inkunabeln
der Gotik und Renaissance.
2. Englische und französische Handschriften des XIV.
Jahrhunderts (*Beschreibendes
Verzeichnis der illuminierten
Handschriften in Österreich*, new
series, vol. 7/2). Leipzig 1936
HUNGER–LACKNER–HANNICK =
H. HUNGER, V. LACKNER, C.
HANNICK, Katalog der griechischen Handschriften der Öster-

reichischen Nationalbibliothek, Teil 3/3: Codices theologici 201–337 (*Museion*, Österreichische Nationalbibliothek publication, new series, no. 4, vol. 1). Vienna 1992
IORGA = N. IORGA, Les arts mineurs en Roumanie. I. Icônes. II. Argenterie. III. Miniatures. Bucharest 1934
IRBLICH = E. IRBLICH (ed.), Thesaurus Austriacus. Europas Glanz im Spiegel der Buchkunst. Handschriften und Kunstalben von 800 bis 1600. Vienna 1996
KRÁSA = J. KRÁSA, Die Handschriften König Wenzels IV. Prague 1971
MAZAL = O. MAZAL, Catalogue of the Western manuscripts in the Österreichische Nationalbibliothek, "Series Nova" (new acquisitions), Part 4: Cod. Ser. n. 4001–4800 (*Museion*, Österreichische Nationalbibliothek publication, new series, no. 4, vol. 2). Vienna 1975
MAZAL-UNTERKIRCHER = O. MAZAL AND F. UNTERKIRCHER, Katalog der abendländischen Handschriften der Österreichischen Nationalbibliothek "Series Nova" (Neuerwerbungen), Teil 3: Cod. Ser. n. 3201–4000 (*Museion*, Österreichische Nationalbibliothek publication, new series, no. 4, vol. 2). Vienna 1967
PÄCHT-JENNI = O. PÄCHT AND U. JENNI, Holländische Schule, vol. 3 (*Öster. Akad. Wiss., Phil.-hist. Kl., Denkschriften* 124. *Veröff. der Komm. für Schrift- und Buchw. des Mittelalt., Reihe I: Die illuminierten Handschriften und Inkunabeln der Österreichischen Nationalbibliothek* vol. 3). Vienna 1975
PETSCHAR = H. PETSCHAR (ed.), Alpha und Omega, Geschichten vom Ende und vom Anfang der Welt. Exhibition catalogue, Österreichische Nationalbibliothek, Vienna. Vienna,

New York 2000
PFÄNDTNER = K.-G. PFÄNDTNER, Die Psalterillustration des 13. und beginnenden 14. Jahrhunderts in Bologna, Herkunft – Entwicklung – Auswirkung. Neuried 1996
SCHMIDT = G. SCHMIDT, Die Armenbibeln des XIV. Jahrhunderts. Graz, Cologne 1959
SÖRRIES = R. SÖRRIES, Christlich-antike Buchmalerei im Überblick. Wiesbaden 1993
V. BLOH = U. V. BLOH, Die illustrierten Historienbibeln (*Vestigia Bibliae* 13/14, 1991/92). Berne (et al.) 1993

Introduction Füssel
(pp. 14–35):
O. MAZAL, Geschichte der Handschriftenkunde. Wiesbaden 1986 (= Elemente des Buch- und Bibliothekswesens 10). – V. TROST, Skriptorium: Die Buchherstellung im Mittelalter (= Heidelberger Universitätsschriften 25). Heidelberg 1986 (Stuttgart ²1991). – F. MÜTHERICH (et al.), Regensburger Buchmalerei. Catalogue of an exhibition mounted in Regensburg (= Bayerische Staatsbibliothek. Ausstellungskataloge 39). Munich 1987. – C. DE HAMEL, Medieval Craftsmen: Scribes and Illuminators. London 1992. – J. KIRMEIER, A. SCHÜTZ, E. BROCKHOFF, Schreibkunst. Mittelalterliche Buchmalerei aus dem Kloster Seeon. Exhibition catalogue. Augsburg 1994. – J. M. PLOTZEK (et al.), Glaube und Wissen im Mittelalter. Catalogue to an exhibition in the Erzbischöfliches Diözesanmuseum. Cologne. Munich 1998. – C. STIEGEMANN (et al.): 799 – Kunst und Kultur der Karolingerzeit. Karl der Große und Papst Leo III. in Paderborn. 2 vols. Mainz 1999. – M. BRANDT, Abglanz des Himmels: Romanik in Hildesheim. Catalogue to an exhibition in

Hildesheim Cathedral Museum. Regensburg 2001. – C. DE HAMEL, The British Library Guide to Manuscript Illumination: History and techniques. London 2001. – RALF M. W. STAMMBERGER, Scriptor und Scriptorium. Das Buch im Spiegel mittelalterlicher Handschriften (= Lebensbilder des Mittelalters). Graz 2003.

Introduction Fingernagel
(pp. 36–39):
J. STUMMVOLL (ed.), Geschichte der Österreichischen Nationalbibliothek (*Museion*, Österreichische Nationalbibliothek publication, new series, no. 2, vol. 3, Part 1). Vienna 1968. – Bibliotheca Eugeniana. Sammlungen des Prinzen Eugen von Savoyen. Exhibition in the Österreichische Nationalbibliothek and the Graphische Sammlung Albertina from 15.5.–31.10.1986. Vienna 1986. – O. MAZAL, Königliche Bücherliebe. Die Bibliothek des Matthias Corvinus. Graz 1990. – Natur und Kunst. Handschriften und Alben aus der Ambraser Sammlung Erzherzog Ferdinands II. (1529–1595). Exhibition by the Kunsthistorische Museum and the Österreichische Nationalbibliothek in Ambras Castle, Innsbruck. 23.6–24.9.1995. Vienna 1995. – IRBLICH. – A. FINGERNAGEL, Zum Ursprung der Wiener Hofbibliothek, in: M. CSÁKY, P. STACHEL (eds.), Speicher des Gedächtnisses. Bibliotheken, Museen, Archive, Part 2: Die Erfindung des Ursprungs. Die Systematisierung der Zeit. Vienna 2001, pp. 31–42.

Introduction, pp. 42–47:
G. SED-RAJNA, The Image as Exegetical Tool. Paintings in Medieval Hebrew Manuscripts of the Bible, in: The Bible as Book. The Manuscript Tradi-

tion, ed. by J. L. Sharpe III and K. van Kamoen. New Castle 2002 (reprint), pp. 215–221. – P. H. Brieger, Bible Illustration and Gregorian Reform, in: Studies in Church History, vol. 2. London 1965, pp. 154 ff. – H. L. Kessler, The Illustrated Bibles from Tours (Studies in Manuscript Illumination 7). Princeton 1977. – B. Smalley, The Study of the Bible in the Middle Ages. Notre Dame ³1978. – Euw-Plotzek, pp. 25–41. – W. Cahn, Die Bibel in der Romanik. Munich 1982. – K.-G. Pfändtner, Zwei Bologneser Bibeln des 13. Jahrhunderts in der Staatsbibliothek Bamberg (129. Bericht des Historischen Vereins Bamberg). Bamberg 1993, pp. 17–73. – R. Gameson (ed.), The Early Medieval Bible, Its Production, Decoration and Use. Cambridge 1994. – Pfändtner. – Louvain Database of Ancient Books by Willy Clarysse (first issued on CD in 1998, now accessible at the regularly updated website http://ldab.arts.kuleuven. ac.be/index2.html"). – R. H. and M. A. Rouse, Manuscripts and their Makers, Commercial Book Producers in Medieval Paris, 1200–1500. Turnhout 2000. – de Hamel, pp. 12–39.

Introduction, pp. 102–106:
Euw-Plotzek, pp. 25–41. – Cahn. – J. Krása, Der hussitische Biblizismus, in: Von der Macht der Bilder. Beiträge des CIHA Kolloquiums „Kunst und Reformation". Leipzig 1983, pp. 54–59. – O. Pächt, Illustration der Bibel, in: Buchmalerei des Mittelalters. Eine Einführung. Munich 1984, pp. 129–154. – Sörries. – H. Heger, Philologischer Kommentar zur Wenzelsbibel (Das "Buch der Bücher", Die Bibel im Mittelalter, Die Problematik von Übersetzungen, Deutsche Bibelübersetzungen des Mitte-

lalters und der Frühen Neuzeit), in: Die Wenzelsbibel. Complete facsimile edition of Codices Vindobonenses 2759–2764, Österreichische Nationalbibliothek, Vienna. Commentary volume. Graz 1998, pp. 51–57. – S. Füssel, Gutenberg und seine Wirkung. Frankfurt am Main 1999. – de Hamel.

Introduction, pp. 206–210:
B. Altaner, A. Stuiber, Patrologie. Leben, Schriften und Lehre der Kirchenväter. Freiburg, Basle, Vienna ⁷1966. – H. Riedlinger, Bibel in der christlichen Theologie, Lateinischer Westen, Geschichte der Auslegung, in: Lexikon des Mittelalters 2 (1983), pp. 47–58. – H. de Lubac, Medieval Exegesis. The Four Senses of Scripture. Edinburgh 1998. – S. Döpp, W. Geerlings (eds.), Lexikon der antiken christlichen Autoren. Freiburg, Basle, Vienna ³2002. – de Hamel, esp. pp. 92–113.

Introduction, pp. 268–273:
(Genealogy, World Chronicles; A. F.): H. Grundmann, Geschichtsschreibung im Mittelalter. Gattungen – Epochen – Eigenart. Göttingen 1965. – W. Lammers, Geschichtsdenken und Geschichtsbild im Mittelalter. Darmstadt 1965. – A.-D. Von den Brinken, Die lateinische Weltchronistik, in: A. Randa (ed.), Mensch und Weltgeschichte. Zur Geschichte der Universalgeschichtsschreibung. Salzburg and Munich 1969, pp. 43–58. – K. H. Krüger, Die Universalchroniken. Turnhout 1976. – M. Haeusler, Das Ende der Geschichte in der mittelalterlichen Weltchronistik. Cologne 1980. – U. Knefelkamp (ed.), Weltbild und Realität. Einführung in die mittelalterliche Geschichtsschreibung. Pfaffenweiler 1992. – K. Schnith, Chronik, in:

Lexikon des Mittelalters 2 (1999) 1956–1960. (History Bibles; K. H.): H. Vollmer, Materialien zur Bibelgeschichte und religiösen Volkskunde des Mittelalters, vols. 1–4. Berlin 1912–29. – Ch. Gerhardt, Historienbibeln (deutsche), in: Die deutsche Literatur des Mittelalters. Verfasserlexikon 4 (²1983), pp. 67–75. – G. Kornrumpf, Die österreichischen Historienbibeln IIIa und IIIb, in: H. Reinitzer (ed.), Deutsche Bibelübersetzungen des Mittelalters (Vestigia Bibliae 9/10, 1987/88). Berne (et al.) 1991, pp. 350–374, here p. 350 f., 368. – N. H. Ott, Historienbibel, in: Lexikon des Mittelalters 5 (1991), p. 45. – U. v. Bloh, Die illustrierten Historienbibeln (Vestigia Bibliae 13/14, 1991/92). Berne (et al.) 1993.

Introduction, pp. 330–334:
(Typology; A. F.): H. Hoefer, Typologie im Mittelalter. Göppingen 1971. – F. Ohly, Skizzen zur Typologie im späten Mittelalter, in: Medium Aevum deutsch. Beiträge zur deutschen Literatur des hohen und späten Mittelalters. Festschrift für Kurt Ruh zum 65. Geburtstag. Tübingen 1979, pp. 251–310. – S. Schrenk, Typos und Antitypos in der frühchristlichen Kunst. Jahrbuch für Antike und Christentum, suppl. vol. 21 (1995). (Bible Moralisée; see below, cat. V:1–2 (Biblia Pauperum; V. P.-A.): H. Cornell, Biblia pauperum. Stockholm 1925. – G. Schmidt, Die Armenbibeln der 14. Jahrhunderts. Graz, Cologne 1959. – K.-A. Wirth, Biblia pauperum, in: Die deutsche Literatur des Mittelalters. Verfasserlexikon 1 (²1978), pp. 843–852. – G. Schmidt, Bibbia dei poveri, in: Enciclopedia dell' Arte medievale, vol. 3. Rome 1992, pp. 487–491.

- J. BACKHOUSE, J. H. MAR-
ROW and G. SCHMIDT, Biblia
Pauperum. Facsimile edition
of Kings Ms. 5, British Library,
London. Commentary. 1994. –
N. H. OTT, Biblia pauperum, in:
Katalog der deutschsprachigen
illustrierten Handschriften
des Mittelalters, vol. 2 (Veröff.
Komm. für Deutsche Lit. des
Mittelalters der Bayer. Akad. der
Wiss.). Munich 1996, pp. 249–
327. (SPECULUM HUMANAE SALVA-
TIONIS; V. P.-A.): J. LUTZ, P.
PERDRIZET, Speculum humanae
salvationis. Mulhouse 1907.
– E. BREITENBACH, Speculum
humanae salvationis. Eine typen-
geschichtliche Untersuchung.
Strasbourg 1930. – A. WILSON,
J. L. WILSON, A medieval
mirror. Speculum humanae sal-
vationis, 1324–1500. Berkeley,
Calif.
(et al.) 1984. – M. NIESNER, Das
Speculum Humanae Salvationis
der Stiftsbibliothek Krems-
münster. Edition der mittel-
hochdeutschen Versübersetzung
und Studien zum Verhältnis von
Bild und Text. Cologne, Vienna
(et al.) 1995. – H.-W. STORK, B.
WACHINGER, Speculum humanae
salvationis, in: Die deutsche Lite-
ratur des Mittelalters. Verfasser-
lexikon 9 (²1995), pp. 52–65. –
B. CARDON, Manuscripts of
the speculum humanae salva-
tionis in the Southern Neth-
erlands (c. 1410–c. 1470). A
contribution to the study of the
15th century book illumination
and of the function and meaning
of historical symbolism. Louvain
1996.

Introduction, pp. 372–376:
SÖRRIES. – N. L. COLLINS,
The Library in Alexandria
and the Bible in Greek (Sup-
plements to Vetus Testamen-
tum, vol. LXXXII). Leiden,
Boston, Cologne 2000. – H.
and H. BUSCHHAUSEN, Codex

Etschmiadzin. Complete facsim-
ile edition of Codex 2374 in the
Matenadaran Mesrop Maštoc' in
Yerevan. Graz 2001. – W. BAUM,
Äthiopien und der Westen im
Mittelalter (Einführungen in das
orientalische Christentum 2). Kla-
genfurt 2001. – S. G. RICHTER,
Studien zur Christianisierung
Nubiens (Sprachen und Kulturen
des Christlichen Orients, vol. 11).
Wiesbaden 2003 – cf. also the
individual essays on the Lem-
mata Bible translations I, II in:
Theologische Realenzyklopädie 6
(1980), pp. 160–228 and in the
introduction to F. D'AIUTO,
G. MORELLO, A. M. PIAZZONI,
"I Vangeli dei Popoli. La parola e
l'immagine del Cristo nelle cul-
ture e nella storia". Exhibition
catalogue. Vatican City 2000.

pp. 48–53: A. KRAFFT, S.
DEUTSCH, Die handschriftlichen
hebräischen Werke der k. k.
Hofbibliothek zu Wien. Vienna
1847, pp. 17–19 (no. 13). – A. Z.
SCHWARZ, Die Hebräischen
Handschriften der National-
bibliothek in Wien (Museion.
Nationalbibliothek publication,
Vienna, essay, vol. 2). Vienna,
Prague, Leipzig 1925, pp. 17–19
(no. 19).
pp. 54–65: P. BUBERL, Die
byzantinischen Handschriften
(Beschreibendes Verzeichnis der
illuminierten Handschriften in
Österreich, new series, vol. 4/1).
Leipzig 1937, pp. 67–129. – O.
MAZAL, Wiener Genesis. Illu-
minierte Purpurhandschrift aus
dem 6. Jahrhundert. Facsimile
of Codex theol. gr. 31 from the
Österreichische Nationalbi-
bliothek. Frankfurt/Main 1986.
– SÖRRIES, pp. 45–55 with pl.
18–29 (with extensive bibliog-
raphy). – B. ZIMMERMANN, Die
Wiener Genesis im Rahmen
der antiken Buchmalerei. Il-
lustrationsverfahren, Darstel-
lungsweise, Aussageintention.
Wiesbaden 2003.

pp. 66–71: BUBERL–GERSTINGER,
pp. 63–67. – HUNGER–LACK-
NER–HANNICK, pp. 336–341.
– L. PROSDOCIMI, Codici di
Andrea Contrario nel testa-
mento di Michele Salvatico, in:
G. P. MANTOVANI, L. PROSDO-
CIMI, E. BARILE, L'umanesimo
librario tra Venezia e Napoli.
Contributi su Michele Salvatico
e su Andrea Contrario (Istituto
Veneto di Scienze, Lettere ed
Arti. Memorie della classe di
scienze morali, lettere ed arti
XLV). Venice 1993, pp. 27–52
(with extensive bibliography on
Andreas Contrarius).

pp. 72–77: HERMANN 1,
pp. 39–42. – C. NORDENFALK,
Die spätantiken Kanontafeln
(Die Bücherornamentik der
Spätantike I). Göteborg 1938,
pp. 147–164 et passim. – E. A.
LOWE, Codices latini antiqui-
ores. A palaeographical guide to
Latin manuscripts prior to the
ninth century, vol. 10. Oxford
1963, no. 1491.

pp. 78–81: B. FISCHER, Die
Alkuin-Bibeln, in: Die Bibel
von Moutier-Grandval, British
Museum Add. Ms. 10 546.
Published to mark the 75th an-
niversary of the Verein Schweiz-
erischer Lithographiebesitzer
(Verband der Schweizer
Druckindustrie, Assocation de
l'industrie graphique suisse,
Schlosshaldenstrasse 20). Berne
1971, pp. 49–98. – R. NOLDEN
(ed.), Die touronische Bibel der
Abtei St Maximin vor Trier.
Trier 2002.

pp. 82–85: HERMANN 1, 66–72. –
BISCHOFF, p. 262 – B. FISCHER,
Lateinische Bibelhandschriften
im frühen Mittelalter (Vetus
latina. Die Reste der altlateinis-
chen Bibel. Aus der Geschichte
der lateinischen Bibel, vol. 2).
Freiburg 1985, pp. 46, 69,
150, 158, 227 f., 230, 232–235,

237, 249, 392. – J. VINTR, Die tschechisch-kirchenslavischen Glossen des 12. Jahrhunderts in der Bibel Sign. 1190 der Nationalbibliothek in Wien (sog. Jagic-Glossen). *Wiener Slawistisches Jahrbuch* 32 (1986), pp. 77–113.

pp. 86–89: H. TIETZE, Die Denkmale des Stiftes Nonnberg in Salzburg. Mit archivalischen Beiträgen von Regintrudis von Reichlin-Meldegg (*Österreichische Kunsttopographie* VII). Vienna 1911, p. 188 and fig. 265. – MAZAL–UNTERKIRCHER, p. 85 f. –AYRES, p. 139, ill. 11. – P. WIND, Aus der Schreibschule von St Peter vom Anfang des 11. Jahrhunderts bis Anfang des 14. Jahrhunderts, in: Hl. Rupert von Salzburg 696–1996 (exhibition catalogue). Salzburg 1996, pp. 375, 388 (note 98), 447 (on no. 163). – FINGERNAGEL–SIMADER.

pp. 90–93: HERMANN, pp. 3, 88 f. – MAZAL, pp. 105 f. – AYRES, pp. 130–144. – FINGERNAGEL–SIMADER.

pp. 94–97: HERMANN 7/2, pp. 61–62, 58–60. – R. BRANNER, Manuscript Painting in Paris during the Reign of Saint Louis. A Study of Styles. Berkeley, Los Angeles, London 1977, p. 85, cat. 223, fig. 242. – F. AVRIL, A quand remontent les premiers ateliers d'enlumineurs laics à Paris? *Les dossiers de l'archéologie* 16 (1976), pp. 36–44. – L. LIGHT: French Bibles, *c.* 1200–1230: a New Look at the Origins of the Paris Bible, in: R. GAMESON (ed.), The Early Medieval Bible: its production, decoration and use (= *Cambridge studies in palaeography and codicology* 2). Cambridge 1994, pp. 155–176. – R. H. ROUSE and M. A. ROUSE, Illiterati et uxorati. Manuscripts and their Makers. Commercial

Book Producers in Medieval Paris 1200–1500, 2 vols. Turnhout 2000.
pp. 98–101: HERMANN, pp. 5, 48–52. – E. MADAS, Die in der Österreichischen Nationalbibliothek erhaltenen Handschriften des ehemaligen Augustiner-Chorherrenstiftes St Dorothea in Wien. *Codices manuscripti* 8 (1982), pp. 81–114, esp. 89. – PFÄNDTNER CX.

pp. 108–123: P. BUBERL, Die illuminierten Handschriften in Steiermark. 1. Teil: Die Stiftsbibliotheken zu Admont und Vorau (*Beschreibendes Verzeichnis der illuminierten Handschriften in Österreich*, vol. 4). Leipzig 1911, pp. 27–33. – H. SWARZENSKI, Two Unnoticed Leaves from the Admont Bible. *Scriptorium* 10 (1956), pp. 94–96. – T. WEHLI, Die Admonter Bibel. *Acta historiae artium* 23 (1977), pp. 173–285. – L. MEZEY, Wie kam die Admonter Bibel nach Ungarn? *Codices manuscripti* 7 (1981), pp. 48–51. – Admont Giant Bible: the complete manuscript with a codological and art-historical introduction by A. FINGERNAGEL, on CD-ROM. Purkersdorf 1998. – A. FINGERNAGEL, Die Admonter Riesenbibel (*Codices illuminati* 1). Graz 2001.

pp. 124–127: MAZAL–UNTERKIRCHER, pp. 261–263. – E. MÜLLER, Geschichtlicher Abriß des Stiftes Lilienfeld seit 1700. Lilienfeld 1979, p. 316. – M. ROLAND, Buchschmuck in Lilienfelder Handschriften (*Studien und Forschungen aus dem Niederösterreichischen Institut für Landeskunde* 22). Vienna 1996, pp. 18–24 passim. – FINGERNAGEL–ROLAND, pp. 3–6. – A. HAIDINGER and F. LACKNER, Die Handschriften des Stiftes Lilienfeld. Anmerkungen und Ergänzungen zu Schimeks Kata-

log. *Codices manuscripti* 18/19 (1997), pp. 49, 57 ff.

pp. 128–137: Die Gotik in Niederösterreich. Kunst und Kultur einer Landschaft im Spätmittelalter. Exhibition in Krems-Stein. Vienna 1959, nos. 92 and 106. – G. SCHMIDT, Italienische Buchmaler in Österreich. *Alte und moderne Kunst* 6, vol. 48 (1961), p. 3. – IRBLICH, no. 12. – FINGERNAGEL–ROLAND, pp. 65–78 and 286–289 (with extensive bibliography).

pp. 138–151: J. V. SCHLOSSER, Die Bilderhandschriften Königs Wenzel I. *Jahrbuch der Kunsthistorischen Sammlungen des Allerhöchsten Kaiserhauses* 14 (1893), pp. 214–317. – KRÁSA. – M. THOMAS, G. SCHMIDT, M. KRIEGER, Die Bibel des Königs Wenzel. Graz 1989. – H. HEGER, I. HLAVÁČEK, G. SCHMIDT, Commentary volume accompanying the facsimile edition of the Wenceslas Bible. Graz 1998. – K. HRANITZKY, Die schönsten Bilder aus der Wenzelsbibel. Graz 1998.

pp. 152–157: K. HOLTER, Die Korczek-Bibel der Österreichischen Nationalbibliothek, *Die Graphischen Künste*, new series 3 (1938), p. 81. – K. STEJSKAL, Votivní obraz v klášterní knihovně v Roudnici. *Umění* 8 (1960), pp. 568 f. – G. SCHMIDT, Malerei bis 1450, in: Gotik in Böhmen. Munich 1969, pp. 244, 245 – KRÁSA, pp. 216, 278. – H. HLAVÁČKOVÁ, Die Buchmalerei des Schönen Stils, in: Prag um 1400. Vienna 1990, pp. 128, 129.

pp. 158–163: HERMANN 5/3, pp. 38–46. –PFÄNDTNER, pp. 94–96. – FINGERNAGEL–ROLAND, pp. 347–348 (M. ROLAND).

pp. 164–175: A. BRÄM, Illuminierte Breviere. Zur Rezeption der

Anjou-Monumentalkunst in der Buchmalerei, in: T. MICHALSKY (ed.), Medien der Macht. Kunst zur Zeit des Anjous in Italien. Berlin 2001, pp. 295-317 (with further bibliography). - E. IRBLICH, G. BISE, Die Bibel von Neapel (Altes Testament), Handschrift aus dem 14. Jahrhundert. Geneva 1978. - M. ROLAND, Apokalypse-Zyklus einer neapolitanischen Bibel, in: PETSCHAR, pp. 186-193.

pp. 176-187: W. WALTHER, Die deutsche Bibelübersetzung des Mittelalters. Braunschweig 1889, pp. 250, 254, 401-413. - K. ESCHER, Die "Deutsche Prachtbibel" der Wiener Nationalbibliothek und ihre Stellung in der Basler Miniaturmalerei des XV. Jahrhunderts. *Jahrbuch der kunsthistorischen Sammlungen in Wien* 36 (1923-25), pp. 47-96. - H. MENHARDT, Verzeichnis der altdeutschen literarischen Handschriften der Österreichischen Nationalbibliothek. Berlin 1960/61, pp. 272 f.

pp. 188-197: G. SCHMIDT, Buchmalerei, in: Gotik in Österreich, Exhibition catalogue. Krems a. d. Donau 1967, pp. 169 f. - K. HOLTER, Buchmalerei, in: J. GASSNER (ed.), Spätgotik in Salzburg. Die Malerei 1400-1530. Exhibition catalogue. Salzburg 1972, p. 240 (no. 276). - F. UNTERKIRCHER, Die datierten Handschriften der Österreichischen Nationalbiblitohek von 1451 bis 1500 (*Katalog der datierten Handschriften in lateinischer Schrift in Österreich* III). Vienna 1974, p. 25. - G. SCHMIDT, Ein unbekanntes Werk Ulrich Schreiers in Polen, in: Von Österreichischer Kunst, Festschrift Franz Fuhrmann, published by the Institut für Kunstgeschichte der Universität Salzburg. Klagenfurt 1981, pp. 37-41.

pp. 198-205: PÄCHT-JENNI, pp. 16-23 (with older bibliography). - The Golden Age of Dutch Manuscript Painting. Catalogue to the exhibition in the Rijksmuseum Het Catharijneconvent, Utrecht, 10.12.1989-11.2.1990, and in The Pierpont Morgan Library, New York, 1.3.1990-6.5.1990. Stuttgart and Zurich 1989. - K. VAN DER HORST, Masters and miniatures: proceedings of the Congress on Medieval Manuscript Illumination in the Northern Netherlands, (Utrecht, 10-13 December 1989) (*Studies and facsimiles of Netherlandish illuminated manuscripts* 3). Doornspijk 1991.

pp. 212-219: HERMANN 6/3, pp. 110-120. - P. D'ANCONA, La miniatura fiorentina nei secoli XI-XVI. Florence 1912, vol. 1, pl. LXXXIV, vol. 2, no. 1410. - E. GAMILLSCHEG, B. MERSICH, O. MAZAL, Matthias Corvinus und die Bildung der Renaissance. Handschriften aus der Bibliothek und dem Umkreis des Matthias Corvinus aus dem Bestand der Österreichischen Nationalbibliothek. Catalogue of an exhibition mounted by the Österreichische Nationalbibliothek (Manuscripts and Incunabula Department), 27.5 - 6.10.1994. Graz 1994, pp. 87 f. (with further bibliography).

pp. 220-223: HERMANN 1, pp. 141-143. - BISCHOFF no. 13. - FILLITZ, pp. 13, 200 and no. 7. - H. SCHABER, Salzburger Buchmalerei unter Bischof Virgil (746/47, 749-784). Doctoral thesis. Salzburg 1998, pp. 9 f., 12, 84 f., 113, 122-127, 147, 150, 153, 160, 164, 177, 188, 196.

pp. 224-227: HERMANN 1, pp. 155-156. - BISCHOFF, pp. 120 f., 132.

pp. 228-231: HERMANN 2, pp. 176-178. - C. PFAFF, Scriptorium und Bibliothek des Klosters Mondsee im hohen Mittelalter (*Österr. Akad. der Wiss., Veröff. der Komm. für Gesch. Österr.* 2). Vienna 1967, pp. 97 f., no. 26. - PETSCHAR, pp. 329 f. (C. EGGER).

pp. 232-235: A. ENDRES, Das St Jakobsportal in Regensburg und Honorius Augustodunensis. Beitrag zur Ikonographie und Literaturgeschichte des 12. Jahrhunderts. Kempten 1903, pp. 32-36. - G. SWARZENSKI, Die Salzburger Malerei von den ersten Anfängen bis zur Blütezeit des romanischen Stils. Stuttgart 1913 (reprinted Stuttgart ²1969), esp. pp. 94 f. - HERMANN 2, pp. 135-138. - E. KLEMM, Die romanischen Handschriften der Bayerischen Staatsbibliothek II (*Katalog der illuminierten Handschriften der Bayerischen Staatsbibliothek in München* III/2). Wiesbaden 1988, cat. 196 on the manuscript group). - FILLITZ, cat. 216 (M. PIPPAL).

pp. 236-241: M. REEVES, The Influence of Prophecy in the Later Middle Ages. Oxford 1969 (reprinted Notre Dame 1993). - M. REEVES, B. HIRSCH-REICH, The *Figurae* of Joachim of Fiore. Genuine and Spurious Collections. *Mediaeval and Renaissance Studies* 3 (1954), pp. 170-199. - M. REEVES, B. HIRSCH-REICH, The *Figurae* of Joachim of Fiore. Oxford 1972. - H. GRUNDMANN, Ausgewählte Aufsätze 2. Joachim von Fiore (*Schriften der Monumenta Germaniae Historica* 25, 2). Stuttgart 1977. - R. E. LERNER, Joachim von Fiore, in: *Theologische Realenzyklopädie* 17 (1988), pp. 84-88.

pp. 242-245: HERMANN 3, pp. 39-40. - O. MAZAL, E. IRBLICH, I. NÉMETH, Wissen-

schaft im Mittelalter. Exhibition of manuscripts and incunabula in the Österreichische Nationalbibliothek, 1975. Vienna ²1980, p. 156 (no. 118). – L. HÖDL, Petrus Lombardus, in: *Biographisch-Bibliographisches Kirchenlexikon* 7 (1994), pp. 360–369.

pp. 246-249: S. R. DALY, Peter Comestor: Master of Histories. *Speculum* 32 (1957), pp. 62–73. – B. SMALLEY, The Study of the Bible in the Middle Ages. Oxford ³1983. – D. LUSCOMBE, Peter Comestor, in: Katherine WALSH, Diana WOOD (eds.), The Bible in the Medieval World. Essays in Memory of Beryl Smalley. Oxford 1985, pp. 109–129.

pp. 250-253: M. GRABMANN, Thomas von Aquin. Persönlichkeit und Gedankenwelt. Eine Einführung. Munich 1941. – C. CSAPODI, Bibliotheca Corviniana. Die Bibliothek des Königs Matthias Corvinus. Budapest 1969. – M.-D. CHENU, Das Werk des hl. Thomas von Aquin (German edition of the complete works of St Thomas Aquinas, suppl. vol. 2). Graz, Vienna, Cologne ²1982. – C. G. CONTICELLO, San Tommaso ed i padri: La Catena Aurea Super Ioannem, *Archives d'histoire doctrinale et littéraire du moyen age* 65 (1990), pp. 31–92.

pp. 254-257: H. LABROSSE, Biographie de Nicolas de Lyre. *Études Franciscaines* 17 (1907), pp. 489–505. – H. HAILPERIN, Rashi and the Christian Scholars. Pittsburgh 1963. – H. DE LUBAC, Exégèse médiévale II, 2. Paris 1964. – M. A. SCHMIDT, Nikolaus von Lyra, in: *Theologische Realenzyklopädie* 24 (1994), pp. 564–566 (with further bibliography). – P. D. W. KREY, L. SMITH (eds.), Nicholas of Lyra. The Senses

of Scripture. Leiden, Boston, Cologne 2000.

pp. 258-267: HERMANN 6/1, pp. 59–74. – C. HUTER, Cristoforo Cortese at the Bodleian Library. *Apollo* (January 1980), p. 14. – W. BAIER, K. RUH, Ludolf von Sachsen, in: *Die deutsche Literatur des Mittelalters. Verfasserlexikon* 5 (²1984), pp. 967–977 – G. MARIANI CANOVA, Miniatura e pittura in età tardogotica (1400–1440), in: M. LUCCO (ed.), La pittura nel Veneto. Il Quattrocento I. Milan 1989, pp. 193–222, esp. 199 ff.

pp. 274-279: HERMANN 6/2, pp. 38–42. – P. S. MOORE, The Works of Peter of Poitiers. Notre-Dame, Ind. 1936. – MAZAL, p. 100. – A. FINGERNAGEL, *De fructibus carnis et spiritus*. Der Baum der Tugenden und der Laster im Ausstattungsprogramm einer Handschrift des Compendiums des Petrus Pictaviensis (Wien, Österreichische Nationalbibliothek, Cod. 12 538). *Wiener Jahrbuch für Kunstgeschichte* 46/47 (1993/94), pp. 173–185. – Magister Petrus Pictaviensis, Genealogia Christi. Barcelona 2000.

pp. 280-285: HERMANN 7/2, pp. 168–177. – K. KOSHI, Die Wiener "Histoire universelle" (Cod. 2576) unter Berücksichtigung der sogenannten Cottongenesis-Rezension. Doctoral thesis. Vienna 1971. – K. KOSHI, Die Genesisminiaturen in der Wiener "Histoire universelle" (Cod. 2576). (*Wiener kunstgeschichtliche Forschungen* I). Vienna 1973. – D. OLTROGGE, Die Illustrationszyklen zur "Histoire ancienne jusqu'à César" (1250–1400). (*Europäische Hochschulschriften*, series XXVIII, Kunstgeschichte,

vol. 94). Frankfurt/Main (et al.) 1989, pp. 43, 320–323 and passim. – M. DE VISSER-VAN TERWISGA, Histoire ancienne jusqu'à César (Estoires Rogier), 2 vols. (*Medievalia* 19; 30). Orleans 1995, 1999. – K. KOSHI, Die Miniaturen der heidnisch-antiken Mythologie und Geschichte in der Wiener "Histoire universelle". *Bulletin of The Faculty of Fine Arts, Tokyo National University of Fine Arts and Music* 34 (1999), pp. 3–97.

pp. 286-301: H. MODERN, Die Zimmern'schen Handschriften der k. k. Hofbibliothek. *Jahrbuch der kunsthistorischen Sammlungen des allerhöchsten Kaiserhauses* 20 (1899), pp. 113–180, esp. 144 f. (no. 22). – H. VOLLMER, Materialien zur Bibelgeschichte, vol. I/1: Ober- und mitteldeutsche Historienbibeln. Berlin 1912, pp. 95–104 (no. 33), pl. XI. – J. A. ASHER, Der übele Kneht, in: H. BACKES (ed.), Festschrift für Hans Eggers zum 65. Geburtstag (*Beiträge zur Geschichte der deutschen Sprache und Literatur* 94, special ed.). Tübingen 1972, pp. 16–427 (on the scribe). – M. and H. ROOSEN-RUNGE, Das spätgotische Musterbuch des Stephan Schriber. Wiesbaden 1981, vol. 2: Commentary, pp. 179–200, esp. 187–190, ill. pp. 218 f. (entry by the scribe and list of expenses). – V. BLOH, pp. 278 f. and passim, ill. 84–86.

pp. 302-315: H. VOLLMER, Materialien zur Bibelgeschichte und religiösen Volkskunde des Mittelalters, vol. I/1: Ober- und mitteldeutsche Historienbibeln. Berlin 1912, pp. 156 f. (no. 63), pl. XVI. – K. HOLTER, Die Wiener Buchmalerei, in: Geschichte der bildenden Kunst in Wien, vol. 2: R.K. DONIN (ed.), Gotik. Vienna 1955, p. 226. – G. KORNRUMPF, Die österreichischen

Historienbibeln IIIa und IIIb, in: H. REINITZER (ed.), Deutsche Bibelübersetzungen des Mittelalters (Vestigia Bibliae 9/10, 1987/88), Berne (et al.) 1991, pp. 350–374, here 359–365. – IDEM, Die "Weltchronik" Heinrichs von München, in: P. STEIN, A. WEISS, G. HAYER (eds.). Festschrift für Ingo Reiffenstein zum 60. Geburtstag (Göppinger Arbeiten zur Germanistik 478). Göppingen 1988, pp. 508 f. – V. BLOH, pp. 318 f. and passim, ill. 82 f.

pp. 316–329: A. W. BYVANCK and G. J. HOOGEWERFF, Noord-Nederlandse miniaturen in handschriften der 14e, 15e, 16e eeuwen. 3 vols. The Hague 1922–1925. – J. G. HOOGEWERFF, De Noord-Nederlandse schilderkunst, vol. I. S'Gravenhage 1936, pp. 535 ff., ill. 296–304, 306–307, 309–311, 316–318. – P. J. H. VERMEEREN, De Nederlandse Historiebijbel der Oestenrijkse Nationale Biblioteek, Codex 2771 en 2772. Het Boek 32 (1955–57), pp. 101–189. – J. DESCHAMPS, Middelnederlandse handschriften uit Europese en Amerikaanse bibliotheeken. Leiden ²1972, no. 50. – PÄCHT-JENNI, pp. 43–85, ill. 80–261, colour pl. IV-VII.

pp. 336–347: R. BRANNER, Manuscript Painting in Paris during the Reign of Saint Louis. A Study of Styles. Berkeley, Los Angeles, London 1977, Cod. 2554: pp. 3, 6, 33 passim, fig. 26c, 39–46; Cod. 1179: pp. 3, 33 passim, fig. 2 (p. 34), 3 (p. 35), 26a, b, 27–38. – Bible moralisée: Codex Vindobonensis 2554 der Österreichischen Nationalbibliothek. Commentary by R. HAUSSHERR. French Bible text transl. by H.-W. STORK. Graz 1992. – S. LIPTON, Images of intolerance: the representation of Jews and Judaism in the Bible moralisée. Berkeley 1999. – J. LOWDEN, The making of the bibles moralisées, 2 vols. Pennsylvania 2000.

pp. 348–355: H. CORNELL, Biblia pauperum. Stockholm 1925, pp. 83 f. – G. SCHMIDT, Der Codex 370 der Wiener Nationalbibliothek. Wiener Jahrbuch für Kunstgeschichte 17 (22) (1956), pp. 15–48. – SCHMIDT, pp. 15 f. – Krumauer Bildercodex. Österreichische Nationalbibliothek Codex 370. Facsimile edition (Codices selecti 13). Commentary volume by G. SCHMIDT and F. UNTERKIRCHER. Graz, Vienna, Cologne 1967. – G. SCHMIDT, Die Fresken von Strakonice und der Krumauer Bildercodex. Umění 41 (1993), pp. 145–152.

pp. 356–361: SCHMIDT, pp. 10 f., 60 ff. (with older bibliography). – [Facsimile edition:] Die Wiener Biblia pauperum. Codex Vindobonensis 1198. Ed., transcribed and transl. by F. UNTERKIRCHER. Introduction by G. SCHMIDT (3 vols.). Graz, Vienna, Cologne 1962 – FRITZSCHE, pp. 51 ff. – FINGERNAGEL – ROLAND, pp. 261–264 (cat. 105) (M. ROLAND). – G. BRUCHER (ed.), Geschichte der Bildenden Kunst in Österreich, vol. II, Gotik. Munich 2000, pp. 511–512 (cat. 248) (M. ROLAND).

pp. 362–371: G. SCHMIDT, Die Malerschule von St Florian. Beiträge zur süddeutschen Malerei zu Ende des 13. und im 14. Jahrhundert. Graz, Cologne 1962, esp. pp. 87 f., 150 ff. – F. UNTERKIRCHER, Ambraser Handschriften. Ein Tausch zwischen dem Kunsthistorischen Museum und der Nationalbibliothek im Jahre 1936. Jahrbuch der kunsthistorischen Sammlungen in Wien 59 (1963), pp. 225–264, here 235 (on older bibliography). – Die Zeit der frühen Habsburger. Exhibition, Wiener Neustadt 1979. Vienna 1979, cat. 248 (G. SCHMIDT). – FRITZSCHE, pp. 91–92. – FINGERNAGEL–ROLAND, pp. 293–302 (cat. 123) (M. ROLAND).

pp. 378–381: A. Z. SCHWARZ, Die Hebräischen Handschriften der Nationalbibliothek in Wien (Museion. Nationalbibliothek publication, Vienna, essay, vol. II). Vienna, Prague, Leipzig 1925, p. 11 (no. 11). – T. METZGER, Les arts du livre (calligraphie, décoration, reliure) chez les juifs d'Espagne, à la veille de l'expulsion, 1492, in: R. GOETSCHEL (ed.), L'expulsion des juifs d'Espagne. Maisonneuve et Larose 1996, pp. 163–182, esp. 166, note. 13.

pp. 382–387: K. WEITZMANN, Die byzantinische Buchmalerei des 9. und 10. Jahrhunderts (Österr. Akad. d. Wiss., Phil.-hist. Kl., Denkschriften 243, Veröff. d. Komm. für Schrift- und Buchw. des Mittelalt., series IV, vol. 2, part 1). Vienna 1996 (= reprint of the Berlin edition of 1935) – BUBERL-GERSTINGER, pp. 7–13. – H. BUCHTHAL, A Byzantine Miniature of the Fourth Evangelist and its Relatives. Dumbarton Oaks Papers 15 (1961), p. 130. – HUNGER-LACKNER-HANNICK, pp. 134–136.

pp. 388–393: BUBERL-GERSTINGER, pp. 50–58. – H. HUNGER, C. HANNICK, Katalog der griechischen Handschriften der Österreichi-schen Nationalbibliothek, Teil 4: Supplementum graecum (Museion, Österreichische Nationalbibliothek publication, new series, vol. 1, Part 4). Vienna 1994, pp. 97–100. – I. SPATHARAKIS, A Dove whispers in the Ear of the Evangelist. Jahrbuch der Österreichischen Byzantinistik 49 (1999), pp. 267–288.

pp. 394-403: IORGA, pp. 45-53, fig. 27-76. - Mittelalterliches Bulgarien. Exhibition of manuscripts and maps held in the Österreichische Nationalbibliothek, 24.5-15.10.1977. Vienna 1977, pp. 20-22. - BIRKFELLNER, pp. 113-116. - C. COSTEA, Ilustraţia de manuscris în mediul cărturăresc al mitropolitului Anastasie Crimcovici. Apostolul (Viena, Nationalbibliothek cod. sl. 6), in: Studii şi cercetări de istoria artei, *Seria Artă Plastică* 39 (1992), pp. 41-57.

pp. 404-409: IORGA, pp. 45-53, pl. I-VI. - S. HAFNER, B. Kopitar und die slawischen Handschriften der Athosklöster. *Südost-Forschungen* 18/1 (1959), pp. 89-122. - BIRKFELLNER, 86-88. - P. Š. NĂSTUREL, Le Mont Athos et les Roumains. Recherches sur leurs relations du milieu du XIVᵉ siècle à 1654 (*Orientalia Christiana Analecta* 227). Rome 1986, pp. 180-202. - J. PROLOVIČ, Tetraevangeliar aus Studenica, in: Studenica et l'art byzantin autour de l'année 1200 (*Colloques scientifiques de l'Académie Serbe des Sciences et des Arts*, vol. XLI, Classe des sciences historiques, vol. 11). Belgrad 1988, pp. 525-533. - W. LUKAN, Bartholomäus Kopitars "Bibliothekarischer Bericht" - Ein Dokument des Austroslawismus und die Probleme seiner Veröffentlichung. *Österreichische Osthefte* 37/1 (1995), pp. 147-194.

pp. 410-413: S. GRILL, Vergleichende Religionsgeschichte und Kirchenväter. Beigabe: Die syrischen Handschriften der Nationalbibliothek in Wien (*Heiligenkreuzer Studien* 11). Horn, Lower Austria 1959, p. 54. - W. STROTHMANN, Die Anfänge der syrischen Studien in Europa (*Göttinger Orientforschungen* 1). Wiesbaden 1971, pp. 11-15. - B. ALAND, Bibelübersetzungen I. (4. Die Übersetzungen ins Syrische) 4.2. Neues Testament, in: *Theologische Realenzyklopädie* 6 (1980), pp. 189-196. - A. BREYCHA-VAUTHIER, Description du manuscrit de Vienne, in: C. ABOUSSOUAN (ed.), Le livre et le Liban jusqu'à 1900. Paris 1982, pp. 126-127. - D. G. K. TAYLOR, S. P. BROCK, The Hidden Pearl: The Syrian Orthodox Church and its Ancient Aramaic Heritage, vol. III. Rome 2001, pp. 163-164.

pp. 414-419: H. and H. BUSCHHAUSEN, Armenische Handschriften der Mechitharisten-Kongregation in Wien. Catalogue to a special exhibition in the Österreichische Nationalbibliothek. Vienna ²1981. - C. BURCHARD (ed.), Armenia and the Bible, Papers Presented to the International Symposium Held at Heidelberg, July 16-19, 1990 (*University of Pennsylvania Armenian Texts and Studies* 12). Louvain 1993. - W. SEIBT (ed.), The Christianization of the Caucasus (Armenia, Georgia, Albania). Lectures at the International Symposium in Vienna, 9-12 December 1999 (*Österr. Akad. der Wiss., Phil.-hist. Kl., Denkschriften* 296.; *Veröff. der Komm. für Byzantinistik*, vol. IX). Vienna 2002. - M. K. KRIKORIAN, Die armenische Kirche, Materialien zur armenischen Geschichte, Theologie und Kultur. Frankfurt/Main, Berlin (et al.) 2002. - M. E. STONE, D. KOUYMJIAN, H. LEHMANN, Album of Armenian Paleography. Aarhus 2002.

pp. 420-425: Aethiopien - Buchmalereien. Introduction by J. LEROY, texts by S. WRIGHT and O. A. JÄGER. Paris 1961. - E. HAMMERSCHMIDT, Äthiopien - Christliches Reich zwischen Gestern und Morgen. Wiesbaden 1967. - E. HAMMERSCHMIDT, O. A. JÄGER, Illuminierte äthiopische Handschriften (*Verz. der Orient. Hss. in Deutschland* 15). Wiesbaden 1968 - E. ULLENDORF, Ethiopia and the Bible. Oxford 1968. - P. BRANDT, Geflecht aus 81 Büchern: Zur variantenreichen Gestalt des äthiopischen Bibelkanons. *Aethiopica* 3 (2000), pp. 79-115.

pp. 426-429: G. FLÜGEL, Die arabischen, persischen und türkischen Handschriften der Hofbibliothek zu Wien, vol. 3. Vienna 1865, cat. no. 1544. - G. GRAF, Geschichte der christlichen arabischen Literatur, vol. 1. Vatican City 1944. - S. H. GRIFFITH, The Gospel in Arabic. An Enquiry into its Appearance in the First Abbasid Century. *Oriens Christianus* 69 (1985), pp. 126-167. - J.-D. THYEN (ed.), Bibel und Koran. Eine Synopse gemeinsamer Überlieferungen. Cologne 1989.

pp. 430-437: P. WITTEK, Der Stammbaum der Osmanen. *Der Islam* 14 (1925), pp. 94-100. - Muhammad ibn Ramadan, Darwis: Subhatu'l-Ahbar (Haberler Tesbihi). Vienna, Österr. Nationalbibliothek, Cod. A. F. 50. Facsimile edition of the Dogan Kardes (with accompanying texts by S. RADO, Y. ÖZTUNA und K. HOLTER). Istanbul 1968. - Muhammad ibn Ramadan, Rosenkranz der Weltgeschichte. Complete reprint of Codex Vindobonensis A. F. 50 in the original format. Graz 1981. - PETSCHAR, pp. 210-211 (RUMPF-DORNER).

Detail from fol. 8v-9r of the Greek Gospel Book (Matthew) (ill. p. 386)

Glossary

(Sources: *Imagination –
Zeitschrift für Freunde des
alten Buches* (vol. 1993, issue
1, pp. 28–31, and issue 2,
pp. 19–23), edited by Manfred
Kramer and chief editor Norbert
Cziep. Akademische Druck- und
Verlagsanstalt, Graz; *Lexikon
des gesamten Buchwesens;
Lexikon des Mittelalters; Lexikon
für Theologie und Kirche*

AMBO

(Medieval Lat., from Gk. *ámbon*,
perhaps becoming *anabaínein* =
to go up.) Pulpit or lectern in a
church from where parts of the
service were performed.

ANTITYPE ▶ TYPE

APOCALYPSE

(Gk. *apokalypsis* = revelation.)
Text in which the course and
end of the world are propheti-
cally disclosed in visions, as
in the (Secret) Revelation of
John, the last book of the New
Testament. Describes the im-
minent collapse of the world,
followed by the defeat of Satan
and the advent of the kingdom
of heaven.

ARISTOTELIANISM

Term used to describe various
philosophical models based
on the writings of Aristotle
(384–322) from Stageira (Mac-
edonia). Aristotle was known
to the West in the Middle Ages
above all through translations
of his works from the Arabic;
his philosophy formed the foun-
dation of western Scholasticism.

BIBLE MORALISÉE

(Fr. = "moralizing Bible".) A
type of picture Bible consisting
of short biblical passages and re-
lated commentaries and accom-
panied by an extensive cycle of
illustrations, comprising up to
2,700 pairs of typological pic-
tures, the majority in the shape
of medallions. Early examples
of the genre featured 8 picture
medallions per page (= 4 pairs).

BIBLIA PAUPERUM

(Lat. = "Bible of the poor".)
From the end of the 13th cen-
tury onwards, a widely-used de-
votional book in which the life
of Christ was portrayed from
a typological point of view and
illustrated accordingly. The
illustrations in such "Bibles
of the poor" thereby represent
the most important source for
our understanding of typology.
In their entirety they provide
a compendium of a tradition
which reaches back to early
Christian times and within
which the instructional and
pictorial system of Christian
art evolved.

BLIND LINES ▶ BLIND TOOLING

BLIND STAMPING ▶ BLIND TOOLING

BLIND TOOLING

Method of decorating a book
binding, whereby lines or orna-
mental designs were imprinted
into the leather with a heated
hand tool or stamp (blind
stamping), leaving a permanent
impression. As well as single
stamps, rollers and plates were
also used. The technique was
employed chiefly in the Middle
Ages.

CALLIGRAPHY

(Gr. *kalligraphia* = beautiful
script.) Fine writing by a scribe
or artist (calligrapher).

CATENA

(Lat. *catena* = chain.) Collection
of commentaries by the Church
Fathers on passages from the
Bible, which are written around
the actual biblical text (in their
most extensive form, in the
margins on all four sides of
the page) and which are cross-
referenced to the corresponding
passage in the main text. In
terms of page design, catena
commentaries are usually writ-
ten in a smaller script and are
clearly distinguished from the
main text.

COLOPHON

(Gk. = final writing.) Conclud-
ing remarks in a manuscript or
incunabulum giving details of
the scribe or printer and the title,
place and date of production.

CORRUPTION

(Lat. *corrumpere* = break into
pieces, destroy.) Term used in
textual criticism to describe
a word or sequence of words
that, in the course of being tran-
scribed from one manuscript
to the next, has been rendered
incorrectly or altered; we also
speak of "corrupt" passages of
text.

DROLLERY

(Fr. *drôlerie* = amusing idea.)
Hybrid figures of men or beasts
and other fabulous creatures,
appearing in the scrollwork
on the pages of Gothic manu-
scripts and also in initials and
borders. They inhabit the edge
of the page and often form
self-contained scenes. Not only
do they reveal – particularly in
the drolleries of the late Mid-
dle Ages – a tendency towards
satire (and thereby towards a
critique of society?), but they
also offer an ironic commentary
on the official practices of art,
particularly in their representa-
tion of demons.

EPISTOLARIUM

(Lat. *epistola* = letter.) Collec-
tion of letters.

FLEURONNÉE

(Fr. *fleuronné* = flowered.) A
form of decoration characteris-
tic of manuscript illumination
in the Gothic era, chiefly used
with initials. In most cases com-
bined with the body of a letter
which has been developed out
of the shape of a Lombard ini-
tial. Depending on their degree
of elaboration, *fleuronnée* forms
are essentially abstract; they
commonly employ the stylized
forms of palmettes and buds
as well as filigree and pearls,
which embroider the main body
of the letter and spill into the
margin beside it. This form of
decoration probably evolved
out of the French and English
silhouetted initials of the Late
Romanesque era.

FLORATOR

Artist responsible for painting
the *fleuronnée* initials in manu-
scripts. In highly developed
scriptoria, a specialist, but
sometimes one and the same
person as the scribe or artist
executing the miniatures.

FLORENSIAN ORDER

The Order formed when
Joachim of Fiore (*c.* 1130–1202)
left the Cistercian order in
around 1190 and founded his
own monastery of S. Giovanni
di Fiore in the Sila mountains in
Calabria. Joachim was granted
papal approval for his new
Order, which embraced a strict
version of the Benedictine Rule.
The monastery had numerous
affiliates. The Order expanded
only within Italy and existed
until 1570.

GOSPEL BOOK

(Lat. *evangelium*, from Gk.
euangelion = good news.) Litur-
gical book which contains the
complete texts of the four Gos-
pels. It also includes the various
prefaces and other theological
matter (canon tables, divisions
into sections and chapter lists).
The capitularies accompany-
ing the Gospel texts helped the
reader locate the pericopes to
be read during divine service
throughout the liturgical year.
The Gospel Book was equated
in notional terms with Christ
and its text commanded the
same reverence as Christ
himself.

GRADUAL

(Lat. *gradus* = step.) Service
book containing the variable
and unchanging antiphons sung
during the Mass.

HAPHTARAH
(PL. HAPHTAROTH)

(Heb. = conclusion.) Reading
selected from the Prophets, read
in the synagogue service on the
Sabbath.

ICONOCLASTIC
CONTROVERSY

In the 6th century the venera-
tion of icons of Christ assumed
the form of an imperial cult
in the Byzantine Empire. This
veneration was intensified by
legends of miracles worked by
individual icons. In 726, as part
of an opposition movement,
Emperor Leo III declared the
use and veneration of icons
a punishable offence. With
this, the iconoclastic contro-
versy broke out in full strength.
Countless works of art were de-
stroyed and monks supportive
of icon-worship were martyred.
The first phase of the iconoclas-
tic controversy ended in 787; a
second phase lasted from 815
until 843.

ICONOGRAPHY

(Gk. *eikón* = image.) Study of
images; academic method con-
cerned with the traditions by
which subjects are represented
in art, as opposed to the history
of form or style. Knowledge of
the subject-matter portrayed
and its religio-historical, literary
and social significance is seen

as a prerequisite for understanding a work of art.

ILLUMINATOR
The artist responsible for the decoration of a manuscript (with miniatures, ornamental initials, borders).

IMPRESE
(It. *impresa* = emblem.) Comparable with more general emblems and devices, imprese employ a combination of word and image to create a personalized statement of an individual's goals and values. These brief and often puzzling emblems were first introduced at the Burgundian court and later spread to Italy.

INITIAL
(Lat. *initium* = introduction, beginning.) Opening letter of a section of text in manuscripts or incunabula, emphasized by its size, script and decoration. Fish and bird motifs, interlace and scrollwork often feature in initials. In the Gothic era initials also incorporated miniatures, mostly of biblical scenes and sometimes occupying a full page.

LEONINE VERSE
A special type of hexameter employed in Latin verse of the Middle Ages, in which each line has a rhyme in the middle (caesura at the third stress) and at the end, as in *Aethiopum terras iam fervida torruit aestas* (Ecloga Theoduli).

LIMP BINDING
A type of binding particularly common in the later Middle Ages, in which the covers are made not of wooden boards, but of soft, flexible material. The gatherings were attached to the limp binding using a special technique (kettle stitching).

LOMBARD INITIALS
Simple decorative initials found in Gothic manuscripts and in printed books of the Late Gothic era. Usually executed in either red or blue, they are sometimes ornamented by means of gaps in the body of the letter. They display a characteristically round-bellied form.

MAJUSCULE
(Lat. *littera maiuscula* = slightly larger letter.) Capital letter. Script type whose letters are the same height and can be fitted between two parallel horizontal lines. By the High and Late Middle Ages, employed only as a display script.

MARTYROLOGY
(Lat. *martyrologium*.) Ecclesiastical calendar of Christian martyrs, organized by feast day; the Greek pendant, containing the saints of the liturgical year, is the menology (Gk. *menologion* = list of months).

MASORAH
(Heb. = tradition.) The body of critical notes made by Jewish scholars in Babylonia and Palestine from the 7th to the 10th century and designed to ensure

the correct handing down of the Old Testament text. The word is derived from the Hebrew root *masar*, "to hand over, transmit".

MATUTINAL
(Lat. *matutinus* = of the morning.) Book containing the morning prayers.

MENOLOGY ▶ MARTYROLOGY

MIAPHYSITISM
Theological position within the christological dispute which divided the Eastern Church in the 5th and 6th century, and which held that in the person of Christ there was only one single, divine nature; Jesus the man had transformed himself into the divine Christ. An attempt to reach a compromise at the Council of Chalcedon in 451 failed. The excommunication of the Miaphysites in the first half of the 6th century led them to break away from the main body of the Church. In Egypt, Syria and Mesopotamia, the Miaphysites held on to their schismatic position throughout the dispute.

MINUSCULE
Quattrolinear script of lower case letters, with ascenders and descenders filling the line spaces.

MISSAL
(Middle Lat. *missale* = Mass book.) Service book containing all the variable and unchanging texts of the Mass for the liturgi-

cal year. It was a compilation of several, originally separate liturgical books which each had a specific function. The first Missals appeared at the end of the 10th century and in the 12th century – as quiet, private saying of the Mass became increasingly popular – displaced the Sacramentary used in ceremonial, public worship. The Missal contains the complete liturgical cycle from the first Sunday of Advent until the last Sunday after Pentecost and the feasts of the saints. It also includes the daily prayers, the prefaces, the canon, the Common of Saints and various votive Masses.

MOROCCO (BINDING)
Term referring to a goatskin primarily used for book-binding and originally made chiefly in Morocco.

MOSAICIST
A mosaicist is an artist who works with mosaic gold or produces mosaics.

OCTATEUCH
(Gk. *oktáteukhos* = eight scrolls.) In the Eastern Church, the name by which the first eight books of the Old Testament (? Pentateuch plus Joshua, Judges and Ruth) are commonly known.

ORATIO MANASSE (PRAYER OF MANASSEH)
Psalm-like prayer of penitence, which according to 2 Chronicles 33:11 ff. is attributed to the converted King Manasseh, but

which was probably written in the Greek language in Palestine around the beginning of the Christian era.

PANDECT
(Gk. *pan* = all, *déchesthai* = to receive.) Complete Bibles, i.e. manuscripts containing all the books of the Old and New Testament.

PARASHA SYMBOLS
(Heb. = explanation.) Symbols, sometimes ornamental, usually noted in the margin, indicating the portion from the Torah read in the synagogue service.

PENTATEUCH
(Gr. *pentáteukhos* = five scrolls.) The first five books of the Old Testament.

PERICOPES
(Gr. *perikopé* = a shortening.) The selected passages from the Old and New Testament read out during the Mass over the course of the liturgical year.

PRAXAPOSTOLOS
(Gk. *Praxapóstolos*.) Lectionary used exclusively in the Eucharist and containing all the non-Gospel readings from the New Testament (with the exception of Revelation).

PREFIGURATION ▶ TYPE

PSALTER
(Gk. *psaltérion* = zither-like stringed instrument.) In the 9th century the Psalter was almost the only liturgical book in the

hands of the laity. It remained so until the arrival of the first Books of Hours at the end of the 13th century. The Psalter played a prominent role in the life of the laity and even more so in the life of the clergy. In the Middle Ages the Psalter was recited daily, outside the hours of divine service; every priest and monk had to know it by heart.

PSEUDO-CUFIC
Form of writing which outwardly resembles the Cufic script but which elaborates it into an ornamental script which pays no attention to the meaning of the words.

QUATREFOIL
A primarily Gothic decorative motif in which four semicircular arches describe a roughly square central field. Quatrefoils are chiefly found as framing elements in architecture, but are also employed in stained glass, wall painting and manuscript illumination.

RECTO
Recto (r) describes the right-hand page of a book which is lying open, i.e. the front side of a leaf in a codex. Manuscripts are numbered according to leaves, or folios, rather than pages. For example, 43 recto is the front side of the 43rd folio in the manuscript.

RITUAL
Book of rites used by a bishop, priest or deacon officiating at a sacrament.

Detail from fol. 13v of a Greek
illuminated manuscript (Matthew)
(ill. p. 390)

SEPTUAGINT
The oldest and most important
translation of the Old Testament
into Greek. The name derives
from a legend, according to
which 72 Jews completed the
translation in 72 days.

SQUARE SEPHAR-
DIC SCRIPT
Hebrew script which is almost
square in outline, used in the
Sefarad sphere (Spain and
southern France).

SUPRALIBROS
Decoration of a binding with a
coat of arms impressed onto the
cover, also serving as an indica-
tion of ownership.

TREE OF JESSE
The representation of the
ancestry of Christ according to
Isaiah (11:1), in the form of a
tree growing up out of the sleep-
ing Prophet's body and bearing
in its branches pictures (busts
and full-length portraits) of the
forefathers of Christ.

TYPE
Person or event in the Old Tes-
tament considered to prefigure
a person or event (antitype) in
the Christian world of the New
Testament.

VERSO
Verso (v) describes the left-hand
page of a book which is lying
open, i.e. the reverse side of a
leaf in a codex. Manuscripts are
numbered according to leaves,
or folios, rather than pages.
For example, 43 verso or 43v is
the back of the 43rd leaf in the
manuscript.

VESPERAL
(Lat. *vesper* = evening.) Book
containing the words and
hymns to be used at vespers.

VULGATE
The Latin translation of the
Bible made by St Jerome at the
end of the 4th and beginning of
the 5th century.

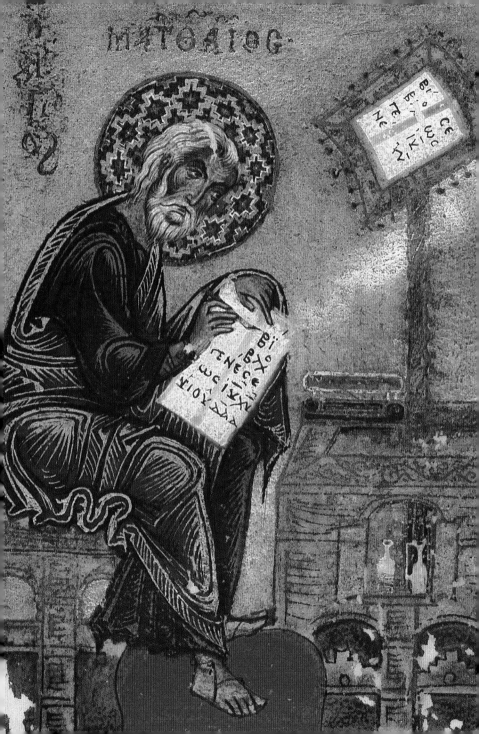

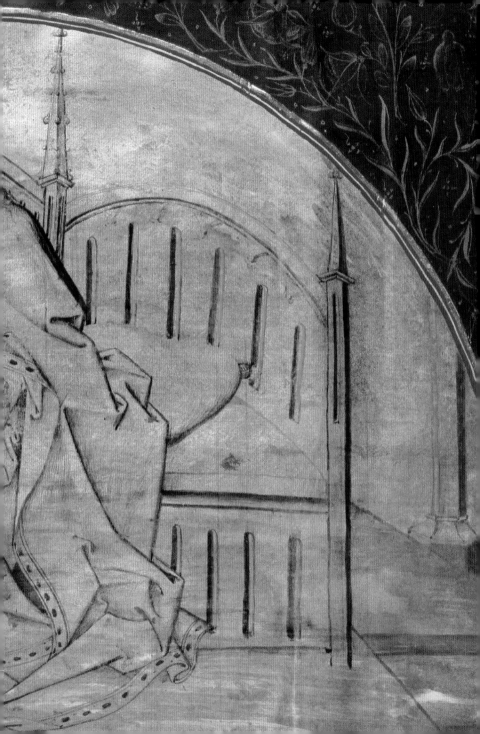

Index of authors

Dr Christine BEIER (C. B.)
Österreichische Akademie der
Wissenschaften
Institut für Kunstgeschichte der
Universität Wien, Pächt-Archiv

Dr Andreas FINGERNAGEL (A. F.)
Österreichische Nationalbibli-
othek
Handschriften-, Autographen-
und Nachlass-Sammlung

Prof. Dr Stephan FÜSSEL (S. F.)
Johannes Gutenberg-Universi-
tät, Mainz
Institut für Buchwissenschaft

PD Dr Christian GASTGEBER
(C. G.)
Österreichische Akademie der
Wissenschaften
Institut für Mittelalter-
forschung, Abteilung Byzanz-
forschung

Dr Katharina HRANITZKY (K. H.)
Österreichische Akademie der
Wissenschaften
Institut für Kunstgeschichte der
Universität Wien, Pächt-Archiv

Dr Ulrike JENNI (U. J.)
Österreichische Akademie der
Wissenschaften
Institut für Kunstgeschichte der
Universität Wien, Pächt-Archiv

Erzbischof Hon.-Prof. Dr Mes-
rob K. KRIKORIAN (M. K. K.)
Patriarchal-Delegat für Mittel-
europa und Schweden
Armenisch-apostolische Kirche
Wien

Prof. Dr Clemens LEONHARD
(C. L.)
Westfälische Wilhelm-
Universität Münster, Seminar
für Liturgiewissenschaften

Dr Karl-Georg PFÄNDTNER
(K.-G. P.)
Bayerische Staatsbibliothek
Handschriftenerschließungs-
zentrum

Gabriele PINKAVA (G. P.)
Österreichische Akademie der
Wissenschaften
Institut für Mittelalter-
forschung, Abteilung Byzanz-
forschung

Dr Veronika PIRKER-AUREN-
HAMMER (V. P.-A.)
Österreichische Galerie
Belvedere
Sammlung Mittelalter

PD Dr Mihailo POPOVIĆ (M. P.)
Österreichische Akademie der
Wissenschaften
Institut für Mittelalter-
forschung, Abteilung Byzanz-
forschung

Ao. Universitätsprofessor
Stephan PROCHÁZKA (S. P.)
Universität Wien
Institut für Orientalistik

Mag. Solveigh RUMPF-DORNER
(S. R.-D.)
Österreichische National-
bibliothek
Sammlung von Inkunabeln,
alten und wertvollen Drucken

Mag. Friedrich SIMADER (F. S.)
Österreichische Nationalbibli-
othek
Handschriften-, Autographen-
und Nachlass-Sammlung

Mag. Maria THEISEN (M. T.)
Österreichische Akademie der
Wissenschaften
Kommission für Schrift und
Buchwesen des Mittelalters
(Schwerpunkt: Ostmitteleuropa)

PD Dr Martin WAGENDORFER
(M. W.)
Universität Wien
Institut für Österreichische
Geschichtsforschung

◄ History Bible of Evert van
Soudenbalch, Cod. 2771, detail
from fol. 8v: Left-hand side of the
double-page diptych: God the
Father enthroned.

Acknowledgements

The editors and publisher wish to thank all the authors who have contributed to the making of this book. We are especially grateful to the University of Vienna, the Austrian Academy of Sciences and the University of Mainz for their constructive co-operation.

Our thanks also go to the many members of staff at the Austrian National Library for their unstinting support in the Photographic Studio, the Institute of Restoration, the Department of Reprography, the Incunabula and Valuable Prints Collection, and lastly the Manuscripts, Autographs and Bequests Collection.

The editors would like to take this opportunity to thank the publisher once again for the energetic commitment and scrupulous attention to detail brought to this project.

1000 Chairs

1000 Lights

Decorative Art 50s

Decorative Art 60s

Decorative Art 70s

Design of the
20th Century

domus 1950s

Logo Design

Scandinavian Design

100 All-Time
Favorite Movies

The Stanley Kubrick
Archives

**Bookworm's delight:
never bore, always excite!**

TASCHEN
Bibliotheca Universalis

20th Century
Photography

A History of
Photography

Stieglitz.
Camera Work

Curtis. The North
American Indian

Eadweard Muybridge

Karl Blossfeldt

Norman Mailer.
MoonFire

Photographers A–Z

Dalí. The Paintings

Hiroshige

Leonardo.
The Graphic Work

Modern Art

Monet

Alchemy & Mysticism

Braun/Hogenberg.
Cities of the World

Bourgery. Atlas of
Anatomy & Surgery

D'Hancarville.
Antiquities

Encyclopaedia
Anatomica

Martius.
The Book of Palms

Seba. Cabinet of
Natural Curiosities

The World
of Ornament

Fashion. A History from
18th–20th Century

100 Contemporary
Fashion Designers

Architectural Theory

The Grand Tour

20th Century
Classic Cars

1000 Record Covers

1000 Tattoos

Funk & Soul Covers

Jazz Covers

Mid-Century Ads

Mailer/Stern.
Marilyn Monroe

Erotica Universalis

Tom of Finland.
Complete Kake Comics

1000 Nudes

Stanton.
Dominant Wives

Imprint

Page 1:
Vienna Genesis, Cod. theol. gr. 31, detail from fol.
1r: The Fall in three scenes: Eve offers Adam the apple.

Pages 2/3:
Lilienfeld Bible, Cod. Ser. n. 2594, detail from fol. 8v
(Genesis): The Creation of Adam and Eve.

Pages 4/5:
History Bible, Cod. 2823, detail from fol. 103v
(Exodus): Moses has ascended Mount Sinai and receives the Tablets of the Law from God.

Pages 6/7:
Bible moralisée, Cod. 2554, detail from fol. 3r
(Genesis): God gathers up Enoch.

Page 8:
Greek Gospels and Praxapostolos, Cod. suppl. gr. 52, detail from fol. 1v: Representation of the Trinity, surrounded by an angelic host.

Endpapers:
Neapolitan Luxury Bible, Cod. 1191, fol. 23v–24r
(Genesis, Exodus): Jacob prophesies to his sons. Death of Jacob. On the right, the sons of Israel enter Egypt.

EACH AND EVERY TASCHEN BOOK PLANTS A SEED!
TASCHEN is a carbon neutral publisher. Each year, we offset our annual carbon emissions with carbon credits at the Instituto Terra, a reforestation program in Minas Gerais, Brazil, founded by Lélia and Sebastião Salgado. To find out more about this ecological partnership, please check: www.taschen.com/zerocarbon
Inspiration: unlimited. Carbon footprint: zero.

To stay informed about TASCHEN and our upcoming titles, please subscribe to our free magazine at www.taschen.com/magazine, follow us on Twitter, Instagram, and Facebook, or e-mail your questions to contact@taschen.com.

Project management: Petra Lamers-Schütze, Cologne
Translation: Karen Williams, Whitley Chapel
Design: Birgit Eichwede, Cologne
Production: Horst Neuzner, Cologne

Printed in China
ISBN 978-3-8365-5913-3

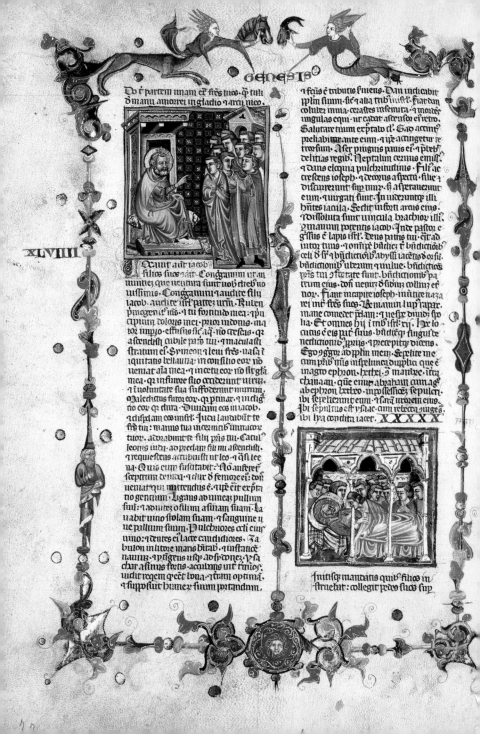

do e partem unam extra fres tuos. qua tuli
di manu amorrei in gladio + arcu meo.

XLVIIII Vocauit aut iacob
filios suos + ait. Congregamini ut an
nuntiem que uentura sunt uob; diebz no
uissimis. Congregamini + audite filii
iacob. audite isrl patrem urm. Ruben
p̄mogenitꝰ m̄s. tu fortitudo mea. + princi
pium doloris mei. prior in donis ma
ior imp̄io. effusus es sic aq̄. no crescas. qa
ascendisti cubile p̄ris tui. + maculasti
stratum eiꝰ. Symeon + leui frēs. uasa i
niquitatis bellātia. in consilio eor no
ueniat aīa mea. + in cetu eor no sit glā
mea. qa in furore suo occiderunt uirū.
+ in uoluntate sua suffoderunt murum.
Maledictus furor eor. qa pertinax. + in
dignatio eor. qa dura. Diuidam eos in iacob.
+ dispergam eos in isrl. Iuda laudabunt te
frēs tui. manus tua in ceruicib; inimicor
tuor. adorabunt te filii p̄ris tui. Catul̄
leonis iuda. ad predam fili mi ascendisti.
+ requiescens accubuisti ut leo. + q̄si lee
na. Quis suscitabit eum. No auferet
sceptrum de iuda + dux de femore eiꝰ. donec
ueniat qui mittendus est. + ip̄e erit exp̄c
tatio gentium. Ligans ad uineam pullum
suum. + ad uineam asinam suam. La
uabit uino stolam suam. + sanguine u
ue pallium suum. Pulchriores oculi eiꝰ
uino. + dentes eius lacte candidiores. Za
bulon in littore maris habitabit. + in statio
ne nauium. pertingens usq; ad sydonem. Ysa
char asinus fortis. accubans int terminos.
uidit requiem q̄ esset bona. + terram optima.
+ supposuit humerum suum ad portandum.

i factus e tributis s̄uiens. Dan iudicabit
ppl̄m suum sic + alia tribus in isrl. Fiat dan
coluber in uia. cerastes in semita. + mordens
ungulas equi. ut cadat ascensor eiꝰ retro.
Salutare tuum exp̄ctabo d̄ne. Gad accinc
tꝰ prehabit ante eum. + ip̄e accingetur re
trorsum. Aser pinguis panis eiꝰ. + p̄bebit
delicias regib;. Neptalim ceruus emissꝰ.
+ dans eloquia pulchritudinis. Filiꝰ ac
crescens ioseph. + decorus aspectu. filie
discurrerunt sup murum. Sed exasperauer̄t
eum. + iurgati sunt. In uiderunt illi
h̄entes iacula. Sedit in forti arcus eiꝰ.
+ dissoluta sunt uincula brachior illiꝰ.
p manus potentis. Inde pastor egressus est lapis isrl. Deus p̄ris tui erit ad
iutor tuus. + omnip̄s b̄ndicet tibi b̄ndictionib;
celi desup. b̄ndictionib; abyssi iacentis deor
sum. b̄ndictionib; uberum + uulue. b̄ndictiones
p̄ris tui + fortitudine sunt. b̄ndictionib; pa
trum eiꝰ. donec ueniret desiderium collium eter
nor. Fiant in capite ioseph. + in uertice naza
rei int frēs suos. Beniamin lupus rapax.
mane comedet p̄dam. + uespere diuidet spo
lia. Et omnes hii in tribubz isrl. xij. Hec lo
cutus est eis pater suus. b̄ndixitq; singulis
b̄ndictionib; p̄priis. + precepit eis dicens.
Ego aggregor ad ppl̄m meum. Sepelite me
cum patrib; meis in spelunca duplici. que e
in agro ephron hethei. contra mambre. in
terra chanaan. quam emit abraham cum agro
ab ephron hetheo. in possessionem sepulcri.
Ibi sepelierunt eum. + saram uxorem eiꝰ.
Ibi sepultus est ysaac cum rebecca coniuge.
Ibi + lya condita iacet. L.

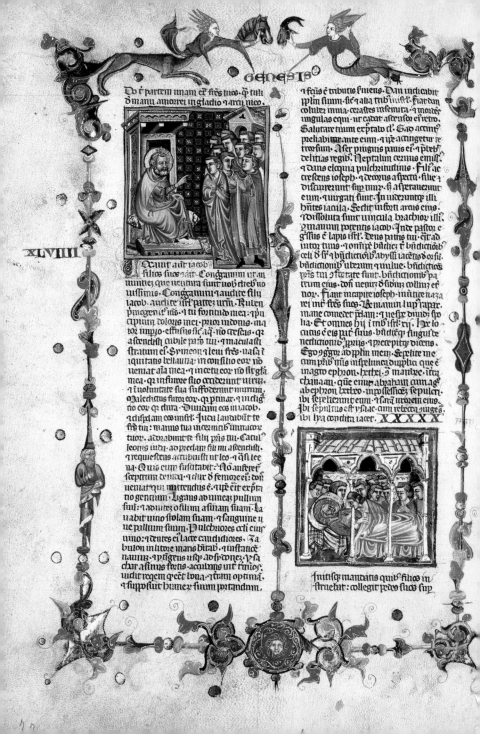

Finitisq; mandatis quib; filios in
struebat. collegit pedes suos sup